A Visitor's Guide

The Detroit Institute of Arts

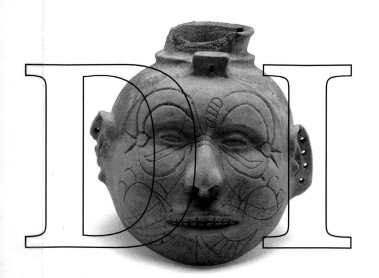

A Visitor's Guide

The Detroit Institute of Arts

Edited by Julia P. Henshaw

The Detroit Institute of Arts

in association with

Wayne State University Press

© 1995 The Detroit Institute of Arts
Founders Society

Julia P. Henshaw, Director of Publications

Elaine D. Gustafson, Assistant Editor

Matthew Sikora and Melinda Guerin,
Editorial Assistants

**This publication received a generous
grant from the Getty Grant Program and
was also supported by Metropolitan
Detroit Cadillac Dealers, the State of
Michigan, the City of Detroit, and the
Founders Society**

Distributed by Wayne State University
Press, 4809 Woodward Avenue, Detroit,
Michigan 48201–1309

Library of Congress Cataloging-in-
Publication Data

Detroit Institute of Arts.
 The Detroit Institute of Arts: a
visitor's guide / edited by Julia P.
Henshaw.
 p. cm.
 Includes index.
 ISBN 0–8143–2618–8 (cl. : alk:
paper). — ISBN 0–8143–2619–6
(pbk. : alk. paper)
 1. Art—Michigan—Detroit—
Catalogs. 2. Detroit Institute of Arts—
Catalogs. I. Henshaw, Julia P. (Julia
Plummer), 1941– II. Title.
N560.A529 1995
708.174'34—dc20 95–32832
 CIP

Table of Contents

This visitor's guide highlights more than 700 works of art from our permanent collection. It provides useful information about the museum's history, collection, services, and programs. It also contains ideas to help you look at, think, and talk about art. This guide serves as clear evidence that one of America's greatest museum collections is in Detroit. Visitors are the reason museums exist as public places, open to all. *Welcome.*

DIA HISTORY

DIA COLLECTION

The works of art illustrated here have been chosen by the museum's curators as some of the most important and interesting objects in the DIA. While the texts contain some art-historical information and intriguing facts about each piece, the real meaning of any work of art lies in its connection to you and your life. Visual language is universal and the diverse cultures represented in this guide allow us to communicate with people from distant times and places and to discover different ways of looking at the world. There is much to learn about the world through art.

Remember that the museum building itself is also a work of art and enjoy its architecture and rich decorative detail. We hope that this guide will encourage you to visit our galleries often and take full advantage of the cultural and educational experiences that exploring a great art museum can offer.

SAMUEL SACHS II, DIRECTOR

1883

The Detroit Art Loan Exhibition showed painting and sculpture by American and European artists as well as odd bric-a-brac.

1885

The Art Loan excited enough local interest to lead to the founding of the Detroit Museum of Art.

1888

The Detroit Museum of Art opened in a romanesque-style building on Jefferson Avenue just east of downtown.

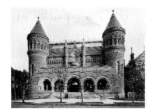

1889

J. W. Dunsmore, a painter from Ohio, was appointed the first director of the Detroit Museum of Art. He held the post for only seventeen months, but taught in the museum art school until 1894.

1896

Armand Griffith, the second director of the museum, began a series of Sunday lectures on subjects ranging from art history to the customs and life in foreign lands.

1896

The first automobile was commercially produced in Detroit.

1885

1900

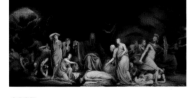

1885

The Court of Death was among the earliest gifts to the Detroit Museum of Art. It entered the collection after the artist toured it across America, charging admission to see the painting.

1889

The new museum received a gift of eighty old-master paintings from Detroit newspaper publisher James A. Scripps, including works by Rubens and De Hooch.

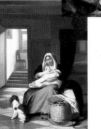

1895

Once in the possession of General George Armstrong Custer, this Cheyenne shield became part of the collection.

1905–10
Detroit schoolchildren visit
the Detroit Museum of Art.

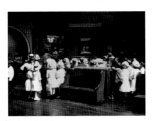

1913
The Ford Motor Company,
founded in 1903, achieved
the remarkable production
rate of 1,000 cars per day.

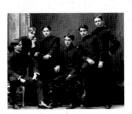

1902
Guard staff of the Detroit
Museum of Art.

1910
Three blocks of empty land on
Woodward Avenue were set aside
for a larger museum building in
Detroit's new Cultural Center.

1914
Charles Moore, a Detroit
newspaperman, became the
third museum director.

1914
World War I begins overseas.

DIA HISTORY
1901
DIA COLLECTION

1914
Seventy-two works by modern American
painters, including Arthur Davies, were
shown in response to the controversial
Armory Show held the previous year.

1911–1919
Works by contemporary American
painters were acquired, such as
these by Melchers and Bellows.

1922
The ground was broken for the new DIA building on Woodward Avenue. It was conceived as a home for both the visual and performing arts.

1929–1935
The DIA's situation during the Great Depression paralleled the dire financial situation of the country, with drastic cuts in staff and reduced activities and services.

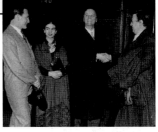

1932
Director William Valentiner (center) and patron Edsel Ford (left) welcome Diego Rivera and his wife Frida Kahlo to Detroit.

1924
William Valentiner, a professional art historian from Berlin, was named director.

1927
The new museum building, designed by architect Paul Cret, opened in October. More than 200,000 people visited it within three months.

1940

1923
Examples of architecture were acquired, including this French Gothic chapel, in order to display the entire range of the arts.

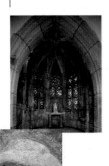

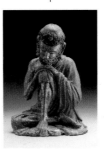

1929
Śākyamuni was an important addition to the Asian collection.

1932
Rivera painting the east wall of the *Detroit Industry* frescoes.

1926
This Benin Queen Mother sculpture shows Director

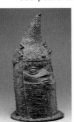 Valentiner's appreciation for the art of many peoples and cultures.

1922
This *Self Portrait* became the first painting by van Gogh to enter a museum collection in the United States.

1941–45

During World War II, art objects were given priority ratings for possible evacuation from the museum. "The Art of War" exhibition was installed.

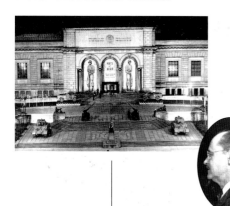

1949

"Design for Modern Living" exhibited contemporary furniture and decoration. Simulated rooms showed the most up-to-date in modern interior design.

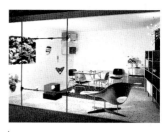

1945

Director E. P. Richardson was an expert in American painting and Flemish art. His writings on the history of painting in America became standard texts for the time.

DIA HISTORY
1941
DIA COLLECTION

Building the American Collection
Founders Society president Dexter M. Ferry, Jr., gave many notable American paintings in the 1940s and '50s, including *The Trapper's Return* and *Watson and the Shark*.

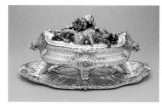

1953

Mrs. Harvey S. Firestone, Jr., began donating her impressive collection of French 18th-century silver, including this tureen, to the museum.

1948

W. Hawkins Ferry (Dexter Ferry's son) collected modern art and supported the museum's efforts to acquire contemporary art, as the *Space Modulator* by Moholy-Nagy indicates.

1961
"Flanders in the 15th Century" was composed of examples of medieval Flemish works of art.

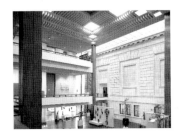

1970s–80s
An active publications program produced permanent collection and special exhibtion catalogues.

1962
"Vincent van Gogh" drew a record attendance of 146,654.

Willis Woods, a specialist in Asian art, was appointed director.

1965
The South Wing was the first expansion of the museum building since 1927. Some of the new space was used to display the growing collection of African and 20th-century Art.

1963
More than 150,000 attended "The Treasures of Tutankamen."

1971
The North Wing opened. It consolidated and expanded office spaces, the library, workshops, and the shipping area. It also provided new gallery space.

1974
Frederick Cummings, curator of European art, became director.

Blockbuster Exhibitions
The early '60s marked the beginning of a number of major exhibitions.

1980

Important Gifts and Bequests
The collection was greatly enhanced by significant bequests from early museum supporters.

1970
Robert Hudson Tannahill bequeathed the fruits of his lifetime of collecting: 557 objects in all. The Matisse *Poppies* is a colorful favorite.

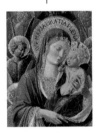

1977
Eleanor Ford left this painting by Benozzo Gozzoli in her bequest to the DIA.

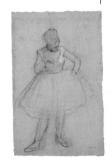

1965
This *Ballet Dancer* by Degas is one of the collection of more than 400 prints, drawings, and watercolors that John Newberry left to the museum.

1971
The *Mantle Clock* was among the contents of Mrs. Horace Dodge's music room, bequeathed to the DIA.

1985

Samuel Sachs II, a specialist in 19th-century European art, was appointed director.

The DIA mounted three centennial exhibitions: "Diego Rivera," "Italian Art in the Time of Donatello," and "Automobile and Culture, Detroit style."

1985

In honor of the DIA centennial, this *Madona and Child* by Luca della Robbia was chosen for the U.S. Christmas stamp.

1983

The first Children's Day was held at the DIA.

1994

The Partnership for Renewal campaign raised $26 million for the DIA.

DIA HISTORY
1981
DIA COLLECTION

1983–1988 Centennial Acquisitions

To celebrate the DIA's centennial, special acquisitions were made, including the Korean *Buddha* and the *Pedestal Clock*.

1991 and 1992

The collection continued to grow, with purchases of paintings by Heade and Lichtenstein.

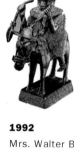

1992

Mrs. Walter B. Ford donated this African Equestrian Figure from her collection to the DIA.

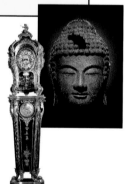

1983

Romare Bearden was commissioned to create the mosaic *Quilting Time*.

Acknowledgments

The concept for this visitor's guide was developed by Julia P. Henshaw, Director of Publications, working with Rob Wittig, of Ligature, Chicago, and Mitchell Rice, Tony Porto, and Glenn Deutsch of Three Communication Design, Chicago. Essential support was provided by many staff members especially those in the Photography, Publications, and Education Departments.

The texts were written by members of our staff, whose names appear below. We acknowledge their willingness to be flexible and understanding of the somewhat unusual demands that such a collaborative approach requires.

Without a generous grant from the Getty Grant Program, this ambitious project would have been impossible to execute, and our thanks go to Metropolitan Detroit Cadillac Dealers for their support as well.—SS II

For a more complete history of the DIA, see William H. Peck, *The Detroit Institute of Arts: A Brief History*, 1991

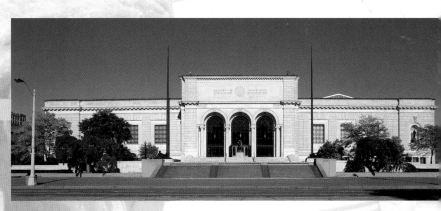

Authors

African, Oceanic, and New World Art
Michael Kan
David Penney
Lisa Roberts
Matthew Sikora
Joseph Trottier

American Art
Nancy Rivard Shaw
James W. Tottis
Roxanne Stanulis
Kurt Wunderlich

Ancient Art
Elsie Holmes Peck
William H. Peck
Penelope Slough

Asian Art
Laurie Barnes
Mary Louise Totten

European Art
Tracey Albainy
Peter Barnet
Elena Calvillo
Alan P. Darr
Elaine D. Gustafson
Julia P. Henshaw
Lisa Kochanski
Mary Beth Kreiner
Iva Lisikewycz
J. Patrice Marandel
Phyllis Ross
Axel Rüger
Samuel Sachs II
Susan Vicinelli

Graphic Arts
Nancy Barr
Ellen Sharp
Nancy Sojka

20th-Century Art
Bonita Fike
Karla Loring
Jan van der Marck
MaryAnn Wilkinson

Film and Video
Lawrence Baranski
Elliot Wilhelm

How to Use This Book

This guide is intended to help make your visit to the DIA more enjoyable and meaningful. The works of art included here have been chosen by the curators as good examples of the art of different cultures. But there's no substitute for a visit to the museum to see the original works in the galleries, in a building specially designed to display them. When you visit, you can choose your favorites.

Collections

The collections within this guide are arranged alphabetically by department name and then either thematically or chronologically. You'll find specific section names in this corner.

Art

Each piece of art included in this book is accompanied by some information about it from the museum staff. The entire collection numbers more than 60,000 items, of which approximately 20,000 are works on paper.

Details

The details throughout this guide give you a closer look at the art from our collection. It's like having your own magnifying glass with you.

All objects in the museum are original works of art. Only a small percentage are on view at any given time. This is because the DIA loans works to other museums throughout the world for special exhibitions; works are sometimes removed for conservation treatment or photography; and many works of art are kept in storage.

Mesopotamia

Mesopotamia, the land between the Tigris and Euphrates Rivers, was the fertile river plain where civilization was born and where writing first appeared. Southern Mesopotamia was under the control of a series of kings from 3000 B.C. to the 6th century B.C. In its early history, Mesopotamia was a collection of agricultural city-states. These later gave way to larger centrally controlled empires which spread through conquest.

Gudea of Lagash
2141–22 B.C.; Mesopotamian, Neo-Sumerian period; Paragonite; height 41 cm (16 1/8 in.); Founders Society Purchase, Robert H. Tannahill Foundation Fund; 82.64

Of all the rulers of ancient Mesopotamia, Gudea, *ensi* (governor) of Lagash, emerges the most clearly across the millennia due to the survival of many of his religious texts and statues. He ruled his city-state in southeast Iraq for twenty years, bringing peace and prosperity at a time when the Guti, tribesmen from the north eastern mountains, occupied the land. His inscriptions describe vast building programs of temples for his gods.

This statuette depicts the governor in worship before his gods wearing the persian-lamb fur cap of the *ensi* and a shawl-like fringed robe with tassles. The serene, heavily lidded eyes and calm pose create a powerful portrait of this pious ruler.

A Sumerian cuneiform inscription on Gudea's back describes the building of a temple to the goddess Geshtinanna, consort of Gudea's personal god, and the making of this statue for her.

Glossary

Look for red words in captions or within the text. These words are defined in the glossary, pages 316–317.

Special Information

These boxes are full of intriguing facts about artists and the works they created. Look here for information that's beyond what you might expect to find.

DETROIT CONNECTION

Keep an eye out for this feature too! It points out special connections between the city of Detroit and donors, artists, and works of art.

Please Don't Touch

Works of art in museums are very fragile, even those made of stone and metal. This is why we ask you not to touch.

However, there is one exception to this rule. The *Donkey* is the only piece in the DIA that *can* be touched. It was purchased in 1928 by DIA Director William Valentiner after he saw children playing with another cast of this *Donkey* in the Berlin zoo.

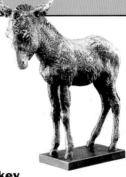

Page Numbers

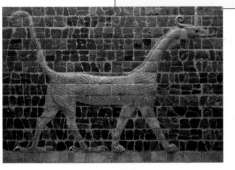

94
95

The mythical *Dragon of Marduk* with scaly body, serpent's head, viper's horns, front feet of a feline, hind feet of a bird, and a scorpion's tail, was sacred to the god Marduk, principal deity of Babylon.

Donkey
1927; Renée Sintenis (German, 1888– 1965); Bronze; height 77 cm (30 1/2 in.); City Appropriation; 28.181

Dragon of Marduk
ca. 604–562 B.C.; Mesopotamian, Neo-Babylonian period; from the Ishtar Gate, Babylon; Molded, glazed bricks; 1.2 x 1.7 m (45 1/2 x 65 3/4 in.); Founders Society Purchase; 31.25

The striding dragon was a portion of the decoration of one of the gates of the city of Babylon. King Nebuchadnezzar, whose name appears in the Bible as the despoiler of Jerusalem (Kings II 24:10–16, 25:8–15), ornamented the monumental entrance gate dedicated to Ishtar, the goddess of love and war, and the processional street leading to it with scores of pacing glazed brick animals: on the gate were alternating tiers of Marduk's dragons and bulls of the weather god Adad; along the street were the lions sacred to Ishtar. All of this brilliant decoration was designed to create a ceremonial entrance for the king in religious procession on the most important day of the New Year's Festival.

Reconstruction of the Ishtar Gate in the Vorderasiatisches Museum, Berlin

MESOPOTAMIA

DIA ANCIENT ART

How to Read a Caption

The first line of the caption is the title of the work. Next comes the year the work was completed; then the artist's name if known, followed by his or her nationality and dates of birth and death; the materials used; the object's dimensions (height and width); and finally a credit line telling how the work was acquired (by gift or purchase fund); and the museum's accession number (this is a catalog system that identifies each work, beginning with the year in which it was acquired).

Cross references

You'll find cross references for more information about certain topics or artists.

Location

This corner helps you locate major sections within the book. For example, these two pages are from the Ancient Art section and are specifically about Mesopotamian art.

DIA A VISITOR'S GUIDE HOW TO USE THIS BOOK

The Museum Building

There are galleries on all three floors of the DIA, as illustrated on the maps below. Our administrative offices and Research Library occupy most of the third floor. The core of the building was designed in the 1920s; two large wings were added on north and south in the 1960s.

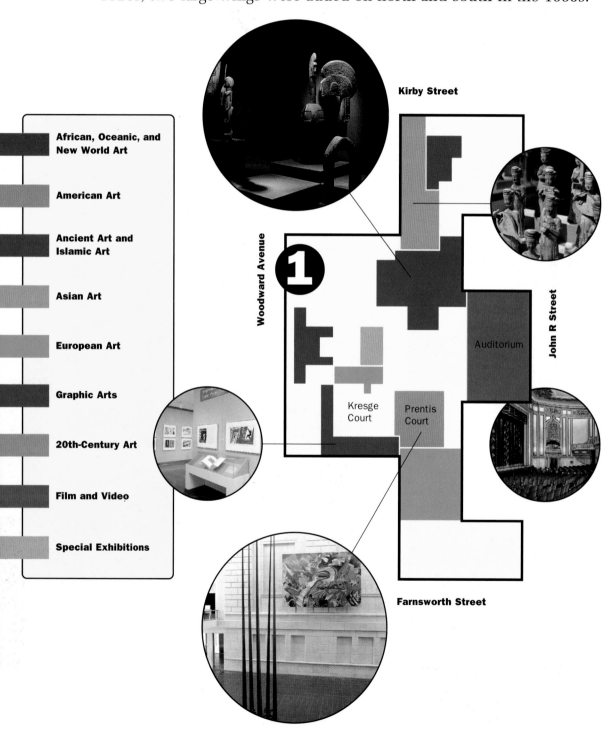

African, Oceanic, and New World Art

American Art

Ancient Art and Islamic Art

Asian Art

European Art

Graphic Arts

20th-Century Art

Film and Video

Special Exhibitions

Kirby Street

Woodward Avenue

John R Street

Auditorium

Kresge Court

Prentis Court

Farnsworth Street

2

Great Hall

Rivera
Court

3

Administrative Offices

Museum Information

The Founders Society, a non-profit organization, provides major funding for museum projects, including acquisitions, special exhibitions, and publications. Membership benefits include free admission to the museum and all special exhibitions, a members-only discount at the DIA museum shops, and the satisfaction of knowing that you have helped support one of Michigan's finest cultural institutions, making it possible for us to provide outstanding programs for all our visitors.

Location
5200 Woodward Avenue
Detroit, Michigan 48202–4904
Telephone 313–833–7900
TDD 313–833–1454
Facsimile 313–833–9169

The DIA is located in Detroit's University Cultural Center approximately two miles north of downtown Detroit.

Directions to the Museum
From I-94: Exit Woodward/John R, south three blocks
From I-75: Exit Warren, west four blocks to Woodward and north one block
From US-10: Exit Warren/Forest, east three blocks, north three blocks

Parking
Parking is available in an underground garage (Farnsworth at Woodward) or in metered spaces surrounding the museum building.

Hours
11 am–4 pm Wednesday through Friday
11 am–5 pm Saturday through Sunday
Closed Monday, Tuesday, some holidays

Admission
$4 Adults
$1 Children and students
(These are recommended fees; you may pay what you like but you must pay something).
Free to DIA members.

Food Services
Enjoy full meals or snacks at the Kresge Court Cafe, a self-service cafe; or the American Grille, a full-service restaurant; and the Crystal Gallery Cafe.

Information Center
Museum maps, brochures, and an introductory video are located in the Farnsworth lobby.

Classes and Lectures
For current information, call us at 313–833–7978.

Museum Shops
Visit our museum shops for publications, jewelry, and gift items related to the museum's collection; DIA Founder's Society members receive 10% discount on purchases over $5. The shop is open during museum hours. Satellite shops are located at Twelve Oaks Mall, Novi, and the Somerset Collection, Troy.

Research Library
The Research Library is open to qualified individuals by appointment. Call 313–833–7936.

Ticket Office
Tickets may be purchased in advance of museum events. Call 313–833–2323.

Tours
Hour-long introductory tours of the museum collection are conducted for the general public: Wednesday through Saturday at 1 pm; Sunday at 1 and 2:30 pm.

Tours are also available for school groups and adult groups; please call 313–833–7951.

Volunteer Opportunities
There are many interesting and vital functions that volunteers perform for the museum. For information call 313–833–0247.

The Collection

D I A

The name of the Department of African, Oceanic, and New World Cultures reflects the fact that art museums are thoroughly rooted in European traditions of art making and aesthetics. In the 19th century, art museums were conceived to house artistic productions derived from these "fine arts" traditions and to instruct the public about European "high culture." Objects made by African woodcarvers or Native American bead workers were completely excluded from many art museums in the past because they did not fit the European-based definitions of art. While this was not true of the DIA, whose collection includes important examples of these "non-western" cultures acquired early in its history, the art of these geographically and socially disparate cultures is still lumped together in one department.

1

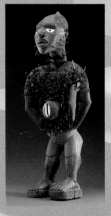

In the late 20th century, the understanding of how "art" is defined has become a culturally relative issue, as each culture possesses its separate traditions of creativity and visual meaning.

The objects displayed in the galleries of this department ask the visitor to leave behind any Eurocentric conceptions about "art" and try on a different culture's point of view.

"Art" as customarily experienced in a museum is an object that is isolated and singled out for aesthetic contemplation. On the other hand, the Camel Saddle made by the Tuareg people of Saharan Africa would have been experienced by its owner as a useful piece of equipment, as well as a satisfyingly decorated one. The saddle was lavished with ornament because the transportation camels offered was fundamental to the Tuareg way of life as traders and organizers of caravans. When the saddle is displayed in an art museum, it is treated as if it were art in the European tradition. The object then has a foot in both worlds: the world of the Tuareg where camel saddles are lavishly decorated, and the world of the art museum, where special categories of objects function in the cultural role of "art."

Similar observations can be made about the storage *Basket* made by a Western Apache woman of Arizona. She made it to fulfill a utilitarian purpose, but a woman's skill in making baskets was also a measure of her stature in society. Her baskets represented family wealth and their designs often descended from mother to daughter, with each generation adding variations based on dreams, which were considered gifts from the spirit world. The cultural traditions of Apache basketry promoted creative and technical virtuosity.

On a basic level, objects allow us to enter into another world. As a purely visual experience, we can appreciate how the arcs of the two elongated faces on the ends of the Easter Island *Gorget* echo the crescent of the gorget itself. The shape of this ornament is based upon the most precious material recognized by Easter Islanders: the milky-white tooth of a sperm whale. These "jewels" were handed down from father to son, and with each generation they accumulated the power, or mana, of the ancestor. The crescent faces on the ends of the gorget are jewels that have become ancestors, their heads conforming to that treasured shape. The art of African, Oceanic, and New World cultures pose a special challenge to the museum visitor: to see the collections as objects of visual delight, but then to learn something of the different cultural traditions that informed the creation of the objects.

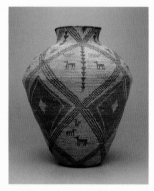

3

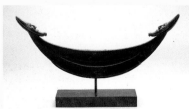

4

For nearly four hundred years the magnificent African kingdom of Benin flourished in present-day Nigeria. Divine kings, or *obas,* dominated almost every aspect of their subjects' political, religious, and social lives. Only kings could commission bronze works, so the art of casting bronze served to heighten the immense authority of the royal family. That power ended in the late 19th century when British troops destroyed Benin's capital city.

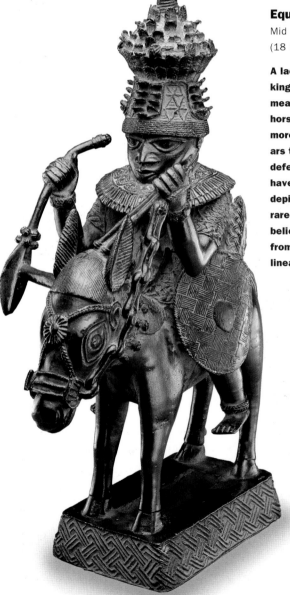

Equestrian Figure

Mid 16th century; Nigeria, Benin; Bronze; height 47 cm (18 1/2 in.); Gift of Mrs. Walter B. Ford; 1992.290

A lack of written records from many lost African kingdoms sometimes prohibits pinpointing the exact meaning of a work; the true identity of this bronze horse and rider, which was placed on royal altars more than three hundred years ago, has eluded scholars to this day. The figure, which may represent a defeated king or warrior from another culture, could have celebrated a great victory in battle. Or it could depict the Benin *oba* himself, since horses were a rare luxury reserved for royalty. Other scholars believe the rider commemorates Oranmiyan, a prince from a neighboring kingdom who founded the royal lineage and introduced horses to the new kingdom.

Oba Supported by Attendants

1500–1897; Nigeria, Benin; Bronze; height 40 cm
(15 3/4 in.); Founders Society Purchase, donation
from Mr. and Mrs. James A. Bereford; 72.435

In a culture without written records, these plaques
hung on the walls of interior courtyards of the royal
palace and served to recount important events
in the history of the kingdom. This work depicts a
king with a human torso but with legs formed
by mudfish; he needs the help of his two attendants
to stand. According to Benin tradition, ailing kings
who were thought to have lost their power were put
to death. After one legendary *oba's* legs became
paralyzed, he claimed his legs had been miraculously
transformed into mudfish to avoid execution.

The *oba's* ability to accomplish great things is
symbolized here by the elephant trunk ending in a
human hand.

elephant trunk with
human hand

frog

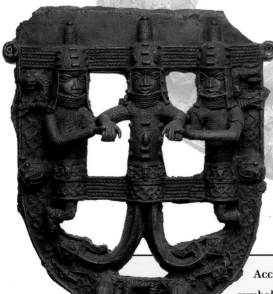

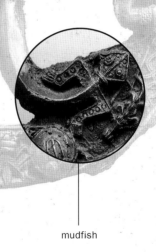

mudfish

According to tradition, the mudfish was a
symbol of Benin kings because both were
capable of crossing into different environments. The
African mudfish can move across both land and water; similarly,
kings were believed to move across both earthly and spiritual realms.
For the same reason, frogs and crocodiles also symbolize kings.

Many cultures believed their king possessed tremendous power because he had descended directly from mythological gods and goddesses. Queen mothers were often honored for their role in continuing the royal lineage. A Yoruba king once said, "Without the mothers, I could not rule."

Mother and Child

1850–1950; Cameroon, Bamileke; Wood; height 59 cm (23 in.); Founders Society Purchase, Eleanor Clay Ford Fund for African Art; 79.22

Before being granted full power to rule, newly installed Bamileke kings were required to father a child to prove their ability to continue the royal lineage. The mother of the king's first child was commemorated by a sculpture of this type; she was often elected head of domestic affairs and placed in charge of the king's other wives. Emphasizing this royal power, the mother is shown dispassionately looking ahead, while her child's body seems agitated and almost contorted in the act of feeding. These figures were generally placed at the entrance to a royal residence.

Mask (Ngaady-a-Mwash)

Late 19th–early 20th century; Zaire, Kuba; Wood, shells, beads, raffia, pigment; height 82 cm (32 1/2 in.); Founders Society Purchase, Mr. and Mrs. Allan Shelden III Fund, funds from the Friends of African Art and the Pierians, Inc.; 1992.215

The *Ngaady-a-Mwash* is one of a triad of masks that are danced to symbolize mythical characters and culture heroes important to the origins of Kuba kingship. Ngaady-a-Mwash is the sister and wife of the Kuba's legendary original king. The interplay between masked dancers who portray Ngaady-a-Mwash and two of her mythical suitors teaches the people the balance of power between the king and his subjects. These masks are worn during dances for initiation rites, funeral ceremonies, and royal gatherings.

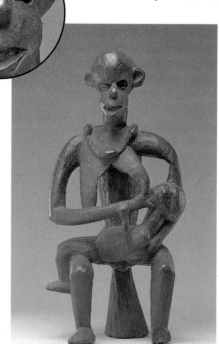

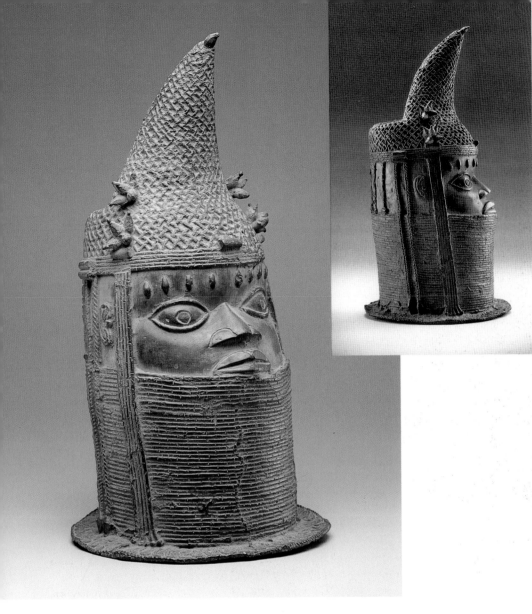

Royal Portrait

1750–1850; Nigeria, Benin; Bronze; height 53 cm (21 in.); City of Detroit Purchase; 26.180

This regal head commemorates the important central role in Benin politics fulfilled by the Queen Mother, or *iye oba*, who held the rank of a high chief. Her son, the king, consulted with her about all questions of leadership and policy-making during his reign. Ironically, all direct contact between the king and his mother was forbidden; they communicated from separate palaces through messengers. This bronze head, which shows the queen's distinctive "chicken's beak" hairdo, would have adorned the ancestral shrine established in her honor after her death.

Symbols of Royal Power

Most African art serves a practical purpose. For kings, even the smallest piece of jewelry helps secure their honored positions by publicly demonstrating royal wealth. Surrounded by attendants and luxurious objects produced by the finest craftsmen in their kingdoms, kings present an image of complete power to their subjects.

Soul-Washer's Badge

19th century; Ghana, Asante; Gold; diameter 8.6 cm (3 3/8 in.); Founders Society Purchase, New Endowment Fund, and Friends of African Art Fund; 81.701

Ghana is part of an area that was a major source of gold for European and Islamic markets prior to the discovery of the metal in the Americas. The Asante and other rulers there maintained large courts of officials. One group of high-ranking attendants at court who participated in ceremonies glorifying the king wore a special gold disk known as a "soul-washer's badge." This badge was taken from the king's bedroom by Lieutenant R.C. Annesley of the 79th Queens Own Cameron Highlanders, part of the British military expedition which captured the Asante capital of Kumasi on February 4, 1874.

Stool

19th–20th century; Zaire, Luba-Songye; Wood; height 52.7 cm (20 3/4 in.); Founders Society Purchase, Robert H. Tannahill Foundation Fund; 75.1

Songye stools upheld by human figures symbolize the might of a chief who is supported by some-one of inferior rank. Among the neighboring Luba peoples similar stools were made for use by kings as their throne for state occasions. It is thought that the Songye adopted this type of stool from the Luba.

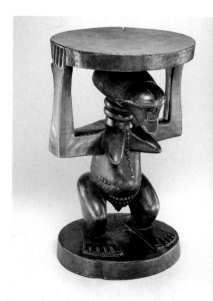

Bracelet

16th–18th century; Nigeria, Yoruba; Ivory; diameter 11 cm (4 1/4 in.); Founders Society Purchase, Acquisitions Fund; 80.42

The king of Owo, a village in Nigeria, was traditionally the only person who could wear ivory ornaments. This ivory bracelet may have been worn by the king during Ore, an important ancient festival. The female heads may represent Olokun, the goddess of the sea, and the crocodiles may be sacrificial victims for her. The crocodile's ability to both walk on land and swim in water acts as a metaphor for kingship as it is believed that kings also live in two realms, the world of ordinary life and the world of the gods and spirits.

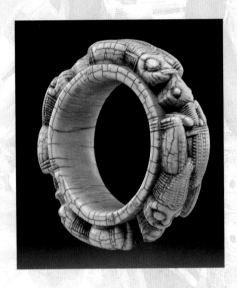

Throne

19th century; Cameroon, Bamenda; Wood, beads; height 47 cm (18 1/2 in.); Founders Society Purchase, Eleanor Clay Ford Fund for African Art; 79.18

African beadwork is outstanding for its frequent use on large three-dimensional objects. Since beads were valuable objects imported from Europe, a lavish beaded throne like this was literally "fit for a king." The leopard depicted on this throne was considered "lord of bush" and was traditionally equated in African symbolism with the king, lord of his people.

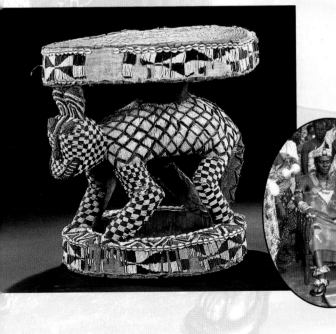

DETROIT CONNECTION

His Royal Highness Odee-fuo Boa Amponsem III, king of Denkyira, Ghana, visited the DIA in 1992. Here, he is lavishly attired in the robes and bright gold jewelry of traditional African kings.

SYMBOLS OF ROYAL POWER

DIA AFRICAN ART

An Ancient Kingdom

In the 13th and 14th centuries, the great African empires of Mali, Ghana, and Songhai flourished in the Inland Niger Delta, an area formed by a huge bend in the Niger River. The fabled cities of Timbuktu and Djenne were the important trading centers of Mali.

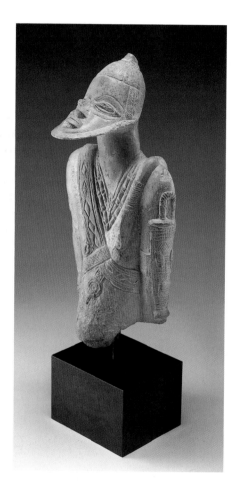 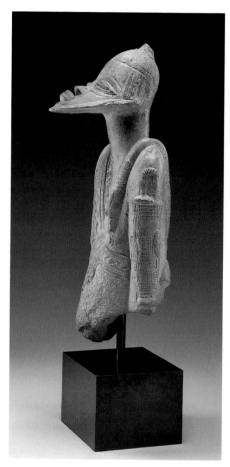

Warrior Figure

1339–1400; Mali, Inland Niger Delta (Djenne); Terracotta; height 38 cm (15 in.); Founders Society Purchase, Eleanor Clay Ford Fund for African Art; 78.32

This majestic and dignified figure probably represents a warrior king, decked out in elaborately detailed jewelry and armed with a quiver and a distinctive type of dagger on his upper left arm. These daggers are still worn by the nomadic Tuareg people, who dominate the caravan routes crossing the Sahara desert. It is quite possible that the warrior was originally mounted on a horse, now destroyed.

Africa and Europe

European contacts with West Africa go back to the 16th century when the Portuguese established trading posts on the west coast of Africa. These early contacts resulted in a thriving trade in gold and ivory. The intervention of Portuguese soldiers equipped with firearms empowered a number of African kings to consolidate their kingdoms in the early 16th century.

Knife Case

16th–18th century; Zaire, Kongo-Portuguese; Carved ivory; height 32 cm (12 3/4 in.); City of Detroit Purchase; 26.183

When Portuguese sailors arrived on the African coast for trading purposes, some commissioned ivory pieces to present as gifts to the nobility in Europe. This knife case was probably produced for such a gift as it combines African style with European form. The top displays four European men carved in high relief. Two hold daggers across their chests; the others clasp their hands in prayer. The surface is ornamented with a delicate interlaced design that may relate to the woven patterns used in Kongo textiles and baskets.

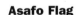

Asafo Flag

ca. 1863; Ghana, Akan, Fante; Cloth; 101.6 x 182.9 cm (40 in. x 6 ft.); Founders Society Purchase, Acquisition Fund; 83.17

Asafo flags such as this were owned collectively by Fante military organizations of Ghana. They were commissioned by each captain for the day of his investiture and were also displayed and danced on special occasions such as the royal yam festival and at funerals. The appliqué and embroidered designs on both sides of the flag show figures casting a net in which a large fish is caught. The message is: Europeans erected a strong stone fort (Anomabu Fort) but Africans can use many men to "catch" the fort.

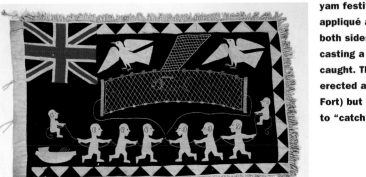

Traditionally in Zaire all exceptional power derived from the ability to communicate and interact with the spirit world. Only kings, priests, and public diviners possessed this power. Kings were endowed with special forces which they derived from their ancestors. Priests and public diviners were traditionally healers and judges who defended individuals against malevolent forces and adjudicated disputes with the help of spirits which were made accessible through powerful objects and sculptures such as the *Nail Figure*.

Nail Figure (nkisi n'kondi)

ca. 1875–1900; Zaire, Yombe; Wood, screws, nails, blades, cowrie shell, other materials; height 116.8 cm (46 in.); Eleanor Clay Ford Fund for African Art; 76.79

This *Nail Figure* served as doctor, judge, and priest. It was carved to capture the power of spirits (*minkisi,* singular *nkisi*) which was necessary for healing and adjudicating disputes. The figure was filled with powerful magical substances (*bilongo*) by priests (*naganga*) who tended it in a shrine and made its spirit powers available to individuals. The large cowrie shell held strong medicines that gave the sculpture its power. This *nkisi n'kondi* would have originally worn a large beard and a straw skirt.

When an agreement was reached both sides would swear an oath before the *nkisi n'kondi* and drive iron blades or nails into it to seal the oath. In this way the figure's supernatural powers could be called upon to punish those who broke their oaths.

Ancestor Figure

Late 19th–early 20th century; East Congo/Zaire, Hemba; Wood; height 76 cm (30 in.); Gift of Mr. and Mrs. Andre Nasser; 1986.54

The Hemba created a type of sculpture (called *singiti*) which was made to honor important departed ancestors. These figures are idealized portraits of specific individuals and were housed in special shrines where they were worshiped and fed offerings so that the living could tap the strong supernatural powers of the dead. The style is very distinctive, the heads having an almost egglike shape with curved eyebrows and aquiline features, giving the figures an aloof expression.

Figure

19th century; Zaire, Bena Lulua; Wood; height 51 cm (20 in.); Founders Society Purchase with funds from various contributors; 82.49

The Bena Lulua made distinctive carvings with elaborate patterns engraved on the surface alluding to extremely complex body scarification. The concentric circles and spirals probably allude to the ripples created by stones thrown into water. This figure represents an important chief, for his neck is covered with strands of rare beads and his waist is encircled by a leopard-skin garment which could be worn only by chiefs. A conch shell carved on the figure's back held a powerful potion. Figures like this were taken by warriors into battle to strengthen morale and to help repel the enemy.

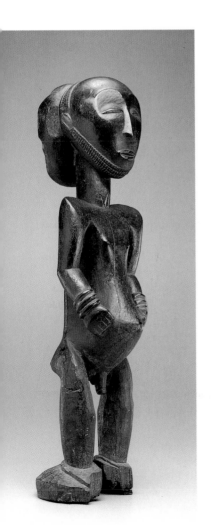

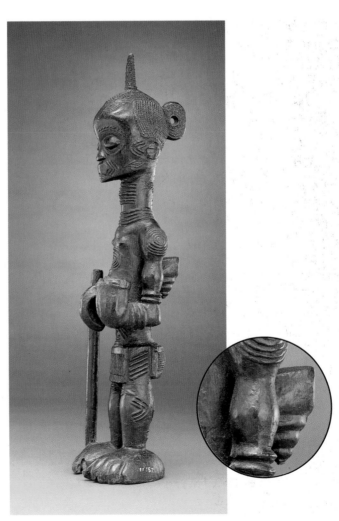

Where Spirits Reside

Contact with the spirit world where ancestors reside is an important part of African culture. These figures provide a physical place for the spirits to materialize in this world.

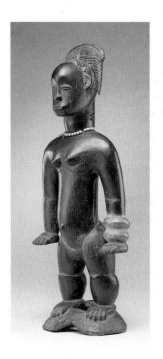

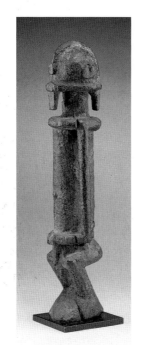

Male and Female Masks

1850–1950; Nigeria, Upper Benue River (Waja); Wood, ocher, brass tacks; height, male 158.8 cm (62 1/2 in.), female 157.6 cm (62 in.); Founders Society Purchase, Eleanor Clay Ford for African Art; 78.41-.42

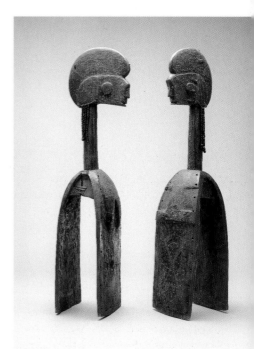

Standing Woman

19th–20th century; Côte d'Ivoire, Guro; Wood, beads; height 52 cm (20 1/2 in.); Bequest of Robert H. Tannahill; 70.95

Figures such as this *Mi iri ni* ("small wooden people") were used by the Guro of Côte d'Ivoire as sacred intermediaries between the human and supernatural realms. Placed against the back wall of a shrine house to receive prayers and offerings of eggs and kola nuts, they were asked to carry messages in the forms of dreams from protective spirits called *zuzu* to help the living solve problems.

Figure

20th century; Mali, Dogon; Wood; height 29.21 cm (11 1/2 in.); Founders Society Purchase, Benson and Edith Ford Fund; 1989.77

This highly abstract, almost phallic, small Dogon figure exhibits the monumental quality and simplicity that typifies the Dogon style. Such figures were used to capture spirit forces and are frequently covered with the remains of sacrificial blood and millet.

Despite their enormous size, yoke masks like this male and female pair are worn over the shoulders and possibly danced in ceremonies. A male and female pair of masks in this style are extremely rare and suggest that they portray the potent original ancestral couple to a group. The masks would have been worn with large costumes made from fiber and attached to the holes along the edges of the yokes.

Ideal Women

Idealized female figures with their large breasts and wide hips represent the essential strength, vitality, and fertility of women.

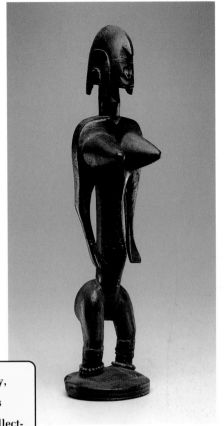

Standing Female Figure

19th–20th century; Mali, Bamana; Wood, copper, beads; height 51.8 cm (20 3/8 in.); Bequest of Robert H. Tannahill; 70.46

The Bamana tribe's Jo Association uses these figures as part of the initiation of young men into adulthood. After six years of instruction, a symbolic death is enacted and the young men are "reborn" as adults. Then, while dancing, the initiates hold these figures—whose large breasts and swelling abdomens allude to a young woman's capacity for childbearing—to advertise that they are now ready to take a wife.

In the early 20th century, European artists such as Picasso admired and collected this type of dramatically stylized figure; African works strongly influenced the development of Cubism.

For works by Picasso, see pages 249, 274–275

Female Figure

Early 20th century; Ghana, Brong; Wood, gold, silver, paint; height 61 cm (24 in.); Founders Society Purchase, Eleanor Clay Ford Fund for African Art; 76.94

This pose mimics a dance posture and the sculpture was probably used as part of a stage set used by a popular band when playing to celebrate births, weddings, and funerals. The aristocratic high forehead and dramatic angling of arms and legs of this dynamic figure identify it as Brong.

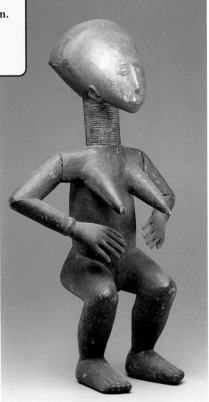

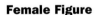

DIA AFRICAN ART

Animals

Animals were keenly observed in traditional African art and are shown not only for their beauty and ornamental quality but also for their potent symbolism. For example, in ancient Benin only kings could hunt a leopard because, as king of beasts, this animal was a metaphor for the very institution of kingship.

Headrest

1850–1950; Zaire, Yaka; Wood, brass studs, copper, brass wire; 17.5 x 24.1 cm (6 7/8 x 9 1/2 in.); Founders Society Purchase, Eleanor Clay Ford Fund for African Art; 78.76

This beautiful headrest made by the Yaka of Zaire supported the wearer's neck so that his or her elaborate coiffure would not be destroyed while sleeping. The headrest is supported on the back of a pangolin (also called the scaly anteater) whose scaly body is suggested by the many brass studs. This animal was sacred to many people in Zaire for its extraordinary appearance and for its ability to roll itself up in a hard ball to prevent harm from even such a powerful enemy as a leopard. Pangolin scales are used as protective charms against evil.

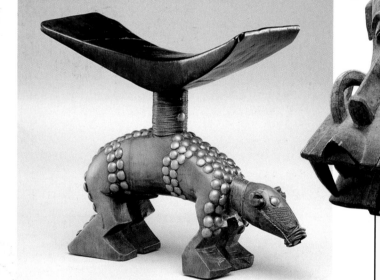

For a Korean pillow, see page 146.

Helmet Mask

19th–20th century; Senufo; Wood; height 96.5 cm (38 in.); Gift of Governor and Mrs. G. Mennen Williams; 66.485

The Senufo mask commonly known as "firespitter" is a composite representation created from a number of fearsome animals found in the wild. It combines the horns of an antelope, the jaws of a crocodile, the tusks of a warthog, and the figure of a chameleon to represent the "power of the bush."

Firespitter

Masks like this were used to frighten away negative forces that might disturb the productive life of an agricultural community. They were used in dances at night with burning coals and straw spewing from their mouths. This activity gave them their popular name, "firespitter."

Musical Instruments

African musical instruments are frequently decorated with human and animal forms. Instruments were important prestige items in the royal courts of central Africa. Magnificent effigy harps were owned by kings, diviners, and oral historians who participated in elaborate court dances.

Harp

19th century; Zaire, probably Zande; Wood, hide, metal, beads; height 42 cm (16 1/2 in.); Founders Society Purchase, Henry Ford II Fund, and Benson and Edith Ford Fund; 82.29

The magnificent realm of King Munza of the Mangbetu empire was described by a German explorer in the 1870s. In the explorer's sketches, King Munza is shown dancing before his many wives in a huge vaulted room. Perhaps this rare harp was one of the instruments used to accompany the king in such lavish functions, for the Zande made such harps to be used by court minstrels. Strings would have been attached from the sounding board to the side of the elegant female figure.

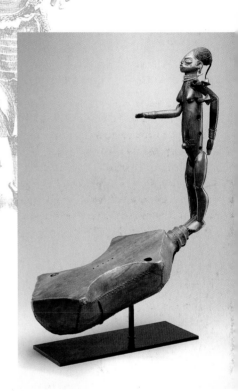

Slit Drum

Early 20th century; Zaire, Barambo; Wood, pigment; height 1.2 m (48 in.); Founders Society Purchase, Ralph Harman Booth Bequest Fund; 1986.26

Large wooden slit drums are used by chiefs or prominent nobles to transmit the coded tones of important messages over long distances, from village to village. Carved from a single tree trunk, the drum's walls vary in thickness and when struck produce a variety of tones, pitches, and rhythms which convey announcements and coded messages. The horned buffalo shape and large size of this drum reflect the high social status of its original owner. Drums of this type are installed in the center of the village in a special structure where they can be protected from the rain and sun.

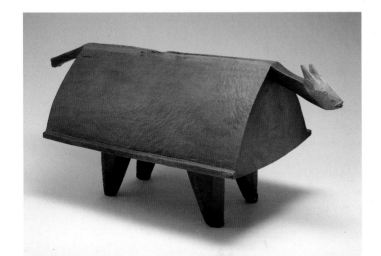

In initiation ceremonies female masks used in traditional African cultures are almost always worn by men who portray the important mythological role of females. Most of these male initiation societies are secret; women are strictly forbidden to handle or even see the wearers of these masks.

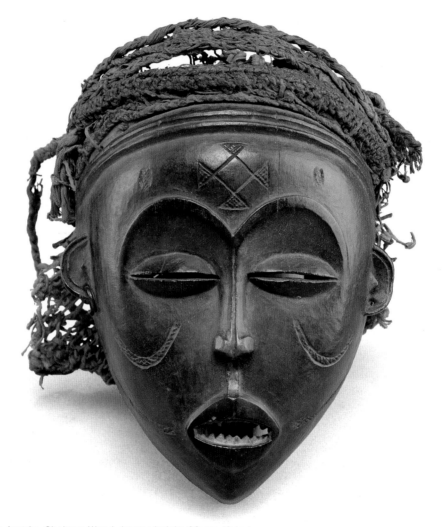

Mask

Early 19th century; Angola, Chokwe; Wood, hemp; height 20 cm (8 in.); Bequest of W. Hawkins Ferry; 1988.193

The Chokwe of Angola use a beautiful mask called *Mwana pwo* in their initiation ceremonies known as *mukanda*. Although they are exclusively worn by men, *Mwana pwo* masks represent female ancestors and emphasize the features that are most admired in young women. The masks are worn with a tightly knit body suit which includes false breasts and a bustlelike fringe worn over the hips. The dance mimics the graceful gestures of women and transmits fertility to the male spectators.

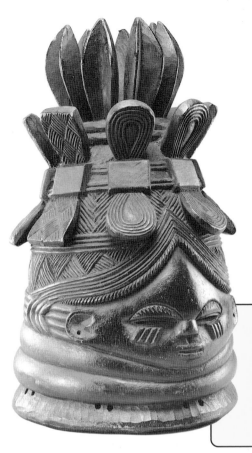

Sande Society Mask

19th–20th century; Sierra Leone, Mende; Wood; height 41.3 cm (16 1/4 in.); Founders Society Purchase, New Endowment Fund; 1990.268

All Mende women are members of the Sande society which instructs girls in their responsibilities and protects the rights of women in the community. The features of this mask convey Mende ideals of female morality and physical beauty. The downcast eyes indicate a spiritual nature and the high forehead indicates good fortune; the elaborate hairstyle reveals close ties within the community of women. This mask would have been worn with a costume of black raffia that completely hides the identity of the individual.

An Exception

Although most African female masks are used by men masquerading as women, the *Sande Society Mask* is a notable exception since it is used by a women's society to which no men are admitted.

Female Mask

1900–25; Northern Mozambique, Makonde; Wood, pigment; height 21.6 cm (8 1/2 in.); Founders Society Purchase, Ralph Harman Booth Bequest Fund, Abraham Borman Family Fund, and Joseph H. Boyer Memorial Fund; 80.19

The Makonde wear masks for two important dance ceremonies: the *mapiko,* which is associated with the initiation of men and women into adulthood, and the *ngoma,* which is a ceremony instructing youths about the responsibilities of marriage and adult family life. The ovoid-shaped mask is painted red to represent skin. Although the white lip labret designates this as a female mask, it can only be worn by a man, although it could be used in either ceremony.

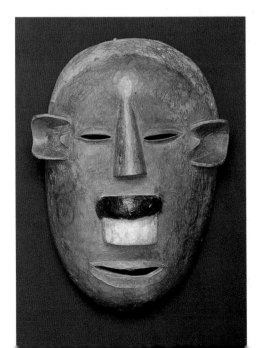

Most of the great works of art made in Central and South America before the voyage of Columbus have been found in tombs. Enormous amounts of time, energy, and materials were spent to properly equip the societies' leaders and the elite for their journey from this earth.

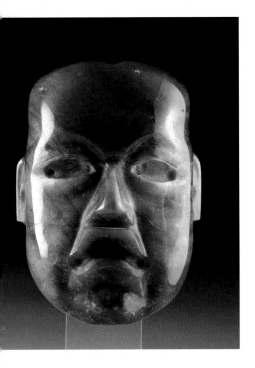

Maskette

900–600 B.C.; Olmec, Vera Cruz; Jadite; height 12 cm (4 5/8 in.); Founders Society Purchase, W. Hawkins Ferry Fund; 85.42

This powerful maskette would have been worn by an Olmec god-king as a pendant during life and buried with him at death. In this culture, jadite was valued above gold as a material, for its rich blue-green color symbolized all-important, life-sustaining water. The snarling mouth and babylike features are associated with a rain-giving water deity. It is rare to find a piece of gem-quality jadite this large, so the maskette would have been a highly prestigious, potent ornament suitable for a king.

Effigy Vessel

800–1000 A.D.; Huari; Ceramic; height 22 cm (9 in.); Founders Society Purchase with funds from Richard A. Manoogian; 1991.113

This beautifully burnished Hurai effigy vessel shows a court official wearing a poncho similar to the tunic on the opposite page, which indicated its wearer's precise rank in the society.

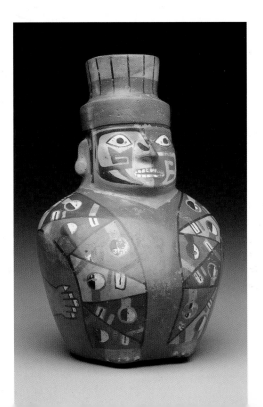

Peruvian Textiles

Large, spectacular textiles woven in sophisticated techniques
were made in ancient Peru. Colorful mantles and ponchos
were treasured as emblems of high rank in society. Due
to the ideal cool and dry climactic conditions of coastal
Peru, these textiles have survived almost intact for
thousands of years.

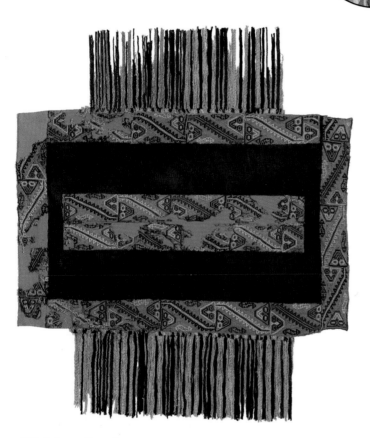

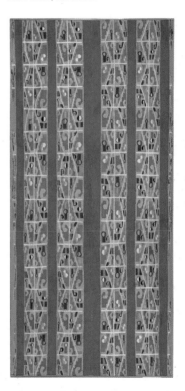

Tunic

800–1000 A.D.; Huari;
Cotton, wool; height 210 cm
(83 in.); Founders Society
Purchase with funds from Lee and
Tina Hills; 1986.25

Miniature Poncho

100 B.C.–100 A.D.; Paracas; Cotton, camelid fiber; height 85 cm
(33 1/2 in.); Founders Society Purchase with funds from Founders
Junior Council, and J. Lawrence Buell, Jr., Fund; 1993.22

This finely woven and embroidered miniature poncho was made for a
high-ranking child and was probably worn on state occasions before
being buried with its owner. This extremely intricate embroidery
imitates the geometry of a woven textile because of its repeated
pattern of interlocking double-headed serpents, which probably
represent an agricultural deity.

Elaborate costumes woven in an
intricate slit tapestry technique
were the formal dress of the
nobility of the ancient Huari
empire, worn at court and placed
on the body for burial. The com-
plex patterns on this tunic may
look totally abstract, but they are
based on stylized eyes and
mouths full of fangs symbolizing
powerful feline deities.

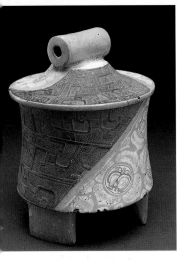

Precolumbian cultures viewed the world as a multi-layered universe with various divisions, attended by numerous deities whose activities and relationships metaphorically expressed the forces of nature and the cosmos. Death was considered a transition and journey from one realm of existence to another. The elaborate preparation and offerings associated with burying the dead reflect the importance of equipping one's soul for this transition to life in the next world.

Tripod Vessel

300–600; Maya; Carved and stuccoed blackware; height 26 cm (10 in.); Founders Society Purchase, Arthur H. Nixon Fund; 1984.12

Mortuary offerings were placed in the tombs of Mayan noblemen to assist the deceased in their passage to the watery underworld. Funerary objects such as this were often decorated with symbols of water, marine vegetation, and animals. The painted body and lid of this vessel depict white water lilies floating against a green-blue background; the water lily was seen as a plant that connects the underworld of water to the air of our world above. The petals of the lilies enclose red hieroglyphic signs which allude to illustrious rulers and their titles. The carved areas, colored red, feature a complex array of interlocking scrolls which also symbolize water.

Embracing Couple

700–900; Maya; Terracotta; height 24 cm (9 in.); Founders Society Purchase, Katherine Margaret Kay Bequest Fund, and New Endowment Fund; 77.49

This figurine clearly symbolizes the Mayan belief in the essential balance of dual powers that allows the universe to function. Here an old man, symbolizing a god associated with the sun, daylight, and life, embraces a young woman, representing the moon goddess, night, and death. The piece also functions as a whistle, and it is thought that these whistles were played at funeral ceremonies, as such pieces were buried with the dead to aid in their transition to another level of existence.

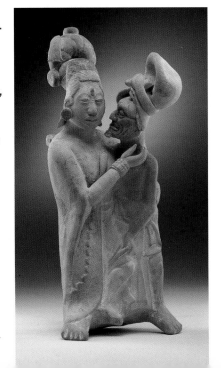

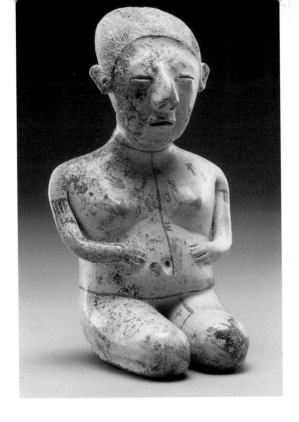

Palma with Maize God Receiving a Human Sacrifice

250–950; Vera Cruz; Basalt; height 48 cm
(19 in.); City of Detroit Purchase; 47.180

This *Palma* is a replica in stone of a piece of palm worn as protective gear around the waist of the players in a ritual ball game played between two teams representing the dualistic cosmic forces of the universe. The captain of the losing team was killed as a sacrifice to placate the gods and to assure the continuing fertility of the land. Here a monkey-headed god stands on the chest of a sacrificial victim. Behind him are stalks of corn, the staple food of ancient Mexico.

Kneeling Female Effigy Figure

1st century B.C.; Nayarit; Terracotta; height 28 cm
(11 1/4 in.); Gift of Mr. W. Hawkins Ferry; 1984.33

The cultures of west Mexico buried their dead in shaft-chamber tombs accompanied by a variety of ceramic offerings. The tombs, often as deep as fifty feet, were prepared in advance and signs of reuse suggest they functioned as family crypts. Numerous effigy figures representing family members or servants were placed in the tombs to assist the deceased as their counterparts had done in life. This large, hollow female effigy figure represents the Chinesco style, distinguished by an emphasis on naturalism and oriental-like facial features. Small red designs decorate the body, probably representing body paint or tatoos.

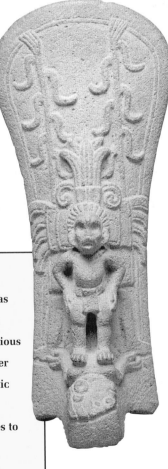

Ball Games

All the cultures of the Americas incorporated ball games as an important part of solemn religious rituals. Columbus took a rubber ball back to Europe as an exotic novelty from the New World and thus introduced ball games to European culture, where they became merely athletic events.

PRECOLUMBIAN ART • LIFE AND DEATH

DIA NEW WORLD ART

Native American imagery often symbolizes complex philosophical ideas. The faces and creatures carved or modeled on these objects were intended as metaphorical expressions of spiritual concepts.

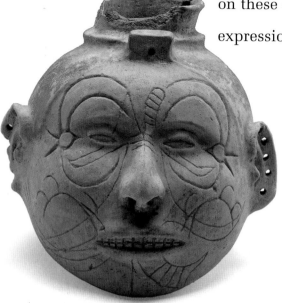

Head Effigy Vessel

1300–1500; Mississippian; Buffware and pigment; height 18 cm (7 1/4 in.); Founders Society Purchase with funds from the Mary G. and Robert H. Flint Foundation; 1986.43

The *Head Effigy Vessel* addresses an ongoing relationship between the worlds of the living and the dead. The pot depicts the head and the face of a deceased ancestor, a spiritually endowed leader, whose physical remains are laden with spiritual power. "Power" has the ability to ward off disease, to increase good fortune, or to cause benefit or destruction depending upon how it is used.

Power comes to individuals as a gift from the spirit world and ultimately from the Creator. The frog seated on the *Effigy Platform Pipe* represents a spiritual intermediary through whom power flows. The act of smoking tobacco is intended as an offering, a gift in return for the spirit being's blessings. Note that the frog faces the smoker when the pipe is used. The same is true of the human face carved on one side of the *Pipe Bowl*. This pipe bowl was once part of a bundle of "war medicine" that protected warriors from their enemies while in combat. Part of the ritual for activating the power of the bundle was the act of smoking tobacco in acknowledgment of the blessings and spiritual gifts that the bundle represented.

Frog Effigy Platform Pipe

1st–2nd century; Havana; Earthenware; height 7 cm (2 3/4 in.); Founders Society Purchase with funds from Flint Ink Corporation; 1986.61

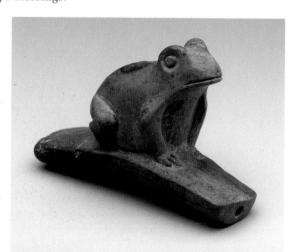

Both the pair of *Drumsticks* and the *Bowl* are carved with images that address the differences between male and female. Many Native American cultures recognize the complementary and yet different social roles of men and women in community life. This mutual dependency extends to religious ritual, as acknowledged by the male and female faces carved in the drumsticks used for the most sacred episodes of the Delaware Big House ceremony, and the male and female heads that face one another across a feast bowl probably used to serve meals that are an important part of Native American religious practice.

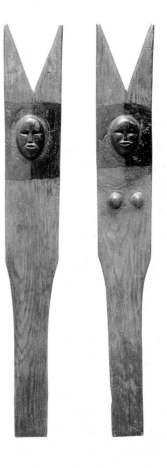

Pipe Bowl

1750–1800; Miami; Catlinite; height 7 cm (3 1/8 in.); Founders Society Purchase; 81.265

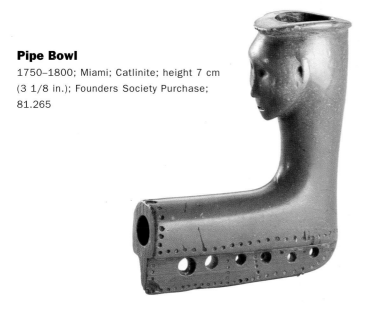

Bowl

ca. 1800; Cherokee or Iroquois; Wood and brass; height 34 cm (13 5/8 in.); Founders Society Purchase with funds from Richard A. Manoogian, New Endowment Fund, Joseph H. Boyer Memorial Fund, and Mr. and Mrs. Walter B. Ford II Fund; 1991.205

Drumsticks

1875–1900; Delaware; Wood and pigment; height 49 cm (19 5/8 in.); Founders Society Purchase, Dabco Frank American Indian Art Fund, and Henry Ford II Fund; 1983.28

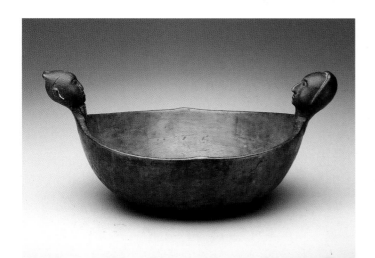

Symbols of Power

In Native American belief, the universe is a sphere having the sky world above and the watery underworld below, with the terrestrial disk of the earth dividing them. The earth is divided into four quadrants by the cardinal directions north, south, east, and west. The human task on earth is to keep the upper world and the underworld in balance.

The sky above is the realm of the powerful Thunderbird, whose eyes shoot out bolts of lightning and whose beating wings create thunder. The earth is the mother and procreator of life. In the waters beneath the earth is the underworld, where spirits also dwell. There are many symbols associated with each realm which can be seen on Native American works of art. These symbols help make the sources of spiritual power accessible on earth.

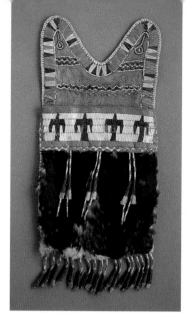

Pouch

1800–25; Eastern Sioux; Buckskin, mallard duck scalp, porcupine quills, tin cones, and dyed deer hair; height 26 cm (10 1/3 in.); Founders Society Purchase; 81.488

The Thunderbirds visible in the center correspond to the four cardinal directions and serve as powerful guardian spirits of the sky. The scalps of many mallard ducks are used for the rich green of the lower portion of the pouch, representing the watery underworld.

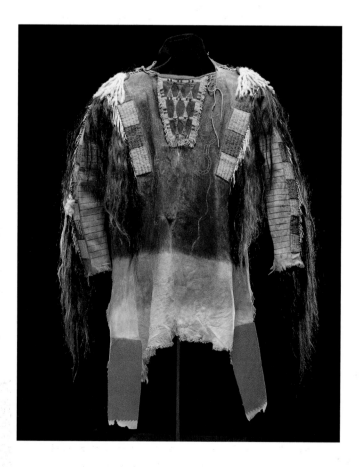

Man's Shirt

1860; Northern Cheyenne; Buckskin, buffalo hide, wool fabric, ermine skin, human hair, glass beads, pigment, porcupine quills; height 117 cm (46 in.); Founders Society Purchase with funds from Flint Ink Corporation; 1988.27

The owner of this shirt painted red "power circles" arranged in a chain descending from the shoulders, from which a bolt of lightning strikes. The painted images of flying birds on the breast and back probably represent guardian spirits who offered blessings as gifts in a vision or a dream.

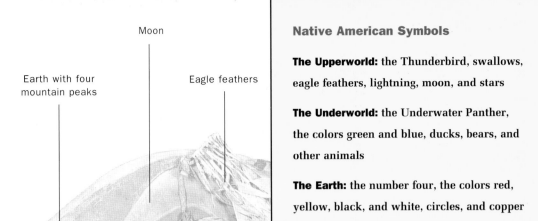

Moon

Earth with four
mountain peaks

Eagle feathers

Native American Symbols

The Upperworld: the Thunderbird, swallows, eagle feathers, lightning, moon, and stars

The Underworld: the Underwater Panther, the colors green and blue, ducks, bears, and other animals

The Earth: the number four, the colors red, yellow, black, and white, circles, and copper

Thunderbird

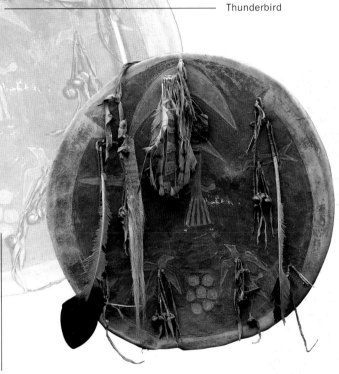

Copper bells

The Pleiades
(stars)

Four small
birds

Shield

1860–68; Southern Cheyenne; Buffalo rawhide, tanned buckskin, bells, feathers, corn husks, natural pigment; height 49.5 cm (19 1/2 in.); Gift of Detroit Scientific Association; 76.144

This shield probably belonged to Little Rock, a Cheyenne man who was killed at the Battle of the Washita in 1868. The power of the shield was evoked by its owner for spiritual and physical protection. The symbols and colors used on the shield present a complete picture of the spiritual world. The light circle at the edge is earth with peaks of mountains in the four directions; the crescent moon above and the group of seven circles representing the star cluster of the Pleiades are set against the blue sky, with four birds circling a large Thunderbird.

During the 19th century, American Indian women artists experimented with several different media and techniques when producing objects for both their own use and for exchange or sale. The introduction of European glass "seed" beads, silk ribbon, and cotton and wool cloth contributed to innovations in the design of shoulder bags, moccasins, and other elements of clothing. Older modes of artistic expression were adapted and combined with the new, conveying the vitality and dynamism of American Indian art and culture.

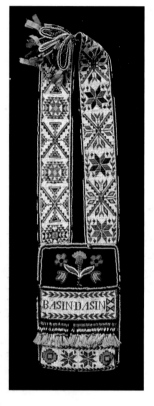

Shoulder Bag

ca. 1850; Chippewa; Wool, beads; height 73 cm (29 in.); Founders Society Purchase; 81.78

Creating and wearing articles of dress and formal clothing is an important means of cultural expression among Native American people. This elaborately decorated pouch, with a broad shoulder strap, was worn as part of an ensemble for ceremonial and social events. The method of double-weft bead weaving, requiring the use of a box-loom, quickly became the most popular technique employed throughout the Great Lakes and is still used today.

Moccasins

ca. 1890; Eastern Sioux; Buckskin, rawhide, fabric, glass beads; length 25.4 cm (10 in.); Founders Society Purchase with funds from Flint Ink Corporation; 1988.31

Moccasins were created by women artists as part of their traditional role of preparing clothing for their families. The floral patterns stem from a number of sources: European decorative arts, printed cotton textiles, or as a result of the training American Indian women received at mission schools. Regardless of origin, floral patterns employed by artists on clothing and domestic objects were reconfigured and then incorporated as symbols of American Indian identity.

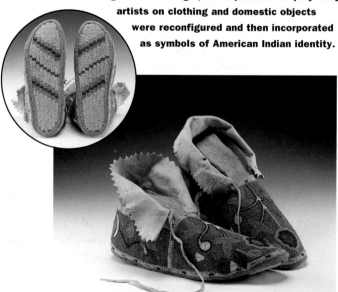

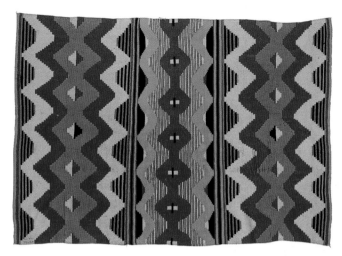

Wearing Blanket

ca. 1870; Navajo; Wool; height 193 cm
(76 in.); Gift of Descendants of Helen
Weeks Winchester and Captain Harrison
Samuel Weeks; 1987.93

**This blanket was purchased from a Navajo woman by
Captain Harrison Samuel Weeks in 1876 while he was
stationed at Fort Union, New Mexico. It was meant to be
worn around the shoulders with the large central panel
falling vertically down the back. During the 19th century
the introduction of new commercial dyes and yarns and
the growth of a tourist market spurred by the opening
of trading posts sparked creative experimentation with
color and complex designs.**

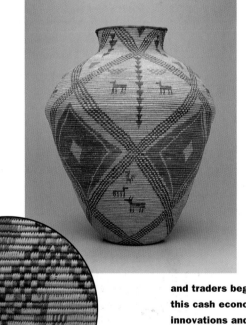

Basket

ca. 1900; Western Apache, Tonto;
height 71 cm (28 in.); Willow, devil's
claw, and wood; Founders Society
Purchase, Mr. and Mrs. Peter W. Stroh,
and Stroh Brewery Foundation Fund;
79.179

**American Indian baskets were used
for storage, as serving dishes, for trans-
porting grain, wood, and water, and for
ritual or ceremonial use. During the late
19th and early 20th centuries, tourists
and traders began collecting baskets. The impact of
this cash economy upon basket production resulted in
innovations and modifications of older shapes and
designs. This type of jar-shaped basket (*olla*) represents
a new form produced specifically for sale to tourists.
Skillfully decorated with animal figures and geometric
motifs, this exceptionally large basket displays the
compact stitching and smooth, even texture associated
with Western Apache basketry.**

The cultures of the Pacific coast of British Columbia and Alaska have ancient connections to northeast Asia and the circumpolar region of the Arctic circle. This mix of influences resulted in artistic traditions distinct from others on the North American continent. Carved images of creatures—human, animal, or combinations of both—were used to symbolize the relationship between humans and the natural world.

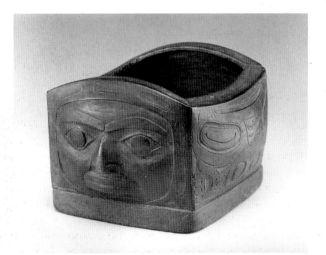

Winged Object

ca. 300 B.C.; Okvik, St. Lawrence Island, Bering Strait region; Walrus ivory; length 18.8 cm (7 3/8 in.); Founders Society Purchase, Mr. and Mrs. Peter Stroh, and Stroh Brewery Foundation Fund; 83.7

The *Winged Object* functioned as a counterweight for a harpoon used to hunt seals and walruses. The thin, weblike tracery of engraved designs and the animal head carved in rounded relief were intended to please the *inua* or spirit of the hunted quarry. The Okvik were early Arctic ancestors of the Eskimo; they inhabited villages on both the North American and Asian sides of the Bering Straits as well as the several islands in between.

Bent Corner Bowl

Early 19th century; Kaigani Haida, southeast Alaska; Red cedar and hardwood; length 21.5 cm (8 5/8 in.); Founders Society Purchase, New Endowment Fund, Henry Ford II Fund, and Henry E. and Consuelo S. Wenger Foundation Fund; 88.12

The sides of the bowl, carved from a single piece of wood bent at the corners, illustrate a mythic being drawn from clan mythology. Its face is visible on both ends of the bowl, while its body is represented on the sides with conventionalized abstractions of body parts. The Kaigani Haida lived in villages located on the Alaskan mainland.

Mask

19th century; Kwakiutl, southern British
Columbia; Wood, copper, human hair,
paint; height 29 cm (11 3/8 in.);
Founders Society Purchase, Henry Ford
II Fund; 80.47

A Kwakiutl clan chief wore this mask
when greeting rival chiefs invited for
a feast and potlatch. It reminded the
guests of their host's great riches and
their indebtedness to his generosity.
This Kwakiutl mask represents a myth-
ic ogress of the forest, Dz'onokwa,
who skulked through villages at night
to steal children to eat. She was also
the "master of wealth," represented
by the copper of her eyebrows,
and so an appropriate symbol for the
ceremonial feast.

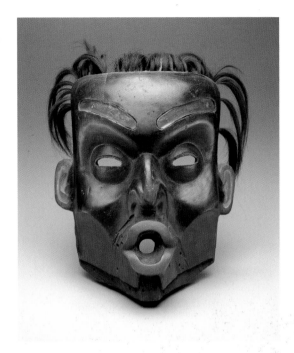

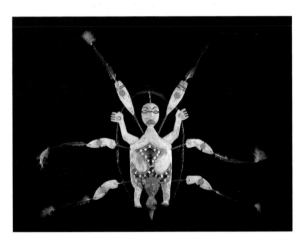

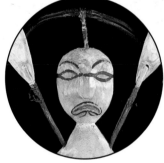

Mask

Late 19th century; Yupik Eskimo, lower
Kuskukwim river region, Alaska; Wood,
feathers, paint; height 63.5 cm (25 in.);
Founders Society Purchase, Stroh
Brewery Foundation Fund; 77.69

A Yupik Eskimo shaman (traditional healer and holy
man) commissioned this mask ringed with miniature
seal flippers and kayak paddles to represent his power
to travel to the spirit world beneath the sea. The
shaman sponsored masquerades during festivals in
which the community thanked the spirits of the animal
world for allowing themselves to be killed for food.
Wood was scarce in the central Alaskan tundra lands
inhabited by the Yupik. Artists fashioned masks from
odd pieces of driftwood that floated downriver from
the forested interior of Alaska.

The American collections in the Robert Hudson Tannahill Wing constitute one of the finest and most representative museum collections of 18th-, 19th-, and early 20th-century American art. The galleries offer an outstanding survey of the nation's achievements from all periods of American history, including acknowledged masterpieces in painting, sculpture, furniture, and other decorative arts.

The first acquisitions were made almost immediately after the Detroit Museum of Art was founded in 1883. By 1927, when the re-named Detroit Institute of Arts opened its doors to the public, the American holdings had grown considerably in size and importance. To showcase this ever-increasing wealth of material, the collection was installed in its own wing of the museum. In the nineteen galleries devoted to American art one proceeds from the art of the colonial period, through rooms devoted

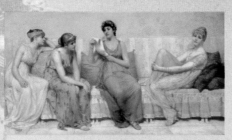

to history painting, landscape art, portraiture, tonalist paintings, civil war scenes, academic works, barbizon and impressionist works, and the Ash Can School. Paintings, sculpture, furniture, and other decorative arts are arranged in sympathetic relationships to each other, gaining interest and vitality from the harmonizing atmosphere of the architectural treatment. Galleries are painted in colors chosen to enhance the works of art and to evoke associations with the spirit of the American past.

Some of the museum's decorative arts are featured in a series of period rooms from the eastern United States. Portions of two rooms from Whitby Hall, a country house built outside Philadelphia in 1754, were incorporated into the American Wing in 1927. In 1953 two other rooms were acquired from houses on the Delaware River—a bedroom from Vauxhall Gardens, built in the 1720s in Salem, New Jersey, and a bedroom from Spring Garden Mansion, built about 1770 in New Castle, Delaware.

In recent years efforts have been made to renovate and restore some of the galleries in the American wing. In 1992 a grant from the Americana Foundation returned our gallery for paintings by Whistler to its 1927 splendor.

Another goal has been to acquire major examples of late 19th-century furniture and decorative arts. Examples by Charles Honore Lannuier, Herter Brothers, Louis Comfort Tiffany, Leon Marcotte, Charles Tisch, and many other important designers have joined the collection. Silver by Tiffany and Company, Gorham Manufacturing Company, and numerous others have been added, as well as several very fine examples of 19th-century American glass.

These portraits provide an excellent example of 18th-century taste in the New England colonies. Only wealthy people with high social standing could afford to have their portraits painted.

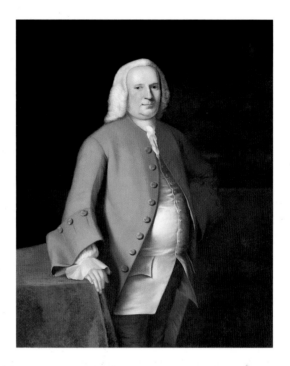

James Pitts

1757; Joseph Blackburn (American, ca. 1700–ca. 1780); Oil on canvas; 127 x 101.6 cm (50 x 40 in.); Founders Society Purchase, Gibbs-Williams Fund; 58.357

Mrs. James Pitts

1757; Joseph Blackburn (American, ca. 1700–ca. 1780); Oil on canvas; 127 x 101.6 cm (50 x 40 in.); Founders Society Purchase, Gibbs-Williams Fund; 58.358

This pair of portraits was painted by the English émigré artist Joseph Blackburn, who worked in the New England colonies from the mid-1750s through the mid-60s. Of all the itinerant artists, he was the most able to express the British rococo style for the American market. James Pitts was a wealthy Boston merchant who inherited a large fortune upon his graduation from Harvard University; in 1732 he married Elizabeth Bowdin.

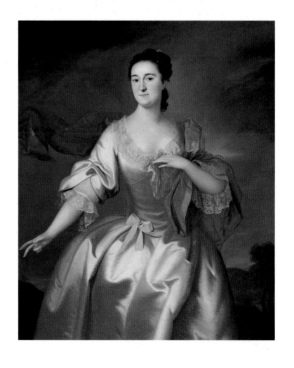

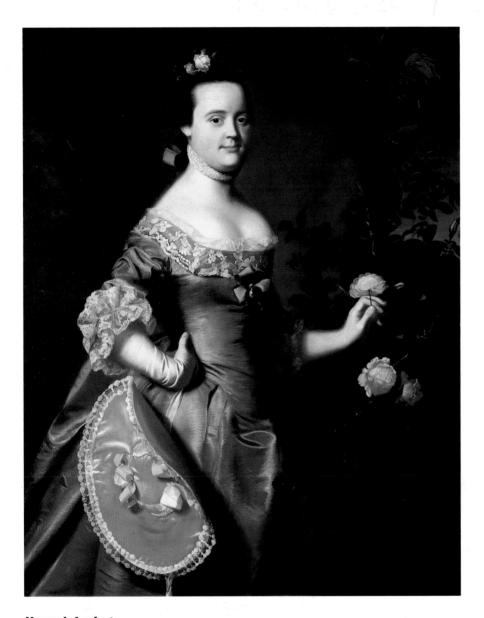

Hannah Loring

1763; John Singleton Copley (American, 1738–1815); Oil on canvas; 126.4 x 99.7 cm
(49 3/4 x 39 1/4 in.); Gift of Mrs. Edsel B. Ford in memory of Robert H. Tannahill; 70.900

This painting was most likely executed as a wedding portrait to commemorate the
marriage of Hannah Loring to the prosperous merchant John Winslow. Miss Loring, a
member of a wealthy Boston family, and her husband were loyal to the British king. They
were among the group whose tea ended up in Boston Harbor. By 1775 she was widowed
and was forced to flee Boston with her family when the British withdrew
from the city. Unable to return, her property having been confiscated,
she spent the remainder of her life in Canada where she was
forced to live under greatly reduced circumstances.

For another work by Copley, see page 58.

Dr. Edward Hudson

1810; Thomas Sully (American, 1783–1872);
Oil on canvas; 73.7 x 60.3 cm (29 x 23 3/4 in.);
City of Detroit Purchase; 26.89

Mrs. Edward Hudson

1814; Thomas Sully (American, 1783–1872);
Oil on canvas; 73.7 x 60.3 cm (29 x 23 3/4 in.);
City of Detroit Purchase; 26.90

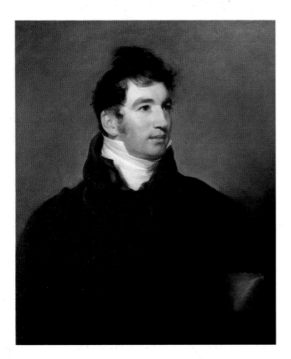

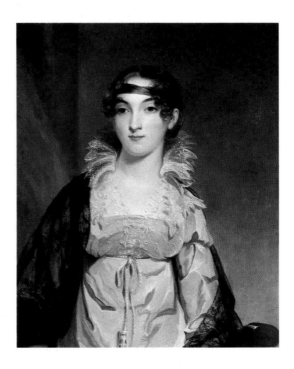

Sully painted many of Philadelphia's most distinguished citizens, such as Dr. Hudson, a highly regarded dentist, and his wife. Ladies of society flocked to him because of his unparalleled ability to portray their feminine charm and beauty. These two portraits were completed when the artist was at the peak of his artistic maturity. They are excellent examples of Sully's unique ability to create flattering, graceful portraits which were highly prized during his lifetime.

Sully was born in England but the reputation he acquired in America earned him an important commission in 1838 to paint the young Queen Victoria, who had just recently come to the throne.

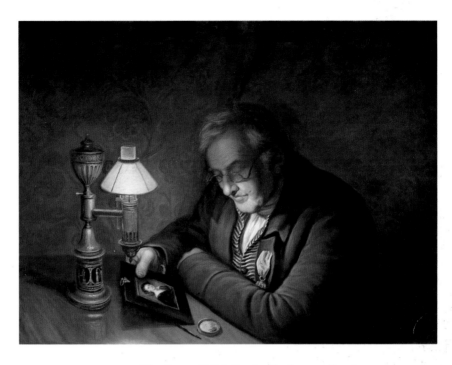

The Lamplight Portrait, James Peale

1822; Charles Willson Peale (American, 1741–1827); Oil on canvas; 62.2 x 91.4 cm (24 1/2 x 36 in.); Gift of Dexter M. Ferry, Jr.; 50.58

This portrait miniature seen above as a "picture within a picture" is also in the DIA collection.

Charles Willson Peale was the leading portrait painter in America for many years. He taught painting to several generations of his family and, in 1795, helped to establish a small art school in Philadelphia. The development of a science museum absorbed his middle years, but later in life he returned to painting. At age eighty-one he produced this affectionate portrait of his brother, James, showing the retired miniaturist gazing fondly at a portrait miniature of Rembrandt Peale's oldest daughter, Rosalba, painted by Charles's daughter, Anna.

For a painting by Rembrandt Peale, see page 61.

Rosalba Peale

1820; Anna Claypoole Peale (American, 1791–1878); Watercolor on ivory; 7.2 x 6 cm (3 1/8 x 2 3/4 in.); Founders Society Purchase; Gibbs-Williams Fund; 53.345

COLONIAL PORTRAITS

DIA AMERICAN ART

The art forms of these periods were inspired by objects produced in Europe, most often England, in the 18th and early 19th centuries. Although the American Colonists wanted to escape the oppression of their European homelands and establish new lives in America, it is obvious that these immigrants wasted no time in attempting to emulate the lifestyles they left behind.

The Alsop Secretary

1770–76; Attributed to George Bright (American, 1726–1805); Mahogany and pine; height 2.6 m (8 ft. 6 1/2 in.); Founders Society Purchase, Robert H. Tannahill Foundation Fund, Gibbs-Williams Fund, and Louis Hamburger Fund; 66.131

This desk is a leading example of American furniture from the rococo or Chippendale period. Made in Boston, it reflects the sophisticated features associated with the center of furniture production in colonial America. In addition to the many intricacies inside, the desk's exterior features, such as the hairy claw feet, the rosettes with trailing leaves and flowers, and the carved and gilded moldings framing the mirrors, serve as not only a testament to the designer but to the carvers as well.

High Chest of Drawers

1760–75; Anonymous; Mahogany and brass; height 2.46 m (8 ft. 3/4 in.); Founders Society Purchase, Robert H. Tannahill Foundation Fund, and Henry Ford II Fund; 73.3

The classic high chest of drawers, with broken-scroll pedimented top and curved cabriole legs, was introduced in 1730 and remained popular in New England for sixty years. The high chest of drawers became popular in Philadelphia in the 1750s. Its basic form is consistent with that of New England, but its treatment is influenced by pieces from London in the Chippendale or English rococo style. The juxta-position of strongly architectural motifs, fluted quarter columns supporting a broken-scroll pediment, and the naturalistic foliate carving are derived from the English rococo style. With its softly modeled, richly carved design and monumental form, this *High Chest of Drawers* is an outstanding example of the Philadelphia Chippendale style.

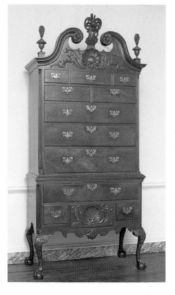

Tall Case Clock

1775–88; Thomas Harland (American, 1735–1807); Mahogany; height 2.22 m (7 ft. 3 1/2 in.); Gift of Mrs. Alger Shelden, Mrs. Susan Kjellberg, Mrs. Lyman White, Alexander Muir Duffield, and Mrs. Oliver Pendar in memory of Helen Pitts Parker; 59.149

A handwritten note found inside the clock explains that it was originally made for Elias Brown, a wealthy merchant in Preston, Connecticut. As was commonly practiced, the name of the clockmaker is inscribed on the dial. However, a more unusual feature of this clock is the presence of an additional name, Abisha Woodward, on the face. Woodward was a woodworker who lived in Preston until 1788 and is thought to be responsible for making the clock's case. The cabinetmaker achieved a delightful balance between sophisticated and provincial elements in the design and execution of this clock.

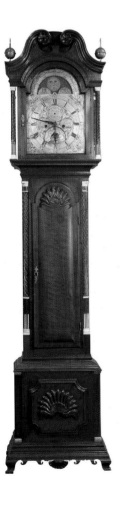

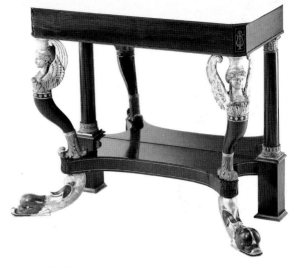

Pier Table

ca. 1815; Attributed to Charles Honore Lannuier (American, active 1779–1819); Rosewood; 86.4 x 96.5 cm (34 x 38 in.); Founders Society Purchase, Robert H. Tannahill Foundation Fund; 1989.1

This table, designed to be placed against a wall, or pier, between two windows, is attributed to Charles-Honoré Lannuier, a French cabinetmaker who emigrated to New York in 1805 and became one of the leading proponents of the late neoclassical **style in America. From the styles of the Directoire, Consulat, and early Empire, he created a New York style, exceedingly light and delicate compared to French examples, and far closer in spirit to the fashionable furniture of his Anglo-American contemporaries. With a top only thirty-eight inches wide, the table is unusually light, and has some ravishing details that may be unique; the brass lyres on the apron are inlaid into the ebony panels with contrasting rosewood, and the curves of the platform above the dolphins have delicate carved acanthus leaves finished in verd-antique (a green patina).**

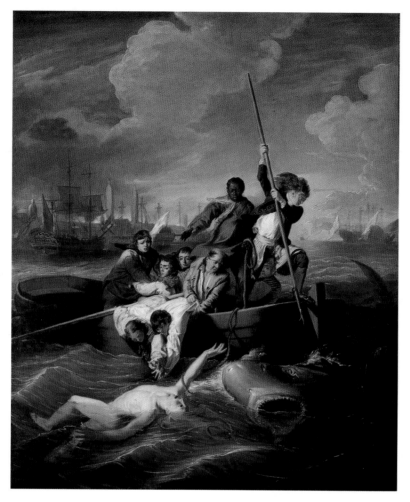

Watson and the Shark

1782; John Singleton Copley (American, 1738–1815); Oil on canvas; 91.4 x 77.5 cm (36 x 30 1/2 in.); Founders Society Purchase, Dexter M. Ferry, Jr., Fund; 46.310

Brook Watson had been sent to sea at fourteen; he decided to go for a swim while his ship was docked in the shark infested waters of Havana Harbor. The painting depicts the moment when the shark is coming by for his third and possibly final attempt to make a meal out of Watson. The men in the boat were successful in harpooning the shark and heroically rescued the swimmer. Upon returning to the ship, Watson's left leg was amputated and he was fitted with a peg leg. Later in life he became Lord Mayor of London and was often satirized with his peg leg playing an important feature. This is one of three versions which Copley painted to commemorate the heroic rescue of Brook Watson.

***Rescue Group* is a preparatory sketch made by Copley for *Watson and the Shark*.**

Rescue Group (Eight Men)

1777–78; Black and white chalk, squared and numbered in red chalk, on green-gray paper; 36.2 x 55.9 cm (14 1/4 x 22 in.); City of Detroit Purchase; 48.203

Still as she fled her eyes she backward threw
As fearing evil that pursued her fast
And her fair yellow locks behind her flew

From Edmund Spenser's *Faerie Queene,* 1590

The Flight of Florimell

1819; Washington Allston (American, 1779–1843); Oil on canvas; 91.4 x
71.1 cm (36 x 28 in.); City of Detroit Purchase; 44.165

The subject of this painting is based on a passage from Edmund Spenser's
Faerie Queene, an epic poem published in 1590. Many American artists,
including John Singleton Copley and Benjamin West, looked to Spenser's
work for inspiration. Allston's representation of Florimell, a symbol of
virtue and chastity who flees an unseen evil, follows Spenser's description
of the heroine very closely.

And I looked, and behold a pale horse: and his name that sat on him was Death, and Hell followed with him. And Power was given unto them over the fourth part of the earth, to kill with the sword, and with hunger, and with death, and with the beasts of the earth. Revelation 6:8

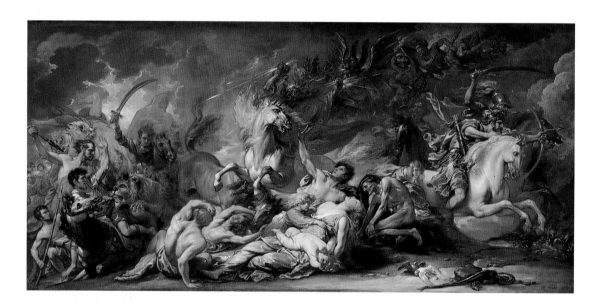

Death on the Pale Horse

1796; Benjamin West (American, 1738–1820); Oil on canvas; 59.5 x 128.5 cm (23 1/2 x 50 1/2 in.); Founders Society Purchase, Robert H. Tannahill Foundation Fund; 79.33

The title of this painting is taken from the final book of the Bible, the Revelation of Saint John the Divine, which has often been interpreted as a symbolic description of warfare. In this horrifying chronicle of the destruction of humankind, the rugged irregular forms, the dramatic contrasts of light and dark, and the dynamism of the turbulent movement combine with the distorted faces and pitiful gestures of the dead and dying to convey a sense of terror. The violent furor exhibits a destructive dynamism that makes this one of the most awesome depictions of the methods by which a world may be annihilated.

In 1796 England was at war with revolutionary France, and Benjamin West's picture may have been intended to comment on what was happening, or was expected to happen, in the contemporary world.

Scale

Due to the limitations of reproducing art in books, often the relative proportions of the pieces are lost. The actual size of the painting below is five and one half times larger than the size of the one on the left!

50 1/2 in.

23 ft.

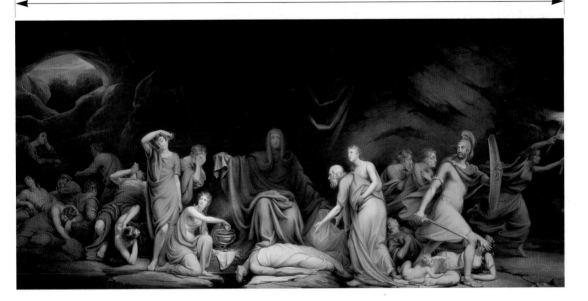

The Court of Death

1820; Rembrandt Peale (American, 1778–1860); Oil on canvas; 3.5 x 7.1 m (11 ft. 6 in. x 23 ft. 5 in.); Gift of George H. Scripps; 85.3

Rembrandt Peale chose to paint a subject intended to be a moral statement for contemporary times. The work is based on a poem by an Anglican bishop describing how mortal man is called by death. To the far left of the central figure of Death are War and his agents, who trample over the bodies of his victims, a widow and an orphan. To Death's right is a mass of humanity representing sins from intemperance to suicide, all of which are associated with those who have died from leading decadent lives. Below the feet of Death is the body of a man cut down in the prime of life, which demonstrates the power Death holds over everyone. Approaching the central figure is Old Age, who is supported by Faith and, after leading a long, productive, and pious life, welcomes Death with outstretched arms.

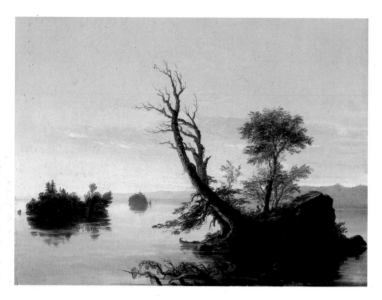

American landscape painting came of age in the mid-19th century. Thomas Cole was the leader of the landscape painters and co-founded with Thomas Doughty the Hudson River School. Cole and his colleagues carefully recorded every aspect of nature, from the blazing sunset to the humblest plant, and were also instrumental in creating a new lyrical spaciousness in landscape painting. Frederic Church, Martin Johnson Heade, and other members of the second generation of the Hudson River School (often referred to as the Luminists) added the glowing atmosphere, flickering light, and textural differentiations that so poetically describe the American experience of nature.

American Lake Scene

1844; Thomas Cole (American, 1801–48); Oil on canvas; 46.4 x 62.2 cm (18 1/4 x 24 1/2 in.); Gift of Douglas F. Roby; 56.31

Like many other artists of his generation, Cole sought to express the spiritual in the actual. Here, a small lake, a cloudless sky, a fallen tree, and a lone Indian evoke the peace and tranquility of the American wilderness.

A contemporary critic recognized Cole's intention when this picture was exhibited in New York in 1844. "It is the very poetry of solitude," he wrote, "and you hold your breath lest the echo of your voice should frighten you.... It looks like the earth before God breathed on it."

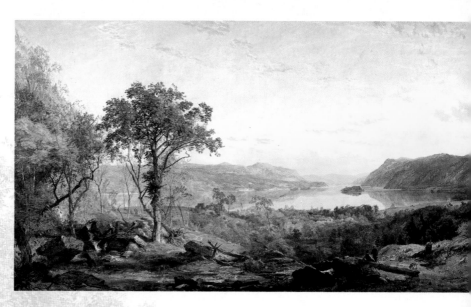

Indian Summer

1866; J. Francis Cropsey (American, 1823–1900); Oil on canvas; 1.3 x 2.4 m (4 ft. 5 in. x 7 ft. 11 in.); Founders Society Purchase, Robert H. Tannahill Foundation Fund, James and Florence Beresford Fund, Gibbs-Williams Fund, and Beatrice Rogers Fund; 78.38

Indian Summer is an outstanding example of Cropsey's dominant theme, the colors of fall in America. One of his largest canvases, it provides a panoramic view of a small town on the Hudson River. While most of his contemporaries concentrated on the romantic aspects of untamed nature, he turned his attention to that of the domesticated countryside. Through paintings such as this one, Cropsey demonstrated how man could live in harmony with nature's wonders. While this canvas has remained in America, others found their way to England where a fascinated public marveled at the vibrant hues of an American autumn unknown to them.

The Wolf River, Kansas

ca. 1859; Albert Bierstadt (American, 1830–1902); Oil on canvas; 123 x 97.2 cm (48 1/2 x 38 1/4 in.); Founders Society Purchase, Dexter M. Ferry, Jr., Fund; 61.28

In 1859 Bierstadt wrote in a letter of his awe and satisfaction upon arriving at Wolf River. He remained in the area for two weeks and produced several sketches. This painting is a product of some of those sketches. It depicts two travelers on horseback crossing the river to trade at an Indian encampment. It is doubtful that this is an actual scene but rather one invented to provide his eastern patrons with a romanticized view of the exotic American west.

LANDSCAPE

AMERICAN ART

DIA

Cotopaxi

1862; Frederic Edwin Church (American, 1826–1900); Oil on canvas;
121.9 x 215.9 cm (48 x 85 in.); Founders Society Purchase with funds from
Mr. and Mrs. Richard A. Manoogian, Robert H. Tannahill Foundation Fund,
Gibbs-Williams Fund, Dexter M. Ferry, Jr., Fund, Merrill Fund, and Beatrice
Rogers Fund; 76.89

Cotopaxi, **the quintessential 19th-century vision of nature's sublime and
terrifying power, was painted on commission for the well-known book
collector and philanthropist James Lenox when Church was at the height
of his fame. The painting made a tremendous impact on the American art
public, who perceived it as a geological parable of the Civil War then in
progress. The viewer's attention is focused on two principal motifs—the
burning disc of the rising sun in its contest with the smoldering volcano.
The colors radiate with fiery intensity against a low, pearlescent skyline.**

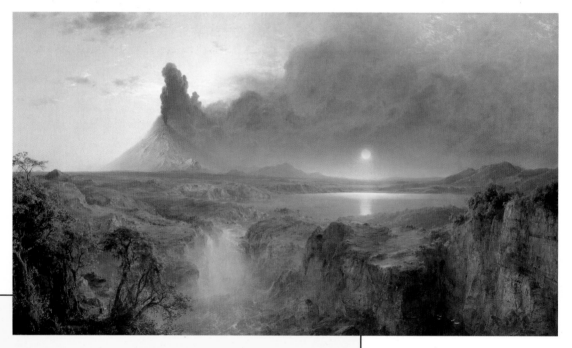

The Civil War

In this cosmic drama of light dispelling darkness, Church mir-
rors the contemporary tragedy of the Civil War and offers hope
for its resolution through the cross formed by the sun's reflection
on the lake. No other representation so summarized American
ideals at this critical point in the nation's history.

For an image of the Civil War, see page 69.

The Fisherman's Wedding Party

1892; Thomas Moran (American, 1837–1926); Oil on canvas; 61 x 83.8 cm
(24 x 33 in.); Bequest of Alfred J. Fisher; 67.118

In the late 19th century many American artists were drawn to Venice with its dazzling light and exotic and colorful appearance. *The Fisherman's Wedding Party* is the culmination of Moran's ability to capture the luminous city. While using a light, cool palette to render the atmosphere of the lagoon, the artist focuses on the colorful fishing boats that were one of the marvels of the city.

Moran was so impressed by Venice that he shipped an ornate gondola back to his home in East Hampton, Long Island. He employed a Mohawk Indian, George Fowler, to pole the gondola around the grounds as a popular diversion for family and guests.

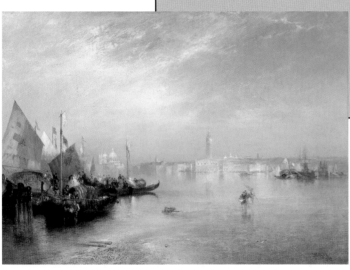

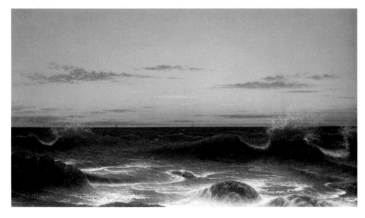

Seascape: Sunset

1861; Martin Johnson Heade (American, 1819–1904); Oil on canvas; 66 x 112 cm (26 x 44 in.); Founders Society Purchase, Robert H. Tannahill Foundation Fund; T1991.1

Heade's depictions of the sea are characteristically disquieting, with harsh, cold light, jutting rocks, and dark, empty water. *Seascape: Sunset* is a prime example in a series of coastal views painted by Heade in the 1860s, all apparently stimulated by the Rhode Island coast. Intent on conveying mood and capturing the fleeting, often hostile elements of nature, Heade sacrificed realistic representation, while elongating form, distorting perspective, and exaggerating color contrasts. The soft ribbons of the clouds, chosen to reinforce the horizontal rhythms of the composition, are a signature of Heade's work. The incoming waves, frozen in time at the peak of cresting, contribute to the surreal effect.

LANDSCAPE

DIA AMERICAN ART

William Page and **Mrs. William Page**

1860–61; William Page (American, 1811–85); Oil on canvas; 153 x 92.1 cm (60 1/4 x 36 1/4 in.); Gift of Mr. and Mrs. George S. Page, Bliss S. Page, Lowell Briggs Page, and Mrs. Leslie Stockton Howell; 37.60–.61

This pair of portraits was painted to celebrate William Page's marriage to his third wife, Sophia Candace Stevens Hitchcock. She had traveled to Rome with Bertha Olmstead, the sister of New York's Central Park designer, Frederick Law Olmstead, and became one of Page's students. The Pages were married in 1857 and were an important part of the American artist colony in Rome. Sometimes referred to as the "American Titian," Page spent countless hours on his wife's portrait in an attempt to replicate the flesh tones which he so admired in the work of Titian.

Pandora

1864; Chauncey Ives (American, 1810–79); Marble; height without pedestal 165 cm (65 in.); Founders Society Purchase, Gibbs-Williams Fund, and Edward T. Rothman Fund; 82.28

Representing the Greek myth of Pandora, this is Ives's most famous work. The first version of the subject, produced in 1851, was the hit of the Crystal Palace Exhibition in London in 1862. In this second version, Ives made changes in the shape of the jar and in the tilt of the subject's head. The classical ideal for which Ives aimed is most obvious in the face and hair, whereas the rest of the figure emphasizes 19th-century naturalism.

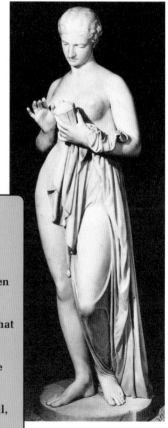

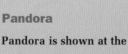

Pandora

Pandora is shown at the moment she can no longer resist the temptation to open the jar, thereby unleashing into the world all the ills that beset humanity. She saved only hope, which lay at the bottom of the jar. Thus, though victims of every evil, we always retain hope.

According to a contemporary reviewer, the attention given to *Domestic Happiness* "has exceeded that given to any other single production that has appeared on the walls of the Gallery since it was first opened…I have heard eminent members of the profession remark on the difficult parts of this composition that they could not name the male artist who was able to surpass them."

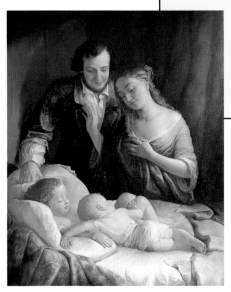

Domestic Happiness

1849; Lily Martin Spencer (American, 1822–1902); Oil on canvas; 1.4 x 1.1 m (55 1/2 x 45 1/4 in.); Bequest of Dr. and Mrs. James Cleland, Jr.; 34.274

The only well-known female genre painter of her generation, Lily Martin Spencer specialized in themes of domesticity. *Domestic Happiness* is one of her most important works. The scene is based on a preliminary drawing of her two oldest sons asleep in each other's arms. Their parents, aglow with pride, watch them. Spencer's children eventually totaled thirteen, seven of whom lived to maturity. Lily was the breadwinner; her husband, Benjamin, tended the house and the children.

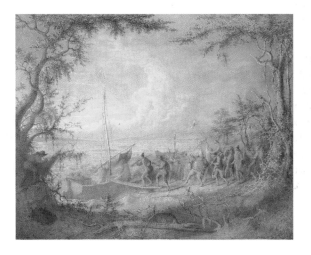

Embarkation from Communipaw

1861; John Quidor (American, 1801–81); Oil on canvas; 68.6 x 87 cm (27 x 34 1/4 in.); Founders Society Purchase, General Membership Fund; 62.176

Quidor was especially fond of painting literary subjects, particularly those from American writers. In this canvas he has adapted an aspect of Diedrich Knickerbocker's (Washington Irving) satirical book *History of New York*. The fictional narrative tells the story of how early Dutch colonists lived on the coast of New Jersey in the village of Communipaw. Their happy life was disrupted by a nearly disastrous encounter with the British. In the scene depicted, Olaffe Van Kortlandt picks up a conch shell and blows it, signaling the colonists to follow him to the boats in search of a new place to live. After some harrowing experiences on the high seas, the group of explorers led by Van Kortlandt sent for their families and belongings and settled on Manhattan Island.

The Trappers' Return

1851; George Caleb Bingham (American, 1811–79); Oil on canvas; 66.7 x 92.1 cm
(26 1/4 x 36 1/4 in.); Gift of Dexter M. Ferry, Jr.; 50.138

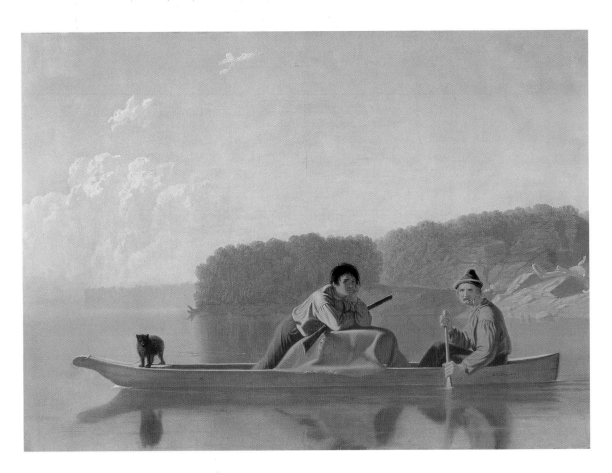

Raised in central Missouri, Bingham found the most enduring subjects of his art in
the trappers and boatsmen who populated his state's great rivers, the Missouri
and the Mississippi. Combining the elements of water, foliage, hazy morning light,
river men, and their simple crafts, he created a sequence known as "The River
Paintings."

The Trappers' Return is the second version of *Fur Traders Descending the Missouri*
(1845, The Metropolitan Museum of Art, New York), which is generally considered
the artist's finest work in the genre idiom. Both pictures present a dugout canoe
moving slowly downstream with an old French trader paddling in the stern and his
son amidships with an animal chained to the bow. The arrangement of the figures
and the general mood invest them with a sense of timelessness all the more
striking for the specificity of the scenes depicted.

Mysterious Critter

Many viewers of this painting wonder what
type of animal accompanies the trappers. Some have
suggested a cat, a fox, or even a bear cub.

Defiance: Inviting a Shot Before Petersburg, Virginia, 1864

1864; Winslow Homer (American, 1836–1910); Oil on panel; 30.5 x 45.7 cm (12 x 18 in.); Gift of Dexter M. Ferry, Jr.; 51.66

Winslow Homer served as a war correspondent for *Harper's Weekly* magazine during the Civil War. By the summer of 1864, the southern cause was lost but the Army of Northern Virginia fought on, defending the Confederate capital at Richmond. At Petersburg, which guarded the approach to Richmond from the south, the siege lasted nine months through the winter of 1864-65. This sets the scene for Homer's young Union soldier to taunt the enemy. Bored with trench warfare, he stands defiantly and challenges the Confederates to shoot at him. Homer went to the Petersburg front on two occasions, which provided him the first-hand experience to paint this soldier's defiant stance.

The Banjo Player

ca. 1852-56; William Sidney Mount (American, 1811–79); Oil on canvas; 66.7 x 92 cm (26 1/4 x 36 1/4 in.); Gift of Dexter M. Ferry, Jr.; 38.60

As an amateur musician, composer, and music lover, Mount evinced a lifelong interest in musical subjects. The violin was his favorite instrument, but he painted at least two banjo players, one a black musician, and this unfinished work. Mount's descendants spoke of the artist's intention "to paint additional figures dancing in the barn." Technical examination confirms that sketchy outlines in faded white paint of two high-stepping figures can be discerned to the right of the musician.

In the late 19th century, America became a modern nation. The most progressive of its artists were trained in the art centers of Europe, Munich and Paris being the most popular. Their paintings stressed figures rather than landscape and followed the dictum of "art for art's sake" promoted by James McNeill Whistler and other advanced artists. Color is limited to the light of evening, of gray days, or of dimly lit interiors; the scene may be glimpsed through a veil of mist.

Nocturne in Black and Gold: The Falling Rocket

ca. 1875; James Abbott McNeill Whistler (American, 1834–1903); Oil on panel; 60.3 x 46.4 cm (23 3/4 x 18 1/4 in.); Gift of Dexter M. Ferry, Jr.; 46.309

This work, which is a depiction of a fireworks display in London's Cremorne Gardens, is probably Whistler's most infamous painting. It was the central issue of a libel suit which involved the art critic John Ruskin and the artist. Ruskin had publicly slandered the work by making the statement, "I have seen, and heard, much of cockney impudence before now; but never expected to hear a coxcomb ask two hundred guineas for flinging a pot of paint in the public's face." Whistler won the libel suit; however, he was awarded only the token damages of one farthing. This is one of Whistler's many "Nocturnes" which are characterized by a moody atmosphere, a subtle palette, and overall tonalist qualities.

Arrangement in Grey: Portrait of the Painter

ca. 1872; James Abbott McNeill Whistler (American, 1834–1903); Oil on canvas; 74.9 x 53.3 cm (29 1/2 x 21 in.); Bequest of Henry Glover Stevens in memory of Ellen P. and Mary M. Stevens; 34.27

In this painting, Whistler explores problems in technique and composition as well as his own psyche; the viewer is confronted by a cool, appraising gaze from a face of deceptive immediacy. The flattened forms, subtle gradations of gray, and asymmetrical composition of the work reveal a strong Japanese influence.

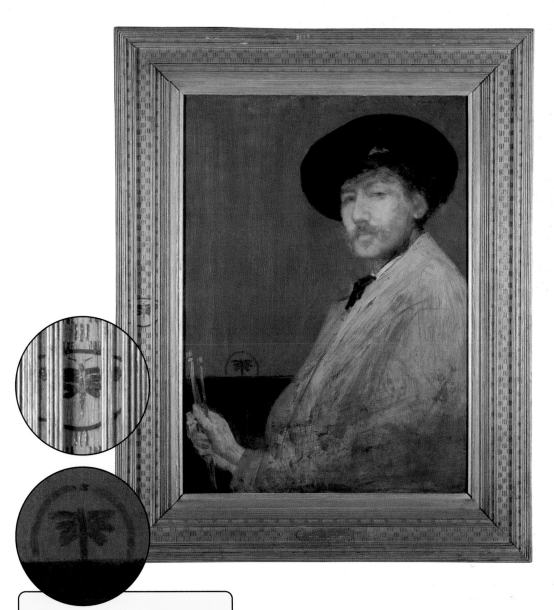

Whistler's Butterfly

Whistler was concerned with the manner in which his canvases were framed and hung. The frame for this work was painted by the artist and signed with the same butterfly signature as the portrait.

The Seasons Triptych

These three paintings by two artists comprise the Seasons Triptych. They were commissioned by Colonel Frank J. Hecker for the music room of his Detroit home through the influence of his close friend the collector Charles Lang Freer.

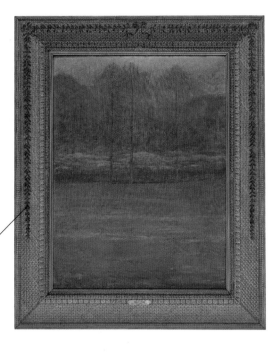

The Frames

This work not only is an example of the collaboration of Tryon and Dewing, but also with the architect Stanford White, who was responsible for the design of the frames, which are an essential element in unifying the entire composition.

Spring

1893; Dwight Tryon (American, 1849–1925); Oil on canvas; 102.9 x 80 cm (40 1/2 x 31 1/2 in.); Bequest of Colonel Frank J. Hecker; 27.314

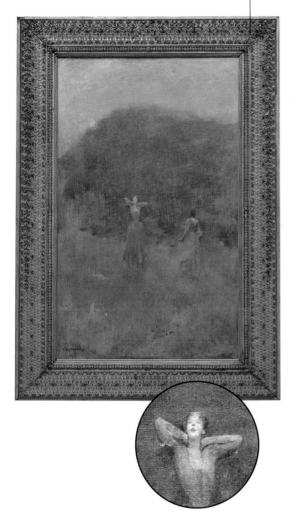

Summer

1893; Thomas Wilmer Dewing (American, 1851–1939); Oil on canvas; 128.7 x 82.6 cm (50 1/2 x 32 1/2 in.); Bequest of Colonel Frank J. Hecker; 27.315

Autumn

1893; Dwight Tryon (American, 1849–1925); Oil on canvas; 102.9 x 80 cm (40 1/2 x 31 1/2 in.); Bequest of Colonel Frank J. Hecker; 27.316

For other images of the seasons, see pages 132–133, 134–135, and 209.

Irises and Calla Lillies

1882–90; Maria Oakey Dewing (American, 1845–1927); Oil on panel; 47 x 34.3 cm (18 1/2 x 13 1/2 in.); Founders Society Purchase, Dexter M. Ferry, Jr., Fund; 1991.112

Although Maria Oakey Dewing had shown an interest in figure painting early in her career, she turned her attention to flower painting following her marriage in 1881 to the artist Thomas Dewing. Her floral subjects were painted both indoors and outdoors in the garden she and her husband maintained at their summer home in Cornish, New Hampshire. *Irises and Calla Lillies* is remarkable for its fusion of intensely observed detail with decorative compositional elements, showing her awareness of Japanese art.

Panel for Music Room

1894; John White Alexander (American, 1856–1915); Oil on canvas; 94 x 197.5 cm (37 x 77 3/4 in.); Founders Society Purchase, Beatrice W. Rogers Fund, Dexter M. Ferry, Jr., Fund, and Merrill Fund; 82.26

The similarity between painting and music was one of the great preoccupations of the late 19th century. The French Symbolists, English artists such as Albert Moore and Frederick Leighton, and Americans such as Whistler and Thomas Dewing, all featured the subject of young women playing instruments and listening to music. Alexander's rich orchestration of the friezelike composition, with its languid poses, fluid brushwork, and careful color modulation, masterfully evokes their ethereal experience.

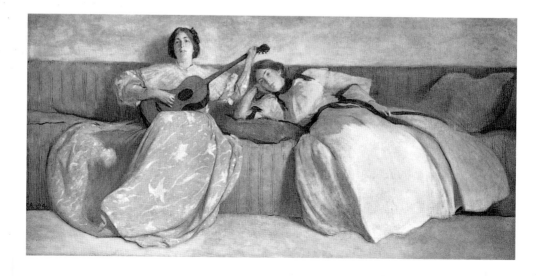

The Apple Orchard

1892; George Inness (American, 1825–94); Oil on canvas; 76.2 x 114.3 cm (30 x 45 in.); Gift of Baroness von Ketteler, Henry Ledyard and Hugh Ledyard, in memory of their father Henry Brockholst Ledyard; 23.100

This painting, which is an excellent example of Inness's late style, depicts the artist's orchard and farm buildings in Montclair, New Jersey. In later works, Inness developed a synthesis of realism and abstraction to achieve a spiritual response to nature which preoccupied the artist toward the end of his life. Inness was not working directly from nature; although there are recognizable and identifiable forms and elements, he was painting from memory, bringing images together in an almost dreamlike manner.

The White Veil

1909; Willard Metcalf (American, 1858–1925); Oil on canvas; 91.4 x 91.4 cm (36 x 36 in.); Gift of Charles Willis Ward; 15.12

Metcalf's use of pointillist strokes to suggest falling snow—the "veil" of the title—and the soft tonalist palette made this one of his most popular paintings, much praised by contemporary critics and art lovers alike. The square shape of the canvas adds to the sense of quiet and serenity that Metcalf sought in his work. Blue-violet underpainting dotted with red unifies the composition and lends an unexpected warmth to the gray winter light. Metcalf spent the first of many winters in Cornish, New Hampshire, in 1909. *The White Veil* is one of two nearly identical canvases with the same title painted during this period.

Mary Cassatt

In 1872 Mary Cassatt first exhibited her work in the Paris Salon, where it attracted the attention of Edgar Degas, who introduced her to the Impressionists, with whom she exhibited several times. Cassatt shared with the Impressionists an interest in everyday scenes and is primarily known for her intimate depictions of women, children, and family members.

Mary Cassatt painted her beloved brother several times, but this portrait was her favorite because, she said, it "was very much like him in those days."

Alexander J. Cassatt

1880; Mary Cassatt (American, 1844–1926); Oil on canvas; 65.4 x 92.4 cm (25 3/4 x 36 3/8 in.); Founders Society Purchase, Robert H. Tannahill Foundation Fund; 1986.60

At the time this portrait was painted, Alexander Cassatt was first vice-president of the Pennsylvania Railroad and one of the most powerful executives in the country. The businessman is seen absorbed in his thoughts, not in the least aware that he is being painted by his sister. Leaning back in his chair, he reveals perhaps a touch of farsightedness as he examines something in his left hand. The portrait suggests both the humanity and reserve that were attributed to Alexander.

In the Garden

1904; Mary Cassatt (American, 1844–1926); Pastel; 66 x 81.3 cm (26 x 32 in.); Gift of Edward Chandler Walker; 08.8

***In the Garden* belongs to a group of pastels, drawings, and paintings done after 1900 and based upon children living in the village near the artist's home in France. Her practice with these child models was to use them again and again so they became accustomed to her and to the demands of posing. The composition has several features common to Impressionism: the high vantage point, the extension of the ground almost to the top of the canvas, the placement of the cropped figures in the immediate foreground, and the bold juxtaposition of the figures and the background.**

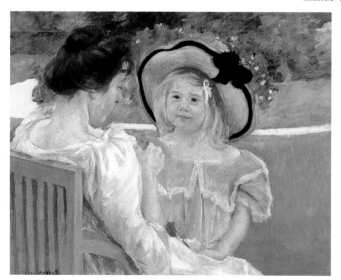

Benson's depictions of his daughters received attention from contemporary critics who saw in them "a new type... something of the character of a fine-blooded racehorse, long in its lines, clean cut, spare of flesh... a product of intensive breeding."

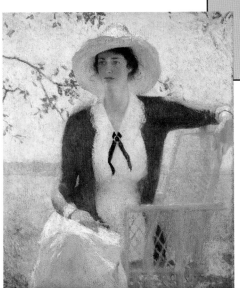

My Daughter Elisabeth

ca. 1914; Frank Benson (American, 1862–1951); Oil on canvas; 111.8 x 94 cm (44 x 37 in.); Detroit Museum of Art Purchase, Special Membership and Donations Fund with contributions from Philip, David, and Paul R. Gray, and their sister, Mrs. William R. Kales; 16.31

Benson's portrait of his eldest daughter, Elisabeth, eloquently summarizes the artist's interests during the early 20th century—the exploration of outdoor light and the depiction of lively, radiant, young womanhood. Although Benson used a camera in his working process, he idealized his subjects when he transferred them to canvas. The images of his daughters in outdoor light remain the quintessential vision of American womanhood at the turn of the century.

Place Centrale and Fort Cabanas, Havana

1895; F. Childe Hassam (American, 1859–1935); Oil on canvas; 54 x 66.7 cm (21 1/4 x 26 1/4 in.); City of Detroit Purchase; 11.5

In 1895 Hassam sailed on a pleasure trip from New York to Cuba aboard a friend's yacht. On his arrival in Havana, he immediately made studies of Fort Cabanas and other colorful subjects. Taken from a high vantage point—the view from his hotel—*Place Centrale* describes the palpable heat of a tropical noon. The painting incorporates many of the techniques of Hassam's European Impressionist colleagues: spontaneous brushwork and broken colors, a cropped viewpoint, and unexpected angles of vision. Barely visible among the typically Impressionist blue shadows of the trees are a number of sketchily rendered figures.

John Singer Sargent

Sargent attained international prominence as a fashionable society portraitist. In both formal and informal scenes Sargent captured his wealthy clients' physical and psychological natures, the gentility and sumptuousness of the era, and the impression of a fleeting moment.

Madame Paul Poirson

1885; John Singer Sargent (American, 1856–1925); Oil on canvas; 149.9 x 85 cm (59 x 33 1/2 in.); Founders Society Purchase with funds from Mr. and Mrs. Richard A. Manoogian, Beatrice W. Rogers Bequest Fund, Gibbs-Williams Fund, and Ralph Harman Booth Bequest Fund; 73.41

The disposition of the elongated figure is natural and straightforward, seen in three-quarter view, with her head turned inquisitively, as though she might have walked immediately into this position and looked at Sargent. The personality of Mme. Poirson is suggested by the aloofness of her gaze and the icy blue color of the background.

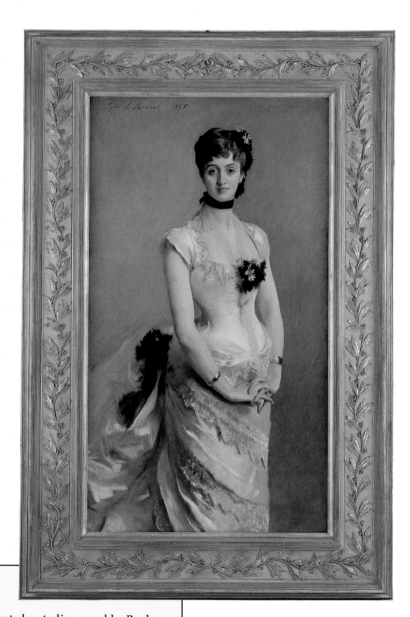

A Rent Payment

In 1883 John Singer Sargent rented a studio owned by Paul Poirson. According to family history this portrait of Poirson's wife was executed in lieu of a rent payment. Sargent's friendly relationship with the Poirsons made this work more personal than the business transaction might suggest.

Mosquito Nets

1908; John Singer Sargent (American, 1856–1925); Oil on
canvas; 56.5 x 71.8 cm (22 1/4 x 28 1/4 in.); Founders
Society Purchase, Robert H. Tannahill Foundation Fund, and
Founders Society acquisition funds; 1993.18

Mosquito Nets **is a beautiful example of Sargent's ability to
translate a momentary impression into a masterful composi-
tion. The picture represents the artist's sister Emily with her
friend Eliza Wedgwood, a member of the famous porcelain
manufacturing family. It was painted in Valdemosa, Majorca,
where the three were spending an autumn holiday. There,
in Eliza's words, "Sargent painted in oils such an amusing
picture of Emily and me—in what John called** *'Garde Mangers,'*
**Emily's invention for keeping out mosquitoes." In this intimate
and affectionate view, we see the women close-up and at a
diagonal angle, reminiscent of "snapshot" views used by
Cassatt and Degas. Emily is seated in an armchair and rests
against one of the red pillows from the sofa beside her;
Eliza is reclining on the sofa.**

Portrait of a Lady in Black

ca. 1895; William Merritt Chase
(American, 1849–1916); Oil on
canvas, 182.9 x 91.4 cm (6 x 3 ft.);
Gift of Henry Munroe Campbell;
43.486

**Chase was deeply influenced by
the Spanish painter Velasquez. He
named a daughter Helen Velasquez
and painted her as an Infanta in
homage to Velasquez's portraits
for the Spanish court. In *Portrait of
a Lady in Black,* the Spanish influ-
ence is obvious in the way Chase
handles the values of reflected
light and the strong emphasis on
the immediate foreground. The
brushwork in the sleeves, collar,
and bodice of the dress are clean,
crisp, and assertive, serving as
a foil to the luminous tones of
the woman's face and arms. Chase
seems to capture, through her
facial expression and standing
pose, the determined attitudes of
a commanding figure.**

The Fencing Master

ca. 1900; Gari Melchers (American, 1860–1932); Oil on canvas; 2 x 1 m (6 ft. 9 1/4 in. x 3 ft. 3 1/2 in.); Gift of Edward Chandler Walker; 13.9

The Fencing Master is one of two oil paintings of this subject by Melchers. They belong to a small group of full-length pictures of men dressed for their occupational roles. These works are not commissioned portraits but genre paintings in which the individuals are posed in characteristic settings and clothes. Here the emphasis is on the design of the painting rather than the particular identity of the subject, French painter Ernest Noir.

DETROIT CONNECTION

Melchers was born in Detroit and later received his training abroad, primarily in Paris and Dusseldorf. He is best known for his portraits and genre scenes.

The Calenders

1889; H. Siddons Mowbray (American, 1858–1928); Oil on canvas; 23.5 x 46 cm (9 1/4 x 18 1/8 in.); Founders Society Purchase, Beatrice W. Rogers Fund; 1984.24

The Calenders was inspired by Edward Lane's 19th-century translation of a collection of traditional Arabic stories, dating back to the medieval period, called The Thousand and One Nights. Three princes disguised as Calenders (a Sufic order of wandering mendicant dervishes), who each had but one eye, shaven chins, and thin, twisted mustaches, entertain a group of Baghdad ladies with tales of their recent misfortunes. Mowbray also worked interchangeably with Greek, Oriental, and Italian Renaissance themes. Regardless of time or place, Mowbray sought to create an aesthetic ambience for his exotic subjects.

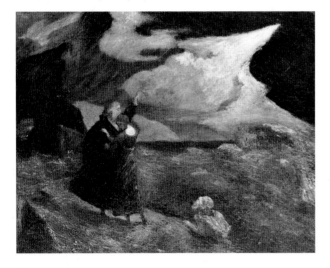

The Tempest

1892, reworked 1896–1918; Albert Pinkham Ryder (American, 1847–1917); Oil on canvas; 70.5 x 88.9 cm (27 3/4 x 35 in.); Gift of Dexter M. Ferry, Jr.; 50.19

Ryder was a reclusive, self-taught artist, whose painting style is both highly personal and very expressionistic. In The Tempest, Ryder combines two of his favorite themes— his love for the sea and his fascination with Shakespeare. The painting is not a literal scene from The Tempest, but a combination of all the major elements from Act 1, Scene 2, placed into one dramatic storm-filled landscape. Ryder reworked the painting for more than twenty years and at one point the artist took a hot poker to the canvas and dragged it through the thickest part of the sky. The Tempest remained in the artist's possession until his death.

Portrait of a Young Lady

1894; Herbert Adams (American, 1858–1945); Polychromed marble with bronze mounts; height 72.4 cm (28 1/2 in.); Founders Society Purchase, Beatrice W. Rogers Fund; 1987.77

While a student in Paris in the late 1880s, Adams began a series of portrait busts of American women that would soon earn him wide critical acclaim. In a marked departure from the bland neoclassical style, his delicate modeling and sensitive use of ornament and costume gave an effect of softness and spontaneity and created a new ideal of feminine charm and beauty. In these busts, Adams experimented with polychromy, tinting plaster in soft tones, and using wood, marble, ivory, and metals in simple combinations.

Woman Sewing

ca. 1913; William McGregor Paxton (American, 1869–1941); Oil on canvas; 76.2 x 63.5 cm (30 x 35 in.); Founders Society Purchase, Merrill Fund; 21.70

Woman Sewing is typical of the work that Paxton was doing after 1910 when he turned his attention to the middle and servant classes. The model for this was a favorite of Paxton's who appears in many other canvases. As with Dutch painting of the 17th century, which he greatly admired, there are often paintings within the painting that have a common relationship with the subject. Here, the painting on the wall is an earlier work employing the same model.

DETROIT CONNECTION

In a letter to DIA administrator Clyde Burroughs, Paxton wrote, "the picture is as good as any I have made...and it is a satisfaction to have it find a permanent home."

The romance of the Orient, fascination with antiquity, and the flowing lines of plant forms were all important design influences in late 19th-century furniture. Sometimes it is China or Japan that the style suggests; sometimes Classical Greece or medieval Europe; and sometimes it is Renaissance Italy or even ancient Egypt that appears to have been quoted. What can be seen in furniture has its parallels in pottery, glass, and silverware.

Cabinet

ca. 1875–80; Herter Brothers (American, 1865-1905); Ebonized cherry with gilt and painted decoration and gilt pressed paper; height 149.2 cm (58 3/4 in.); Founders Society Purchase, Gibbs-Williams Fund; 1988.2

Although the furniture of Herter Brothers was derived from a variety of historical periods, the Anglo-Japanese style associated with the designs of Christian Herter is the most distinctive. Having become acquainted first-hand with the work of the English design reformers, including E. W. Godwin, on a trip to England in 1870, Christian developed an original style based on their precepts which required straight lines and flat surface ornamentation. This cabinet exhibits the restraint associated with the firm's best work. It retains its original gilt pressed paper, as well as its brass pulls, escutcheon, key, and beveled mirrors.

For a piece by E. W. Godwin, see page 233.

Herter Brothers

Herter Brothers was the most progressive American interior design and furniture production firm of the late 19th century in America. The newly rich were ensured both tasteful and elegant interiors when they entrusted the Herters with the decoration of their homes. Gustave Herter and his younger half-brother Christian were both born in Stuttgart, Germany, and trained in Europe before emigrating to the United States. The firm created furniture and decoration derived from a variety of historical periods.

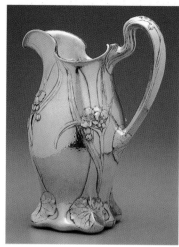

Pitcher

1912; William Christmas
Codman (American, 1839–
1921); Silver; height 27.31 cm
(10 3/4 in.); Founders Society
Purchase, Mrs. Charles Theron
Van Dusen Fund, and American
Art General Fund; 1991.134

**Codman was chief designer
of Gorham Manufacturing
Company from 1891 until his
retirement in 1914. In 1896 the com-
pany introduced his revolutionary new
program to produce a line of hand-
made silver, called Martelé (hand-ham-
mered) in the Arts and Crafts tradition.
Codman said that the new work was
to be "modern art," and the modern
art of 1900 was art nouveau. Thus he
parted company with most of the other
American makers of Arts and Crafts
silverware. Pieces signed by Codman
are rare, though we know he personal-
ly designed the entire Martelé line.
This voluptuous pitcher, with leaf and
undulating lily-of-the-valley motifs, is
one of the most important manifesta-
tions of art nouveau in America.**

Art Exhibition Stand

1860–64; Gustave Herter (American, active 1830–98);
Carved walnut; height 119.4 cm (47 in.); Founders Society
Purchase, Gibbs-Williams Fund; 1989.4

**This art exhibition stand in Renaissance Revival style was
probably commissioned for an art gallery in one of several
great mansions built in the United States during the
Victorian period. Among the extraordinary features are the
four standing winged lions supporting the outer corners.**

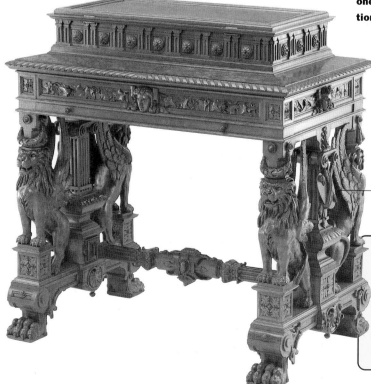

At each stand end are a
carved artist's palette,
brushes, and implements
that symbolize the func-
tional role of the piece.

Louis Comfort Tiffany was trained as a painter, but after 1880 he devoted himself primarily to decorative work and to the design and production of glass. He is often confused with his jeweler father, Charles Lewis Tiffany, founder of the New York silver concern that still bears the family name. Others misuse the term "Tiffany" for any maker of stained glass in turn-of-the-century America.

Jack-in-the-Pulpit Vase

1915; Louis Comfort Tiffany (American, 1848–1933); Glass; height 49.53 cm (19 1/2 in.); Founders Society Purchase, American Art General Fund, and funds from Jerome M. and Patricia J. Shaw; 1990.295

Of all the producers of art glass during the final years of the 19th and early 20th century, no one was more imaginative and inventive than Louis Comfort Tiffany. Contemporary critics were lavish in their praise of the shimmering spectral qualities of his Favrile glassware, which made its debut in 1893. Glass of different colors was combined while still molten; it was then blown and sometimes twisted and twirled on the gather to achieve effects suggestive of flowers, lava, and marble. Tiffany was especially admired for his iridescent glass, particularly in shades of blue and gold, the colors used in this unusually large vase.

Armchair

1880–90; Attributed to Louis Comfort Tiffany (American, 1848–1933); Ash wood and brass inlay; height 83.2 cm (32 3/4 in.); Founders Society Purchase, Beatrice W. Rogers Fund, Edward E. Rothman Fund, and Eleanor and Edsel Ford Exhibition and Acquisition Fund; 1990.293

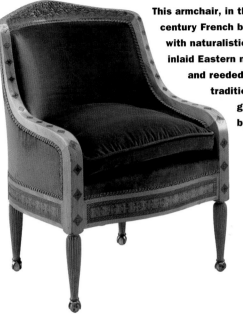

This armchair, in the shape of a late 18th-century French bergère, is endowed with naturalistic surface decoration and inlaid Eastern motifs. The legs, tapered and reeded in the 18th-century tradition, end in feet made of glass balls held in place by brass claws.

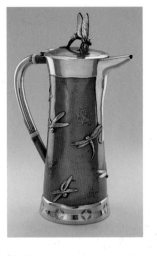

Pitcher

ca. 1893; Tiffany and Company (American); Sterling silver; height 44.77 cm (17 5/8 in.); Founders Society Purchase with funds from Mr. and Mrs. Charles Theron Van Dusen in memory of Charles Theron Van Dusen; 1984.6

During the late 19th century, Tiffany and Company established itself as an innovative producer of jewelry and silverware, including many refined pieces that reflect the ideals of the Aesthetic Movement. This stunning ewer was inspired by both Classical Roman sources—note the head of Bacchus applied beneath the spout and the

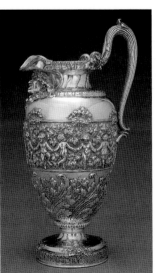

frieze of dancing cherubs and satyrs—and by natural forms. There are only three known examples of this design, one of which was made for exhibition at the 1893 World's Columbian Exhibition in Chicago.

Coffeepot

ca. 1879; Tiffany and Company (American); Sterling silver, copper, ivory, and brass or gold; height 23.5 cm (9 1/4 in.); Founders Society Purchase, with funds from Mr. and Mrs. Charles Theron Van Dusen and Beatrice W. Rogers Fund; 1985.11

The tall cylindrical coffeepot with its free-floating dragon-flies represents the Japanese influence on the avant-garde art of the 1870s. Edward C. Moore, Tiffany's chief design-er, undoubtedly fell under this influence. In fabricating the piece, he employed the Japanese technique *mokume,* in which brass or silver is mixed in copper to achieve a swirled effect. The *mokume* waves achieve a cloudlike quality, interspersed among the applied dragonflies.

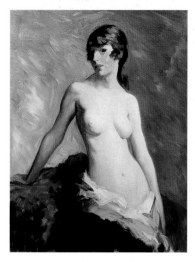

In the opening decade of the 20th century, a group of New York realists replaced the dictum of "art for art's sake" with a new philosophy, "art for life's sake." Led by Robert Henri, the men of the so-called Ash Can School treated themes new to American art: the streets and the tenements of the city. This approach to art was shocking to some and deplorable to others. Henri and his revolutionary "black gang," as hostile critics dubbed them, succeeded in gaining acceptance for their work, though their place at the vanguard was short-lived.

The Young Girl

ca. 1915; Robert Henri (American, 1865–1929); Oil on canvas; 104.1 x 83.8 cm (41 x 32 in.); City of Detroit Purchase; 19.148

The Young Girl belongs to a little-known group of paintings of nudes by Henri from the mid-teens to the early 1920s. They were posed, for the most part, by professional models and were executed as a means of studying the human body. In paintings such as this, Henri does not attempt to evoke associational values or use the girl's facial expression to establish rapport with the viewer. She serves instead as a vehicle with which to explore the more abstract qualities of rhythm, color, and volume.

McSorley's Bar

1912; John Sloan (American, 1871–1951); Oil on canvas; 66 x 81.3 cm (26 x 32 in.); Founders Society Purchase; 24.2

This celebration of male companionship attests to Sloan's conviction that the real artist finds beauty in common things. Sloan often stopped at this New York neighborhood saloon, fascinated by the range of humanity he found there. McSorley's Old Ale House retains this mood and character even today, with one notable change; in 1970 protests by feminists put an end to what had for over one hundred years been an exclusively male domain.

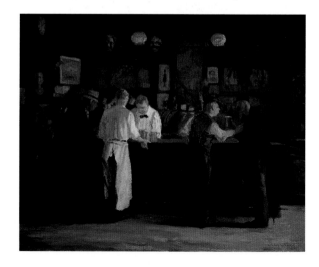

A Day in June

1913; George Bellows (American, 1882–1925); Oil on canvas; 106.7 x 121.9 cm (42 x 48 in.); Detroit Museum of Art Purchase, Lizzie Merrill Palmer Fund; 17.17

George Bellows was a realist with a technique perfectly adapted to his frank impressions. An amateur ballplayer, he maintained a life-long interest in sports, and his paintings of polo matches and prize fight rings are often considered his finest work. The crowds in attendance at the fights were presented in summary fashion, since they were mere accessories to the main event, but they were not the only crowds Bellows painted. As is evident here, he became singularly expert at conveying the sense of motion of a crowd, in this case a group of elegant New Yorkers enjoying a late afternoon outing in Central Park. In the background is the symbol of the 20th-century American city—a skyscraper.

For another work by Bellows, see page 255.

Winter

ca. 1919; Ernest Lawson (American, 1873–1939); Oil on canvas; 101.6 x 127.6 cm (40 x 50 1/4 in.); Gift of Richard H. Webber; 23.19

Although Lawson was associated with Henri's group, his work does not reflect the urban aspects which preoccupied his colleagues. Thus, with *Winter,* Lawson chose to paint a landscape, probably an area around Cornish, New Hampshire, where his family spent the summers of 1919 and 1920.

This work was not always a winter scene. In 1920 it was exhibited at the Carnegie Institute in Pittsburgh as *Trees in Blossom.* Sometime between that show and the time Detroit acquired it in 1923, Lawson painted a heavy blanket of snow over the blossoms and spring foliage.

ASH CAN SCHOOL

AMERICAN ART

DIA

Mural Project

These paintings were part of a mural project conceived by artists Walt Kuhn (1880–1949), Arthur Davies, and Maurice Prendergast in 1914. The three painters executed a set of four large canvases which they exhibited in the spring of 1915 in New York City. John Quinn, one of America's foremost collectors of European avant-garde art and a great admirer of the work of these Americans, purchased all four: *Promenade;* its companion piece, *Picnic* (now in the Carnegie Museum of Art, Pittsburgh); *Dances;* and Kuhn's *Man and Sea Beach* (now lost).

Dances

1914–15; Arthur B. Davies (American, 1862–1928); Oil on canvas; 2.12 x 3.51 m (7 ft. x 11 ft. 6 in.); Gift of Ralph Harman Booth; 27.158

Davies was briefly captivated by the fragmented forms and transparent planes of cubism. Many of his admirers preferred his depictions of ethereal maidens in imaginary landscapes; one pronounced these dancing harlequinade figures "garish as a tartan, and as stimulating." Like many of his contemporaries, Davies was a great appreciator of the "gesture" of the dance, ranging from the interpretations of Isadora Duncan and the fiery spirit of the Duncan Girls, who formed a popular group at the time, to the subtle movements of Ruth St. Denis, who was famous for her sensuous performances.

This work was originally purchased from the John Quinn collection to adorn the Garden Court (now Rivera Court) and is pictured here among the fountains and plantings in 1930.

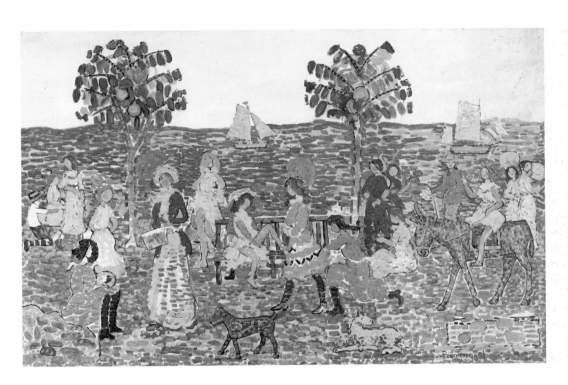

Promenade

1914–15; Maurice Prendergast (American, 1858–1924); Oil canvas; 2.3 x 3.5 m (7 ft. 4 3/4 in. x 11 ft. 2 in.); City of Detroit Purchase; 27.159

Though less tightly orchestrated than many of Prendergast's seaside processionals, *Promenade* is typically organized into three horizontal bands of grass, sea, and sky. The friezelike arrangement of the figures is abstractly echoed in coloristic sequences which are for the most part applied in broad, rectangular strokes, with the white ground visible around the blocks of color. While the immediate inspiration for this technique can be traced to the French painter Georges Seurat (whose works Prendergast studied on his trips to Europe and also at the Armory Show of 1913 in New York), Prendergast developed an individual style in which the dabs of color are so large they no longer are subservient to the scientific theories of the rendering of light, but are instead components of a colorful mosaic pattern.

The arts of the ancient Mediterranean world of Egypt, Greece, and Rome, as well as the ancient Near East and Islam, are well represented in the Department of Ancient Art. The scope of the collection is broad in both time and geography; it exhibits a range that includes prehistoric objects from the caves of Mount Carmel in Israel to gold artifacts from the Bronze Age in Ireland. Virtually every artistic medium is represented including pottery, stone, glass, textile, and metal. Categories of art include sculpture, architecture, painting, weapons, armor, jewelry, textiles, and mummies.

When a new building was planned for the Detroit Institute of Arts in the 1920s, it was acknowledged that the arts of antiquity were central to the story of world art, and the galleries for ancient art were situated at the core of the museum on the second floor. The ancient galleries are arranged chronologically and geographically, beginning with examples of art from prehistory and proceeding through the Near East, Egypt, Greece, Etruria, and Rome.

1

The first objects from antiquity and Islam to join the collection were donated by Frederick Stearns, a Detroit pharmaceutical manufacturer, in 1890. He gave a large number of things that he had purchased in the Near East and Egypt, including mummies, seals, mosaics, pottery, and other artifacts. For a brief period the museum contributed to the Egypt Exploration Fund and received objects from their excavations as a result. Early donors included Lillian Henkel Haass and her daughter, Constance Haass McMath, who were among the most generous contributors to the ancient collections. Howard Carter, the discoverer of the tomb of Tutankhamun, was commissioned as an agent for the museum and through him six Egyptian objects were acquired.

The great strength of the collection is in its high quality, diversity, and its broad representation of most of the important periods in the history of ancient art. Of special interest are Old Kingdom Egyptian tomb reliefs including a chapel wall, a balustrade fragment, and representative parts from other types of tomb decoration. Greek ceramics, particularly red- and black-figure ware, are well represented. Mesopotamian art is illustrated by Assyrian and Babylonian reliefs, seals, pottery, and a remarkable statue of Gudea, ruler of Lagash. Roman art is particularly well represented with sculpture, a wide range of portrait heads and figures, and by mosaic and fresco, pottery and household objects.

The Islamic collection was expanded in the 1920s under the leadership of the first curator of Near Eastern art. The arts of Islam are exhibited adjacent to the galleries of Asian Art on the first floor and includes the book arts, calligraphy and miniature painting, and objects of glass, ivory, lacquer, wood, and stone, with strong collections of metalwork, ceramics, and textiles.

As part of its activities the department has also presented major exhibitions of Egyptian, Near Eastern, Classical, and Islamic art and curators have participated in excavations in Iraq and Egypt.

1 *Olpe (pitcher)*, ca. 720 B.C.; Greek, late geometric period; Earthenware; height 49.6 cm (19 1/2 in.); Founders Society Purchase, New Endowment Fund; 1994.171

2 *Canopic Jar* page 104

3 *Head of Emperor Augustus* page 116

4 *Double-Walled Ewer in the Form of a Rooster* page 123

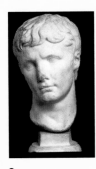

3

4

Mesopotamia, the land between the Tigris and Euphrates Rivers, was the fertile river plain where civilization was born and where writing first appeared. Southern Mesopotamia was under the control of a series of kings from 3000 B.C. to the 6th century B.C. In its early history, Mesopotamia was a collection of agricultural city-states. These later gave way to larger centrally controlled empires which spread through conquest.

Gudea of Lagash

2141–22 B.C.; Mesopotamian, Neo-Sumerian period; Paragonite; height 41 cm (16 1/8 in.); Founders Society Purchase, Robert H. Tannahill Foundation Fund; 82.64

Of all the rulers of ancient Mesopotamia, Gudea, *ensi* (governor) of Lagash, emerges the most clearly across the millennia due to the survival of many of his religious texts and statues. He ruled his city-state in southeast Iraq for twenty years, bringing peace and prosperity at a time when the Guti, tribesmen from the north eastern mountains, occupied the land. His inscriptions describe vast building programs of temples for his gods.

This statuette depicts the governor in worship before his gods wearing the persian-lamb fur cap of the *ensi* and a shawl-like fringed robe with tassles. The serene, heavily lidded eyes and calm pose create a powerful portrait of this pious ruler.

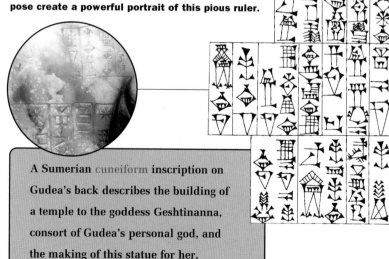

A Sumerian cuneiform inscription on Gudea's back describes the building of a temple to the goddess Geshtinanna, consort of Gudea's personal god, and the making of this statue for her.

The mythical *Dragon of Marduk* with scaly body, serpent's head, viper's horns, front feet of a feline, hind feet of a bird, and a scorpion's tail, was sacred to the god Marduk, principal deity of Babylon.

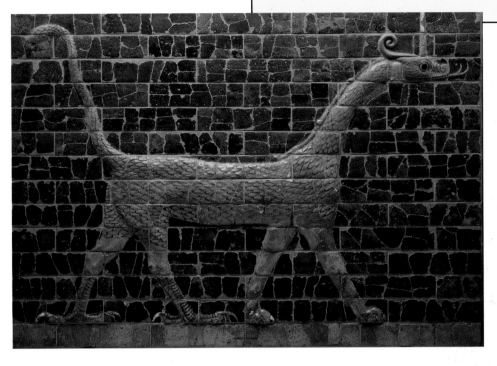

Dragon of Marduk

ca. 604–562 B.C.; Mesopotamian, Neo-Babylonian period; from the Ishtar Gate, Babylon; Molded, glazed bricks; 1.2 x 1.7 m (45 1/2 x 65 3/4 in.); Founders Society Purchase; 31.25

The striding dragon was a portion of the decoration of one of the gates of the city of Babylon. King Nebuchadnezzar, whose name appears in the Bible as the despoiler of Jerusalem (Kings II 24:10–16, 25:8–15), ornamented the

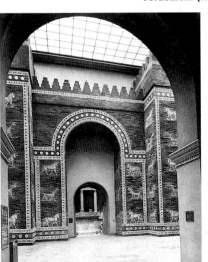

monumental entrance gate dedicated to Ishtar, the goddess of love and war, and the processional street leading to it with scores of pacing glazed brick animals: on the gate were alternating tiers of Marduk's dragons and bulls of the weather god Adad; along the street were the lions sacred to Ishtar. All of this brilliant decoration was designed to create a ceremonial entrance for the king in religious procession on the most important day of the New Year's Festival.

Reconstruction of the Ishtar Gate in the Vorderasiatisches Museum, Berlin

MESOPOTAMIA

DIA ANCIENT ART

The Kingdom of Assyria

The northern Mesopotamian kingdom of Assyria, in existence by 1500 B.C., would become a great empire between the 9th and the 7th centuries B.C. The kings of this mountainous region were conquerors who led their armies on an endless succession of foreign campaigns and celebrated their success by building enormous stone palaces. Royal archives of inscribed clay tablets have left us a vast encyclopedia of Mesopotamian history.

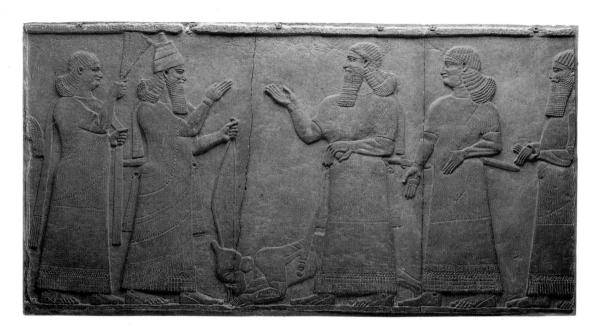

Tiglath-Pileser III Receiving Homage

745–27 B.C.; Mesopotamian, Neo-Assyrian period; Limestone; height 1.2 m (48 in.); Founders Society Purchase, Ralph H. Booth Fund; 50.32

Tiglath-Pileser, a powerful king of Assyria, built a royal palace at Nimrud in northern Iraq. Its principal rooms and courtyards were decorated with large relief sculptures designed to awe visitors to his court. The king's power and majesty were expressed in scenes of war, the hunt, and solemn court ceremonies. In this relief Tiglath-Pileser, wearing a tall headdress and holding a bow, is receiving three courtiers; a helmeted warrior prostrates himself at the king's feet. Behind the royal figure stands a servant with a fly whisk. Horizontal lines of a cuneiform inscription describing a military campaign run just above the heads of the figures. Tiglath-Pileser's campaigns into Syria and Palestine are documented in the Bible (II Kings 15:19, 29; 16:7).



Persepolis

The Achaemenid Persians of central Iran ruled an empire which comprised Iran, Mesopotamia, Syria, Egypt, and parts of Asia Minor and India from the 6th to the 4th century B.C. Their ceremonial capital was Persepolis in southern Iran founded by King Darius the Great (522–486 B.C.); Persepolis was burned by Alexander the Great in 331 B.C. Only the columns, stairways, and door jambs of its great palaces survived the fire. The stairways, adorned with reliefs representing the king, his court, and delegates of his empire bringing gifts, demonstrate the might of the Persian monarch.

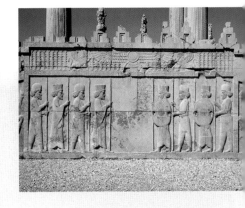

The east stairway of the Audience Hall.

Spearman

5th century B.C.; Iranian, Achaemenid Dynasty; Limestone; height 16.4 cm (10 3/8 in.); Founders Society Purchase, Robert H. Tannahill Foundation Fund; 78.47

This fragment from a stair balustrade depicts a file of Persian spearmen wearing the characteristic fluted felt or feathered headdress. Only the head of one warrior survives with a portion of his spear and that of the soldier behind him. Although unfinished (the beard's curls are not defined), the smooth contours of the suave profile and the richly curled hair demonstrate the elegance of Achaemenid court art.

View through the Audience Hall to the palace of Darius.

Earring

Late 5th–early 4th century B.C.; Iranian, Achaemenid Dynasty; Gold and faience; 7.7 x 5.3 cm (3 x 2 1/8 in.); Founders Society Purchase with funds from Mrs. Charles C. Andrews; 1989.7

Many of the Persian courtiers and delegates on the reliefs of Persepolis are shown wearing elaborate earrings. This earring, probably from Susa (the southern administrative capital of the empire), is characteristic of jewelry of this period. When in motion, the beads tremble like a tiny chandelier and the gold surfaces brilliantly reflect the light.

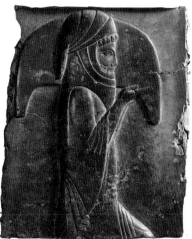

Court Official

359–338 B.C.; Iranian, Achaemenid Dynasty; Limestone; height 65 cm (25 5/8 in.); Founders Society Purchase, The Antiquaries Fund, and Robert H. Tannahill Foundation Fund; 79.31

The palace of Darius the Great was restored by Artaxerxes III by the addition of a western staircase with relief representations of dignitaries from the twenty-six subject states of the empire bearing gifts to the "king of kings." Each foreign group is led by a Persian official holding a staff.

This relief illustrates such a marshall wearing the Persian headdress and robe with a dagger thrust into the belt. His left hand once grasped that of the leader of the next delegation. In front of him a fragment of the garment of another envoy survives.

This late relief, flatter and more linear than those of the reigns of Darius and Xerxes, nonetheless still conveys the power and refinement of the Achaemenid court.

Court Servant with Covered Tray

5th century B.C.; Iranian, Achaemenid Dynasty; Limestone; height 54.6 cm (21 1/2 in.); Gift of Lillian Henkel Haass; 31.340

This relief depicts a Persian court servant holding a covered tray on his shoulder. He wears the distinctive Persian garment of long sleeves and draped skirt, with a folded soft cap.

South Arabian Sculpture

In the early first millennium B.C., a series of independent states arose in southwest Arabia which included the kingdoms of Qataban, Saba', and Hadramaut. These were known to Greece and Rome as they lay on the overland caravan routes bringing incense and other luxury items from Arabia, India, and Africa. The plaque with male head and the stele were excavated at the cemetery of Timna, capital of ancient Qataban. The female head is thought to come from this site also.

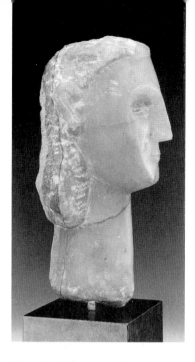

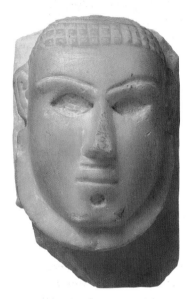

Plaque with Male Head

1st century B.C.; South Arabian (Yemen); Alabaster; height 16.5 cm (6 1/2 in.); Gift of Mrs. Robert T. Keller; 1992.357

The eyes and brows of this head were originally inlaid in a darker stone and the "dimple" on the chin with bronze, indicating perhaps a tattoo which was probably meant as a mark of nobility or power. Other pieces have survived with the metal inlay intact.

The South Arabian taste for abstract forms is reflected in the treatment of the smooth beard and geometric hairstyle, combined here with a more naturalistic rendering of the face derived from Greco-Roman sculpture.

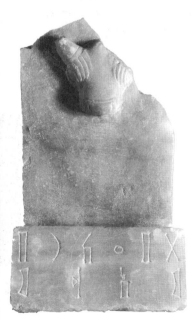

Funerary Stele

3rd century B.C.; South Arabian (Yemen); Alabaster; height 32 cm (12 5/8 in.); Gift of K. T. Keller; 51.293

This commemorative stele is decorated with the head of a bull, symbol of the moon god 'Anbay, chief god of the state. It is inserted into a separate alabaster base inscribed in the South Arabian alphabetic script with "Taba'karib," the name of the deceased or dedicant, and with "M'dm," his clan or tribe name.

Female Funerary Head

1st century B.C.–early 1st century A.D.; South Arabian (Yemen); Alabaster; height 30 cm (11 3/4 in.); Founders Society Purchase, the Robert H. Tannahill Foundation Fund, and funds from members of The Antiquaries; 1992.210

The South Arabian kingdoms developed a unique school of funerary sculpture based on formal, geometric principles and influenced by the Greco-Roman world and a local cult of ancestor worship. The large eyes of this woman were once inlaid with dark limestone or blue lapis lazuli, the roughly carved hair covered by a plaster wig. As a funerary portrait, it might have adorned a burial chamber or the niche of a temple sanctuary as a votive offering.

Ancient Silver

From earliest times, objects made of silver were used to demonstrate power and wealth. The precious metal was fashioned into jewelry, parade armor, ritual vessels, and elaborate tableware. Works of art in silver were commissioned not only by rulers but also by wealthy individuals who wished to imitate the splendor and richness of the royal court.

Helmet

ca. 400 B.C.; Thracian; Silver; height 24 cm (9 1/2 in.); Founders Society Purchase, Sarah Bacon Hill Fund; 56.18

The richly ornamented helmet was fashioned for a wealthy member of a northern Thracian tribe living near the Danube River in modern Romania or Bulgaria. It was hammered from one sheet of silver with a high dome to accommodate the top-knot of hair worn by many Thracians.

The main elements of the design are in low relief; the details were chased and engraved. On the brow piece fierce eyes with bushy eyebrows stare out. One cheek piece bears a horned animal, the other a huge bird of prey with a fish in its beak and a rabbit in its claws. The back and upper edges are embellished with linear designs of rosettes, vines, feathers, and scallops. The interpretation of the imagery is uncertain, but the motifs may refer to traditional myths well known to contemporary Thracians and appropriate to the elaborate armor of a warrior.

Bowl

6th–7th century A.D.; Iranian, Sasanian Dynasty; Silver-gilt; diameter 13.7 cm (5 3/8 in.); Founders Society Purchase, Sarah Bacon Hill Fund; 62.266

The Sasanian empire (226–641 A.D.), which stretched from the Tigris to the Ganges threatening even the great power of Rome and Byzantium, left a legacy of works in silver unrivaled in the ancient world. Plates with representations of the king as hunter were products for the court, ewers with motifs of dancing women were for ritual use, and, late in the period, silver vessels were commissioned for the growing middle class.

This drinking bowl is hammered, gilded, and carved with the design in chased relief. A guinea fowl decorates the interior while vine scrolls with birds, guinea fowl, and a bear, fox, and dog eating grapes fill the exterior. At the center is a ram wearing a jeweled, ribboned collar. The imagery of animals and vines is borrowed from the late classical cult of Dionysus while the ram, symbol of the war god Verethragna, is a potent symbol of Sasanian royalty.

The works here demonstrate the basic principles of Egyptian sculpture in its symbolic formality. For over three thousand years the Egyptians adhered to a prescribed set of rules as to how a work of art in three dimensions should be presented. Egyptian art was highly symbolic and a painting or sculpture was not meant to be a record of a momentary impression. Apparent differences were the result of subtle changes, not an altered conception of art or its role in society.

Seated Man
2465–2323 B.C.; Old Kingdom, Dynasty 5; Polychromed limestone; height 40 cm (15 3/4 in.); Founders Society Purchase, Sarah Bacon Hill Fund; 50.74

The *Seated Man* is a representation of someone who lived in the Pyramid Age, during the Old Kingdom. Unfortunately we do not know his name or titles because the statue has no inscription.

By contrast, the subject of the standing statue of *Sebek em hat* can be identified as a leader of a group of priests in the temple of a deified king at Heliopolis (near Cairo).

The small *Seated Scribe* was once part of a votive offering to Thoth, the patron god of writing. It is a particularly graceful example of the artistic production during the reign of Amenhotep III (1391–53 B.C.) in the New Kingdom.

Nebwenenef, high priest of Amun, can be dated rather precisely to the first fifteen years in the reign of Ramses II (1290–24 B.C.) because it is recorded in the priest's tomb that he was identified by an oracle of the god Amun and installed in that high office in the first year of his king's rule.

Seated Scribe
ca. 1350 B.C.; New Kingdom, Dynasty 18; Basalt; height 6.4 cm (2 1/2 in.); Gift of Mrs. Lillian Henkel Haass and Miss Constance Haass; 31.70

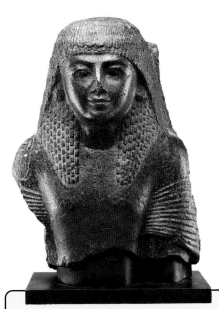

Head of a Man
3rd–2nd century B.C.;
Ptolemaic Period; Basalt;
height 8.9 cm (3 1/2 in.);
City of Detroit Purchase;
40.48

The bust of *Nebwenenef* is different from the standing figure of *Sebek em hat* in scale, quality of workmanship, and detail, but not in the way they both adhere to the canonical rules of Egyptian art.

Nebwenenef, High Priest of Amun
1290–24 B.C.; New Kingdom, Dynasty 19, reign of Ramses II; Granite; height 36.5 cm (14 3/8 in.); Founders Society Purchase with funds from various contributors; 1990.292

The identity of the person represented by the *Head of a Man* is unknown because the inscription is lost; however, he lived during the Ptolemaic dynasty, which was founded by one of Alexander the Great's generals. The man was likely an important leader, perhaps a priest or a general, and had himself portrayed with strength and self-assurance.

Of the materials used by the Egyptian sculptor—clay, wood, metal, ivory, and stone—stone was the most plentiful and permanent, available in a wide variety of colors and hardness. Sculpture was often painted in vivid hues as well. Egyptian sculpture has two qualities that are distinctive; it can be characterized as cubic and frontal. It nearly always echoes in its form the shape of the stone cube or block from which it was fashioned, partly because it was an image conceived from four viewpoints. The front of almost every statue is the most important part and the figure sits or stands facing strictly to the front. This suggests to the modern viewer that the ancient artist was unable to create a naturalistic representation, but it is clear that this was not the intention.

Sebek em hat, a Leader of Priests
ca. 1780 B.C.; Middle Kingdom, late Dynasty 12–early Dynasty 13; Limestone; height 48.3 cm (19 in.); Founders Society Purchase, Sarah Bacon Hill Fund; 51.276

Egyptian Beliefs and the Afterlife

The need to preserve the body from decay was probably the most important part of the Egyptian belief in a life after death because the spirit was thought to inhabit it at times. In the Predynastic period before 3,000 B.C. and the beginning of the Pharonic Age, the body was placed in a grave in the sand with some simple offerings. The natural heat and dryness preserved it with little need for embalming or other preparation. As society developed in Egypt and tombs became much more elaborate, it was necessary to treat the body to protect it from decay.

Mummies could be elaborately wrapped in decorative patterns, as on the example of the Roman period in the collection. The face was usually covered with a mask of plaster or precious metal fashioned as a likeness of the deceased.

The removed internal organs were separately treated and, during much of Egyptian history, placed in jars of clay or stone. These so-called Canopic Jars were closed with stoppers fashioned in the shape of four heads—human, baboon, falcon, and jackal—representing the four protective spirits called the Four Sons of Horus.

In addition to the decorations on the tomb walls, in some periods, models for the use of the spirit were included in the funerary arrangements. A model boat was transportation on the waters of eternity. Likewise, models of granaries, butcher shops, and kitchens would guarantee the continued well-being of the deceased in the life after death.

> "It has been often said that the ancient Egyptians were preoccupied with thoughts of death and the preparation for it. One only has to see the elaborately decorated tombs to think this might have been so. In fact, the Egyptians loved life so much that they literally wanted to 'take it with them' and their tombs prove that they only wanted to enjoy the good things of life for eternity."
>
> William H. Peck, Curator

Canopic Jars
1070–712 B.C.; Egyptian, Dynasty 21–22; Limestone; height 48.3 cm (17 1/2–19 in.); Founders Society Purchase, Bernard and Theresa Shulman Foundation; 70.619–.622

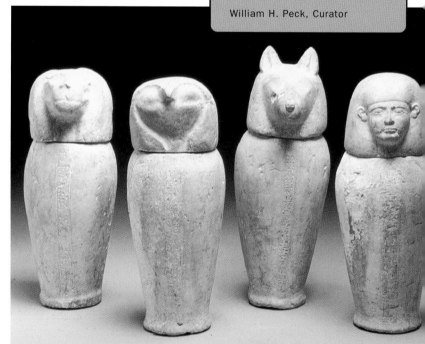

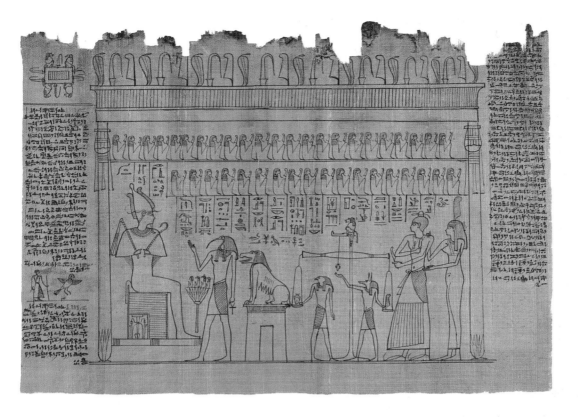

Papyrus of Nes-min (detail)

ca. 300 B.C.; Early Ptolemaic period; Ink on papyrus; one of 24 leaves: total size 35 cm x 11 m (13 2/3 in. x 36 ft. 2 in.); Founders Society Purchase, Mr. and Mrs. Allan Shelden III Fund, Ralph Harman Booth Bequest Fund, and Hill Memorial Fund; 1988.10.13

This page is only a small part of a complete manuscript of *The Book of the Dead* made for a man named Nes-min. *The Book of the Dead* was a collection of prayers and spells believed to provide aid for the spirit of the deceased in the next life. In this vignette Nes-min is led into the presence of Osiris and the gods who judge the dead by Ma'at, goddess of truth. His judgment is represented by the weighing of his heart against an ostrich feather, symbolizing truth and right-doing. If he did not pass this individual judgment, his heart would be fed to the "devourer," the monster crouching in readiness before Osiris.

Mummy

30 B.C.–395 A.D.; Roman period; Linen wrappings and gold mask; height 1.5 m (5 ft.); Gift of Mr. H. Kirke White; 01.4

How to Make a Mummy

The essential steps are:

1 Remove the soft internal organs, lungs, liver, stomach, intestines, and brain

2 Completely dry out the body, then prepare it with spices, balms, or bitumen

3 Wrap the body in linen bandages

Please do not attempt this yourself!

EGYPT

ANCIENT ART

DIA

Egyptian Tombs

Much of what we know about art and life in ancient Egypt has been preserved in the tombs that were prepared for the protection of the dead. The Egyptians believed that the next life had to be provided for in every detail and, as a result, tombs were decorated with depictions of the deceased at his funerary meal, activities of the estate and countryside, and the abundant offerings necessary to sustain the spirit.

The offering list on the relief of Ka aper includes various kinds of drink and food, as well as colored eye paint to protect the eyes from the harsh Egyptian sun.

Because the spirit of the deceased was thought to live in the company of the gods, the standard formula inscribed in tombs asks for "bread and beer and all things good and pure on which a god lives."

Peasants Driving Cattle and Fishing

2465–2323 B.C.; Old Kingdom, Dynasty 5; Painted limestone; 46.9 x 146.9 cm (18 1/4 x 69 in.); City of Detroit Purchase; 30.371

Cattle cross a canal, fishermen haul in their nets, and, in other reliefs, geese and ducks are piled up in front of an image of the deceased. These depictions are typical of the magical representations placed in the tomb to insure the quality of the next life. These detailed depictions tell us much about the daily life of ancient Egypt and provide us with information which makes the ancient Egyptians come alive today.

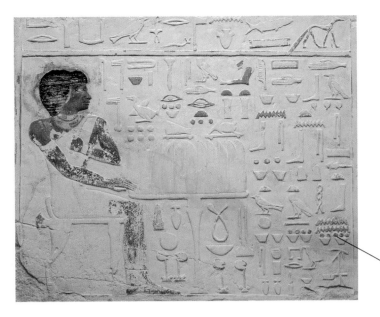

Hieroglyphics listing quantities
of bread

Ka aper with Funerary Offerings

2465–20 B.C.; Old Kingdom, early Dynasty 5; Painted limestone; 50.5
x 61.9 cm (19 7/8 x 24 3/8 in.); Founders Society Purchase, Sarah
Bacon Hill Fund; 57.58

A strict method of representation was developed early in the
history of Egyptian art and a series of rules were established which
changed very little over three thousand years. A good example of
this is the representation of Ka aper at his table, surrounded by
hieroglyphic texts which name the offerings made for his spirit. His
image is made up of parts realized from different viewpoints—head
in profile, shoulders seen from the front, and lower body again as
from the side.

The Egyptian artist was trained to convey a symbolic idea of a person
or thing, not a naturalistic representation.

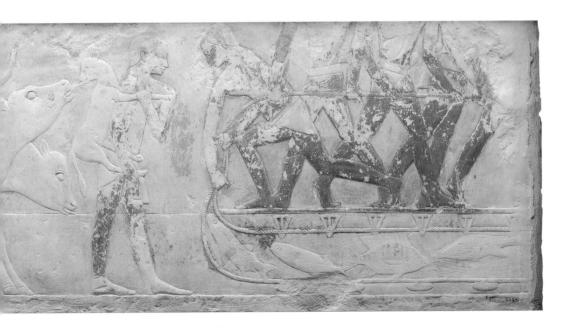

Holy Animals

In the religion of ancient Egypt deities were associated with various aspects of nature and the cosmos, particular geographical localities, or even episodes in human experience such as birth and death. Osiris, originally a god of vegetation and fecundity, was the most important deity related to the afterlife. His wife, Isis, was his principal mourner but also served as an image of motherhood. Some deities had animals associated with them and some were depicted as having animal characteristics. The ibis-headed god Thoth, as an example, was the patron of scribes and writing as well as being a moon god.

In the Late Period images of gods and sacred animals were produced by the hundreds of thousands. The quality of such votive objects varied but this image of a graceful cat is one of the great masterpieces of its type.

The *Sacred Cat of Bast* is associated with the goddess Bast or Bastet, and she was sometimes represented as a human figure with the head of a cat. The natural grace, and perhaps the motherly qualities of the cat, suggested to the Egyptians some aspect of the goddess.

The *Falcon of Horus* wearing the double crown of Upper and Lower Egypt is an image of divine kingship. The king was associated with the sky god as the "Living Horus," and he was thought to represent the rule of the gods on earth. Statues such as this were sometimes used as containers for the preserved remains of the animal or bird they represented. This example is hollow and has an opening under the tail through which a mummified falcon could have been inserted.

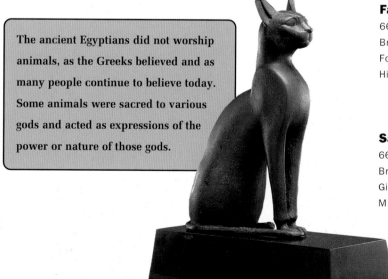

The ancient Egyptians did not worship animals, as the Greeks believed and as many people continue to believe today. Some animals were sacred to various gods and acted as expressions of the power or nature of those gods.

Falcon of Horus
664–525 B.C.; Late Period, Dynasty 26; Bronze; height 39.4 cm (15 1/2 in.); Founders Society Purchase, Sarah Bacon Hill Fund; 59.119

Sacred Cat of Bast
664–525 B.C.; Late Period, Dynasty 26; Bronze; height 26.4 cm (10 3/8 in.); Gift of Mrs. Lillian Henkel Haass and Miss Constance Haass; 31.72

Greek and Roman Influences

Some new artistic influences were introduced when Egypt came within the sphere of the Hellenistic (Greco-Roman) world. One of the most important of these was the realistic painted representation of individuals. This portrait is an excellent example. Only from the Roman frescoes at Pompeii and Herculaneum in Italy have similar realistic examples of portraiture been preserved. We know from contemporary authors that realistic portraiture was highly regarded by the Greeks and the Romans and it is only by accident of preservation that the best examples have been found in Egypt. The faces of people represented in the mummy portraits reflect the mixed population of Egypt when Greek was the language of the ruling class and the country was a part of the Roman Empire.

Mummy Portrait of a Woman

ca. 130–60 A.D.; Egyptian, Roman period; Gilt and encaustic on wood panel; 44.8 x 24.8 cm (17 5/8 x 9 3/4 in.); Gift of Julius H. Haass; 25.2

Painted on a wooden panel, this mummy portrait was placed over the face of a mummified body and secured to it with linen wrapping.

Many mummy portraits were created in a technique called "encaustic" in which the pigment was mixed with melted wax and applied warm to the wood panel with a small spatula.

The use of vivid colors in a wax medium enhances the realistic quality of the portrait.

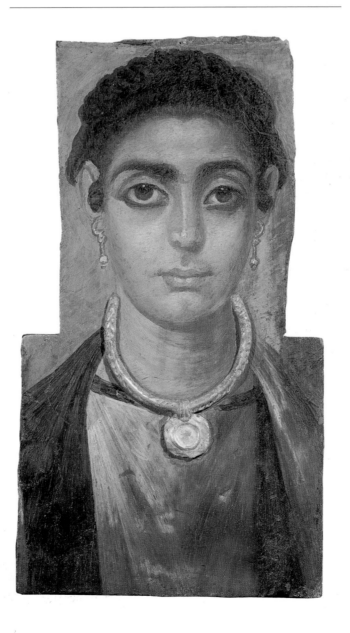

The Greeks developed a style that incorporated an idealized yet realistic approach to the representation of the figure. Greek artists moved toward an expression based on observation of living beings and refinement of anatomical elements. Gods and goddesses were imagined in human form but ideal in proportion, without imperfections. The unclothed human figure in its most perfect manifestation was admired for its harmonious beauty. The archetypical proportions of the human body were the measure and standard of beauty for all things.

Torso of Apollo

2nd century A.D.; Roman copy of 5th century B.C. Greek original; Marble; height 148.6 cm (58 1/2 in.); City of Detroit Purchase; 26.122

The handsome young figure represents Apollo, the Greek god of light, music, archery, healing, atonement, prophecy, and flocks and herds. He was a popular deity with both the Greeks and the Romans, and many statues of him stood in his temples and public spaces. In this later Roman copy Apollo wears a belt over one shoulder to which a quiver for arrows would have been attached at his back.

Panathenaic Prize Amphora

ca. 375–70 B.C.; Greek; Attributed to the Asteios Group; Ceramic, Attic black-figure ware; height 83.6 cm (33 in.); Founders Society Purchase, General Membership Fund; 50.193

The amphora is a fine example of the vessels presented to the winner of an event in the athletic games held every four years in Athens. On one side Athena, the patron goddess, is shown as protector, wearing an archaic form of helmet and carrying a shield and spear. On the other side four male figures are shown running, indicating that the prize was for the winner of a foot race. An inscription running vertically down the vessel records the amphora as a prize "From the games in Athens."

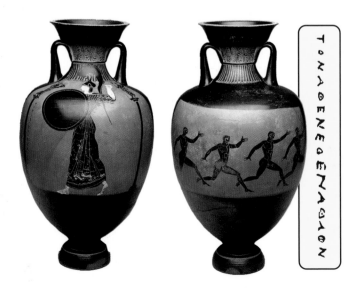

Venus Genetrix

1st century A.D.; Roman copy of late 5th century B.C. Greek original; Marble; height 153.7 cm (60 1/2 in.); Gift of Mr. and Mrs. Henry Ford II; 74.53

Toward the end of the 5th century B.C. a famous Greek statue of Aphrodite, the goddess of love, was created, probably to decorate a temple in Athens. It was such a popular image that it was later copied many times. The type became known throughout the Greco-Roman world and was associated with the Roman goddess Venus.

In more complete examples, Aphrodite is shown holding the apple awarded her in the contest among goddesses when she was judged the most beautiful. Female nudity was not sanctioned in art until later in Greek history but artists discovered a way to reveal aspects of feminine grace. Aphrodite's garments cling to her body, outline and emphasize the contours, creating the illusion of female beauty at its most sensuous.

Torso of Aphrodite

Greek, Hellenistic period; 1st century B.C. copy of 4th century B.C. original; Marble; height 68.6 cm (27 in.); Founders Society Purchase, General Membership Fund; 24.4

The torso is an impressive example of the respect and enthusiasm the ancient Greeks felt for renowned works of art by famous Greek artists of an earlier time. The DIA Aphrodite is an adaptation based on a statue by the 4th century B.C. artist Praxiteles. This revered sculpture of the goddess Aphrodite was created for her temple at Knidos, on the Aegean coast of modern Turkey.

GREECE

ANCIENT ART

DIA

Greek Deities and Heroes

The ancient Greeks lived in a world filled with divine and semi-divine beings. Their religious beliefs and folk traditions were expressed in human terms with gods and goddesses, demi-gods, and heroes often conquering animals and mythical beasts. Even such an abstract idea as poetic inspiration was given human form. Representations of all these beings are found in Greek art: in temples or public spaces and on everyday objects of bronze, ceramic, and precious materials. Concepts which today are considered exclusively religious were an integral part of daily existence.

Volute Krater

320–10 B.C.; The Baltimore Painter; Greek, South Italian, Apulian; Ceramic; height 120 cm (47 1/2 in.); Founders Society Purchase with funds from various contributors; 1983.25

Intended to serve as a funerary offering, this volute krater, set in its own stand, was created in a Greek colony in southeastern Italy. On the obverse (front) of the krater, an image of the deceased with his horse is shown as part of a funerary monument. Above is a scene of banqueting. The colonial artist, in a style characteristically his own, has densely packed the reverse surface of the vessel with a complex assembly of the major deities of the Greek pantheon. Zeus, enthroned in the center, is flanked by gods and goddesses identified by the attributes they hold. Below Dionysus and Ariadne ride in a chariot drawn by two panthers. Greeks and Amazons battle above.

Head of Aristaeus

150–100 B.C.; Greek, Hellenistic period; Marble; height 51.12 cm (20 1/8 in.); Founders Society Purchase, Membership and Donations Fund; 41.9

Aristaeus was the divine son of the god Apollo and the nymph Cyrene. He was known in the ancient world as the founder and patron deity of the city of Cyrene in Libya, a Greek colony in North Africa. This head, from a colossal statue, portrays the god with a rather bland face surrounded by tousled assymetrical curls, which are given dramatic life by being carved in high relief. On Aristaeus's head is a mural crown— a round flat-topped headdress with four vertical raised strips, perhaps intended to represent the defensive towers of the city walls. The enormous statue could have stood in a temple in Cyrene dedicated to Aristaeus.

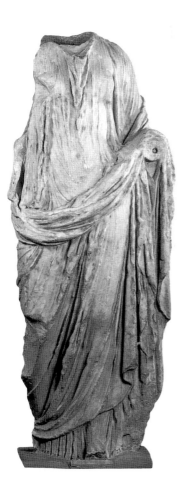

Draped Woman

2nd–1st century B.C.; Greek,
Late Hellenistic period; Marble;
height 1.5 m (61 in.); City of
Detroit Purchase; 24.113

The beautifully draped statue of
a mature woman may be a repre-
sentation of Calliope, the muse of
epic poetry. A flat surface on the
folds of the cloak against the left
arm of the figure may have held a
tablet, an attribute of Calliope. She
might have been fashioned as a
funerary monument, representing a
deceased matron as Calliope, or as
part of a public sculpture with all
nine muses portrayed. Her stance
produces a gentle curve to her
body. Since the back of the statue
is unfinished, it was presumably
set against a wall or in a niche.
The work of art appears to be a
late Hellenistic copy of an early
Hellenistic creation, elegant even
though incomplete.

Finger Ring

2nd–1st century B.C.; Greek, Ionian, Hellenistic
period; Gold bezel set in bronze; length 4.1 cm
(1 5/8 in.); Gift of Mrs. William Clay; 28.121

This heavy ring has been set with a gold oval
deeply chiseled with a scene of the hero
Theseus slaying the minotaur, a monstrous
creature with the body of a man and the head
of a bull. The story of Theseus's triumph is
recorded with dramatic clarity, and the artist
has beautifully adapted the carefully modeled
figures to the long narrow shape of the bezel.

Column Krater (detail)

ca. 470–65 B.C.; The Leningrad Painter;
Greek, Attic red-figure ware; Ceramic; height
40 cm (15 5/8 in.); City of Detroit Purchase;
24.120

This vessel, with handles reminiscent of
columns, was designed as a container in
which to mix wine and water for serving at
social gatherings. On the most important
side of the krater, Helios, the sun god,
wearing a rayed sun disk on his head, is
shown standing in his chariot drawn by two
winged horses. He represents the sun in
its daily journey across the sky; the ocean
waves and a leaping dolphin lie below.

GREECE

ANCIENT ART

DIA

The Etruscans and Their Influence

The Etruscans were a mysterious people, their place of origin unknown, their language little understood. In the 7th and 6th centuries B.C. they controlled the major part of the Italian peninsula, living in walled city-states set on hilltops. Their art shows influences of earlier Italic cultures, the eastern Mediterranean, and Greece, but their style is uniquely their own. Even though most of the art of the Etruscans that has come down to us was created for funeral purposes, its strength and vigor fill it with life.

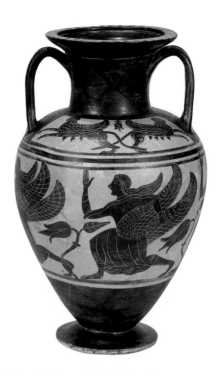

Head of a Man

Second half of the 1st century B.C.; Roman, Republican period; Marble; height 40.64 cm (16 in.); City of Detroit Purchase; 27.211

The Etruscans emphasized realism, an element important to them in the representation of dead ancestors and honored living contemporaries. Roman portraiture of the Republican period is a remarkably successful integration of Greek and Etruscan influences. Greek artists understood anatomy and the naturalistic rendering of living forms. This head of an old man may have been a funerary portrait and is striking in its uncompromising realism. The bald head with blood vessels visible under the skin, the sunken eyes and sagging skin produce a harsh portrayal of old age. The abstract design created by the lines across the brow, at the outer edges of the eyes, and on the neck reflect another indigenous influence—the love of surface pattern. The Romans of the Republic were a tough, puritanical, pragmatic people who found super-realism entirely congenial for representations of revered dead ancestors, as well as for portraits of the living.

Black-Figure Neck Amphora

Late 6th century B.C.; The Micali Painter; Etruscan; Ceramic; height 44.6 cm (17 5/8 in.); City of Detroit Purchase; 27.281

This large storage jar, decorated with motifs connected with death, was probably intended as a tomb offering. The principal scene is of five female figures in swift rhythmic motion. Four of the figures are winged and may represent demons of death pursuing a mortal woman. The lively energy of the silhouetted women is clearly shown in the arms, legs, and flying hair. The incised white lines within the figures bring elegance to flowing skirts and patterned wings.

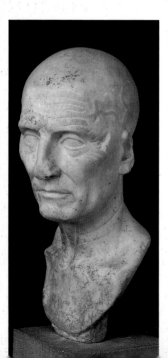
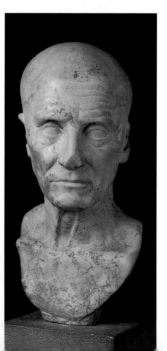

Horseman

ca. 430 B.C.; Etruscan; Bronze; height 26.7 cm
(10 1/2 in.); City of Detroit Purchase; 46.260

The rider is a fine example of the Etruscans' skill in adapting the artistic style of another culture to create a work of art entirely their own. The naturalistic modeling of the figure, cast in solid bronze, shows Greek influence and inspiration, but the stiff folds of the toga, a garment characteristically Etruscan and Roman, adds a new dimension, as does the archaic face with large staring eyes and rigid expression. The disparate elements have been successfully blended together into a calm, dignified figure fashioned as a votive offering for a temple or grave.

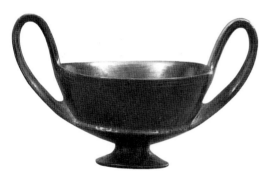

Kantharos

Late 6th century B.C.; Etruscan; Ceramic, bucchero ware; height 10.1 cm (4 in.); Bequest of Robert H. Tannahill; F70.46

Designed for the drinking of wine, this shape was extremely popular in Etruria and was exported to areas around the Mediterranean in the late 7th and 6th centuries B.C. The cup was probably a copy in clay of a more expensive metal vessel, the highly polished black surface a fair imitation of metallic sheen. Etruscan graves have yielded hundreds of *kantharoi*, along with many other ceramic vessels intended for eating and drinking, as part of funeral feasts or as tomb offerings.

Fragments

Often ancient works of art have been damaged with the passage of time. One of the curator's jobs is to display these pieces in a way that suggests their original appearence. The rider has been given a plexiglass saddle to help the viewer imagine the original bronze horse.

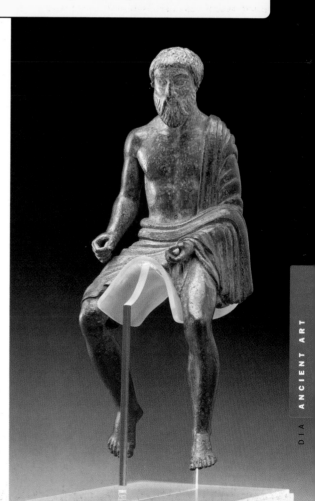

The Romans inherited much from the Etruscans, but they also borrowed many ideas from the Greeks. Sculpture was used to decorate public and private buildings and much of Roman art was

made as official propaganda to glorify the ruler, proclaim victories, or to make pious references to the state and its governance. From the time of Augustus, the first emperor, artists created idealized representations of the imperial family. Such statues could portray important personalities in armor to proclaim a military victory, as an orator in reference to learned activities, or even as a deity to suggest an association with the gods.

Head of Emperor Augustus

First half of the 1st century A.D.; Roman; Marble; height 48.3 cm (19 in.); Gift of Mr. and Mrs. James S. Holden; 24.101

This portrait of Rome's first emperor is an idealized, youthful image, which harks back to the representation of athletes and heroes of 5th-century B.C. Greece. It follows the portrait well known from a marble statue of Augustus, discovered in the villa of Augustus's wife Livia outside of Rome. That handsome likeness was the source of inspiration for hundreds of portraits of the emperor all over the expanding Roman Empire. The statue may have served as the cult figure in a temple to the deified emperor, or stood in a public or private place of honor.

Togate Statue of a Youth

Possibly the young Nero, ca. 50 A.D.; Roman; Marble; height 1.4 m (56 in.); Founders Society Purchase with funds from various contributors; 69.218

The draped toga, the most characteristic form of male dress among the Romans, was assumed at the time when a young man came of age and took on adult responsibilities. This statue is thought to represent the young Nero at about fifteen years of age when he was adopted by the Emperor Claudius. Nero can be recognized by his wide forehead, small chin, projecting ears, and hair arranged in bangs. In later life as emperor, he developed double chins and a reputation for debauchery, indications of which are not yet evident in this youthful portrait.

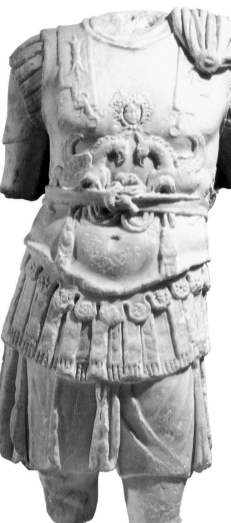

Torso in Armor

ca. 200 A.D.; Roman; Marble; height 112.4 cm
(44 1/4 in.); Founders Society Purchase, Matilda R.
Wilson Fund; 72.273

**One of the standard types of sculpture adopted from
the Greeks was the depiction of a victorious general
or emperor as a warrior wearing the cuirass, or body
armor. In the center of the breastplate is a head of
the Gorgon, Medusa, presumably to instill fear in
an opponent. On the shoulder straps are lightning
bolts associated with the hero Hercules and the
belt at the waist is tied in a square knot called
a "Hercules Knot." The two eagle-headed griffins
also suggest strength or valor. The lappets, or
hanging tabs below the edge of the breastplate,
are also decorated with Medusa heads.**

For medieval armor, see page 181.

Head of Honorius as Augustus

ca. 400 A.D.; Roman, probably from Constantinople;
Marble; height 10.2 cm (4 in.); Gift of Dr. William R.
Valentiner; 37.157

**This late Roman head is of an emperor designate per-
haps ten years old and is part of a group of portraits
of the emperor Theodosius I and his sons. The boy,
with down-cast eyes and a rather closed facial expres-
sion, wears a jeweled diadem and would probably have
had a metal rayed crown with a central gemstone
set behind the diadem. The portrait was completed
just before the monolithic Roman Empire was divided
between Honorius and his brother.**

Roman Decorative Arts

The highly organized and well-integrated political structure of the Roman Empire made it possible for citizens in even the most distant provinces to enjoy a level of material comfort and sophistication close to that of Rome itself. Styles and technical innovations spread rapidly, providing, for the wealthy, a luxurious way of life.

Fragment of a Painted Wall

Mid 1st century A.D.; Roman; Fresco; 264.2 x 50.8 cm (104 x 20 in.); Founders Society Purchase, Hill Memorial Fund; 70.649

The rooms of Roman houses of the first century A.D. were frequently covered with painted fresco decoration. In one style, continuous scenes covered the walls; in another, smaller scenes were framed against a solid background; and in the third style, delicate individual motifs, like this candelabrum, were used. The very tall, fanciful candleholder, ornamented with leaves, would have been an elegant echo in paint of a real bronze one that would have lighted the room.

Personification of the River Tigris

Late 2nd–early 3rd century A.D.; Roman from Syria; Mosaic of stone tesserae; 1.4 x 1.4 m (56 3/4 x 56 1/4 in.); Founders Society Purchase, General Membership and Donations Fund; 40.127

This wonderfully naturalistic representation of the river Tigris as a bearded man wearing a wreath of river grasses formed one corner of the floor of a room in a house in Seleucia Pieria, the port of the city of Antioch. The decorative scheme of the floor was apparently the personification of the four eastern provinces of the Roman Empire surrounded by the personifications of their four principal rivers, each identified by name in Greek. The elaborate metaphor in mosaic was set in what was probably the dining room of the house.

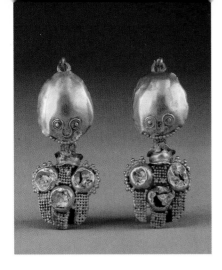

Pair of Earrings

3rd century A.D.; Roman from Syria or
Judaea; Gold; height 2.2 cm (7/8 in.); City
of Detroit Purchase; 27.275

Ancient gold jewelry was generally
formed from thin sheets of gold, rather
than solid gold. By this method, the
maximum effect could be achieved using
the minimum amount of a precious and
expensive material. These earrings are
formed of a hollow oval which conceals
the ear loop behind it. They have as
pendants stylized clusters of hollow
grapes ornamented with very small gold
granules. The geometric grape design in
many variations was popular throughout
the Roman Empire in the second and
third centuries A.D.

Spoon

4th century A.D.; Roman; Silver; length 16
cm (6 3/8 in.); Gift of Mrs. Lillian Henkel
Haass; 50.86

Spoons are an invention of great antiqui-
ty, perhaps developing from shells used
to scoop up food. Spoons were frequently
made in matching sets of twelve and
were used as tableware in the houses
of the wealthy. This silver spoon is an
elegant and restrained example created
during the later Roman Empire. An egg-
shaped bowl is attached to the long
tapering handle by a curving volute. Two
simple incised parallel lines embellish
the flat rectangular lower part of the
handle; a triple-knobbed collar forms
the transition between the two sections
of the handle.

Ribbed Bowl

1st century B.C.–1st century A.D.; Roman
from the eastern Mediterranean; Glass;
height 4.9 cm (2 in.); Founders Society
Purchase, Cleo and Lester Gruber Fund;
1990.270

The molded glass bowl is an example of
the handsome luxury tableware available
in early Roman Imperial times. The beau-
ty of translucent glass was just beginning
to be appreciated, and a wide variety of
shapes in different colors was produced
for affluent homeowners. This vessel,
with its sharply defined ribs, was proba-
bly an imitation of similar, much more
expensive bowls of gold and silver. The
glassmakers were experimenting in tech-
niques and designs in the first stages of
what was to become an enormous indus-
try in mass-produced glass for domestic
use throughout the Roman world.

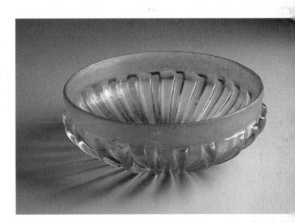

actual size

ROME

ANCIENT ART

DIA

The faith of Islam arose in western Arabia with God's revelations to the Prophet Muhammad (ca. 570-632) by the angel Gabriel. These sacred messages were written down by 651 as the holy book, the Qur'an. In 622 Muhammad left Mecca for Medina in a journey called the *hijra* which marks the beginning of the Muslim calendar (1 A.H.). In 630 he designated Mecca the spiritual and geographical center of Islam.

Islam demonstrates its faith in the building of religious monuments and the illumination of the Qur'an and celebrates all aspects of daily life by adorning the most humble of objects. Arabic calligraphy was the vehicle that spread the message of Islam and thus became the central, most venerated art form. The arabesque, derived from the classical vine scroll, evolved into Islamic art's most distinctive motif.

Although the Qur'an prohibits the worship of idols, it does not forbid representations of humans, animals, and birds in a secular context. Living beings, however, are not permitted as decoration in religious buildings or in the Qur'an.

Doors

Early 17th century; Persian, Safavid Dynasty; applewood, painted, lacquered, and gilded; height 2 m (6 ft. 6 in.); City of Detroit Purchase; 26.7

These doors are decorated with medallions showing single figures and couples feasting in a lush garden, reflecting the luxurious lifestyle of the Persian rulers in the 17th century. The doors are said to come from the pleasure pavilion of Shah 'Abbas I in Isfahan and the style of paintings reflect the influence of Riza-i Abbasi, the shah's leading court painter.

For paintings by Riza-i Abbasi, see page 128.

The Seljuks

The Seljuks, Central Asiatic tribesmen, entered the Islamic world at the beginning of the 11th century. A few decades later they occupied the whole of Iran. A branch called the Seljuks of Rum moved west to settle in Asia Minor (now Turkey). From the 11th century until the coming of the Mongols in the early 13th, the Seljuks ushered in a period of relative peace in which all the arts flourished under their patronage.

The Seljuk period is one of the most creatively exciting in the history of Islamic art. Although of humble nomadic beginnings, the Seljuks—once settled—commissioned buildings of majestic proportions and objects of matchless beauty.

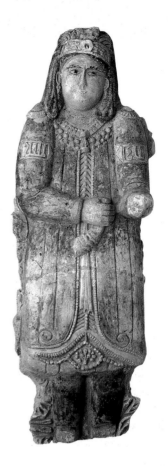

Mina'i Bowl

Late 12th–early 13th century; Persian, Seljuk Dynasty; Ceramic; 9.8 x 21 cm (3 7/8 x 8 1/4 in.); City of Detroit Purchase; 30.421

In their desire to imitate contemporary Chinese Song ceramics, the Seljuks were responsible for the most important innovation in early medieval Islamic pottery. They rediscovered a frit body of clay, quartz, and potash, an ancient Egyptian invention which permitted a variety of color and decoration.

Mina'i (enameled) was the most elaborate Seljuk pottery style, requiring several firings for pigments and gold leaf. Its figural style, derived from wall and miniature painting, preserved in a durable medium an almost vanished aspect of Seljuk art. This luxury ware was produced in Kashan for an emerging wealthy middle class.

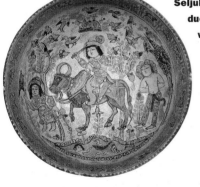

For another scene from the *Shahnama,* see page 126.

The mina'i bowl depicts a scene from the *Shahnama* (The Book of Kings), the 11th-century Persian poet Firdausi's epic poem. The subject, the victorious Iranian King Faridun leading his vanquished Arab foe Zahhak, was chosen for narrative and symbolic reasons.

Figure of a Court Official

Early 13th century; Persian, Seljuk Dynasty; Stucco, polychromed, and gilded; height 1 m (40 in.); City of Detroit Purchase; 25.64

The Central Asiatic origin of the Seljuks is aptly illustrated in this stucco relief which must have formed part of a larger composition decorating a palace. The official's round face, long eyes, and small mouth demonstrate an eastern facial type foreign to the Indo-European Iranians but adopted by them as the ideal of beauty into the 19th century.

The figure wears the winged crown of ancient Sasanian Iran, an invader's conscious identification with the history of the conquered foe. The boots and stiff caftan, however, betray his nomadic beginnings.

ISLAM

ANCIENT ART

DIA

Seljuk Metalwork

One of the great periods of Islamic metalworking occurred under Seljuk rule. Three bronze objects with openwork decoration exemplify the harmony of shape and design achieved by the Seljuk craftsman. A lampstand which originally supported a tray and lamp rests on three hooved legs. Its cylindrical shaft and base are covered with a pierced and engraved design of palmette scrolls surrounding medallions which enclose sphinxes and human-headed birds. The meaning of these magical creatures is unclear but it appears that they are beneficent.

Two other pieces also demonstrate the extraordinary delicacy and power of Seljuk metalwork. A lamp or incense burner of unusual shape and a monumental base for a lampstand are both decorated with Kufic inscriptions bestowing blessings on the owner. Openwork designs of linked roundels and intertwined palmette scrolls adorn the surfaces.

Objects meant to diffuse light (candlestands and lamps) or disperse scented smoke (incense burners) were often covered with lacy, perforated patterns.

Openwork Lamp or Incense Burner
12th century; Persian, Seljuk Dynasty; Bronze; height 16.5 cm (6 1/2 in.); City of Detroit Purchase; 30.440

Base of Lampstand
Late 12th–early 13th century; Persian, Seljuk Dynasty; Bronze; height 31.8 cm (12 1/2 in.); City of Detroit Purchase; 30.447

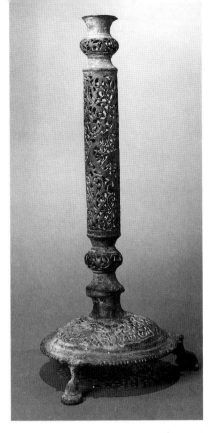

Openwork Lampstand

12th century; Persian, Seljuk Dynasty;
Bronze; height 48.3 cm (19 in.); City
of Detroit Purchase; 29.362

Ring

12th century; Persian, Seljuk
Dynasty; Gold and turquoise;
height 3.2 cm (1 1/4 in.);
Founders Society Purchase
with funds from Mrs. Charles
C. Andrews; 1993.69

**The Seljuks fashioned much of their
jewelry from sheet metal and embell-
ished it with stones. Heavy claws hold
a turquoise on a high, truncated bezel
which is decorated with engraved leafy
arabesques and a Kufic inscription
("blessing"), picked out in niello
(a mixture of gold, silver, lead, and
copper sulfides).**

Double-Walled Ewer in the Form of a Rooster

Late 12th–early 13th century; Persian, Kashan, Seljuk Dyn-
asty; Ceramic; height 27 cm (6 3/4 in.); Founders Society
Purchase with funds from various contributors; 1989.34

**This rare double-shelled ewer imitates in ceramic the
Seljuk metalwork technique of openwork decoration, a
masterpiece in the annals of pottery production.**

**A pierced outer shell representing deer, sphinxes, and
human-headed birds covers a solid inner shell designed
to hold the liquid contents. Inscriptions and willow
leaves encircle the lower body and neck, above which
rises a rooster's head with an open crest to receive liq-
uid and a pierced beak for pouring. The rooster, perhaps
identified here as the Simurgh (a magical being able to
protect against evil), in this case possibly was intended
to guard the owner of the ewer from poison.**

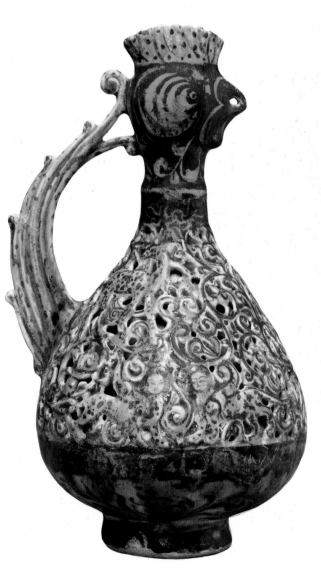

ISLAM

ANCIENT ART

DIA

The Mamluks

The Mamluks (meaning "those owned") were originally Central Asiatic tribesmen who were slaves and bodyguards to the Ayyubids (a Kurdish dynasty ruling Egypt and the eastern Mediterranean in the 12th and 13th centuries). After the fall of that state in 1250, the Mamluks established a powerful empire which included Egypt, Syria, Palestine, southeast Anatolia, and South Arabia, controlling the region for over two hundred and fifty years. They halted the Mongol advance and expelled the last crusaders from the Near East. Their piety was reflected in the great religious complexes and beautiful works of art they commissioned. This religious zeal made them generous patrons of architecture and art.

Plaque

Mid 15th century; Egyptian, Mamluk Dynasty; Ivory and wood; height 9.5 cm (3 3/4 in.); Gift of Kirkor Minassian; 27.593

The Ayyubid tradition for inlaid, carved wood doors, cenotaphs (funerary monuments), and minbars (pulpits) was continued under the Mamluks and refined with the addition of carved ivory inlays set into precious woods. Polygonal, star-shaped elements were cut and carved separately to be later assembled into large compositions based on geomtric patterns with radiating stars.

This polygonal ivory plaque (one of three in the collection), is characteristic of the fully developed style of Mamluk carving. A beaded trefoil medallion is set against graceful floral scrolls with split leaves. The plaque would have formed a point in a star pattern, part of a larger composition used to adorn a door or pulpit.

Bottle

1300–20; Syrian, Mamluk Dynasty; Glass; height 36.8 cm (14 1/2 in.); City of Detroit Purchase; 30.416

Extraordinary examples of enameled, gilded glass were produced under the Mamluk sultans. This technique was commissioned exclusively by the court and its religious foundations.

Bottles of this shape were used for decanting wine. This bottle with applied foot and neck ring is typical of early 14th-century Mamluk glass types. Its gilded and enameled decoration reflect that period's predilection for bands of calligraphy and floral motifs.

This bottle was commissioned by Dawud, Rasulid Sultan of Yemen, and bears his blazon, a five-petaled rosette.

This rug is but one example of the museum's large holdings of Islamic rugs and textiles. Carpets from Anatolia, Persia, Islamic Spain, Egypt, and India and fabrics dating to the Abbasid, Fatimid, Seljuk, Safavid, and Ottoman dynasties form an important collection of the art of the Islamic weaver.

Rug (detail)

ca. 1500; Egyptian, Mamluk Dynasty; Wool; 1.4 x 2 m (53 1/2 x 79 in.); Gift of an anonymous donor; F49.14

Mamluk rugs in their narrow choice of colors and exotic designs are unique in the Islamic world. They appeared suddenly in Cairo at the end of the 15th century. Egypt, a tropical country, had no tradition of pile weaving, a craft more suited to colder climates. Perhaps weavers fleeing the destruction of Tabriz in Iran were employed by Mamluk patrons.

The rug's characteristic subtle colors and delicate floral motifs demonstrate the remarkable style of Mamluk carpets.

Pitcher

13th–14th century; Syrian, Mamluk Dynasty; Glass; height 13 cm (5 1/8 in.); Founders Society Purchase, The Antiquaries Fund, and Cleo and Lester Gruber Fund; 1987.78

The elaborate gilded and enameled glass commissioned for the sultan tended to overshadow more humble products. Undecorated vessels of colorless, transparent glass are, nonetheless, objects of refinement. This pitcher's graceful spout, sloping angular body, and its rainbowlike iridescence (produced by acids in the soil acting on the glass surface when later buried) combine to create an object of quiet elegance.

ISLAM

ANCIENT ART

DIA

Ardashir Battling Bahman, Son of Ardawan

First half of the 14th century; Persian, Ilkhanid Dynasty; Opaque watercolor, ink, and gold on paper; 59 x 39.7 cm (23 1/4 in x 15 5/8 in.); Founders Society Purchase, Edsel B. Ford Fund; 35.54

The *Shahnama,* The Book of Kings, was written in the 11th century by the Persian poet Firdausi. It extols the valor of the ancient kings of Iran. The richly colored painting here depicts the historic hero Ardashir (on the right) as he battles Bahman (on the left), the son of his enemy, for the crown of Persia.

This copy of the *Shahnama* was probably commissioned between 1335 and 1336 by the Vizier (prime minister) Ghiyath al-Din in the Mongol capital city of Tabriz. Persian painting was born there, with the development of a Mongol style influenced by the Baghdad school and Chinese art. The Persian aesthetic integrates a sense of drama with an expanded use of color.

For another scene from the *Shahnama,* see page 121.

Qur'an Manuscript

ca. 1425–50; Persian, Timurid Dynasty; Opaque watercolor, ink, and gold on
paper; 44.5 x 38.1 cm (17 1/2 x 15 in.); City of Detroit Purchase; 30.323

**The Timurids ruled most of Iran and Central Asia for much of the 15th
century. As patrons of the arts they established *kitabkhanas* (royal library-
workshops) in Samarkand and Herat, producing luxurious Qur'ans (the holy
book of Islam) as declarations of their piety. These Qur'ans, of imposing
size, were written in a variety of monumental cursive scripts and illuminated
with a rich repetoire of ornamental motifs. The delicacy and intricacy
of expression achieved by the royal Timurid style dazzles the eye on this
sumptuous object of veneration.**

For European manuscripts, see pages 157 and 169.

Courtly Life

The art of Islam reflects its rulers' taste for luxurious adornment and furnishings, symbols of their power and position. The caliphs (secular and religious heads) surrounded themselves with sumptuous objects of glass, precious metals, and ivory, and lived in palaces richly decorated with wall paintings and stucco reliefs. Paintings, metalwork, ceramics, and wood and ivory carvings illustrated royal wealth in scenes of courtly life, feasting, and hunting.

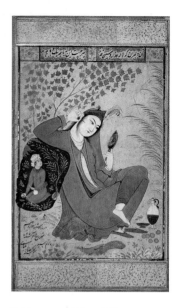

Youth in European Dress

1634; Riza-i 'Abbasi (Persian, active 1587–1635), Safavid Dynasty; Opaque watercolor on paper; 14.6 x 19.2 cm (5 3/4 x 7 5/8 in); Gift of Robert H. Tannahill in memory of Dr. William R. Valentiner; 58.334

When the Safavid ruler Shah 'Abbas I (1587–1629) moved the capital of Persia to Isfahan in 1589, Riza-i 'Abbasi was his most influential court painter. Riza created a style which relied on a calligraphic line and an original sense of color. His album pages reflect the shah's and the public's taste for intimate works. They mirror the luxurious taste of the Safavid court with its fondness for elaborate textiles, Chinese porcelain, and exotic garments.

Woman with a Mirror

1619; Riza-i 'Abbasi (Persian, active 1587–1635), Safavid Dynasty; Opaque watercolor on paper; 24.1 x 12 cm (9 1/2 x 4 3/4 in.); Gift of Mrs. Edsel B. Ford; 44.274

Bracelet

11th century; Syrian, Fatimid Dynasty; Gold; width 7 cm (2 3/4 in.); Gift of Mrs. Roscoe B. Jackson; 26.15

"Sovereignty belongs to God" is the inscription on this bracelet, spelled out in grains of gold, intertwined with floral scrolls, and adorned with filigree.

Little remains of the rich legacy of early Islamic jewelry, but what has survived demonstrates its great quality. The Fatimids (909–1176) ruled Tunisia, Egypt, and Syria for two hundred years and commissioned luxury objects of exquisite workmanship. This bracelet, made in Syria, illustrates the heights achieved by the Fatimid goldsmith.

It is said that even the great Shah 'Abbas was so overcome by the beauty of a portrait by Riza that he bowed and kissed the hand of his court painter.

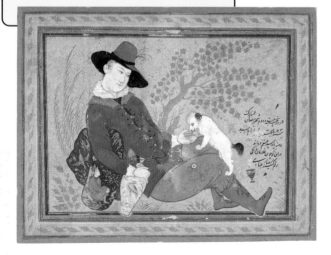

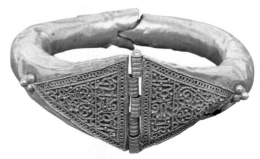

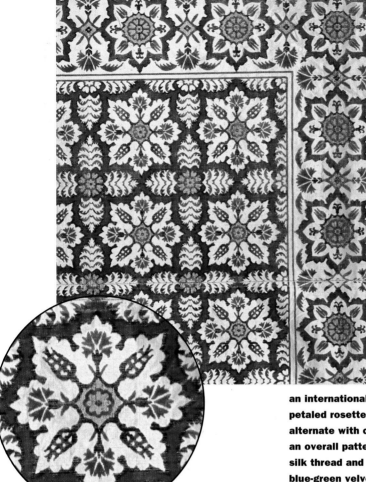

Floor Covering (detail)

Second half of 16th century;
Turkish, Ottoman Dynasty;
Voided silk velvet, compound
satin, silver; 4.9 x 2.7 m (16 ft.
1 in. x 8 ft. 9 1/2 in.); Gift of
Mr. and Mrs. Eugene H. Welker;
48.137

**In the 16th century, Ottoman
imperial workshops at Istanbul
and Bursa produced some of
the most sumptuous fabrics
ever created. These prized tex-
tiles were distributed as gifts
and exhibited at ceremonies.**

**This enormous floor covering
was probably woven at Bursa,
an international center for the silk trade. Eight-
petaled rosettes enclosing carnations and rosebuds
alternate with crosses of serrated leaves to form
an overall pattern. Glittering silver-wrapped yellow
silk thread and ivory satin contrast with red and
blue-green velvet. The pile of one half of the floor
covering lies in one direction while the other half
lies in the opposite, creating a magical shimmer.**

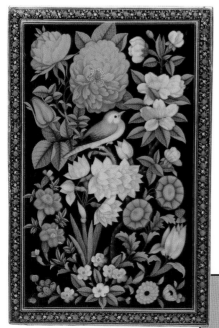

Mirror Case

Mid 19th century; Persian, Qajar Dynasty; Papier-
mâché; 20 x 13.2 cm (7 7/8 x 5 1/4 in.); Founders
Society Purchase with funds from Mrs. Charles C.
Andrews; 1991.5

**The Safavid 17th-century tradition for luxury objects
in painted lacquer was continued under the Persian
Qajars. This technique, employing an undercoat
of gesso and a lacquer varnish, produced richly
decorated pieces of great charm. This mirror case
(the reverse is illustrated) depicts a nightingale on
a rosebush amid hyacinths, primroses, and other
blossoms. A Persian sensibility is here integrated
with an interest in European botanical studies.**

Romance

As in Persian poetry, the
bird symbolizes the lover,
while the rose is his beloved.

ISLAM

ANCIENT ART

DIA

❶

The Department of Asian Art is responsible for the art of east, south, south-east, and central Asia. Major geographic areas represented in the Department of Asian Art are Japan, China, Korea, and India. Also a part of this collection are notable examples of Cambodian, Nepalese, Tibetan, Vietnamese, Ryūkyūan, and Indonesian art. The collection of approximately 2,600 objects includes screens, hanging scrolls, hand scrolls, manuscripts, miniature paintings, lacquer, ceramics, monumental sculpture, small carved objects, bronzes, furniture, armor,

1

weapons, games, and textiles. Many are fragile works which are rotated seasonally to protect them from damage from light, temperature, and humidity. Most of the important works are on view at one time or another during the course of the calendar year.

1 *Dog Chasing Contest
Screen* (detail), 1624–
1643; Japanese, Edo
period; Ink, paint, and
gold on paper; 187 x 472
cm (66 3/4 x 123 1/2 in.);
Founders Society Purchase
with funds from various
contributors; 81.9

2 *Ewer,* Early 12th century;
Korean, Koryŏ dynasty;
Blackware; height 21.7
cm (8 1/2 in.); Founders
Society Purchase with
funds from Mr. and Mrs.
Charles Endicott; 1983.4

3 *Early Autumn* (detail),
13th century; Chinese;
Hand scroll, ink and color
on paper; 26.7 x 120 cm
(10 1/2 x 47 1/4 in.);
Founders Society Purchase,
General Membership and
Donations Fund; 29.1

4 *Padmapāni,* 11th century;
Indian; Brass, height 9.5
cm (3 3/4 in.); Gift of H.
Kervorkian; 25.34

The collection is especially strong in early
Chinese, Japanese, Korean, and Ryūkyūan
lacquers. Another area of strength is the
secular art of China, Korea, and Japan, partic-
ularly painting and ceramics. Most of these
objects were for use in daily life, though some
were luxury items for the wealthy and have survived only
because they were used on special occasions. The DIA collec-
tion of Indian and Southeast Asian sculpture includes some
extremely important masterpieces. For example, the Late
Chola dynasty bronze of the goddess Pārvatī is among the
finest examples of this period in existence. An earlier Chola
figure of the malevolent goddess Châmundâ is part of a well-
known group of "seven mother" goddesses now in major
museums around the world. The small devotional image of
Garuda is an exquisite example of Cambodian miniature
bronze sculpture of the renowned Angkor period.

Other individual objects which should not be missed are two
exceedingly rare Buddhist sculptures. Because of Korea's tur-
bulent history, few objects of great antiquity have survived.
The only Korean monumental cast iron piece on exhibition in
this country is the *Head of Buddha.* Also infrequently seen,
owing to the fragility of lacquered wood, is a sutra container
in the form of *Śākyamuni,* which is a 14th-century Chinese
masterpiece of gentle subtlety and realism.

3

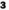

4

Natural objects and festivals associated with seasonal change have long been celebrated subjects among artists in East Asia, especially in Japan.

Spring has white flowers, autumn has the moon,
Summer has cool breezes, winter has the snow,

When useless things do not clutter your mind,
You have the best days of life.

Saying of the Buddhist master Wu Men, 1228

Three Seasons?
The snow-covered pine represents winter, the moon stands for summer and autumn, and cherry blossoms welcome spring.

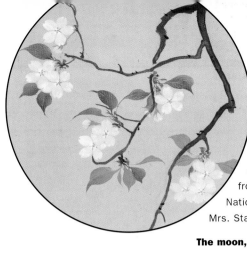

Triptych of the Seasons

Sakai Hōitsu (Japanese, 1761–1828); Edo period; Ink and color on silk; Founders Society Purchase with funds from Gerald W. Chamberlin Foundation, Inc., Michigan National Corporation, Mrs. Howard J. Stoddard, and Mr. and Mrs. Stanford C. Stoddard; 82.30.1–3

The moon, branches of spring cherry blossoms, and snow-laden pine, express an appreciation for the best aspects of all the seasons. This was a poignant and revered subject for Sakai Hōitsu and other followers of the Japanese master Ogata Kōrin. Hōitsu's version of the classic subject is subtle and delicate.

For a work by Ogata Kōrin, see page 136.

In the evening lanterns are lit, more numerous than the stars in the sky. Making night brighter than day... The scent of perfumed sleeves of silken gauze is wafted on the breeze from

the river, tortoise-shell combs and silver hairpins glitter in the moonlight...

Nō Robe, Karaori Type

18th century; Japan, Edo period;
Metallic and glossed silk karaori brocade
on an unglossed twill-weave silk ground;
height 152.7 cm (59 3/4 in.); Founders
Society Purchase, Henry Ford II Fund; 1984.23

Restrained, formal, and masked, Nō dramas developed into the national theater of Japan under the patronage of shoguns. An all-male cast of performers combine mime, music, chant, and costume. The drama is set against an austere and unchanging stage with a lone, ancient pine painted on the back wall; robes set the mood. An actor's inspired selection of a costume signifies masterful role interpretation.

This robe is a Karaori, an outer robe generally used for women's roles and the most resplendent of all Nō costumes. Originally, karaori, meaning "Chinese weaving," described imported, figured fabrics; later it referred to elaborate brocades woven in the Nishijin district of Kyoto. The contrasting types of silk give this robe extraordinary subtlety and depth. This robe, with a design of butterflies, chrysanthemums, and grasses, was used for plays in which autumnal imagery was prominent.

Document Box

17th century; Japan, Momoyama period; Lacquer and gold *maki-e*; 17.8 x 27.9 x 44.5 cm (7 x 11 x 17 1/2 in.); Founders Society Purchase with funds from an anonymous donor; 81.1

This is a prime example of 16th- to early 17th-century Kōdai-ji style lacquer ware decorated with paulownia and chrysanthemum crests among autumnal motifs of pampas grass and bush clover. Spectacular effects were achieved by sprinkling gold (*maki-e*) in wet lacquer to form flat modulated "pear skin" grounds accentuated by needle engraving. In 1606 the wife of the powerful warlord Toyotomi Hideyoshi built a family mausoleum on the grounds of the Kyoto temple Kōdai-ji. This daring new style of lacquer was created for the temple's furnishings and had a tremendous influence on later Japanese lacquer and painted ceramics.

Entertainments of the Four Seasons in Kyoto (detail)

Maruyama Ōkyo (Japanese, 1733–95); Edo period; Hand scroll; Ink on paper; 28.5 cm x 14.1 m (11 1/4 in. x 46 ft. 3 1/2 in.); Founders Society Purchase, Edsel and Eleanor Ford Exhibition and Acquisition Fund, Alan and Marianne Schwartz Fund, with funds from Michigan National Corporation, Mrs. Howard J. Stoddard, and Mr. and Mrs. Stanford C. Stoddard; 1983.21

Maruyama Ōkyo was the master of the realist school of painting in 18th-century Japan. Ōkyo's brilliant talent in genre painting is evident in his execution of the popular time-honored theme of seasonal activities. A scene of a summer night gathering along the cool banks of the Kamo River at the intersection of Shijo Street is preceded by a scene of spring cherry blossoms and followed by scenes of the fall lantern festival and the winter preparations for the New Year's festivities. Between the scenes are sections of spontaneous cursive-style narrative text by the renowned calligrapher Takahashi Munenao.

Gentle spring zephyrs scarcely rustle a branch... of...cherry blossoms at their peak...the wind in the pines...echoes gently... promising that the spring to come will hold countless blessings...

Takahashi Munenao (1701–1785), from the *Entertainments* scroll

The great Japanese decorative style known as "Rimpa" means "school of Kōrin," after its most famous practitioner Ogata Kōrin (1658–1716). It is a compound of the last syllable of Kōrin's name, *rin,* elided with the word for school, *ha*. Rimpa art captures the essence of natural objects through skilled, sensitive ordering of images and space.

Corn and Pampas Grass Fan

Ogata Kōrin (Japanese, 1658-1716); Edo period; Color on gold and silver paper; each 22.9 x 22.6 cm (9 x 8 7/8 in.); Founders Society Purchase, Stoddard Fund for Asian Art, Acquisitions Fund; 78.66

Kōrin was the foremost decorative painter of the Edo period and his art is credited with bridging the worlds of the old aristocratic imperial city of Kyoto and the Tokugawa shogunate's brash new bourgeois military capital at Edo (Tokyo). Born the son of a wealthy Kyoto textile merchant, Kōrin led a privileged life and only turned to painting for a livelihood when the family fortune was exhausted. A world of easy grace is reflected in the elegant sophisticated paintings of sunlit corn and moonlit pampas grass on this fan. A talent for pattern and composition coalesced in Kōrin's personal style, which is noted for forceful abstract design and the keen observation of nature that is so evident here.

Box for Writing Implements with Design of Water Buffalo and Bush Clover

Signature of Ogata Kōrin (Japanese, 1658-1716); Edo period; Lacquer with gold, mother-of-pearl, and lead inlay; 29.5 x 21 x 5 cm (11 1/2 x 8 1/4 x 2 in.); Founders Society Purchase, with funds from Mr. and Mrs. Charles M. Endicott, Mr. and Mrs. George M. Endicott, Miss Elizabeth Ann Stoddard, Mr. Simeon H. Stoddard, and Mr. Stanford D. Stoddard; 80.29

Although this box bears the signature of Ogata Kōrin and its simplicity, decorative flatness, and use of broad pewter inlays is related to his lacquer works, this particular *suzuribako* is believed to be the work of one of his followers. Restrained elegance achieved through the masterful juxtaposition of contrasting materials for maximum effect is a primary trait of Rimpa lacquer.

Reeds and Cranes Screen (one of a pair)

Suzuki Kiitsu (Japanese, 1796–1858); Edo period; Color on gilded silk; each 1.8 x 3.7 m (5 ft. 9 1/2 in. x 12 ft. 1 1/4 in.); Founders Society Purchase with funds from Gerald W. Chamberlin Foundation, Inc., Mr. and Mrs. Charles M. Endicott, Mrs. Howard J. Stoddard, Mr. Howard P. Stoddard, and Mr. and Mrs. Stanford C. Stoddard; 79.28

Folding screens, invented by the Chinese to avert drafts and prying eyes, became an important format for Japanese painters. This expansive pair of screens begins with the masterful arrangement of Manchurian cranes among water reeds. Every major master in the Rimpa school executed at least one painting of the "thousand cranes," symbols of longevity. Kiitsu is often considered the last great master of the Rimpa school. His satisfying balance of realism and the decorative application of touches of red, green, and blue within a predominantly monochrome palette on a shimmering gold ground make this one of his most popular and exemplary works.

For cranes as symbols of longevity, see page 144.

Bowl with Design of Figs and Leaves

ca. 1990; Itō Motohiko (Japanese, born 1939); Stoneware with cloth impressed surface, underglaze painted decoration, and ash glaze; height 13 cm (5 in.); Founders Society Purchase, with funds from Mr. and Mrs. Stanford C. Stoddard; 1994.27

Itō Motohiko is an artist specializing in tableware decorated with powerful, evocative distillations of natural beauty. This contemporary bowl continues the traditions of the Rimpa style. Its shape echoes that of Kōrin's favored round-fan format, which had a profound influence on the circular ceramic compositions by Kōrin's younger brother, Ogata Kenzan. The principle of using a selected vignette from nature in a carefully orchestrated space is seen in all their work.

RIMPA STYLE

DIA ASIAN ART

Wine and tea have played important roles in the art and culture of East Asia. In China ritual meals were prepared for deceased loved ones. The finest Shang Dynasty (16th-11th century B.C.) bronze ritual vessels were used to warm and serve wine. The Buddhist practice of drinking tea was introduced to Japan from China in the 8th century. Sophisticated utensils imported from China were gradually supplanted by Japanese objects embodying concepts of solitude and elegant simplicity, reinforcing the underlying ideals of discipline and harmony. Tea ceremony wares challenge the viewer to delight in their visual nuances as distillations of nature's beauty.

Ritual Wine Vessel
13th-11th century B.C.; China, Shang Dynasty, Anyang Phase; Bronze; height 22.1 cm (8 1/2 in.); City of Detroit Purchase; 53.169

This ancient vessel, called a *jue*, was probably used on an ancestral altar during funerary rites and then placed in the tomb to ensure the deceased's safe and happy passage into the spiritual realm. Occupying this *jue's* major frieze is the most prevalent Shang bronze motif, the *taotie* (ferocious animal) mask, intended to dispel evil spirits. Above this frieze is a band of stylized cicadas, which live longer than any other insect and symbolize happiness and eternal youth.

The spirits enjoy wine and food;
They predict for you a hundred blessings.

The Book of Songs, 1122–256 B.C.

The Tea Ceremony

In Japan the tea ceremony became a highly structured ritual for preparing tea in the company of guests. Many utensils are used in the preparation of ceremonial tea—the tea bowl, brazier, kettle, ladle, tea storage jar, water jar, whisk, powdered tea caddy, tea scoop, waste water bowl, and various trays to support tea ceremony objects or offer sweets. Each is an art object to be appreciated by the participants.

An occasion for drinking a bowl of tea prepared with care, for each guest to examine the tea utensils, and for eminent people to engage in intellectual discussions....

Miscellaneous Stories about Drinking Tea, 1620

Tea Storage Jar

Late 16th–early 17th century; Japan, Momoyama period; Bizen ware; High-fired stoneware; height 42.8 cm (16 3/4 in.); Founders Society Purchase, New Endowment Fund and Henry Ford II Fund; 1989.73

In Japan the rise of the military class with their passion for rustic simplicity in ceramic wares fueled a boom in the production of high-fired stonewares. The "Six Old Kiln" sites (Bizen, Tamba, Shigaraki, Echizen, Seto, and Tokoname) had long been producing humble wares. As the ruling class patronized the tea ceremony, these kilns were in demand to supply simple wares, which became expressions of the restraint and cultivated appreciation valued in this rite. In this cultural milieu, accidental occurrences during firing, such as deposits of ash, stone bursts, and fire or cord marks, became features that potters deliberately tried to reproduce with great care. By the time this Bizen jar was produced, there was nothing accidental about the fire marks or the well-placed spot of ash glaze on its shoulder.

Tray with Design of Cranes and Chrysanthemums

First half of the 14th century; China, Yuan Dynasty; Carved black lacquer; diameter 29.2 cm (11 1/2 in.); Founders Society Purchase, Stoddard Fund for Asian Art, and funds from the Gerald R. Chamberlin Foundation, Inc.; 80.25

A distinct group of extraordinarily fine carved lacquers known as "two bird" dishes were produced in China during the Yuan Dynasty (1279–1368). Based upon the method of carving and construction, this example is believed to date from the first half of the 14th century. During this time black lacquer was deeply carved to expose a background of ocher lacquer below a thin layer of red lacquer. This tray was originally owned by Buddhist monks and later used by tea ceremony enthusiasts in Japan.

CEREMONIAL OBJECTS

DIA ASIAN ART

The scholar was the most admired and emulated figure in Chinese, Japanese, and Korean society. Scholars passed rigorous examinations on classical literature, which enabled them to become court officials and government emissaries. Although emperors or wealthy persons may have lacked the scholar's skill, they still sought to enter his circle of friends and engage in cultivated pursuits such as writing, painting, and collecting.

Freehand Copy of Zhang Xu's Writing of the Stone Record (detail)

Dong Qichang (Tung Ch'i Ch'ang, Chinese, 1555–1636); Ming Dynasty; Hand scroll; Ink on satin; 26.7 cm x 3.3 m (10 1/2 in. x 10 ft. 9 1/4 in.); Founders Society Purchase, Henry Ford II Fund; 77.63

Mastering the use of the brush was a primary scholarly pursuit. Scholars refined their brushwork by copying the works of famous calligraphers. Here the scholar Dong Qichang looks to the wild, free-flowing *kuang cao* cursive style of Zhang Xu (ca. 700–750) for inspiration. The 8th-century text praises the achievements of the Xuanzong emperor (713–755) and his cabinet ministers.

Box for Writing Implements with Design of Squirrels among Grapes

17th century; Ryūkyū Islands; Lacquer with gold and mother-of-pearl inlay; 27 x 21.5 cm (10 1/2 x 8 1/2 in.); Founders Society Purchase with funds from Collins Holding Company, Mr. and Mrs. Charles M. Endicott, and an anonymous donor; 81.683

It is thought that boxes for writing implements, larger boxes for stationery, and tables were travel accessories for the feudal lords of southern Japan who controlled much of the trade between Japan and the Ryūkyū Islands to the south during the Edo period. Ryūkyūan lacquer craftsmen used locally harvested mother-of-pearl, prized for its superior color, to create inlaid works for patrons in the islands, China, and Japan.

The pairing of squirrels with grapes is a visual pun for longevity. It was an exceedingly popular motif throughout East Asia in paintings and the decorative arts from the 17th century onward. Here the undulating edge of the writing box is a sensitive complement to the incised inlay intertwined with painted gold embellishment.

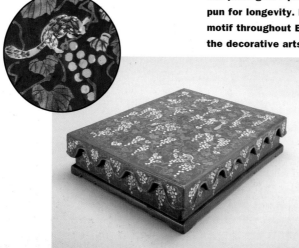

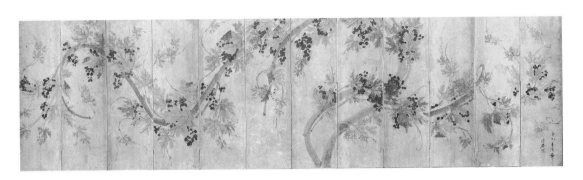

Grapevine Screen

ca. 1825; Ch'oi Sok-hwan (Korean, active early to
mid 19th century); Chosŏn Dynasty; Ink and light
color on paper; 80.6 x 298.7 cm (31 3/4 x 117 5/8
in.); Founders Society Purchase with various funds
and contributions from the Korean community,
1988.62

**The Korean word for grape, *p'o-to,* is similar in
sound with the word for peach, *to,* a traditional
symbol of immortality. Thus, the motif on this
screen was meant to convey wishes for a long life
to the viewer, as well as make a statement about
the owner's literary and artistic sophistication.**

Table with Floral Scroll Design

14th century; Korea, Late Koryŏ Dynasty; Black
lacquer with mother-of-pearl and twisted wire inlay;
14 x 27.9 x 50.2 cm (5 1/2 x 11 x 19 3/4 in.);
Founders Society Purchase with funds from the
Friends of Asian Art, John and Annette Balian, and
Mr. and Mrs. Stanford C. Stoddard; gifts of Mr. and
Mrs. Lawrence Fisher, Dr. and Mrs. Leo S. Figiel, and
Dr. and Mrs. Steven J. Figiel, by exchange; 1993.17

**Scholars were collectors of art and arbiters of
taste. Small tables were used as trays and
pedestals for useful objects. Floral scrolls are an
enduring theme on Korean lacquer work. Koryŏ
lacquers are noted for their impressive floral
designs executed in inlaid wire and mother-of-
pearl. This table bridges the stylistic gap between
earlier Koryŏ works employing inlay of miniscule
mother-of-pearl pieces with later works like the
stationery box to the right, which is made with
large pieces of mother-of-pearl.**

Stationery Box with Design of Lotus Blossoms and Scrolls

Early 17th century; Korea, Chosŏn Dynasty; Lacquer
with incised mother-of-pearl inlay; 13.2 x 30 x
43.5 cm. (15 1/8 x 17 1/8 x 5 1/8 in.); Founders
Society Purchase with funds from
an anonymous donor; 82.33

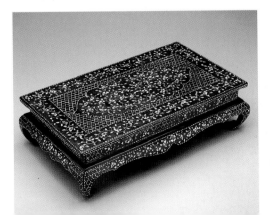

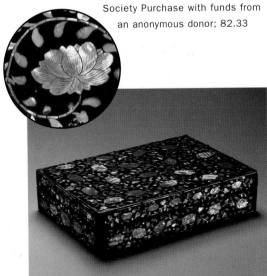

DOMAIN OF THE SCHOLAR

DIA ASIAN ART

Scholarly Painting

Two of the most influential painters in Ming Dynasty China were Shen Zhou and his protégé Wen Zhengming. When compared, the mature styles of the teacher and student are apparent. Wen's brushwork is often called "elegant" in contrast to Shen's brusque vigorous style. These two artists set the standards for scholarly Chinese painting until Dong Qichang (see page 140) developed his theories late in the 16th century.

Ode to the Pomegranate and Melon Vine

ca. 1506–09; Shen Zhou (Chinese, 1427–1509) and Wang Ao (Chinese, 1450–1524); Ming Dynasty; Hanging scroll; Ink and color on paper; 148.9 x 75.6 cm (58 5/8 x 29 3/4 in.); Gift of Mr. and Mrs. Edgar B. Whitcomb; 40.161

This collaborative effort by two talented friends working at the height of their creative powers, the famous painter Shen Zhou and the scholar and great statesman Wang Ao, was executed for their mutual friend Wu Chunhong. Shen's soft colored washes interspersed with vigorous spiked brushstrokes are the perfect complement to Wang's poem, which he executed in the sweeping grass cursive style.

The subjects for both painting and poem are the pomegranate branch laden with ripe bursting fruit and the swiftly growing, highly productive melon vine (known in English as a loofa). These two plants, both symbols of fecundity, carry the wish that Wu might be blessed with a long hoped-for son.

The First Prose Poem on the Red Cliff

1558; Wen Zhengming (Chinese, 1470–1559); Ming Dynasty; Hanging scroll; Ink on paper; 141.3 x 33 cm (55 3/8 x 13 in.); Founders Society Purchase, Robert H. Tannahill Foundation Fund; 76.3

The Chinese concept of our fleeting existence in the boundless universe is expressed in Wen Zhengming's painting and calligraphic rendition of Su Dongbo's classic poem written in 1082. Three scholars are depicted contemplating life and nature over wine on a moonlight Yangzi River cruise at the foot of the scenic Red Cliffs. Part of the poem reads:

The clear breeze over the river, or the bright moon between the hills,

These we may take...free,

And they will never be used up.

These are the endless treasures of the Creator,

Here for you and me to enjoy together.

Professional and Nonconformist Painting

Professional artists primarily painted to make a living, unlike the scholar painters, who painted mainly for pleasure. The hand scroll by Wang Wen shows the work of an artist who combined elements of both scholarly and professional styles.

Herdboys and Water Buffaloes (detail)

15th century; China, Ming Dynasty; Hand scroll; Ink and color on silk; 31 cm x 4.6 m (12 1/4 in. x 9 ft. 10 1/8 in.); Gift of Mrs. Walter R. Parker; 31.284

Professional painters depicted subjects popular with the common people and executed them in a lighthearted approachable manner. No scholarly background in the classical literature is required to delight in the springtime pastoral scene *Herdboys and Water Buffaloes.*

View from the Keyin Pavilion on Paradise Mountain (detail)

1562; Wang Wen (Chinese, 1497–1576); Ming Dynasty; Hand scroll; Ink on coarsely woven silk; 39.4 cm x 9.1 m (15 1/2 in. x 19 ft. 3 in.); Founders Society Purchase, with funds from Mr. and Mrs. Lawrence P. Fisher, by exchange; 1993.51

During Wang Wen's years as a scholarly official in the provincial capital of Nanjing, he was influenced by the works of professional painters at court. After retirement Wang painted the view from his pavilion atop Paradise Mountain at the confluence of tributaries to Lake Tai in Zhejiang Province. Although the brushwork and composition are akin to scholarly painting, the unpretentious subject and playful execution are in keeping with professional painting.

Auspicious symbols, whose origins are found in Asian lore and legend and the Chinese Daoist tradition of nature-mysticism, play on words connecting living beings with good fortune. Visual representations of the land of the immortals and the creatures that inhabit it are a recurrent theme. Animistic principles maintain that every creature, plant, and rock is imbued with a sentient spirit.

Cranes dance in clouds above millennium old trees...

Chen Zi-an (656–695 A.D.)

The crane, a symbol of longevity, is often combined with references to tortoises and pine trees, other symbols of venerable age. Both are believed to be abundant on the Isle of Immortality.

Nō Mask Box with Design of Insects and Mount Horai

Late 16th–early 17th century; Japan, Momoyama period; Lacquer with gold *maki-e;* 25 x 35 x 27 cm (9 3/4 x 13 3/4 x 10 1/2 in.); Founders Society Purchase, Ralph Harman Booth Bequest Fund, Abraham Borman Family Fund, Joseph H. Boyer Memorial Fund, Benson and Edith Ford Fund, Henry Ford II Fund, and K.T. Keller Fund; 1983.38

The fabled "Mountain of Immortality," known as Mount Horai, is depicted on this box. It was said to be found somewhere on an island in the East China Sea and endowed with the power to insure immortality. In Japan, this theme was popular on early lacquer works. When the common Mount Horai imagery of cranes and tortoises frolicking on a rocky shoreline dotted with bamboo and pines was combined with an assortment of insects, birds, and flowers, a very rare and special congratulatory design was created.

Tray with Design of Cranes in Flight

17th century; Ryūkyū Islands; Red lacquer on wood with inlaid mother-of-pearl and incised gold decoration; 4.6 x 30 x 30 cm (1 3/8 x 11 3/4 x 11 3/4 in.); Founders Society Purchase, with funds from Mrs. Howard J. Stoddard, and Mr. and Mrs. Stanford C. Stoddard; 1987.32

Above an inlaid bank of bamboo and reeds, nine cranes fly amid scattered clouds of incised gold. The central scene is framed by four dragons within elongated windows set against a diaper-patterned ground composed of coins. These symbols invoke a blessing of long life (cranes), power (dragons who command the clouds), and wealth (coins).

Box with Design of Auspicious Symbols

18th century; Korea, Chosŏn Dynasty; Ox horn mounted on wood; 26 x 52.5 x 31 cm (10 1/4 x 20 3/4 x 12 1/4 in.); Founders Society Purchase, New Endowment Fund and funds from the Korean community; 1986.3

Ox horn decoration, known as *hwagak,* was unique to Korea and mainly used for sewing boxes, small chests, and clothes boxes of high-born women. Each panel is a self-contained scene of propitious images: the paired dragon and phoenix are emblems of masculinity and femininity; the deer, crane, and tortoise symbolize long life; and birds, flowers, and butterflies signify marital bliss.

The laborious and time-consuming *hwagak* technique requires a horn to be soaked or steamed with water, flattened, separated into thin layers, cut into uniform rectangles, painted on the reverse side, and glued to a wooden frame with the painted side facing inward. Finally, the outer surface was polished to a brilliant luster. The finished work shows us an exuberant view of the Chosŏn woman's world.

Embroidered Screen with Longevity Symbols

18th century; Korean, Chosŏn Dynasty; Embroidery on silk panels; 1.41 x 3.66 m (55 1/2 x 144 in.); Founders Society Purchase with funds given as a centennial gift by the Founders Junior Council and with funds from the Korean community; 1985.14

Longevity is held in high esteem and is one of the most frequent and popular subjects in Korean art. Enduring eternally and sustaining life, the sun, clouds, water, and mountains are the background for other symbols of long life in a landscape paradise. The pine and bamboo, noted for their hardiness and resiliency, are often compared to venerable old men. Various legends associate cranes, tortoises, and deer with happiness, good luck, and long life. Deer are said to be the only creatures able to find the sacred fungus, a supernatural mushroom of immortality.

Mythical birds and beasts are symbols of protection, power, and divinty in Asia. In religious art fantastic creatures often accompany deities as mounts or guardians. Pairs of tiger and dragon or dragon and phoenix represent universal balance and harmony.

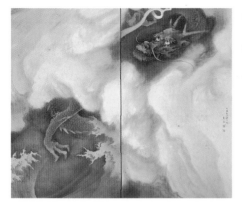

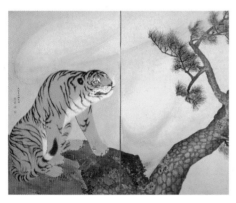

Tiger and Dragon Screens

1781; Maruyama Ōkyo (Japanese, 1733–95); Edo period; Ink, color, and gold on paper; each 168 x 188 cm (66 1/4 x 74 in.); Founders Society Purchase with funds from various contributors; 81.693

The tiger is believed to repel evil, while the dragon attracts good fortune. The compound images of the tiger conjuring up the wind and the dragon rising from the crested waves to summon billowing clouds have been the subject of paired paintings by masters of Chinese and Japanese art since the 12th century. Ōkyo's screens continue the lineage of imminent artists contributing to this tradition. Ōkyo renders both animals in extraordinary detail, with controlled brushwork giving a rich, soft texture to the tiger's pelt, while moist scales and vapors lightly washed with gold impart a reptilian feeling to the dragon.

Pillow

Late 12th century; Korea, Koryŏ Dynasty; Celadon with inlaid slip decoration; 12 x 23 cm (4 3/4 x 9 in.); Founders Society Purchase, New Endowment Fund, and Benson and Edith Ford Fund; 80.39

In Asia ceramic pillows were placed under the neck, comfortably supporting the head while cooling the skin. The lion, tiger, rooster, and dog are the four symbolic animals protecting the home. The lions here probably relate to their symbolic function of protecting the home from fire. This particular pillow exemplifies the innovative, carefree spirit of the Korean potter.

Admiring Chinese celadon glazes made to resemble jade, the Koreans produced a celadon which became world renowned for its inlays of black and white under a unique "kingfisher blue" glaze.

For an African headrest, see page 34.

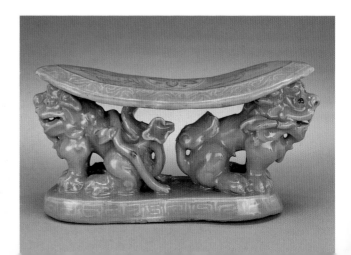

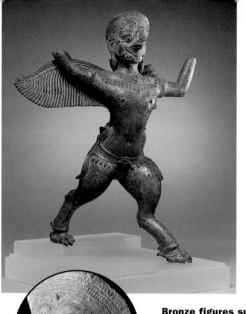

Garuda

First half of the 12th century; Cambodia, Khmer people;
Bronze; height 24.8 cm (9 3/4 in.); Gift of Mr. Albert
Kahn; 43.419

Garuda is a half-man, half-eagle steed for Vishnu, a
god in the Hindu cosmology. The eagle has long been
an emblem of victory, and Garuda is often a symbol
of Khmer imperial power for the Cambodians. In this
bird-king, there is manifest harmony between power
(the forceful stride) and grace (the slender torso which
balances the upraised arms), creating a magical figure
of royal virility.

Bronze figures such as this spiritually charged image were probably
kept in private sanctuaries and seen only by the most holy or powerful
individuals. This Garuda is strikingly similar to the Garuda atlas relief
figures of the south gallery at the great temple of Angkor Wat.

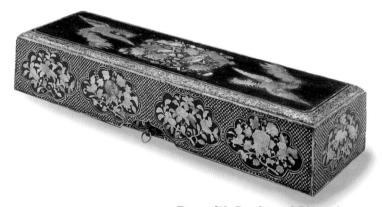

Box with Design of Phoenixes and Lotus Blossoms

17th century; Ryūkyū Islands; Lacquer with mother-of-pearl inlay; 44.5 x 13 x
8.4 cm (17 1/2 x 5 1/8 x 3 5/16 in.); Founders Society Purchase with funds
from an anonymous donor; 1983.5

The close ties between the Ryūkyū kingdom and the Ming Dynasty of China
are clearly reflected in the motifs of this exquisite mother-of-pearl inlaid
lacquer box. A single phoenix symbolized the empress, good government,
and happiness; when used in a pair, as on this box, phoenixes symbolized
faithful love.

The marks on the interior—a fan-shaped symbol and the Chinese character
tian (heaven) in an archaic script—may identify these pieces as belonging
to the 17th-century Ryūkyūan king and queen.

Fabric ties were attached to small rings on either side of the bottom
section to secure the box and its contents. This box may have been a gift
from the Ryūkyūan monarchy to a Japanese lord or lady, since 17th-century
Japanese nobility particularly fancied such Chinese-styled objects.

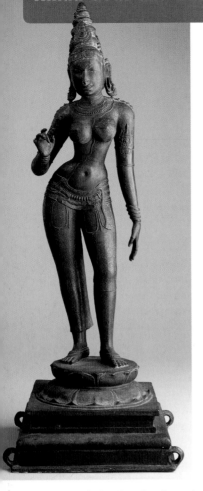

Three of the most important Hindu deities are Vishnu, Shiva, and the great Mother Goddess. Each deity has many different aspects and manifestations. For example, Pārvatī is a benevolent form of the Mother Goddesss, while Châmundâ is her malevolent form.

Pārvatī

13th century; Tamil Nadu, South India, Chola Dynasty; Bronze; height 104 cm (40 3/4 in.); Founders Society Purchase, Sarah Bacon Hill Fund; 41.81

Pārvatī is called "daughter of the mountain" because her father, Himāvat, personified the Himalaya mountains, the realm of the gods. Pārvatī is the female who embodies the divine power of the Hindu god Shiva. Anonymous sculptors created traditional bronze images of Hindu deities such as this to be carried in processions. The rings on each corner of the base would have accommodated carrying poles. In procession, such figures were usually clothed, bejeweled, and covered with flower garlands by devotees. Thus, few spectators would see the delicate detail evoking a clinging textile engraved on the surface. Pārvatī is a lush vision of the female force and fertility, a balanced duality of control and voluptuousness.

Shiva Who Bears the Crescent Moon

Mid 11th century; Tamil Nadu, South India, Chola Dynasty; Bronze; height 47 cm (18 1/2 in.); Founders Society Purchase, Acquisitions Fund; 80.38

This small sculpture of Shiva would have been paired with a smaller image of Pārvatī. Here Shiva is portrayed as the pillar, animator, and light of the universe. He is associated with a host of identifying emblems, the most important of which is the auspicious crescent moon over his right ear. The moon is the symbol of cyclical time and the vessel of *soma,* the drink of immortality and the water of life. Although Shiva's stance is static and erect, there is a youthful liveliness in the form and features, consistent with his association with the principle of life itself, its breath and fire.

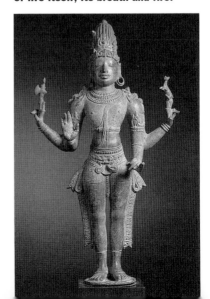

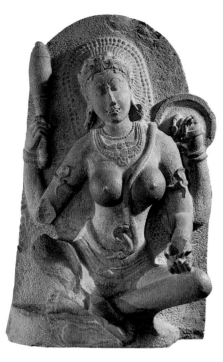

Châmundâ

11th century; Tamil Nadu, South India, Chola Dynasty;
Black dolerite; height 112 cm (44 in.); Founders Society
Purchase, L. A. Young Fund; 57.88

**Châmundâ, or Kālī, the Black One as she is sometimes
called, is the wrathful manifestation of the Mother
Goddess who combats and defeats various demons.
With forbidding sensuality, Châmundâ is easily recog-
nized by her fangs, the serpent which winds around her
waist and over her shoulder, and the ominous image of
a ghostly figure floating headless at her feet. Based
on an ancient bloodthirsty tribal goddess, Châmundâ is
death and destruction; yet she is worshiped by Hindu
women in childbirth as she is also the guardian of chil-
dren. Perhaps the ultimate representation of woman's
life-giving powers and fierce protection of her young,
Châmundâ nevertheless is dreaded and her sanctuaries
are placed far away from villages.**

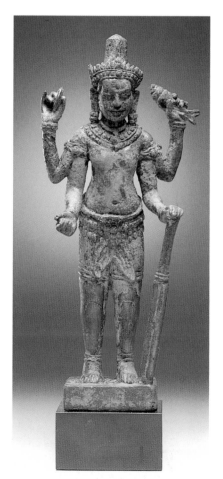

Vishnu, the Preserver

Late 12th century; Cambodia, Reign of Jayavarman VII;
Bronze; height 23 cm (9 1/8 in.); Founders Society
Purchase, General Membership Fund; 41.82

**This figure of Vishnu, the preserver of the universe, was
a small devotional image for a private sanctuary, like
the Cambodian figure of Garuda. The beneficent Vishnu,
associated with the life-giving sun, enjoyed tremendous
popularity in Cambodia.**

For Garuda, see page 147.

Buddha was a human, not a god, who had extinguished all worldly aspirations and cravings, thereby escaping from the cycle of death and rebirth. Founder of the Buddhist faith, Buddha Śākyamuni, whose given name was Siddhārtha Gautama (ca. 563–478 B.C.), abandoned his life as a prince in Nepal to become a selfless sage. Devotees of the many sects that have evolved believe that an infinite number of Buddhas exist to rule specific regions of the cosmos.

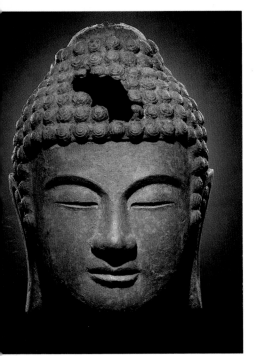

Head of Buddha

Late 8th–early 9th century A.D.; Korea, Unified Silla period; Cast iron; height 57 cm (22 1/2 in.); Founders Society Purchase with funds from various contributors and the Korean community; 1988.1

This twice-life-size head was probably part of a colossal seated Buddha enshrined in a temple. Even as a fragment, this head projects an aura of great psychological and spiritual power. The angular face with deeply incised horizontal eyes and crescent-shaped brows are distinguishing Korean stylistic features within the international style of Buddhist art. These features combine with the soft naturalistic rendering of the nose and mouth to create a sense of transcendent yet approachable authority.

Astasāhasrikāprajñāpāramitā

12th century; Nepal or northeast India, Pāla period; Pigment and ink on palm leaf; 5.5 x 47 cm (2 1/4 x 18 1/2 in.); Gift of P. Jackson Higgs; 27.586

This twenty-seven letter title is translated "Manuscript of the perfection of wisdom."

The central painting on this palm leaf depicts the young Buddha Śākyamuni meditating and fasting. The commission and execution of ancient sacred texts and books made of palm leaves were considered meritorious for both the patron and the scribe.

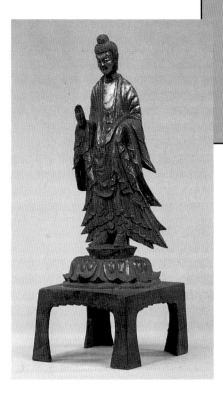

This figure was commissioned "on behalf of the seven generations of parents (who have passed on), for the family now living, and for all infinite creation ... hoping that the entirety of living creatures passing through Maitreya's three stages of transformation will quickly become Buddhas."

Fu Lingdu, November 22, 520

Maitreya, Buddha of the Future

520 A.D.; China, Northern Wei Dynasty; Gilt bronze; height 45 cm (17 3/4 in.); Gift of Mr. and Mrs. Edsel B. Ford; 30.303

Maitreya is considered the successor to the founder of the Buddhist faith. When Maitreya comes in the future, he will bring universal salvation and happiness. Until that time, Buddhists believe that they are reborn after death in accordance with their deeds in life.

This altarpiece is one of the largest and finest surviving examples of Maitreya. The slender form is decoratively enrobed in elongated triangular folds suggesting the mysteries of a higher realm.

Śākyamuni Emerging from the Mountains

Late 13th–mid 14th century; China, Yuan Dynasty; Wood with red lacquer, gilding, and traces of color; height 29.8 cm (11 3/4 in.); City of Detroit Purchase; 29.172

Śākyamuni, the founder of the Buddhist faith, is shown after renouncing his life as a prince and spending six years in the mountains fasting and meditating in search of enlightenment. The sensitive, expressive rendering of an emaciated ascetic announces that peace is the reward of a rigorous spiritual quest. This message especially appeals to the Chan (Zen) Buddhist sect, which maintains that enlightenment is achieved through self-discipline, exhaustive effort, and intense concentration.

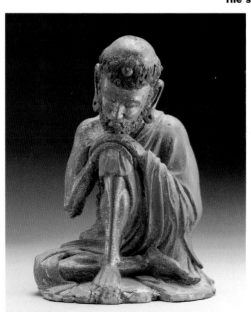

This masterful figure, carved in a period noted for realism and exquisite ornamentation, is the finest Chinese Śākyamuni sculpture of its time still in existence. Yuan Dynasty conventions of representation (the particular meditative pose, bearded face, and bald head fringed with curls) combine with universal attributes of Buddha (the monk's robe, ear lobes elongated by princely jewelry, and forehead bump symbolizing spiritual awakening) to reveal Buddha's unassuming character and profound insight.

All of these ceramics are utilitarian pieces, yet are fashioned in ways that show how beauty and innovation are at the core of the creation of objects, even those used in everyday life.

Measuring Jar

13th century; China, Southern Song Dynasty; Jizhou kilns; Stoneware with underglaze iron slip decoration; height 7.6 cm (3 in.); Founders Society Purchase, gift of Mr. and Mrs. Lawrence Fisher, by exchange; 1993.57

This measuring jar was once part of a graduated set for measuring foodstuffs. The Jizhou kilns were engaged in producing wares for the Chinese middle class and for export. This jar is unique because the decoration continues on the base where a single chrysanthemum blossom is meticulously painted in an area that would have been seen only in the process of scooping. The major zone of decoration imitates the basket weave used for fishing traps, which were similar in shape with a bulbous base and narrowed neck.

Bowl with Garden Scenes

1426–35; China, Ming Dynasty, Reign of Xuande; Porcelain with underglaze cobalt decoration; height 7.5 cm (2 3/4 in.); Founders Society Purchase, Sarah Bacon Hill Fund; 43.67

At the end of the 13th century the Mongols established the Yuan Dynasty (1279-1368) and began to patronize the Jingdezhen kilns to the exclusion of all others as they ascribed protective qualities to white porcelain. One outgrowth of cross-cultural contact within the vast Mongol Empire was the creation of blue and white porcelain during the second quarter of the 14th century using cobalt imported from Persia. This blue and white palace bowl decorated with a garden scene was produced during the reign of one of China's most artistically gifted and culturally refined emperors.

Shallow Dish with Boys Playing among Lotus

ca. 1200 A.D.; China, Jingdezhen, Southern Song Dynasty; Porcelain with a pale greenish blue glaze; diameter 19 cm (7 1/2 in.); Founders Society Purchase with funds from the Friends of Asian Art and Dr. John V. and Annette Balian; 1991.169

The 13th-century imperial court, which patronized a number of kilns, commissioned high-fired Jingdezhen white porcelain accentuated by a sparkling translucent glaze with a definite bluish tinge known as shadow blue *(yingqing)*, such as this bowl decorated with boys playing among lotus. This "100 boys" theme has been popular throughout Chinese history. Gifts to couples on the occasion of their wedding or another festive occasion were often references to the hope for many sons. The shape of this bowl imitates more costly lobed silver or gold bowls.

Jar

Early 17th century; Korea, Chosŏn Dynasty; Porcelain; height 35.6 cm (14 in.); Founders Society Purchase, Acquisitions Fund, and funds from Mr. and Mrs. Charles M. Endicott and Mrs. George M. Endicott; 1984.2

The Korean aesthetic was quite different from Chinese concepts of beauty. Subtlety and spontaneity are the hallmarks of Korean ceramics. During the Chosŏn Dynasty (1392–1910), white porcelain was a luxury item reserved for royalty. An asymmetrical storage jar made of two wheel-thrown bowls joined together is popularly referred to as a full moon jar. Such jars are appreciated by connoisseurs for the subtlety of their distorted globular silhouette.

DIA ASIAN ART FLIGHTS OF FANCY

The DIA collection of European art began with newspaper magnate James Scripps's gift in 1889 of a group of old master paintings concentrating on Italian, Dutch, and Flemish artists.

The museum did not achieve international stature until the arrival of William Valentiner as director in 1924. Valentiner had been trained at the Kaiser Friedrich Museum in Berlin under the legendary director Wilhelm von Bode.

From the opening of the Woodward Avenue building in 1927, the European collection has been displayed in galleries that integrate paintings and sculptures with decorative arts in a wide variety of media. With the support of Mr. and Mrs. Ralph Harman Booth, Eleanor and Edsel Ford, Mr. and Mrs. Julius Haass, Mr. and Mrs. Edgar B. Whitcomb, and other patrons, Valentiner began to build a very rich collection.

1

2

1 *The Flight into Egypt,*
1647–50; Bartolome
Esteban Murillo (Spanish,
1618–82); Oil on canvas;
2 x 1.7 m (6 ft. 10 1/2 in.
x 5 ft. 5 1/2 in.); Gift of
Mr. and Mrs. K. T. Keller,
Mr. and Mrs. Leslie H.
Green, and Mr. and Mrs.
Robert N. Green; 48.96

2 *Virgin and Child* page 167

3 *Portrait of Postman Roulin*
page 226

4 *Table Cabinet* (detail), ca.
1620; Italian (Florence);
Pearwood, ebony, alabaster,
pietre dure, and *pietre*
tenere panels; height 61
cm (24 in.); Founders
Society Purchase, Robert
H. Tannahill Foundation
Fund and gifts from
various contributors by
exchange; 1994.77

The European art collection begins with Early
Christian art created in the last years of the Roman
Empire and continues to about 1900, when the
responsibility of the Department of 20th-Century Art
begins. In the original arrangement of the 1920s, all
European art was installed to the south of the Great
Hall in a circuit of galleries whose architectural details
were designed in period styles to complement the art;
these are now devoted exclusively to the medieval and
Italian collections, while examples of Northern European art
and 19th-century art are displayed in the south wing.

The early years of collecting were primarily devoted to
assembling an outstanding group of works by artists such as
Della Robbia, Bellini, Titian, Rembrandt, Ruisdael, Rubens,
Rodin, and many others. Valentiner's own areas of research
included Italian Gothic and Renaissance sculpture and
17th-century Dutch painting, areas of particular strength in
the collection.

Nineteenth-century painting was enriched with the bequest
of the collector Robert H. Tannahill in 1970. Impressionist
and Post-Impressionist paintings formed the core of his
collection and added strength to the museum. In the last
decade or so the 19th-century collection has been broadened
by the addition of works by previously overlooked artists as
well as by the addition of significant examples of sculpture
and the decorative arts.

The decorative arts of 18th-century France are well repre-
sented by the furniture and porcelain in the Dodge collection
and rare silver from the collection of Mrs. Harvey Firestone.
Examples of Italian furniture and Doccia porcelain are
also outstanding.

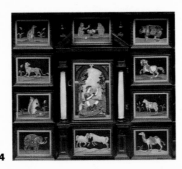

3

4

A Bishop's Staff

A crozier, derived from the form of a shepherd's crook, is a staff carried in procession by bishops and abbots.

Capital and Abacus Block

1100–25; French (Charente); Limestone; height 59.7 cm (23 1/2 in.); Founders Society Purchase, Edward A. Sumner Bequest Fund; 49.416

The capital dates from a time of great revival in monumental stone sculpture in medieval Europe, known as the Romanesque period. The church of Saint-Constant in western France was built during the first quarter of the 12th century and destroyed in 1921. This capital with crossed lions moving in opposite directions was one of a pair surmounting columns toward the back of the small aisleless church. Romanesque churches were frequently boldly decorated with carvings of lions and fantastic animals such as harpies and griffins. The collection in Detroit also includes four smaller capitals from Saint-Constant which originally surmounted colonettes inside of the church.

Crozier Head with Saint Michael and the Dragon

1210–25; French (Limoges); Gilt copper and champlevé enamel; height 31.6 cm (12 1/2 in.); Gift of Mr. and Mrs. Henry Ford II; 59.297

From the 12th through the 14th century the workshops of Limoges produced enameled objects in great numbers, supplying churches throughout Europe with liturgical vessels, reliquaries, and other richly decorated works of art. This crozier head is decorated with an image of Saint Michael overcoming the dragon, an appropriate subject for a ceremonial object used by those charged with protecting others from evil, as the Revelation of Saint John the Divine tells that the Archangel Michael cast the dragon out of heaven.

This crozier has a distinguished modern history. It is one of three illustrated by the great Romantic painter Eugène Delacroix in a drawing now preserved in the Musée des Arts Décoratifs in Paris.

Leaf from Gratian's *Decretum* (detail)

1300–50; French; Ink, tempera, and gold on parchment;
44.5 x 29.2 cm (17 1/2 x 11 1/2 in.); Founders
Society Purchase, General Endowment Fund; 61.248

**Humor, including scatological humor, plays a major
role in the visual arts of the Middle Ages. Serious
subjects are often surrounded by playful or fantastic
embellishments. The main illumination on this folio
from a book of canon (church) law illustrates the
specifics of case 22: a bishop has sworn a false oath
and now his archdeacon refuses to obey him. The
archdeacon gives testimony before the seated pope
who will decide whether the archdeacon has the right
to disobey a superior. The artist pokes fun at the
pope by placing an animal-headed creature dressed
in a similarly shaped tiara in the margin. The orderly
world under law depicted within the main illumination
is thus contrasted with the irrational world that lies
outside those borders.**

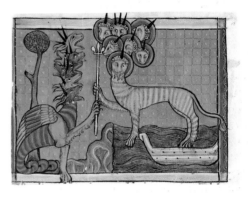

Miniatures from the Burckhardt-Wildt Apocalypse: The Dragon Waging War (recto) and The Beast of the Sea (verso)

ca. 1295; French (Lorraine); Tempera on
parchment; 10.5 x 14.7 cm (4 1/8 x 5 3/4 in.);
Founders Society Purchase with funds from
Founders Junior Council and Mr. and Mrs.
Walter B. Ford II Fund; 1983.20

**The last book of the New Testament, *The
Revelation of Saint John the Divine* (often
called "the Apocalypse"), describes the
attempts of Satan to take over the world and
the ultimate victory of Christ. On the front
of this half-sheet a seven-headed dragon, a
temporary incarnation of Satan, attacks the
offspring of the woman (variously interpreted
as Christians in their relationship to Jews,
the Virgin Mary and/or the larger Christian
community). On the back, the Dragon and
Beast, originally symbolizing Roman Emperors
and their heathen imperial cult, join forces
against the Christian church. The popularity
of this text and its illustrations in the Middle
Ages perhaps reflects both general anxiety
in an age of unrest and an attraction to
the fantastic.**

For Islamic manuscripts, see pages 126–127.

Diptych with Scenes from the Life of Christ

1325–50; French (Paris); Ivory; 24.9 x 26.4 cm (9 7/8 x 10 3/8 in.);
Gift of Robert H. Tannahill; 40.165

As ivory from African elephants became widely available through Mediterranean trade during the 13th century, it quickly surpassed the colorful enamel produced in Limoges as the dominant material for luxury liturgical products as well as for secular items. Diptychs for use in private devotion such as this example were carved in great numbers, often in professional workshops, especially during the 14th century. The narrative is read from left to right starting at the bottom: the Annunciation, Visitation, Annunciation to the Shepherds, Nativity, Adoration of the Magi, Presentation in the Temple, Christ among the Doctors, Marriage at Cana, Last Supper, Crucifixion, Resurrection, Ascension, Pentecost, and Coronation of the Virgin.

Fragment of a Lectern Cover

1350–1400; German (Westphalia); Linen embroidery on linen; 69.2 cm x
1.2 m (27 1/4 x 49 1/8 in.); Founders Society Purchase, Robert H.
Tannahill Foundation Fund with a contribution from David L. Klein, Jr.
Memorial Foundation; 1989.47

This embroidery, which originally could have been as long as
fourteen feet, is one end of a cover for a church lectern.
White-on-white embroideries of this type, traditionally done by
nuns, are associated with Westphalian workshops in the Gothic
period. The friezelike border depicts an episode from the life of
Saint Giles who, according to legend, lived as a hermit in a cave near
the Rhône River in France. When a deer pursued by a royal hunting
party sought shelter with Giles, the saint was accidentally wounded by
an arrow. He refused medical attention but was miraculously healed,
inspiring the king to found a monastery on the spot. The embroidery
depicts the saint in his cave at the left as the king and bishop, both
on horseback, approach from the right with the hunters.

Saints Peter and Paul

ca. 1350; German (Lower Saxony); Gilt bronze; height 32.7 cm
(12 7/8 in.); Gift of Mr. and Mrs. Henry Ford II; 58.379–.380

During the Gothic period in northern Germany images of the
twelve Apostles were frequently included in the decoration of
altarpieces, either within the structure itself or below on the
predella. Although the Apostles are missing their traditional
attributes, the key for Saint Peter and the sword for Saint Paul,
they are each identified by an inscription on the base. Eight of
the original group of twelve Apostles to which these gilt bronzes
belonged survive in various collections. They are unusually large
and finely cast in high relief, datable by stylistic comparison to wood
sculptures to approximately the middle of the 14th century. It is likely
that these pieces were made for an altar in Lower Saxony, a region
with a long medieval history of high quality metalwork.

The museum's Gothic chapel and its rich collection of medieval and Renaissance stained glass provide insight into one of the most significant innovations of the Middle Ages. As windows became larger and more numerous in Gothic buildings, beginning in the 12th century and burgeoning with the ambitious architectural programs of the 13th century, stained glass emerged as the primary vehicle for images, supplanting earlier medieval wall painting in the interior of churches.

Two Clerics

ca. 1205–12; French (Soissons); Stained glass; 73 x 73.5 cm (28 3/4 x 29 in.); Gift of Lillian Henkel Haass; 59.34

This panel showing two clerics in ritual procession is from an ambitious glazing program designed for the east end of the Cathedral of Saints Gervasius and Protasius in Soissons. The windows in the five radiating chapels, begun in the early 13th century, contained an extensive depiction of biblical history, saints' lives, and christological themes. Beginning with the religious wars of around 1567 much of the Soissons glass was destroyed. The two clerics here can be seen as representative of religious life in the 13th century. Each service at Soissons began with a procession from the sacristy to the altar where the liturgy would be celebrated. The procession was led by a cleric carrying a candelabrum with tapers, followed by a cleric with a censer, then one carrying a cross, and then by subdeacons and deacons carrying the gospel books.

The Three Marys

1444; German (Boppard am Rhein); Stained glass; 1.5 m x 73.7 cm (58 x 29 in.); Founders Society Purchase, Anne E. Shipman Stevens Bequest Fund; 40.52

This panel, with its expressive, linear style, is one of many to survive from the important stained glass cycle of the Carmelite church at Boppard am Rhein. Regrettably, none of this remarkable glass remains in the church today. Mary, the mother of Christ, Mary Magdalen (on the left), and Mary of Cleophas (on the right) stand as witnesses to the Crucifixion. The bust of the prophet Jeremiah appears in the trefoil above the three mourning figures holding a banderole with the inscription *jermia pp frotea ano dn xliiii* ("The prophet Jeremiah, in the year of our Lord [14]44"). A document in the Trier city archives confirms that the date 1444 recorded in this panel is the date of the consecration of the north section of the church. This panel was originally part of a large program depicting the Tree of Jesse, or the ancestry of Christ.

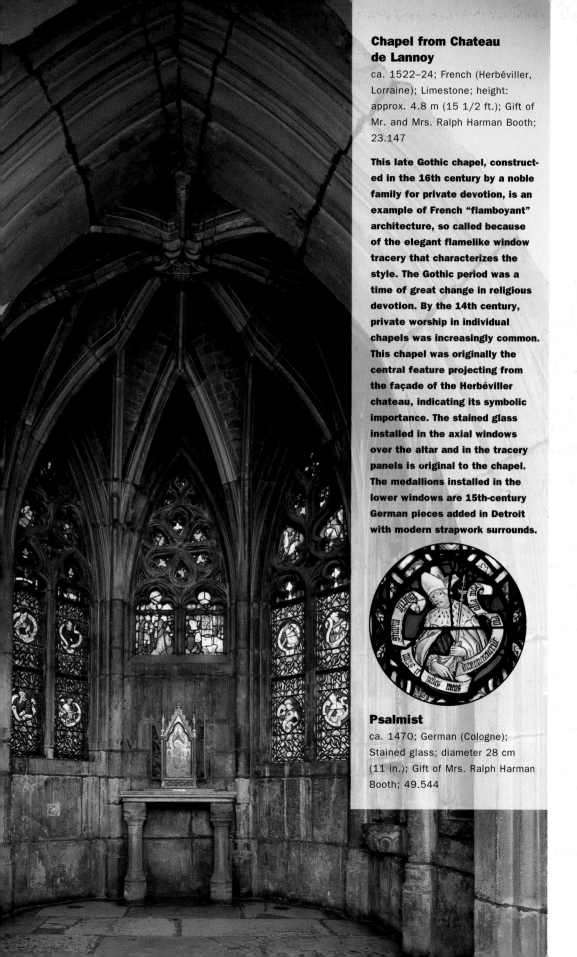

Chapel from Chateau de Lannoy

ca. 1522–24; French (Herbéviller, Lorraine); Limestone; height: approx. 4.8 m (15 1/2 ft.); Gift of Mr. and Mrs. Ralph Harman Booth; 23.147

This late Gothic chapel, constructed in the 16th century by a noble family for private devotion, is an example of French "flamboyant" architecture, so called because of the elegant flamelike window tracery that characterizes the style. The Gothic period was a time of great change in religious devotion. By the 14th century, private worship in individual chapels was increasingly common. This chapel was originally the central feature projecting from the façade of the Herbéviller chateau, indicating its symbolic importance. The stained glass installed in the axial windows over the altar and in the tracery panels is original to the chapel. The medallions installed in the lower windows are 15th-century German pieces added in Detroit with modern strapwork surrounds.

Psalmist

ca. 1470; German (Cologne); Stained glass; diameter 28 cm (11 in.); Gift of Mrs. Ralph Harman Booth; 49.544

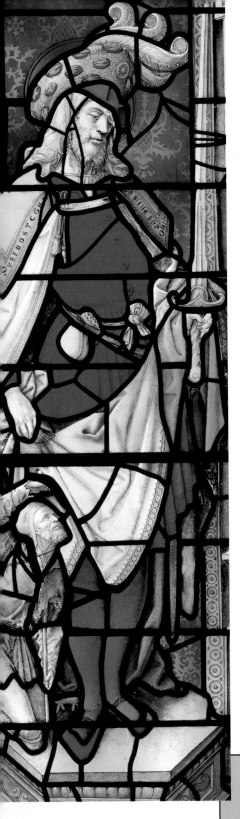

Crucifixion with the Virgin, Saint John, and Angels

1514; Workshop of Veit Hirschvogel the Elder (German, Nuremberg) after design by a pupil of Albrecht Dürer; Stained glass; 45.7 x 34.3 cm (18 x 13 1/2 in.); Gift of Mrs. Ralph Harman Booth; 37.35

The Hirschvogel family was active in Nuremberg in the late 15th and early 16th centuries, painting glass commissions from most of the leading artists of the town, including the great Albrecht Dürer. It appears that two hands were involved here, one with a linear, graphic style that can be seen in the figure of the Virgin and elsewhere, while the work of a more subtle painter can be seen in the figure of Christ and the head of Saint John.

Saint Wenceslas of Bohemia

ca. 1510-25; German (Cologne?); Stained glass; 1.9 m x 59.7 cm (6 ft. 2 in. x 23 1/2 in.); Gift of K. T. Keller; 58.111

The extraordinary quality of the painting and the remarkable state of preservation make this, and four other panels from the series in the museum's collection, major documents of stained glass of the period. The panel is an accomplished blend of German and Netherlandish stylistic tendencies which could have been created in Cologne or perhaps by continental artists working in England in the early 16th century. By the 19th century this panel was at Stoke Poges, a 16th-century manor house in Buckinghamshire, England.

Good King Wenceslas

Wenceslas, Duke of Bohemia in the 10th century, is shown here with a beggar at his feet, evoking his good works. A dukedom in the 10th century, Bohemia later became a kingdom, making Wenceslas the famous "Good King" of the Christmas carol.

Martyrdom of Saint Eustace

1543; Follower of Engrand le Prince (French); Stained glass; 2.1 m x 87 cm (7 ft. 1/4 in. x 34 1/4 in.); Gift of K. T. Keller; 58.113

When Eustace refused to sacrifice to the Roman gods as commanded by the emperor Hadrian, the saint and his family were placed alive in a bronze bull heated by flames to be killed. The legend tells that after three days the family was removed from the bull, and their dead bodies were miraculously undamaged.

By the early 16th century the color range of stained glass had expanded and compositions were increasingly influenced by approaches to pictorial space and narrative derived from Italian painting. The use of grisaille, a black and white drawing technique, on the glass, permitted delineation of facial features, hair, textile patterns, and architectural elements in great detail.

The authenticity of these panels was recently confirmed with the discovery that a restorer in the guise of performing repairs on the original, simultaneously produced a copy which was substituted for the original in Rouen. The genuine window entered the collection of William Randolph Hearst, from whom it passed to the Detroit museum.

Compartmentalization

Nine separate panels here are meant to be viewed as a single work of art.

For 20th-century comparisons, see pages 259 and 303.

The Nativity

1516; Guillaume de Marcillat (French, active in Italy, ca. 1470–1529); Stained glass; 3 x 1.7 m (9 ft. 10 in. x 66 in.); Founders Society Purchase, General Membership and Donations Fund; 37.138

This panel of the Nativity was made for the main choir chapel window in the cathedral of Cortona in Italy. The inscription below the scene *QVE GENVIT ADORAVIT* can be translated "She worships him whom she bore." The French immigrant Marcillat was responsible for the last great revival of monumental stained glass painting in Italy; Vasari included Marcillat's biography in his famous lives of Italian artists. The museum's panel and its companion *Adoration of the Magi* (Victoria and Albert Museum, London) are remarkably well preserved since they were removed from the church in the 19th century.

STAINED GLASS

EUROPEAN ART

DIA

"In earlier times, the Virgin was placed on a throne and held her son with the gravity of a priest holding the chalice.... But at the end of the 13th century we come down to earth again...the Mother and Child gaze at each other, and a smile passes between them.... When we reach the 14th century, we see the Virgin and Child come even closer to humanity.... And finally, the Virgin who for so long had shown such respect and was seemingly unable to forget that her son was also her God, dared to embrace the Child and press her cheek against his."

—Emile Mâle, *Religious Art in France: The Late Middle Ages*, 1908.

Virgin and Child

ca. 1330; Giovanni di Balduccio (Italian, active 1317–49); Marble; height 81.3 cm (32 in.); Founders Society Purchase, Elizabeth P. Kirby Fund; 37.140

This image of the standing Virgin and Child reveals a profound change in the image of the Virgin that occurred by the early 14th century. Rather than confronting the viewer frontally in the Romanesque manner, here the mother and her child engage in an intimate, human relationship. The child energetically grasps the Virgin's mantle in his right hand as he leans back to peer into her face. Giovanni di Balduccio was born in Pisa and worked in Tuscany during his early years, moving north to Lombardy in the mid-1330s.

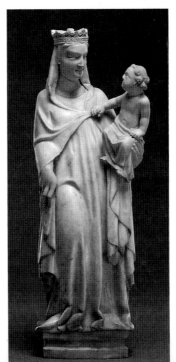

Virgin and Child Enthroned

1200–50; Italian (Umbria); Polychromed wood; height 1.6 m (62 1/2 in.); Gift of Mr. and Mrs. Edsel B. Ford; 30.383

This sculpture portrays the seated Virgin as the Throne of Wisdom (*sedes sapientiae*), a popular devotional image during the Romanesque period. The Virgin appears here not as the mother of a child, but rather as the mother of God, an icon stiffly presenting the figure of the infant Christ on her lap while he raises his arm in a gesture of benediction. Such wood images were placed on altars where they were the objects of religious devotion, but they were also at times carried in processions and appeared in liturgical dramas like the enactment of the story of the Three Wise Men.

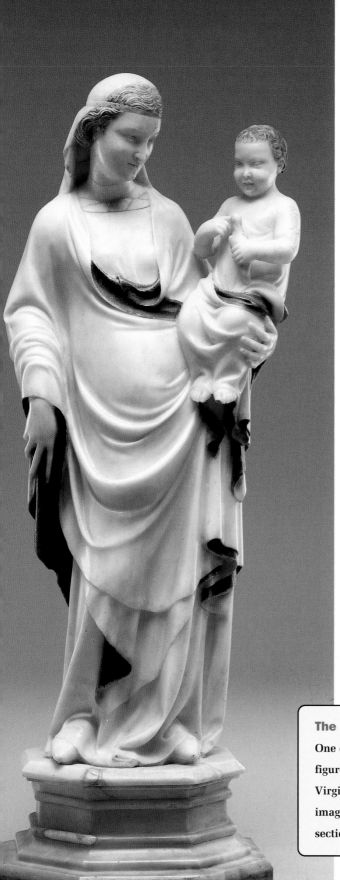

Virgin and Child

1350–60; Nino Pisano (Italian, active
ca. 1343–ca. 1368); Marble with traces
of polychromy and gilding; height 76.2
cm (30 in.); Gift of Mr. and Mrs. Edsel B.
Ford; 27.150

The son of the great 14th-century sculptor Andrea Pisano (ca. 1290–1348), Nino became an accomplished artist in his own right. Nino was receptive to new influences, particularly from France (see page 166), as seen in the lyrical drapery patterns and sweet expressions of this *Virgin and Child*. The Virgin is depicted here as an elegant and courtly lady, a more human interpretation of the Madonna, consistent with developments in spirituality in the 14th century. This finely conceived and finished marble statuette is one of Nino's masterworks.

For an African mother and child, see
page 24.

The Blessed Mother

One of the most frequently depicted
figures in all of European art is the
Virgin Mary. More than twenty
images of her are included in this
section alone!

VENERATION OF THE VIRGIN

DIA EUROPEAN ART

Virgin and Child

1325–50; French (Ile de France); Marble;
height 1 m (40 in.); Founders Society Purchase,
Ralph Harman Booth Bequest Fund; 40.1

While displaying an open book to the viewer,
the Christ child turns to gaze at his mother.
This sculpture, with its softly modeled drapery
and graceful posture, is undoubtedly similar
to the French examples which inspired the lyri-
cism of Nino Pisano's *Virgin* (see page 165).
The sculpture is characteristic of French
Gothic art of the 14th century, when Paris
played a dominant role in Europe. Paris was
the capital of the powerful Capetian monarchy,
the seat of a bishop, the site of a great univer-
sity, and a major trade center. This elegant
"Court Style" was highly influential across
Europe during the 13th and 14th centuries.

Virgin and Child

1450–75; French (Burgundy); Limestone with
traces of polychromy; height 1.1 m (42 1/4 in.);
Gift of Mr. and Mrs. Edgar B. Whitcomb; 36.27

The style of this monumental Madonna is
derived from the work of the revolutionary and
influential sculptor Claus Sluter, who worked
for the powerful dukes of Burgundy in the late
14th century. Sluter created a style which
promoted the independence of the carved figure
from its architectural surrounding and some-
times conveyed a strikingly theatrical realism.
Uncrowned and draped in a heavy wool mantle,
the Burgundian Virgin stands in contrast to the
more elegant image of the Queen of Heaven
that characterizes the 14th-century example.

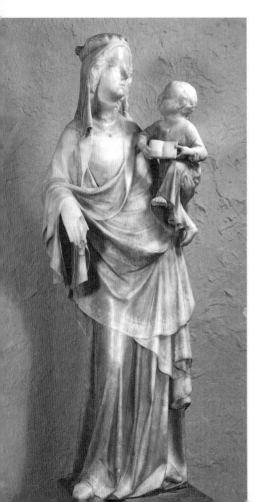

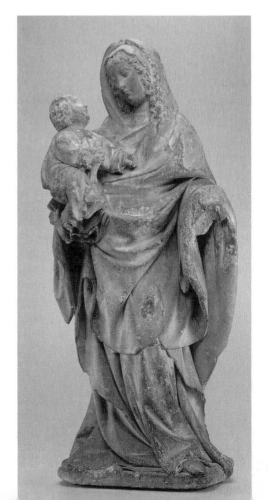

Virgin and Child

ca. 1480; Circle of Michel Erhart (German, Ulm); Lindenwood; height 1.6 m (64 in.); Gift of Ralph Harman Booth; 22.3

The workshop of Michel Erhart was one of the most successful in Ulm, a prolific center of wood sculpture during the late Gothic period. This imposing life-size Virgin, originally polychromed and gilded, would have been the central figure in a large altarpiece. Here the Madonna holds an energetic child, who interacts with the viewer rather than with his mother. The crescent moon beneath the Virgin's feet is an allusion to the Apocalyptic Woman (Revelation 12:1-5), clothed in the sun with the moon at her feet and whose infant son is taken up to God. Furthermore, the moon seen as a symbol of inconstancy, here is vanquished beneath the feet of the Virgin.

Virgin and Child

ca. 1490–1500; Workshop of Tilmann Riemenschneider (German, Würzburg); Lindenwood; height 1.4 m (56 in.); Gift of Mrs. Ralph Harman Booth in memory of her husband; 43.2

Riemenschneider was the head of a large and prolific workshop in Würzburg in Franconia. While artists elsewhere in northern Europe preferred to use oak and walnut, Riemenschneider, Erhart, and others in south Germany chose the fine, even grain of lindenwood. This sculpture was probably originally polychromed and gilded, but during the 1490s Riemenschneider experimented with monochromatic, unpainted lindenwood, creating an effect much like this Madonna. The way the Virgin grasps the child's foot is an unusual detail found on several sculptures from Riemenschneider's workshop. There is evidence that a crown was originally attached to her head.

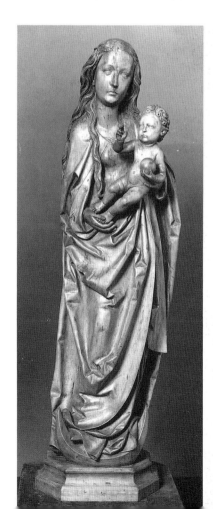

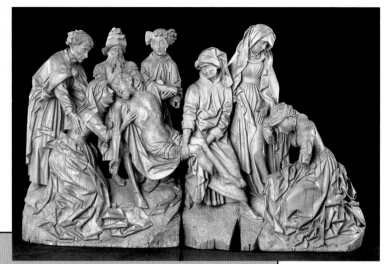

Lamentation

1460–70; South Netherlandish (Brussels); Oak; 87.6 cm x 1.4 m x 24.1 cm (34 1/2 x 55 x 9 1/2 in.); Gift of Mrs. Edsel B. Ford; 61.164

The carefully carved scene is charged with emotion conveyed by the dramatic attitudes of the figures and the complex folds of the voluminous drapery. The finely detailed surface reveals tears on the faces of Nicodemus and the Virgin. The composition is greatly indebted to the great painter Rogier van der Weyden (1399–1464). While there is no evidence that Rogier or his shop actually carved wood sculpture, we know that he and other painters collaborated on sculptural projects, polychroming the carved pieces and possibly providing working drawings for sculptors.

This sculpture represents a moment not described in the narrative of Christ's Passion in the Gospels. As the dead body of Christ is carried to the tomb by Joseph of Arimathea, assisted by Nicodemus, the Virgin reaches out to embrace her son for the last time, while Mary Magdalen bends to weep at his feet.

Nativity with the Annunciation to the Shepherds, Annunciation, and Presentation in the Temple, and Adoration of the Magi

ca. 1520; South Netherlandish (Brabant); Boxwood; 22.9 x 13.6 cm (9 x 5 3/8 in.); Founders Society Purchase, Robert H. Tannahill Foundation Fund, Benson Ford Fund, and Henry Ford II Fund; 79.177

A group of remarkably intricate small sculptures were made from the end of the 15th through the early 16th century in the Duchy of Brabant. Carved in dense, fine-grained boxwood, most were associated with personal religious devotions, such as rosaries, prayer beads, and miniature altarpieces like this triptych, carved with microscopic precision in the style of late Gothic sculpture. These flawless, detailed carvings were greatly prized by the aristocracy of the time and they are still a source of delight.

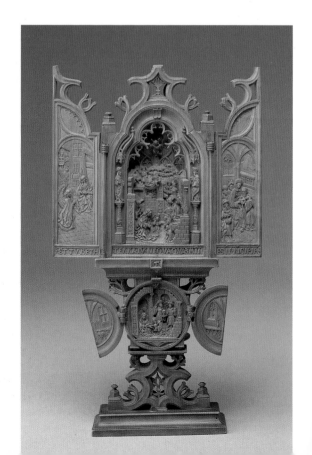

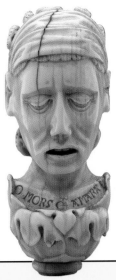

Pendant to a Rosary or Chaplet: Memento Mori

1500–25; Franco-Flemish; Ivory; height 7 cm (2 3/4 in.);
Founders Society Purchase, with funds from various contributors;
1990.315

This small ivory carving conveys one of the most profound themes of the late Middle Ages. The death mask joined to the gruesome skull serves as a *memento mori*, a reminder of the transitory nature of life and the inevitability of death. The repetition of prayers and liturgical texts was an important part of medieval devotion. The rosary is a collection of these texts devoted to the Virgin Mary, which became popular by the 14th century. The strings of beads used to assist those in saying the long sequences of recitations became known as rosaries. This carving is pierced vertically for suspension, consistent with its original function as a pendant to a rosary or chaplet, a shorter string of devotional beads.

The Latin inscription found across the collarbone reads: O MORS QUAM AMARA EST MEMORIA TUA (O Death, how bitter it is to be reminded of you).

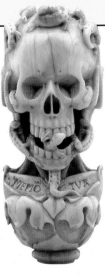

actual size

Book of Hours: Annunciation to the Shepherds

ca. 1500–10; Illuminations attributed to the Master of the David Scenes in the Grimani Breviary and his Workshop (active Bruges, first quarter of the 16th century); binding signed by Lodovicus Bloc (Flemish, active in Bruges, 1494–1529); Ink, tempera, and gold on parchment with leather binding; 237 folios, each folio 8.1 x 5.5 cm (3 1/4 x 2 1/4 in.); Founders Society Purchase, Membership and Metropolitan Opera Funds; 63.146

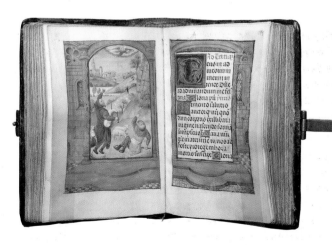

Beginning in the late 12th century secular Christians could mark the passage of the day with the reading of prayers from a book called the Book of Hours. Based on the Breviary used by Christian religious orders and clergy, the Book of Hours included a calendar marked with holidays (here we see the Annunciation to the Sheperds) and the names of saints to be commemorated on each day of the year; a series of prayers in honor of the Virgin Mary to be read at set times of the day; and other prayers and readings. Compact in size, these books were originally handwritten by professional scribes.

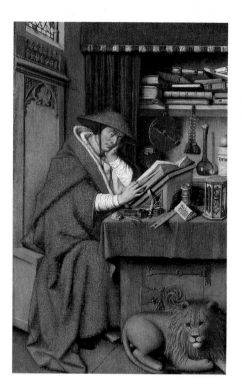

Saint Jerome in His Study

Inscribed 1442; Attributed to Jan van Eyck (Flemish, ca. 1390–1441); Oil on linen paper on oak panel; 19.9 x 12.5 cm (7 7/8 x 4 7/8 in.); City of Detroit Purchase; 25.4

Delicate and intricate in its execution and rich in its symbolism, this small panel painting attributed to the workshop of Jan van Eyck depicts Saint Jerome, the 4th-century translator of the Bible, reading in his study. According to legend, Jerome extracted a thorn from a lion's paw. The books and other objects seen here relate to the saint's intellectual pursuits and take on symbolic meanings. The hourglass is traditionally equated with the passage of time and human mortality. The glass bottle is undisturbed by the light passing through it just as the virginity of Mary was undisturbed by the Holy Spirit when she conceived Jesus. The jar labeled *tyriaca* (an antidote for snakebite) surmounted by a pomegranate (a symbol of the resurrection) refers to Christ as the savior of the world. Based on the inscription on the folded letter on the table, it has been suggested that the figure of Saint Jerome is a disguised portrait of Cardinal Niccolò Albergati.

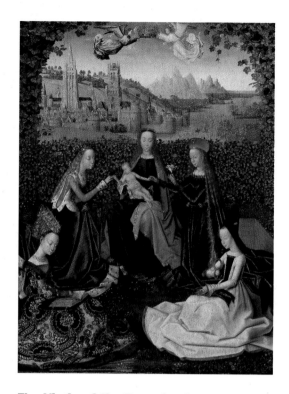

The Virgin of the Rose Garden

1480–85; Master of the Saint Lucy Legend (Flemish, active late 15th century); Oil on oak panel; 79 x 60.3 cm (31 1/8 x 23 3/4 in.); Founders Society Purchase, General Membership Fund; 26.387

***The Virgin of the Rose Garden* unites three devotional subjects, all popular after 1400 and related to the worship of the Virgin Mary: the Virgin Mary attended by virgin saints (among them Ursula, Catherine of Alexandria, Barbara, and Cecilia), the coronation of the Virgin, and the mystic marriage of Saint Catherine to the Christ Child. The walled garden setting, with its realistic enumeration of flowers and plants familiar in Northern Europe at this time, refers both to the Near Eastern concept of a lush, floral Paradise and the Christian interpretation of the Old Testament's *Song of Songs*, which equates Mary's virginity with an enclosed garden. In the background the artist has depicted the city of Bruges prior to 1485, when another level was added to the city's belfry.**

The Crucifixion

ca. 1485–90; Master of the Tibertine Sibyl (Dutch, late 15th century); Oil on oak panel; 1.4 x 1 m (56 5/8 x 40 3/8 in.); Gift of Mr. and Mrs. Edgar B. Whitcomb; 41.126

Accentuating a moralizing rather than a narrative message, *The Crucifixion* reflects the earlier Gothic preoccupation with symbolism rather than the more contemporary interest in naturalism. Christ, significantly smaller than the other figures and placed high on the cross, dominates the sky. His head bends down toward the fainting Virgin Mary, the apostle Saint John, and four women, one of whom is Mary Magdalen. He ignores his earthly foes standing to the right, who are unmoved by the pathetic sight. This distinct separation of "good" and "evil" is further reflected in the middle ground where a pleasant landscape on the left contrasts with the barren tree, snakes, and black birds on the right.

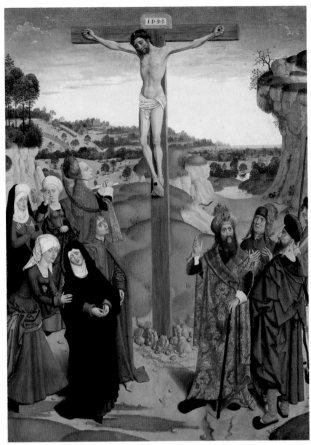

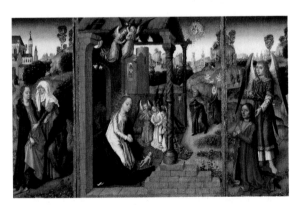

The Nativity with the Visitation and Archangel Presenting the Donor

After 1493–before 1499; Master of the Saint Ursula Legend (Flemish, active 1475–1500); Paint on oak panel; 74.6 cm x 1.3 m (29 3/8 x 52 1/2 in.); Gift of Metropolitan Opera Benefit Committee; 59.122

Altarpieces often consist of several panels with thematically related compositions. The central panel of this triptych refers to three episodes from the Nativity story: in the foreground Mary adores the newborn Christ Child; in the midground an angel announces the birth to a group of shepherds; and the three Magi meet on the road to Bethlehem in the background. The left panel portrays Mary telling her cousin Elizabeth of her pregnancy, while the right panel depicts the donor who commissioned the altarpiece accompanied by his patron saint the Archangel Raphael.

As in *The Virgin of the Rose Garden* (opposite), this painting can be generally dated on the basis of the appearance of the Bruges belfry in the background of the central panel: an octagonal upper section is visible, but the roof, which burned in 1493, has not yet been replaced.

It is documented that Bruegel attended peasant weddings in disguise in order to study them; he might be compared to the isolated observer standing behind the bagpipers at the right.

The Wedding Dance

ca. 1566; Pieter Bruegel the Elder (Flemish, 1525/30–69); Oil on oak panel; 1.2 x 1.6 m (47 x 62 in.); City of Detroit Purchase; 30.374

The Wedding Dance is a splendid example of Bruegel's fascination with the peasant life of his native land. Public and private holidays and festivals provided him with typical situations and characters for his paintings. Here the wedding guests are very simply modeled, the positions of their arms and legs somewhat exaggerated to make the dancers look more awkward, more rustic. Although a modern audience might see this panel primarily as a genre painting, Bruegel's contemporaries would have noted its moralizing overtones: frenzied dance and lustful behavior could lead to sin and damnation.

Portrait of a Woman

ca. 1532–35; Hans Holbein the Younger (German, ca. 1497–1543); Oil and tempera on oak panel; 23.4 x 19.1 cm (9 1/8 x 7 1/2 in.); Bequest of Eleanor Clay Ford through the generosity of Benson and Edith Ford, Benson Ford, Jr., and Lynn Ford Alandt; 77.81

Although Hans Holbein the Younger was a German painter, he spent little time in his homeland after commissions for paintings, religious and otherwise, became scarce in Protestant Germany. He settled permanently in London in 1532, and, as court painter during the reign of Henry VIII, specialized in portraying royalty and landed gentry.

The English style of clothing suggests that Holbein painted this thoughtful portrait of a gentlewoman during the 1530s. The painting is startlingly plain, without informative attributes that might identify the sitter. The artist has concentrated on the woman's personality as expressed in her carriage and demeanor, thereby underscoring inner qualities rather than superficial ones.

The Crucifixion

ca. 1530; Marten van Heemskerck (Dutch, 1498–1574); Oil on oak panel; 39.3 x 35.5 cm (15 1/2 x 14 in.); Founders Society Purchase, Julius H. Haass Fund; 34.15

The Crucifixion, with its background of softly sketched ruins and "curious little windswept figures," is typical of Heemskerck's early Haarlem style, ca. 1527–32. The viewer's attention is first drawn to the prominent figures of Saint John the Evangelist and the Virgin Mary, rather than the figures of Christ and Mary Magdalen. This skewed placement of Christ on the cross, seen without the thieves, transforms the painting into a devotional rather than a narrative depiction of the Crucifixion. With his portrayal of an emotional and grief-stricken Virgin, Heemskerck tells the faithful that through the Virgin they can experience both the suffering and the passion of Christ.

The early 15th century witnessed the emergence of the Renaissance, a rebirth of the arts of antiquity, centered in the city of Florence. Artists revived ancient forms, borrowed subjects from Roman history and mythology, and emulated classical artistic principles, including harmonious proportion, realistic expression, and rational postures. A new awareness of the dignity of the individual prompted an increasingly naturalistic representation of the human figure.

Madonna and Child (The Genoa Madonna)

ca. 1445–50; Luca della Robbia (Italian, 1399/1400–82); Enameled and gilded terracotta; height 49.5 cm (19 1/2 in.); City of Detroit Purchase; 29.355

Although Luca della Robbia also worked in marble, bronze, and wood, he is best known for introducing enameled terracotta sculpture around 1440 and for founding a family dynasty of sculptors working in this medium. Typical of his terracotta sculpture, this relief is one of four versions of the so-called *Genoa Madonna* (one of which was originally in Genoa), each with slight differences in their modeling and expression.

Judith

ca. 1455–70; Antonio di Jacopo Pollaiuolo (Italian, ca. 1429–98); Bronze; height 42.9 cm (16 7/8 in.); Gift of Eleanor Clay Ford; 37.147

Pollaiuolo created in this figure an expressive image of the beautiful biblical heroine and symbol of the Florentine republic. Working in both Florence and Rome, Pollaiuolo produced paintings, engravings, drawings, embroidery designs, and works in silver and is known especially for his development of the bronze statuette.

For the story of Judith, see page 179.

The Florentine prince Lorenzo de' Medici described Pollaiuolo in a 1489 letter as "the principal master of the city... in the opinion of all intelligent people perhaps there never was a better."

Coat of Arms of the Gianfigliazzi and Minerbetti Families

ca. 1445–50; Desiderio da Settignano (Italian, ca. 1429-64); Stone (*pietra serena*); height 2.2 m (7 ft. 1 in.); Gift of Mr. and Mrs. Edsel B. Ford; 41.124

While still an apprentice, Desiderio, who probably trained in the Florentine workshop of Donatello, received a commission to carve the coat of arms of the Gianfigliazzi family. This relief, which hung above the entrance of the Palazzo Gianfigliazzi in Florence until 1906, depicts a smiling putto holding the Gianfigliazzi symbol, a large heraldic shield with the lion rampant, by a ribbon. The lion supports a second shield, bearing the arms of the Minerbetti family (originally ornamented with three swords). This coat of arms is thought to commemorate the marriage between Andrea Tommaso Minerbetti and Costanza Gianfigliazzi in 1427.

Angels

Seraphim are identified by their six wings. As the highest order of angels, seraphim act as divine messengers or intermediaries between humankind and God.

Madonna and Child with Angels

ca. 1460; Benozzo Gozzoli (Italian, 1420–97); Tempera and gold leaf on panel; 65.3 x 50.4 cm (25 3/4 x 19 7/8 in.); Bequest of Eleanor Clay Ford; 77.2

Madonna and Child with Angels presents a fine example of the brilliance of Florentine Renaissance painting in the mid-15th century. Gozzoli's main objective was not to depict a humble Virgin Mary, but the Queen of Heaven, dressed in a sumptuous, jewel-bedecked gown and ermine-lined cloak. She and her child are closely accompanied by their retinue of seraphim. Here the angels are treated as a colorful decorative backdrop. The composition appears somewhat claustrophobic because the edges of the panel were slightly cut down by a previous owner.

Angel of the Annunciation and **Virgin Annunciate**

ca. 1430s or 1450–55; Fra Angelico (Italian, ca. 1400–55); Tempera on panel; 33 x 27 cm (13 x 10 5/8 in.); Bequest of Eleanor Clay Ford; 77.1.1–.2

The Annunciation represents the biblical story in which the Archangel Gabriel announces to the Virgin Mary that she has been chosen to be the mother of Jesus. These two panels were once part of a large altarpiece, placed to the left and right above a central painting and held within an elaborate frame. Fra Angelico represented the moment just after the angel's announcement, as indicated by the gesture of the Virgin, whose bowed head shows that she has submitted to the will of God. The Annunciation was a common theme in 15th-century altarpieces; Italian artists analyzed and depicted every aspect of this miraculous event.

Saint Catherine of Siena Dictating Her Dialogues

After 1447–before 1464; Giovanni di Paolo (Italian, 1403–82); Tempera on panel; 28.9 x 28.9 cm (11 3/8 x 11 3/8 in.); Founders Society Purchase, Ralph Harman Booth Bequest Fund, Joseph H. Boyer Memorial Fund, and other funds; 66.15

This predella panel comes from an altarpiece commissioned by the Sienese guild of the Pizzicaiuoli, purveyors of candles and other dry goods, in 1447. In a series of at least ten paintings Giovanni di Paolo presented the mystical episodes in the life of Catherine (1347–80), a Sienese tertiary of the Dominican order. Contemporary accounts of her life tell that on occasion Catherine would be overcome by rapture, whereupon she was able to explain points of holy doctrine. Her pronouncements, which were dictated to a series of secretaries, were compiled into a book titled _The Dialogue of Divine Providence_. Because Catherine is depicted with the halo of a canonized saint, it is very possible that this panel was not completed until after her canonization in 1461.

Master without a Name

Since paintings from this time were not signed, names of artists are frequently unknown. This artist is called the Master of the Osservanza from a triptych he painted in the Church of the Osservanza near Siena.

The Resurrection

ca. 1435; Master of the Osservanza (Italian, active ca. 1430–50); Tempera and gold leaf on panel; 36.2 x 45.4 cm (14 1/4 x 17 7/8 in.); Gift of Mr. and Mrs. Henry Ford II; 60.61

Poetic in conception and innovative in composition, this painting is a masterpiece of Sienese 15th-century painting. In this scene the still-sleepy soldiers are amazed to see the risen Christ float gloriously above the sealed sarcophagus, holding the banner of victory and the olive branch of peace. The extensive landscape is both naturalistic and symbolic: the Resurrection is equated with the sunrise, perhaps the first such depiction in Italian painting. Originally this was one of five small panels of an altarpiece dedicated to the Passion of Christ.

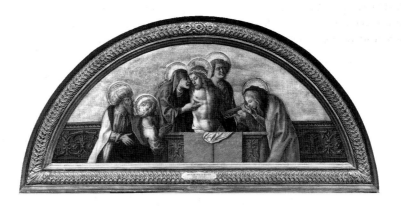

Pietà

ca. 1470; Carlo Crivelli (Italian, active 1457–94); Tempera and gold leaf on panel; 41.9 cm x 1.1 m (16 1/2 x 45 in.); Founders Society Purchase, General Membership and Donations Fund; 25.35

Once part of a multi-paneled altarpiece painted for the church of Porto San Giorgio (on the Adriatic coast of Italy), this painting depicts Christ's mother and followers attending to his corpse. The gestures of the Virgin and of Mary Magdalen draw attention to the wounds of Christ, suggesting that the panel was a devotional image meant to inspire the sympathy of worshipers. The grieving figures of Saint John the Evangelist (on Christ's left), Joseph of Arimathea, and Nicodemus provide examples for the spectator to follow. The intensely expressive figures, emphasized by detailed draftsmanship, are hallmarks of Crivelli's style.

Madonna and Child

ca. 1500; Pietro Perugino (Italian, ca. 1450–1523); Tempera on panel; 80.6 x 64.8 cm (31 3/4 x 25 1/2 in.); Bequest of Eleanor Clay Ford; 77.3

Italian painters of the Renaissance strove to humanize their figures in order to narrow the gap between worshiper and divine personages. In Perugino's depiction of the Madonna and Child no throne or cloth of honor are included to signify their exalted status, only discrete halos. A Renaissance viewer would have recognized that the red robe signifies that the Madonna is a sovereign and the personification of Divine Love. Her blue cloak, the symbolic color of Heavenly Love and Truth, is marked on the shoulder by a gold star, which refers to one of her titles, *Stella Maris,* "Star of the Sea and Port of Our Salvation." The lack of interaction between mother and baby and their aloofness keep this devotional image from becoming entirely secularized.

Madonna and Child

1508; Giovanni Bellini (Italian, ca. 1430–1516); Oil on panel; 84.8 cm x 1 m (33 3/8 x 41 3/4 in.); City of Detroit Purchase; 28.115

One of the first Italian artists to master the use of oil paints, Bellini combined the careful draftsmanship and pure geometry typical of the Italian Renaissance with the astute coloring particular to Venetian artists. This depiction illustrates the Virgin's presentation of the Christ Child giving his blessing. The artist's use of the green curtain serves to create the illusion of an interior space shared with the spectator, thus establishing a more intimate relationship between the viewer and the object of his or her devotion. Bellini painted many depictions of the Virgin and Child, perfecting this type of devotional painting with charming nuances, such as this naturalistic landscape.

Judith with the Head of Holofernes

ca. 1570–80; Tiziano Vecellio, called Titian (Italian, ca. 1488–1576); Oil on canvas; 1.1 m x 94.5 cm (44 1/2 x 37 1/2 in.); Gift of Edsel B. Ford; 35.10

Executed in the last decade of the artist's long life, this interpretation of Judith's story shows Titian's extraordinary freedom of style. Not only has the artist altered the traditional iconography of the subject by replacing the old woman attendant with a black page, but the lower part of the picture displays the loose and broken brushstrokes typical of Titian's late pictures. While the contrast between the expressionist face of the giant and the smooth texture of Judith's is jarring, it also reinforces the disparity between the heroine and her conquest, as if femininity has won over roughness and violence.

There are many interpretations of this heroine; you'll find others on pages 174 and 184.

Interpreting Judith

Judith was a biblical Jewish heroine who used her beauty to seduce, then decapitate, the commander-in-chief of the Assyrian army, Holofernes, and thus save her people. The book of Judith is included in the Old Testament Apocrypha.

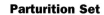

Parturition Set

ca. 1560–70; Attributed to the workshop of Orazio Fontana (Italian, 1510–71); Tin-glazed earthenware (*maiolica*); height of cup 10.2 cm (4 in.), Gift of Mr. and Mrs. Henry Ford II; 59.124

In Renaissance Italy parturition or birthing sets were used to serve nourishing foods— such as meat broth—to women confined to bed during pregnancy and after childbirth. These sets generally consisted of five or more pieces, including various bowls, a tray, a saltcellar, and a pierced cover, all of which fit together in a baluster form when not in use. This set, preserving three pieces, is the largest surviving example.

The painted decoration on each piece depicts a scene in a bedchamber immediately following birth: bathing, swaddling, and nursing the newborn infant. Lively "grotesques," typical of the *maiolica* workshop of Orazio Fontana in Urbino, fill the remaining surfaces.

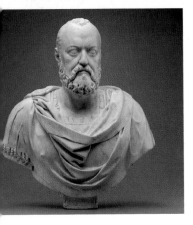

The Medici, who had ruled Florence since the early 15th century, fell from power in 1529 following the siege of the city during the French Wars. A decade later Cosimo I de' Medici restored security and prosperity to the city, while undertaking a military campaign to unify Tuscany under Medici rule.

Grand Duke Cosimo and his successors were active patrons of the arts, enriching Tuscan cities with works of art and architecture and reestablishing the capital city of Florence as a major cultural center.

Bust of Cosimo I, Grand Duke of Tuscany

ca. 1572; Giovanni Bandini (Italian, 1540–99); Marble; height 83 cm (32 5/8 in.); Founders Society Purchase, Robert H. Tannahill Foundation Fund; 1994.1

Grand Duke Cosimo commissioned noted artists—the painter Bronzino and sculptors Giambologna and Bandini among them—to create his official portraits. Giovanni Bandini executed five busts of Cosimo I to be placed above the portals of Florentine palaces as an honor granted to the important families who lived in them. In all examples, Cosimo is portrayed *all' antica*, wearing a mantle and cuirass in emulation of his ancient Roman imperial antecedents. This bust epitomizes the dignified formal character of aristocratic portraiture in later 16th-century Italy.

Eleonora of Toledo and Her Son

ca. 1550; Agnolo Bronzino and Workshop (Italian, 1503–72); Oil on panel; 1.2 x 1 m (48 x 39 3/8 in.); Gift of Mrs. Ralph Harman Booth in memory of her husband Ralph Harman Booth; 42.57

Portraiture was an important political tool for the ducal Medici family. Often sent abroad as gifts, portraits such as this one represented the stability and legitimacy of Medici rule in Florence.

Eleonora of Toledo (1519–62), the wife of Cosimo I, was the daughter of the viceroy of Naples and therefore an important diplomatic liaison for the Florentine ruler. She and Cosimo had eleven children. The identity of this child is uncertain, but most likely he is her second son, Giovanni (1543–62).

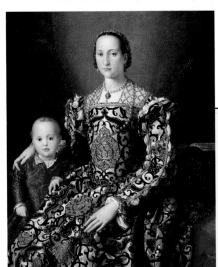

Copies

The usage of portraits necessitated the production of copies, painted by both Bronzino himself and members of his workshop; the first version (ca. 1545) of this portrait is now in the Uffizi Gallery in Florence.

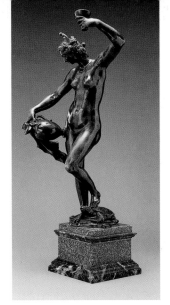

Lion Attacking a Horse

ca. 1600; Cast by Antonio Susini (Italian, active 1580–1624), after a model by Giambologna (1529–1608); Bronze; height 24.1 cm (9 1/2 in.); City of Detroit Purchase; 25.20

Giambologna's closest collaborator, Antonio Susini founded his own workshop in Florence in 1600 and continued to cast bronzes from models made earlier by Giambologna, an important 16th-century sculptor. The quality of the casting and the sharp, precise chasing of this bronze suggest that it derives from a wax model that Susini carefully reworked before casting.

This bronze is one of only two known casts bearing Susini's signature: *"ANT SVSINI FIORE. OPVS."* The animated group, inspired by a monumental Greco-Roman marble and showing the lion ripping the flesh on the horse's back with the horse's head thrust back in agony, captures a climactic moment in a violent drama.

Hebe

ca. 1590; Hubert Gerhard (Dutch, ca. 1540–1620); Bronze; height 76 cm (30 in.); Gift of Mr. and Mrs. Henry Ford II; 59.123

This statuette represents Hebe, the Greek goddess of immortal youth and beauty and the cup-bearer to the gods on Mount Olympus. Gerhard, who trained with Giambologna in Florence, expressed the Florentine mannerist ideal of beauty in this elegant attenuated figure. Designed to be seen from all angles, this spiraling figure is a source of visual delight. *Hebe* was probably one of two female figures made for the perimeter of the monumental Augustus Fountain that Gerhard created in Augsburg, Germany, between 1589 and 1594.

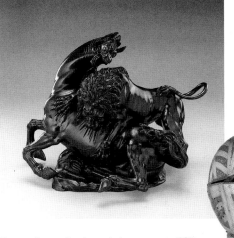

For another animal combat, see page 220.

Boy's Corslet

ca. 1605; Italian; Steel, blued, etched, and gilded; height 74.9 cm (29 1/2 in.); Gift of William Randolph Hearst Foundation; 53.200

This boy's corslet was made for Duke Cosimo II (1590–1621). The armor was used in foot tourneys in which two "champions" would face each other armed with wooden swords, battle-axes, and pikes, separated by a horizontal bar called a *barriera*. This type of armor is called *armatura da barriera* (armor for the barrier). Because the corslet protected only the head, trunk, and arms, strokes below the waist were prohibited. The corslet is decorated with closely set bright steel ridges contrasting with a dark ground etched with gilded foliate scrolls.

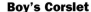

THE GRAND–DUCAL MEDICI COURT

EUROPEAN ART

DIA

The Circumcision

ca. 1523; Francesco Mazzola, called Il
Parmigianino (Italian, 1503–40); Oil on panel;
42 x 31.4 cm (16 1/2 x 12 3/8 in.); Gift of
Axel Beskow; 30.295

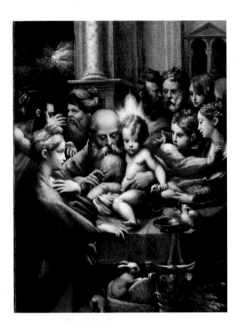

As required of Jewish males, Jesus was
brought to the temple on the eighth day
after birth to be circumcised. In addition to
the child receiving his Hebrew name, the
ceremony marked the covenant between the
Jews and God. Parmigianino celebrates this
moment by contrasting the pale light of the
moon (visible in the background) with the
brilliance emanating from the child's halo.
This latter light represents both spiritual
grace and a physical phenomenon; it is used
to define the modeling of the attenuated and
exaggerated figures and to effect the color
tonations. The descriptive liberties taken by
the artist—the exaggeration of proportions
and the disregard for linear perspective—are
characteristic of his early mannerist style.

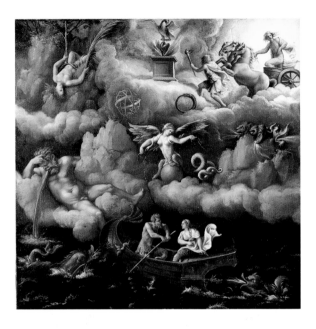

An Allegory of Immortality

ca. 1540; Giulio Romano (Italian, ca. 1492–1546); Oil on
canvas; 69.9 x 69.9 cm (27 1/2 x 27 1/2 in.); Founders
Society Purchase, Mr. and Mrs. Walter Buhl Ford; 66.41

One of Raphael's most talented assistants, Giulio Romano
left Rome in 1524 to work for Federigo Gonzaga, ruler of
Mantua. Romano's paintings contributed to the spread of
Roman mannerism, a style which set the artistic standard
for the next two decades in Italy. This painting illustrates
the sophisticated and obscure symbols that were familiar
to the courts of 16th-century Italy; to decipher the mean-
ings of the various segments was a challenging game
for courtiers. The most easily understood symbols are the
phoenix rising out of the flames (a symbol
of rebirth) and the serpent devouring
its own tail (representing eternity).

Eros and Psyche

ca. 1560; Niccolò dell'Abate (Italian, ca. 1509–71);
Oil on canvas; 99.7 x 92.7 cm (39 1/4 x 36 1/2 in.);
Founders Society Purchase, Robert H. Tannahill Fund;
65.347

Eros (or Cupid), the son of Venus, visited Psyche every
night proclaiming his love but concealing his identity in
the darkness. Eventually Psyche's curiosity overcame
her, and when one night she held a lantern up to see
him, Eros became very angry and left her. The story
ends happily in the reunion and marriage of the lovers.
The scene in this painting is very unusual; most depic-
tions of this theme show either Eros visiting Psyche
or Psyche shining her lantern upon Eros, so the exact
subject here is in dispute.

Born in Modena and active in the early part of his
career in Bologna, Niccolò dell'Abate moved to France
in 1552. He and the other Italian artists working at the
court of the French kings at Fontainebleau spread
the mannerist style which was popular in the artistic
centers of Italy.

For another example of Eros and Psyche, see page 188.

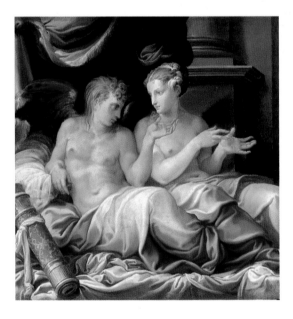

Mars and Neptune

ca. 1540–50; Follower of Jacopo Sansovino
(Italian 1486–1570); Bronze; Mars height
1.2 m (47 in.); Neptune height 94 cm (37 in.);
Gift of Mr. and Mrs. Edgar B. Whitcomb;
49.418

Mars and Neptune were long attributed
to Jacopo Sansovino, a Florentine sculptor
and architect who also worked in Rome
and Venice. These large bronzes were dis-
covered in Venice about 1840.

Mars has been interpreted variously as
a representation of the Roman god of
war himself or as an allegory of Summer
and Fire, while Neptune, god of the sea,
may allude to Winter and the element
Water. These large bronzes may have been
trial works for a monumental Venetian
tomb or used on a staircase or next to
a mantelpiece.

Caravaggio and His Followers

Caravaggio introduced dramatic effects of light and shadow in his paintings and often used ordinary looking people to illustrate religious stories. Artists from Italy, as well as from other European countries, adopted his style.

The Conversion of the Magdalen

ca. 1597–1600; Michelangelo Merisi, called Caravaggio (Italian, ca. 1571–1610); Oil on canvas; 97.7 cm x 1.3 m (38 1/2 x 52 1/4 in.); Gift of the Kresge Foundation and Mrs. Edsel B. Ford; 73.268

In the 16th century a new emphasis was placed on Mary Magdalen's role as a converted sinner. Caravaggio depicts Mary's sister Martha, dressed modestly, reproaching her sister for her wayward conduct and enumerating on her fingers the miracles of Christ. This exact moment of the conversion was obviously a tremendous challenge for the painter because the change is spiritual rather than physical. Caravaggio's solution was to manipulate the light which illuminates the Magdalen, giving her an unearthly glow. The mirror, a traditional image of vanity, now reflects the light of divine revelation.

Judith and Her Maidservant with the Head of Holofernes

ca. 1625; Artemisia Gentileschi (Italian, 1593–ca. 1651); Oil on canvas; 1.8 x 1.4 m (72 1/2 x 55 3/4 in.); Gift of Mr. Leslie H. Green; 52.253

This impressive composition ranks among the masterpieces executed by Artemisia Gentileschi, daughter of the painter Orazio and a strong woman who, against all odds, established herself as a respected painter. The subject is executed with a directness that sets it apart from many other contemporary renditions. The theatrical lighting of the scene echoes in many respects the works of the northern followers of Caravaggio, who had specialized in such effects, while the intense realism of the scene is close to Caravaggio himself.

A Woman Artist

Art training was available to few women at this time; Artemisia Gentileschi was taught by her father, Orazio. Perhaps he portrayed her in *Young Woman with a Violin* above right.

For the story of Judith, see page 179.

Is This Artemisia?

Orazio Gentileschi may have used his daughter, the painter Artemisia Gentileschi, as a model for the woman, thus adding a note of realism to his representation.

Young Woman with a Violin

ca. 1611–12; Orazio Gentileschi (Italian, 1563–1639); Oil on canvas; 83.5 x 98 cm (32 3/4 x 38 5/8 in.); Gift of Mrs. Edsel B. Ford; 68.47

This image of a young woman playing the violin has traditionally been interpreted as a personification of Saint Cecilia, an early Christian martyr and the patron saint of music, whose presumed body had been exhumed intact in 1599. Orazio's interest in realism has been credited to the influence of Caravaggio, an artist whom Gentileschi admired and whose style he popularized.

The Fortune Teller

ca. 1610–15; Bartolomeo Manfredi (Italian, ca. 1587–ca. 1620); Oil on canvas; 1.2 x 1.5 m (47 5/8 x 60 in.); Founders Society Purchase, Acquisitions Fund; 79.30

Manfredi's rendition of deception in this picture is particularly poignant. The young man, so intensely curious about his future, is oblivious to the theft of his money by the fortune-teller's accomplice. The fortune-teller herself, so eager to captivate the young man's attention, does not notice that his friend is relieving her of a chicken. It is perhaps less a moral lesson that is given here than a matter-of-fact pessimistic description of human relationships. Manfredi used dark tonalities to give the scene a sense of a seedy locale, while the life-size scale of the figures makes them part of our world and allows us to participate in their drama.

CARAVAGGIO AND HIS FOLLOWERS

DIA EUROPEAN ART

Interior of Saint Peter's, Rome

1750; Giovanni Panini (Italian, 1691–1765); Oil on canvas; 1.3 x 1.4 m (52 x 56 1/2 in.); Gift of Mr. Edgar R. Thom; 56.43

Panini glorified Rome in countless views of its monuments and in fanciful landscapes where imagined ruins are shown in the proximity of identifiable sights. This view of the interior of Saint Peter's basilica is one of about thirty versions Panini executed for his large, cosmopolitan clientele. Amusingly, the artist has introduced many figures caught in the act of looking at the architecture, so that the viewer is, in a fashion, invited to join them in their exploration of this vast space.

A Bernini in a Panini

The painting by Panini shows Bernini's famous additions to Saint Peter's (the baldachin and *Chair of Saint Peter*, for instance) along with some of the sculpture and monuments added to the interior in the 18th century.

Model for Chair of Saint Peter

1658–60; Gianlorenzo Bernini (Italian, 1598–1680); Terracotta and stucco; height 58.4 cm (23 in.); Founders Society Purchase, Ralph Harman Booth Bequest Fund; 52.220

This is the only surviving sculptural sketch for the *Chair of Saint Peter,* the focal point of the apse of Saint Peter's basilica in Rome. Bernini designed a magnificent gilded bronze throne as a shrine to encase the most venerated relic in the Vatican, the chair from which, by tradition, Saint Peter himself had preached. The reliefs on this model refer to the most significant moments in the life of Saint Peter: on the back is Jesus's charge to Peter, "Feed my Sheep"; on the left side, the giving of the keys to Peter; on the right, the washing of the disciples' feet; and, below the seat, the miraculous draft of fishes. In April 1658 Bernini brought this terracotta model to his patron, Pope Alexander VII. The project represents the crowning achievement of Bernini's career.

The Piazza San Marco, Venice

ca. 1736–37; Giovanni Antonio Canal, called Canaletto (Italian, 1697–1768); Oil on canvas; 75.6 cm x 1.1 m (29 3/4 x 46 3/4 in.); Founders Society Purchase; 43.38

Canaletto specialized in views of his native city, Venice, working for a devoted and often foreign clientele. This view toward the west end of the Piazza San Marco is typical of the artist's "improvements on nature" by showing in one picture both the Campanile and the Torre dell' Orologio. In actuality these two landmarks, shown framing the left and right edges of the composition, cannot be seen simultaneously from one position. Furthermore, the artist has adopted a slightly elevated viewpoint which reinforces the perspective lines created by the paving stones. This painting is an important historical document for it shows what the piazza looked like before alterations were ordered by Napoleon in the early 19th century.

A Family of Artists

Bellotto followed in the steps of his uncle, Canaletto, as one of Europe's leading painters of cityscapes. His international career took him to various parts of the Italian peninsula, as well as to Saxony, Bohemia, and eventually to Poland where he settled.

View of the Tiber with Castel Sant'Angelo

ca. 1742; Bernardo Bellotto (Italian, 1721–80); Oil on canvas; 1.3 x 1.5 m (34 1/2 x 58 1/2 in.); Gift of Mr. and Mrs. Edgar B. Whitcomb; 40.166

This view of some of the most famous and beloved monuments of Rome, including the Castel Sant'Angelo and the dome of Saint Peter's, belongs to the early production of the artist. While it still betrays the influence of his uncle, Canaletto, it also shows some of Bellotto's own style, in particular a sense of immediacy.

The last decades of Medici rule (ca. 1670–1743) were a period of intense artistic activity in the Grand Duchy of Tuscany. The baroque style, though outdated by 1743, continued to dominate Florentine art as an expression of the Grand Duke's dynastic pretensions and absolute rule. Under Medici patronage, Florence led Italy in the production of splendid bronzes, furniture, tapestries, and porcelain.

This bronze sculpture once belonged to the kings of France, as indicated by the royal inventory number on the calf of Bacchus's left leg.

Bacchus and a Young Satyr

ca. 1640; Gianfrancesco Susini (Italian, 1592–1646); Bronze; height 50.2 cm (19 3/4 in.); Founders Society Purchase, New Endowment Fund; 82.27

This finely chased bronze, based on Renaissance sculptures by Michelangelo and Jacopo Sansovino, bears an impressive provenance. First recorded in the d'Este collection in Mantua, the statuette entered the French royal collection around 1700, when Louis XIV acquired it from the estate of André Le Nôtre, the landscape architect for the gardens at Versailles. A nephew of Antonio Susini (see page 181), Gianfrancesco took over the Florentine sculpture workshop in 1624.

For another Cupid and Psyche, see page 183.

Cupid and Psyche

ca. 1710; Giovanni Battista Foggini (Italian, 1652–1725); Bronze; height 34 cm (13 1/2 in.); Founders Society Purchase, Robert H. Tannahill Foundation Fund; 81.695

The story of Cupid and Psyche first appeared in the *Metamorphoses* written by the Roman author Apuleius in the 2nd century A.D. This bronze depicts the dramatic moment when Psyche, encouraged by her jealous sisters, holds an oil lamp over the waking Cupid and discovers his true identity. Foggini, the official sculptor and architect of the Medici court, interpreted the scene in a high baroque style, characterized by dynamic rhythms and theatrical gestures.

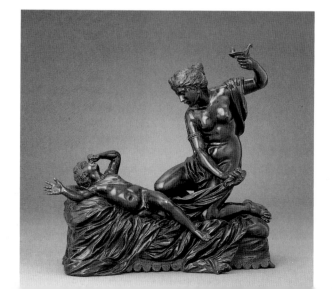

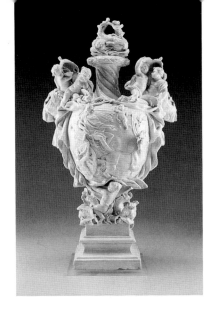

Vase

1748–50; Doccia Porcelain Factory (Italian); designed by
Massimiliano Soldani (Italian, 1656–1740); modeled by Gaspero
Bruschi (Italian, active 1737–78); Porcelain; height 60 cm (23 in.);
Founders Society Purchase, Robert H. Tannahill Foundation Fund;
90.245

**This unique monumental vase was made for Marchese Carlo
Ginori at his villa in Doccia outside Florence; it has no practical
function other than to convey the factory's artistic and techni-
cal virtuosity. Using Florentine sculptors' models in wax and
terracotta originally intended for bronzes, the experimental
Doccia factory produced ambitious groups on a large scale in
an attempt to rival German Meissen porcelain. The vase
represents Apollo driving his golden chariot across the sky at
sunset. On the reverse, Galatea, the sea-nymph, rides her
dolphin on the waves while a Triton awards her a laurel wreath.**

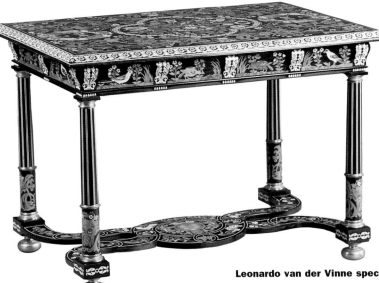

Table

ca. 1667–70; Attributed to
Leonardo van der Vinne (Flemish
[?], active in Florence, ca. 1659–
1713); Veneered with ebony,
fruitwoods, and ivory; height 78 cm
(30 3/4 in.); Founders Society
Purchase, Mr. and Mrs. Walter B.
Ford II Fund; 71.293

**Leonardo van der Vinne specialized in elaborate, colorful
marquetries of precious woods and ivory, often in combination
with inlaid hardstones (pietre dure). His marquetry decorations
depict naturalistic flowers and birds inspired by the Dutch and
Flemish flower paintings that had been popular since the
beginning of the 17th century.**

**This table, bearing the Medici coat of arms on the stretcher,
belongs to a set of four, presumably ordered by the Medici
Grand Duke Cosimo III for the Accademia degli Uffizi
around 1667. Van der Vinne worked for most of his career at
the Florentine Grand Ducal workshops, a state manufactory
founded in the 16th century to supply luxury furnishings to
the Medici court. By the end of the 17th century, extravagantly
detailed pieces such as this table had become an essential
feature in princely interiors throughout baroque Europe.**

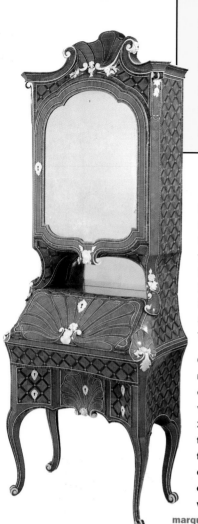

Secretary

ca. 1770; Pietro Piffetti (Italian, 1700–77); Mahogany, oak, and walnut, veneered with kingwood, ivory, and ebony stringing; gilding; ivory mounts; mirrors; gilt metal; height 2.2 m (88 in.); Founders Society Purchase, Robert H. Tannahill Foundation Fund; 73.167

Cabinetmaker to the Sardinian royal family in Turin, Piffetti was one of the most original and virtuoso furniture makers of 18th-century Europe. His furniture forms, conceived as sculptural fantasies, emphasize exuberant curves and an energetic interplay of solid and void. He is equally well known for sophisticated marquetry decorations, combining exotic woods, such as Brazilian kingwood, with ivory and mother-of-pearl, creating a sensual contrast of color and surface. The restrained diamond-pattern parquetry on this desk is embellished by ivory rosettes in the interstices and by ebony and ivory stringing that outlines the form. Piffetti's extravagant furniture embodies the Italian interpretation of the rococo, marked by unrestrained animation and fantastic invention.

Satire on a Nobleman in Misery

1719–25; Alessandro Magnasco (Italian, 1667–1749); Oil on canvas; 74 x 60 cm (29 x 23 1/2 in.); Gift of Luigi Grassi; 36.14

The satirical intent of Magnasco's painting of a nobleman is all too clear: while clutching his sword in one hand and a scroll bearing his family tree with the other, this gallant gentleman is seated in a room with cheap furniture and broken pottery. His meal, spread out on the bench in front of him, consists of only radishes and onions. A shadowy figure behind the man derisively holds his left hand up in an Italian folk gesture, underscoring the pitiable condition to which the nobleman has fallen. Like Don Quixote, the chivalrous character from the Spanish romance written by Cervantes early in the 17th century, this nobleman clings to the past for solace.

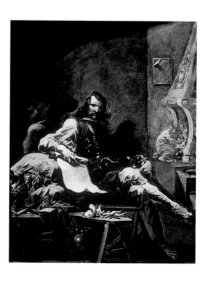

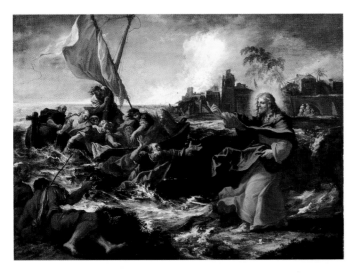

Christ at the Sea of Galilee

ca. 1695–97; Sebastiano Ricci (Italian, 1659–1734); Oil on canvas; 1.2 x 1.7 m (48 3/4 x 65 3/4 in.); Gift of Matilda R. Wilson Fund in memory of Matilda R. Wilson; 76.146

Christ at the Sea of Galilee is an important early work by Ricci. Simon Peter, in his haste to join Jesus, has jumped from the boat and eagerly tries to reach Christ on the beach (John 21: 1–8). Probably the painting was designed for a church or a private chapel.

Ricci's ability to work in any style required by his patrons reflects the many influences that the artist encountered throughout his career. Born in Venice, he responded to the work of Veronese, but the influence of both Bolognese and Roman artists can also be seen in his style.

The Finding of Moses

ca. 1660–65; Salvator Rosa (Italian, 1615–73); Oil on canvas; 1.2 x 2 m (48 1/2 in. x 6 ft. 7 3/4 in.); Gift of Mr. and Mrs Edgar B. Whitcomb; 47.92

Pure landscape painting was not regarded as sufficiently serious in the 17th century, so narrative elements were added to the picture to give it a biblical, mythological, or historical subject. While *The Finding of Moses* is represented in the painting, the true subject is the powerful landscape itself. Rosa's landscape paintings were quite popular in late-18th-century England. His depiction of nature, balancing direct observation with the classical tradition of harmony and order, reflected the English sensitivity to nature.

The Angel Appearing to Saint Jerome

ca. 1640; Guido Reni (Italian, 1575–1642); Oil on canvas; 2 x 1.5 m (78 x 58 1/2 in.); Founders Society Purchase, Ralph H. Booth Fund, Mr. and Mrs. Benson Ford Fund, Henry Ford II Fund, and New Endowment Fund; 69.6

This painting belongs to the late years of the artist's life. At that time Reni had abandoned the smooth finish that had been characteristic of his earlier work in favor of a slightly looser and more animated surface. The abstract elegance of his previous canvases gives way to works which are perhaps less "perfect" but emotionally richer. In this work the spiritual encounter between Saint Jerome and the angel is expressed by a brilliant colorism and an array of gestures which are theatrical without being melodramatic.

The Assumption of the Virgin

1650; Giovanni Francesco Barbieri, called Guercino (Italian, 1591–1666); Oil on canvas; 3 x 2.2 m (10 ft. 1 1/4 in. x 86 1/2 in.); Founders Society Purchase, Robert H. Tannahill Foundation Fund, and Josephine and Ernest Kanzler Founders Fund; 71.1

The Assumption became an important theme during the 17th century after the Counter Reformation. As angels carry the Virgin up to heaven, she points back toward the city of Rome. This gesture represents the interrelationship between heaven and earth, God and man. Below the Virgin is a panoramic view of the city of Rome: from left to right are the Basilica of Saint John the Lateran, the Colosseum, the Capitoline Palace, the Pantheon, and the Church of Saint Ignatius.

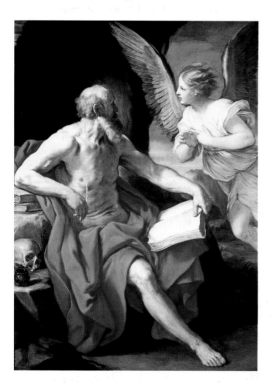

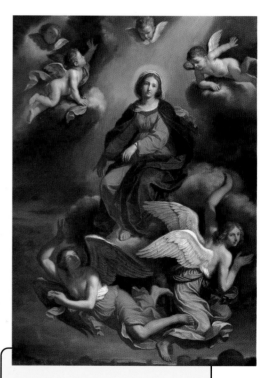

Squint

"Guercino" in Italian means a person with a squint; it was given as a nickname to the Bolognese painter Giovanni Francesco Barbieri.

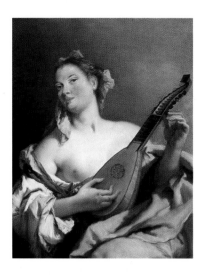

Girl with Mandolin

1753–57; Giovanni Battista Tiepolo
(Italian, 1696–1770); Oil on canvas;
93.3 x 74.9 cm (36 3/4 x 29 1/2 in.);
Gift of Mr. and Mrs. Henry Ford II;
57.180

Tiepolo's work reflects the culmina-
tion of the baroque tradition in
Venice. In this painting the artist
celebrated the ideal of feminine
beauty. The luminous skin portrayed
in melting brushwork only serves
to heighten the sensuous poetry
of the painting. The young woman,
Tiepolo's favorite model named
Cristina, holds an 18th-century
mandolin and listens to the pitch
of the note as she adjusts the keys.
The painting is thought to have
been commissioned for Catherine
the Great, the empress of Russia.

Venus Ordering Armor for Aeneas

ca. 1775; Gaetano Gandolfi (Italian, 1734–1802); Oil on
canvas; 1.9 x 1.4 m (75 x 55 1/2 in.); Gift of Mr. and
Mrs. Allan Shelden III; 74.2

Gaetano Gandolfi belonged to a family of Bolognese
artists. He and his two brothers are commonly credit-
ed with extending the tradition of great mythological
and religious painting that had distinguished their
native city since the 16th century. The subject of this
painting belongs to the repertoire of mythological and
slightly erotic images much in favor during the 18th
century. Gandolfi, like François Boucher and Charles-
Joseph Natoire who painted the same theme earlier,
obviously delighted in representing the contrast
between the muscular body of Vulcan and the soft
and naked flesh of Venus, Vulcan's exacting wife.

At the time this painting was executed,
most European artists were already
striving toward a more austere style
inspired by antique models. Gandolfi
instead carried through the voluble and
theatrical rhetorics of the baroque.

This study for the composition is also in
the collection of the DIA (1991.239).

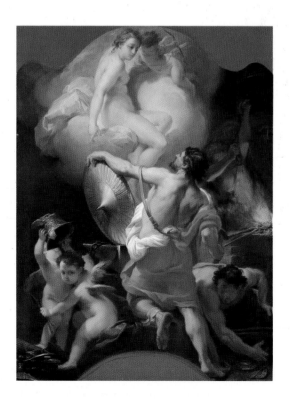

Peter Paul Rubens and Flanders

Very few men in history led a more interesting life than Peter Paul Rubens. Rubens was truly a "renaissance man"; he spoke several languages, was well versed in classical literature and Italian art, and served as a diplomat in the courts of several European rulers. The powerful energy and monumentality of Rubens's paintings were well suited to the royal status of his patrons. His thematically complex works are painted in a manner that guarantees both an understandable story and visual delight.

Archduke Ferdinand, Cardinal-Infante of Spain, at the Battle of Nördlingen

1635; Peter Paul Rubens (Flemish, 1577–1640); Oil on oak panel; 1.2 m x 93 cm (48 1/8 x 36 5/8 in.); Founders Society Purchase, Ralph Harman Booth Bequest Fund; 47.58

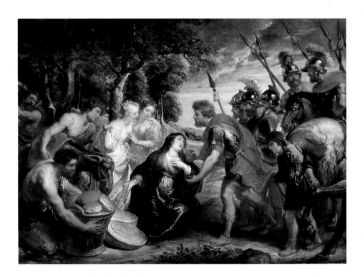

The Meeting of David and Abigail

ca. 1625–28; Peter Paul Rubens (Flemish, 1577–1640); Oil on canvas; 1.8 x 2.5 m (70 1/4 x 98 in.); Gift of James E. Scripps; 89.63

The meeting of David and Abigail provides a biblical narrative ripe with action and romance (I Samuel 25). Afraid that David will attack her husband for refusing to pay for David's protection, Abigail and her servants gather together gifts of food to appease the approaching troops. Thanks to her beauty and to her eloquence, Abigail succeeds not only in avoiding war but also in eventually winning David's heart.

The figures and details that fill this large canvas are partially invented by Rubens and partially taken from other sources, including the artist's collection of antique sculpture.

The son of Spanish King Philip III, Archduke Ferdinand appears in this portrait at the Battle of Nördlingen, where he realized his greatest military victory in a battle that changed the course of the Thirty Years War.

The dazzling and energetic painting style compliments the heroics of the young prince. Equestrian paintings were a very popular form of portraiture for European rulers whose majesty and political power were emphasized by such a composition. Archduke Ferdinand was one of Rubens's most enthusiastic art patrons.

DETROIT CONNECTION

One of the first old master paintings to enter the DIA's collection, this was given by Detroit newspaper magnate James E. Scripps in 1889.

Briseis Given Back to Achilles

ca. 1630–31; Peter Paul Rubens (Flemish, 1577–1640);
Oil on oak panel; 44.3 x 66.7 cm (17 1/2 x 26 1/4 in.);
Bequest of Mr. and Mrs. Edgar B. Whitcomb; 53.356

**This small panel is part of a series of eight oil sketches
made for a group of tapestries depicting the story of
Achilles, one of the heroes of the Greek epic poem the
Illiad. As if on a stage, all of the important characters are
present. The painting is remarkable for the apparent swift-
ness and ease of its execution, the brightness of palette,
and the sensitive rendering of the protagonists' emotions.**

**During the Greeks' campaign against Troy, Achilles had
been awarded the lovely Briseis as part of his share of
the booty. When the expedition leader Agamemnon took
her for himself, Achilles refused to participate in any
further battles. He reconsidered, however, after his best
friend Patroclus was killed and Agamemnon restored
Briseis untouched to him.**

In the Studio

1652; Michael Sweerts (Flemish, 1624–64);
Oil on canvas; 73.5 x 58.8 cm (28 15/16 x 23
1/8 in.); City of Detroit Purchase; 30.297

**Having spent a number of years in Rome,
Michael Sweerts was familiar with Italian art.
He, however, concentrated on smaller depic-
tions of genre scenes and portraits.**

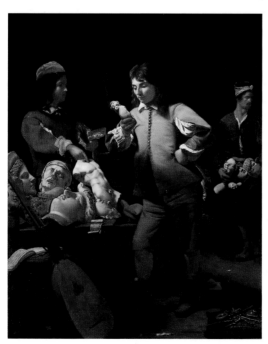

**This painting represents the inter-
ior of an artist's studio in Rome—
a subject he painted on several
occasions. While the plaster
casts, musical instruments, and
books that appear in the painting
are studio props, they can also
be considered as symbols of all
the arts to stress the importance
of a well-rounded education for
any aspiring artist.**

Stories from the Bible were often painted in Protestant Holland in the 17th century. Artists like Pieter Lastman introduced many new subjects into painting, with an emphasis on the Old Testament, which was also a source for Rembrandt and his followers.

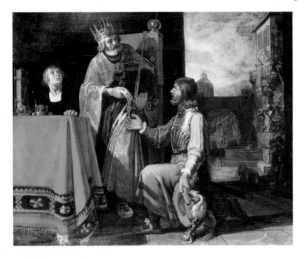

King David Handing the Letter to Uriah

1611; Pieter Lastman (Dutch, 1583–1633); Oil on panel; 50.8 x 61 cm (20 x 24 in.); Gift of Mr. and Mrs. John N. Lord; 60.63

Pieter Lastman, who was Rembrandt's teacher for six months in 1625, painted many particularly rare biblical subjects. In this painting he shows a scene from the story of King David. After having committed adultery with Uriah's wife Bathsheba, David commands Uriah to visit her to disguise the fact that he has impregnated Bathsheba. But Uriah, unconscious of this deception, feels dutybound to rejoin his regiment on the battle-field. Lastman shows the moment when David hands Uriah a letter for his commander asking that he be placed in the front ranks of battle, where Uriah will eventually be killed (II Samuel 11). The scene illustrates how an otherwise righteous ruler can be led into temptation and then turn into a murderer.

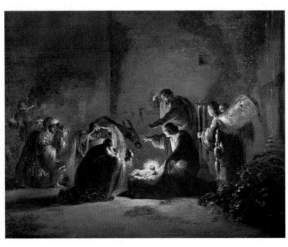

The Adoration of the Magi

ca. 1633–35; Leonaert Bramer (Dutch, 1596–1674); Oil on panel; 43.2 x 53.3 cm (17 x 21 in.); Founders Society Purchase, Joseph M. de Grimme Memorial Fund; Gifts of Mr. and Mrs. Edgar B. Withcomb, Harriet Scripps, and James E. Scripps, by exchange; 1993.19

Like many 17th-century artists Leonaert Bramer traveled to Italy, where he became acquainted not only with the art of the Italians but also with the art of other Dutch artists working there. In this dramatically illuminated nocturnal scene, Bramer intensifies the drama and the visionary quality through a rough application of paint and the nervous, flickering reflections of light. In the pronounced treatment of light and dark, the mood, and the choice of costumes one may detect Rembrandt's influence while the foliage and the rendering of the two angels are close to the art of Lastman.

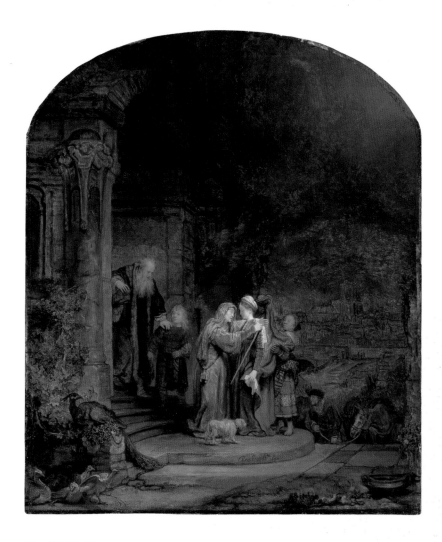

The Visitation

1640; Rembrandt Harmensz. van Rijn (Dutch, 1606–69); Oil on oak panel; 56.5 x 48.1 cm (22 1/4 x 18 7/8 in.); City of Detroit Purchase; 27.200

The Visitation tells the story of the meeting between Mary, who was pregnant with Jesus, and her older cousin Elizabeth, who was pregnant with John the Baptist (Luke 1:36–42). Rembrandt centers the narrative around the two cousins, bathed in a supernatural glow. From the elderly Zacharias, husband of Elizabeth, easing himself down the stairs with the help of a young boy, to Joseph climbing up the hill leading his donkey, the figures are linked by a series of gestures that stress the intimacy and emotions that bind the characters.

Animals play a meaningful part in this painting. The dog, while providing a touch of informality, symbolizes faithfulness. The peacock watching over her chicks, a symbol of pride and vanity, is also a symbol for Christ, because it represents the incorruptiblity of his flesh.

This picture may relate directly to Rembrandt's life. The face of Elizabeth is reminiscent of the artist's mother who died in 1640 just when his wife was about to deliver a child.

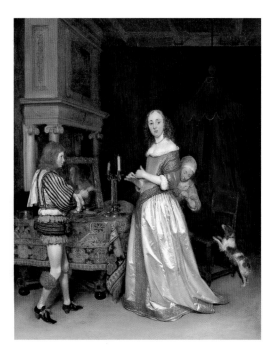

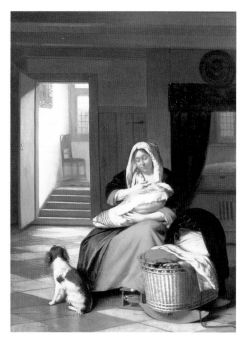

A Lady at Her Toilet

ca. 1660; Gerard Ter Borch (Dutch, 1617–81); Oil on canvas; 76.2 x 59.9 cm (30 x 23 1/2 in.); Founders Society Purchase, Eleanor Clay Ford Fund, General Membership Fund, Endowment Income Fund, and Special Activities Fund; 65.10

Gerard Ter Borch's works often hint at romantic subject matter, but they are always understated and decorous. In this painting, the figure of the woman is not fully dressed. A lace collar would have covered her upper chest, and so the scene, while it appears perfectly proper to the modern viewer, was probably considered tastefully intimate in its own day. Ter Borch was particularly skilled in the depiction of textiles and the luxury items of the wealthy Dutch bourgeoisie.

Mother Nursing Her Child

ca. 1674–76; Pieter de Hooch (Dutch, 1629–84); Oil on canvas; 79.4 x 58.1 cm (31 1/4 x 22 7/8 in.); Gift of James E. Scripps; 89.39

In the Protestant Netherlands, themes which had traditionally been favored by Catholic artists, such as the *Madonna and Child,* were replaced by depictions of domestic virtue. This painting illustrates two qualities highly valued in Dutch culture: an orderly home and a nurturing mother. De Hooch favored this sort of subject matter during the last thirty years of his career. As is evident in this painting, he paid careful attention to the effects of natural lighting within a geometrically defined interior space. Depictions of Dutch women within the confines of the home were more than plentiful in the 17th century, but de Hooch's works are easily recognizable for the sensitivity with which he portrayed his figures of mothers with their children.

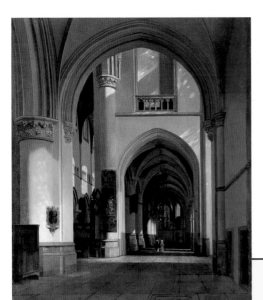

Interior of the Groote Kerk, Haarlem

1676; Job Berckheyde (Dutch, 1630–93); Oil on canvas; 1 m x 87.6 cm (40 1/2 x 34 1/2 in.); Gift of N. Katz; 37.73

Dutch artists of the 17th century tended to specialize in the depiction of two or three genres, thus assuring themselves market recognition. One of Berckheyde's specialties was architecture portrayed with great fidelity. The Church of St. Bavo, the "Great Church" in the artist's hometown of Haarlem, is the subject of numerous such architectural portraits. The view down the aisle towards the ambulatory is enlivened by the play of light and shadow from the windows, which leads the viewer's eyes into the distance.

Fooling the Eye

Although the architectural details are accurately described, the figures of the women in the church are proportionately too small: the artist has tricked the viewer into believing that the building is more massive than it actually is.

Perspective Box of a Dutch Interior

1663; Attributed to Samuel van Hoogstraten (Dutch, 1627–78); Oil on walnut panels and glass mirror; 42 x 30.3 x 28.2 cm (16 5/8 x 12 x 11 1/8 in.); Founders Society Purchase, Membership and Donations Fund; 35.101

Produced in Holland during a twenty-five year period beginning about 1650, the perspective box is an artistic application of linear perspective to create an optical illusion. The illusion is created when the viewer looks into the pentagonal box through a peephole and preceives the painted interior as three-dimensional. Light to the interior is supplied by the reflecting mirror. The images incorporate several themes characteristic of Dutch paintings in the late 17th century: genre, still life, architectural views, and symbols of the vanity of earthly pleasures. The Detroit box is one of only six extant perspective boxes.

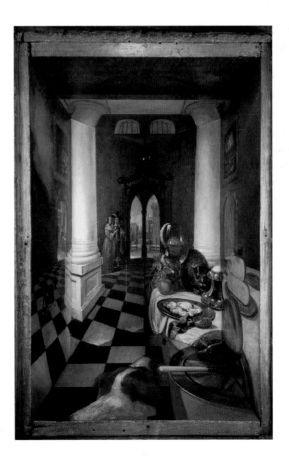

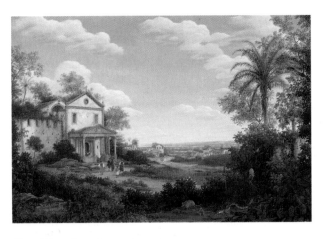

Brazilian Landscape

1665; Frans Post (Dutch, 1612–80); Oil on canvas;
55.9 x 83.2 cm (22 x 32 3/4 in.); Founders Society Purchase,
Membership and Donations Fund; 34.188

In 1637 Frans Post accompanied Johan Maurits, count of
Nassau-Siegen, to the Dutch colony of Pernambuco in Brazil.
The impressions garnered during seven years in South
America became the source for numerous compositions
painted throughout the artist's life. This panoramic view,
completed many years after Post's return to Holland, depicts
a church built in a tropical clearing, perhaps the Jesuit
church at Olinda, the former capital of Pernambuco. The
artist contrasts the church and the colonial settlement in the
background with the lush native flora and fauna that
dominate the foreground. The otherwise peaceful
atmosphere is interrupted by the image of a
cobra eating a rabbit, perhaps a reminder that
the New World could not totally be tamed.

Italian Peasants and Ruins

ca. 1649; Jan Baptist Weenix (Dutch, 1621–
ca. 1661); Oil on canvas; 66.7 x 80 cm
(26 1/4 x 31 1/2 in.); Gift of Mrs. John A.
Bryant in memory of her husband; 41.57

Some Dutch painters of the 17th century
combined a native love for naturalistic
landscapes with an appreciation for the
topography and atmosphere of the Italian
countryside. Many of them traveled south
of the Alps, and the resulting Italianate
paintings include hills, bright sunlight,
blue skies, and classical ruins—a welcome
contrast to the flat land and cloudy skies
of Holland.

Jan Baptist Weenix specialized in such
views, drawing upon a rich portfolio of
sketches to compose Italianate landscapes
both during his stay in Rome (1643–47)
and after his return to Holland. For exam-
ple, the buxom woman in a straw hat, her
baby, and the dog near them are stock
figures that appear in several paintings
by the artist. This one is signed
at the top left "Gio[vanni]
Batt[ist]a Weenix," the Italian
version of his name, in the
manner he preferred to use after
he returned from Italy.

The Cemetery

ca. 1655–60; Jacob Isaaksz. van Ruisdael (Dutch, 1628–82); Oil on
canvas; 1.4 x 1.9 m (56 x 74 1/2 in.); Gift of Julius H. Haass in memory
of his brother Dr. Ernest W. Haass; 26.3

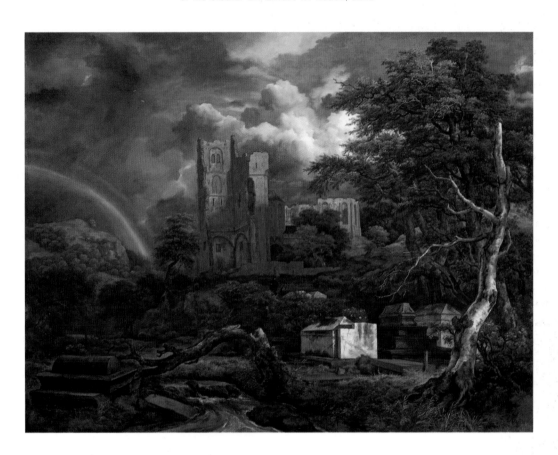

The large size, majestic composition, and mysterious atmosphere
of this haunting landscape rank this painting among the most famous
compositions of the great Dutch artist Jacob van Ruisdael. Using the
cemetery of the Jewish-Portugese community at Oudekerk near
Amsterdam as a point of departure, Ruisdael's painting goes beyond
mere description. The artist has created an allegorical landscape in
which the abandoned tombs, ruined church, storm clouds, and rainbow
allude to the transience of all earthly things. This type of subject
matter is often seen in still-life paintings, where the *vanitas* theme is
represented by a skull, book, flower, or candle (see page 199). It is
unusual to find such symbolic meaning in landscape painting.

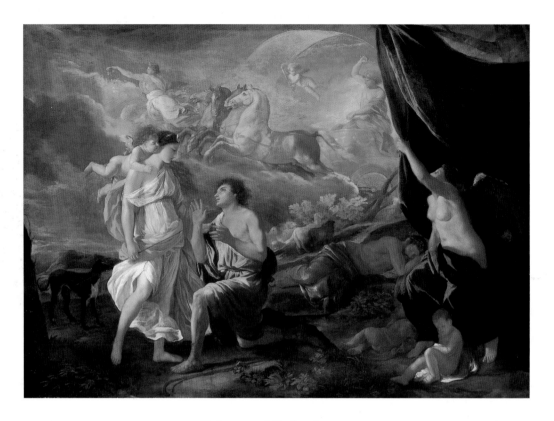

Selene and Endymion

ca. 1628; Nicolas Poussin (French, 1594–1665); Oil on canvas; 1.2 x 1.7 m (48 x 66 1/2 in.); Founders Society Purchase, Membership and Donations Funds; 36.11

Poussin's dramatic use of light and vaporous hues creates the poetic and subtle nuances appropriate to this romantic, idealized scene. The artist worked most of his life in Rome where his work was appreciated by an enlightened group of distinguished and refined intellectuals. In the 17th century this painting was owned by the French Cardinal Mazarin, who consolidated the power of France during the early years of Louis XIV's reign.

Parting Lovers

In Greek mythology, the moon goddess Selene was the lover of a mortal shepherd, Endymion; their meetings could only take place at night. Poussin has chosen to represent the poignant moment when the two must part as the sun god Apollo brings in the new day, driving his chariot across the sky. The winged figure of Night draws back the curtain of darkness that protected the couple.

This sculpture depicts the dramatic event in Homer's *Illiad* when Paris, the son of the king of Troy, captured the beautiful Helen, daughter of Zeus and wife of the king of Sparta, and thus triggered the Trojan war.

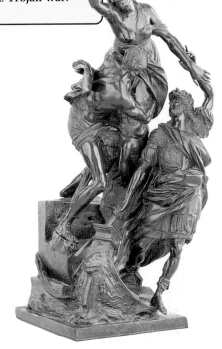

Cabinet-on-stand

ca. 1625–50; French (Paris); Pine and walnut, veneered with ebony on the exterior and kingwood, amaranth (purpleheart), holly, ebony, and stained horn on the interior; gilt bronze; malachite; mirror glass; height 1.9 m (75 in.); Gift of Friends of K. T. Keller; 55.458

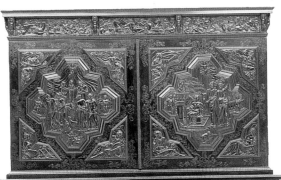

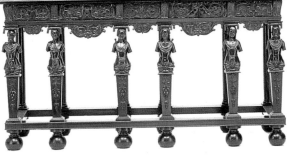

The Abduction of Helen of Troy

ca. 1685; Pierre Puget (French, 1622–94); Bronze; height 97 cm (38 1/4 in.); Founders Society Purchase, Mr. and Mrs. Allan Shelden III Fund; 79.21

The greatest French baroque sculptor, Puget, created this model for a monumental marble group to stand in the gardens of the royal chateau at Versailles. Although many variants and copies have been made of this piece, this bronze appears to be the only 17th-century cast, probably made under Puget's supervision in Toulon in the south of France.

Prominently placed in grand baroque interiors, cabinets-on-stand were highly prized for their sculptural decoration, imported veneers, and their startling illusionism. Their tops provided ideal display surfaces for Chinese porcelains, bronze statuettes, and other *objets d'art.*

The cabinet doors, elaborately carved in relief, illustrate events in Greco-Roman mythology, French literature, ancient history, and the Bible. Scenes from the Old Testament story of Susannah and the Elders decorate the doors of this cabinet. Inside are shallow drawers where small precious objects, such as medals and jewels, could be stored. A second set of doors at center conceals a miniature stagelike setting, contrived of mirrors, malachite, and marquetries of exotic woods and stained horn.

The Purification of the Virgin

1645; Charles Le Brun (French, 1619–90); Oil on canvas; 2.7 x 1.9 m (8 ft. 9 3/4 in. x 6 ft. 5 1/4 in.); Gift of Mr. and Mrs. Allan Shelden III in memory of their son Allan Shelden IV; 73.1

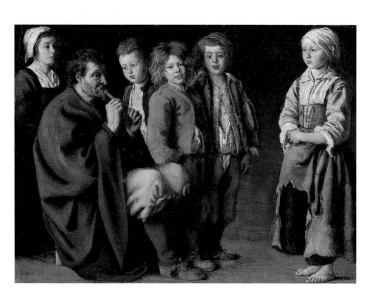

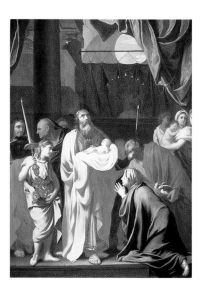

The Village Piper

1642; Antoine Le Nain (French, ca. 1588–1648); Oil on copper; 21.3 x 29.2 cm (8 3/8 x 11 1/2 in.); City of Detroit Purchase; 30.280

Modern scholarship has revealed that there is no sufficient information to differentiate between the works of the three Le Nain brothers, Louis, Antoine and Mathieu, and prefers instead to consider their work thematically under the surname of Le Nain. This small painting on copper illustrates one of the themes for which the Le Nain brothers were famous: a genre scene without a specific narrative content representing a street musician surrounded by urchins. The subject is surprising if one considers French painting of the 17th century primarily as the reflection of the grandiose taste of the royal court. Such intimate works were nevertheless executed in response to a growing demand from an appreciative middle-class clientele.

The dignified composition of this painting eloquently demonstrates the young French artist's successful attempt at mastering the classical qualities of art he had seen in Rome during a stay there from 1642 until 1645. This large altarpiece was painted for the chapel of the Hôtel-Dieu, a hospital in Lyons, where Le Brun stopped on his way back to Paris. The hieratic figures are placed conventionally in front of architecture. The depiction of emotion is replaced by an elegant balance of statuesque figures depicted with notes of vigorous realism.

Le Brun's influence and aesthetic decisions dominated the arts under Louis XIV's rule due to his influential position as painter to the king, director of the French Academy, and director of the Gobelins manufactory.

Christ at the Column

1754; Franz Ignaz Günther (German, 1725–75); Polychromed lindenwood, wrought iron, parchment; height 74.4 cm (25 3/8 in.); Founders Society Purchase, Acquisitions Fund; 1983.13

Günther was the greatest sculptor in 18th-century Bavaria. This figure is impressive for its spiritual expression, lifelike movement, and smoothly painted pearlescent surface. The faceted planes of the drapery reflect a flickering pattern of light across the surface, further animating the figure. Günther's sensitive modeling is especially evident in Christ's face. Painted on the underside of the base in sepia are Günther's initials and date: "1754:F:I:G:," indicating that it was made the year Günther was appointed court sculptor to the Bavarian Electorate.

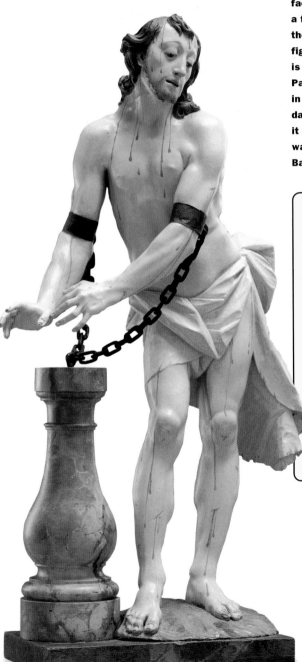

This piece is a variant of a German folk sculpture of the scourged Christ, believed to shed real tears. The miraculous image became the object of a flourishing pilgrimage to the Wieskirche in Bavaria and was copied in engravings and sculpture. Günther's version reinterprets the model with a feeling of exaltation and passion.

German Porcelain

Founded in 1710, Meissen (near Dresden) was the first European factory to produce hard-paste porcelain, in imitation of the Chinese and Japanese ceramics imported by the East India companies. Porcelain fires at extremely high temperatures to a glassy translucency; it can be molded or cast in complex shapes and decorated in a brilliant range of colors. Meissen's monopoly in Germany was not broken until the late 1740s, when other German porcelain centers began to spring up under princely patrons.

Teapot

1723–24; Meissen manufactory, decorated by Johann Gregor Höroldt (German, 1696–1775); Hard-paste porcelain with colored enamel decoration and gilding, silver-gilt mounts; height 13.5 cm (5 3/8 in.); Bequest of Ruth Nugent Head, in memory of Anna E. Kresge and Henry W. Nugent Head, and City of Detroit, by exchange; 1992.43

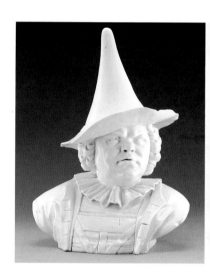

The introduction of chinoiseries at Meissen coincided with the arrival of the painter Johann Gregor Höroldt in 1720. At the request of Meissen's patron, Augustus the Strong, Höroldt imitated the decoration of Japanese porcelain, though in the form of whimsical chinoiseries rather than slavish copies.

As on this teapot, Höroldt portrayed fanciful Chinese figures engaged in daily activities, such as hunting or making tea, within atmospheric landscapes. Framing the scenes are elegant scroll-work cartouches of gilding and iron-red and luster enamels. Exotic flowers copied from Japanese Kakiemon porcelains are scattered over the remaining surface of the teapot. Höroldt's design sketchbook (the *Schulz Codex*) was the primary source for Meissen's decorators during the height of chinoiserie at the factory, ca. 1720–40.

Asian Influences

Europeans in the 18th century made little distinction between the arts of China, Japan, Korea, and India, often combining elements of each in what later became known as "chinoiseries."

The Chinese Emperor

Modeled in 1765; Höchst manufactory, Mainz, by Johann Peter Melchior (German, 1747–1825); Hard-paste porcelain with colored enamel decoration and gilding; height 40.3 cm (15 7/8 in.); Gift of James S. Holden in memory of his mother, Mrs. E. G. Holden; 51.59

The chief modeler at Höchst from 1765 was Johann Peter Melchior, whose first work for the factory was this rare group. A Chinese emperor sits enthroned beneath a fanciful bell-fringed baldachin, with emblems of the arts—painting, sculpture, music, and architecture— scattered on the steps before him. In attendance are a courtier, an artist, who originally held a scroll with pseudo-Chinese writing, and a poet wearing a laurel wreath. While the theme of "the prince" as a patron of the arts dates back to the Renaissance, Melchior here translated it into a fashionable rococo chinoiserie fantasy.

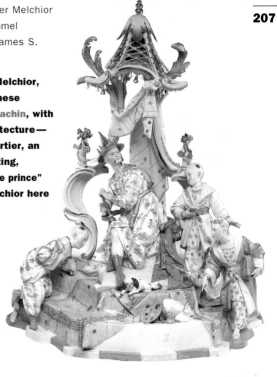

Joseph Fröhlich, Court Jester of Augustus the Strong

ca. 1729–30; Meissen manufactory, Johann Gottlieb Kirchner (German, active at Meissen 1727–33); Hard-paste porcelain; height 50.8 cm (20 in.); Gift of Mr. and Mrs. Henry Ford II; 59.295

Postmaster "Baron" Schmiedel

ca. 1739; Meissen manufactory, Johann Joachim Kändler (German, 1706–75); Hard-paste porcelain; height 47.6 cm (18 3/4 in.); Gift of Mr. and Mrs. Henry Ford II; 59.296

In 1722 Augustus the Strong, Elector of Saxony, undertook an ambitious scheme to transform a Dresden residence into a "palace of porcelain." Renamed the "Japanese Palace" in honor of his immense collection of Asian ceramics, the palace was intended to display Meissen porcelain as well. For a 270-foot-long gallery, Augustus commissioned from Meissen monumental animal and bird sculptures, large painted vases, and architectural elements such as door frames and a small chapel.

Given this demanding task, Meissen hired its first chief modeler, Johann Gottlieb Kirchner, in 1727. Kirchner's early models for the Japanese Palace, such as the life-size bust of Saxon court jester Joseph Fröhlich, explored the technical limits of porcelain as a sculpture medium. A decade later, his successor Johann Joachim Kändler completed a companion portrait of jester "Postmaster" Schmiedel. In their expressive features and vigorous modeling, these baroque busts demonstrate Kirchner's and Kändler's artistic mastery.

In 18th-century France, the magnificence of the table revealed as much about an individual's position as did his or her homes, clothes, and other property. Large and elaborate dinner services of silver or porcelain were arranged on the table for impressive decorative effect. The number of courses and rarity of the foodstuffs further enhanced a host's reputation. Voyages of discovery and expanded trade introduced new vegetables, fruits, game, and fish to the tables of the upper classes.

Tureen

ca. 1750–55; Hannong manufactory, Strasbourg; Tin-glazed earthenware (faience); height 47.6 cm (18 3/4 in.); Founders Society Purchase, Mrs. Edsel B. Ford Fund; 65.25

During the 18th century tureens ceased to be mere vessels for the service of soup, stew, or sauce and became masterpieces of sculpture and trompe-l'oeil. Ceramic factories often modeled tureens in the form of game birds, ranging from a small partridge three inches wide to this life-size turkey. These clever table wares epitomized the 18th century's love of nature and novelty.

Tureen from the Orléans-Penthièvre Service

1733–34; Thomas Germain (French, 1673–1748); Silver; 25.4 x 56.5 x 39.3 cm (10 x 22 1/4 x 15 1/2 in.); Gift of Elizabeth Parke Firestone; 59.18

Silversmith to King Louis XV, Thomas Germain stands out among his contemporaries for the originality and quality of his exuberant rococo silver. His work exemplifies the earliest and most imaginative phase of the rococo style, marked by an abundance of extravagant curves and fantastic ornament. One of his masterpieces, this tureen is part of a large dinner service ordered by Louis-Alexandre de Bourbon, comte de Toulouse (1678–1737) from 1727, and financed by his son, the duc de Penthièvre (1725–93). Called the "Boars's Head Tureen" after the animals' heads and forelegs at either end, this tureen is modeled with three-dimensional vegetables, crustaceans, and game, all cast from life for extraordinary naturalism. Surviving nearly complete, the service provides a rare glimpse into the splendor of the dining tables of the French court during the first half of the 18th century.

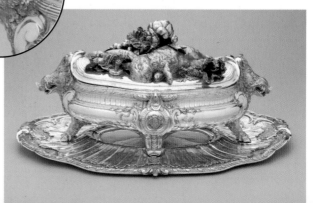

Still Life

ca. 1732; Jean-Siméon Chardin (French, 1699–1779); Oil on canvas; 16.8 x 21 cm (6 5/8 x 8 1/4 in.); Bequest of Robert H. Tannahill; 70.164

Chardin was already famous by 1730 when he started painting small still lifes of kitchen utensils. In this work, the artist pared down the elements to a few, simple objects. Chardin typically used the same elements in other compositions, varying slightly the position of the objects or adding or subtracting a utensil. Hailed as a visionary artist, Chardin is nonetheless rooted in the art of 18th-century France and the metaphysical quality of his compositions (as seen through modern eyes) does not mean that they are timeless. They bring the viewer instead into an earthly world and into the creative process of one of the greatest French painters of all time.

Please Do Not Touch

It is reported that at the Salon of 1725, the public kept touching one of Desportes's works to make sure that there was only paint on the canvas.

Still Life (Summer)

1711; Alexandre-François Desportes (French, 1661–1743); Oil on canvas; 1.4 x 1.1 m (56 3/4 x 44 1/2 in.); Founders Society Purchase, Elizabeth L. Heavenrich Bequest Fund, Mr. and Mrs. Benson Ford Fund, Eleanor Clay Ford Fund; 65.393

Although still life was regarded as a lesser genre in 18th-century France, Desportes and Chardin, as well as a few other painters, specialized in this field. Acclaimed for their realism, these paintings were often part of decorative schemes. It is probable that this still life of summer vegetables and fruits formed part of such a decoration—perhaps representing the four seasons.

For another painting of the seasons, see pages 131–132.

THE ART OF DINING

EUROPEAN ART

DIA

Deprive France, and especially its capital, of luxury, and you will kill a large part of its trade; what is more, you will deprive it of much of its supremacy in Europe. Baroness d'Oberkirch, *Mémoires*, 1782

The 18th century's quest for luxury and novelty led the decorative arts to high levels of refinement and technical virtuosity by the beginning of the French Revolution in 1789.

Pedestal Clock

ca. 1720–25; Case attributed to André-Charles Boulle (French, 1642–1732); Oak, veneered with tortoiseshell and brass; gilt bronze; enamel; height 2.8 m (9 ft. 2 1/2 in.); Founders Society Purchase, Mr. and Mrs. Horace E. Dodge Memorial Fund, Josephine and Ernest K. Kanzler Founders Fund, and J. Lawrence Buell, Jr., Fund; 1984.87

This monumental clock is one of four early 18th-century "Clocks of the Four Continents," so-named because of the sumptuous gilt-bronze half-length figures—representing Africa, Europe, Asia, and America—surrounding the face. A gilt-bronze plaque on the pedestal shows Hercules relieving Atlas of the weight of the world. The case and pedestal are attributed to André-Charles Boulle, who popularized the technique of tortoiseshell and metal marquetry at the French court. The enameled plaque below the dial is inscribed "Julien Le Roy," who provided the works for the clock.

An unusual feature of this clock is its self-lengthening hour hand which extends as it nears the top and bottom of the oval dial.

Toilet Service

1738–39; Sebastien Igonet (French, active 1725–66), Antoine LeBrun (1664–1758), Alexis Loir III (active 1733–55), Etienne Pollet (1695–1766); Silver, glass, hair; mirror height 66 cm (26 in.); Founders Society Purchase, Elizabeth Parke Firestone Collection of Early French Silver Fund; 53.177–.192

The third duke of Cadaval of Portugal ordered this nineteen-piece toilet service for the French princess Henriette of Lorraine on the occasion of their marriage in 1739. The only complete French toilet set to survive from the first half of the 18th century, it includes mirror, ewer and basin, candlesticks, jewel boxes, clothes brush, pin cushion, among other articles.

The royal silversmith Thomas Germain (1673–1748) may have designed this elegant toilet set, actually fabricated by four lesser-known Parisian silversmiths. Commissioned by one of the most important lords of Portugal, the set represents the quality and luxury of the toilet services made for the French court during the first half of the 18th century and later melted down or dispersed.

Pair of Pot Pourri Vases and Covers

1761; Sèvres manufactory, France; Decorated by Charles-Nicolas Dodin (French, 1734–1803); Soft-paste porcelain; height 29.2 cm (11 1/2 in.); Bequest of Anna Thomson Dodge; 71.246–.247

This pair of pot pourri vases, probably purchased by King Louis XV in December 1762, demonstrates the highest achievements in porcelain production in 18th-century Europe. Pot pourris, available in a wide variety of materials and shapes, were a ubiquitous feature of the 18th-century interior. Designed both as pot pourris and as bulb pots, these rare models represent the rococo's fondness for complex and novel forms. The front of each vase depicts a scene of Chinese life based on engravings after François Boucher.

Chest of Drawers

1783; Jean-Henri Riesener (German, active in Paris, 1734–1806); Oak, veneered with amaranth, tulipwood, holly, and ebony; gilt bronze; marble; height 92.7 cm (36 1/2 in.); Bequest of Anna Thomson Dodge; 71.194

This chest of drawers (commode) is one of four that were in the apartment of Madame Elisabeth, the younger sister of King Louis XVI at Fontainebleau. As the official cabinetmaker to Louis XVI from 1774 to 1785, Jean-Henri Riesener supplied the French crown with hundreds of pieces of case furniture—commodes, roll-top desks, secretaries, gaming tables, and other types—ranging from the plain and utilitarian to objects of extreme richness, and all in a refined neoclassical style.

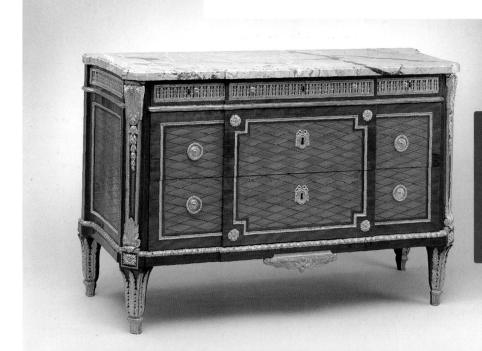

DIA EUROPEAN ART FRENCH DECORATIVE ARTS

Jewel Coffer

ca. 1774; Martin Carlin (French, ca. 1730–85); Oak, veneered with tulipwood, holly, amaranth, soft-paste Sèvres porcelain plaques, gilt bronze; height 94 cm (37 in.); Bequest of Anna Thomson Dodge; 71.196

This elegant jewel coffer is mounted with thirteen plaques of soft-paste Sèvres porcelain, custom-shaped to fit the form and decorated with turquoise blue borders and sprigs of vibrant pink roses. Sèvres-mounted furniture came into fashion around 1760, at first as small, portable tables and later in more complex forms, including jewel coffers, secretaries, and commodes.

This is one of eight nearly identical jewel coffers made by cabinetmaker Martin Carlin during the 1760s and early 1770s. The innovative Parisian merchants and entrepreneurs Poirier and Daguerre in turn sold them to an elite clientele, including Madame du Barry and Queen Marie-Antoinette. This coffer belonged to Maria Feodorovna, wife of the future Czar Paul I; by 1795 it was in her apartments at Pavlovsk Palace, outside of Saint Petersburg.

Made for a lady's apartment, this jewel coffer also served as a desk for personal correspondence. The drawer of the stand was originally fitted with a velvet-covered writing slide and compartments for writing implements. The locked coffer above contains seven stacked trays, each to hold a matched set of jewelry.

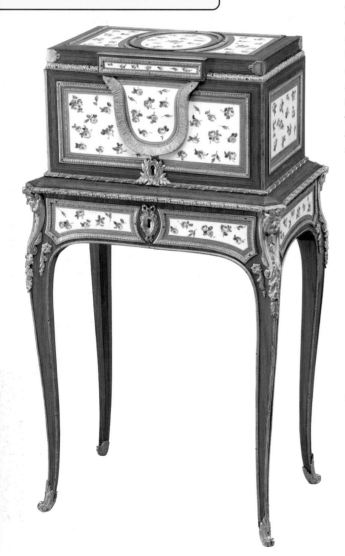

For a view of Pavlovsk Palace, see page 214.

Delivered to the aunts of King Louis XVI, Mesdames Adelaïde and Victoire, on July 15, 1786, this mantel clock contains three separate mechanisms and enameled dials to indicate the time of day, the phase of the moon, and the date and month of the year.

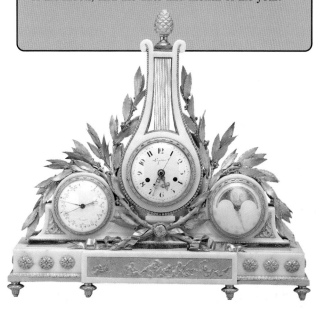

Candelabrum

ca. 1775; Design attributed to Charles-Louis Clérisseau (French, 1721–1820); made by Jean-Claude-Thomas Chambellan, called Duplessis *fils* (French, ca. 1730–83); Gilt and *gros-bleu* enameled bronze; height 1.5 m (59 in.); Founders Society Purchase, Mr. and Mrs. Horace E. Dodge Memorial Fund; 71.394

One of a pair of large candelabra, this exemplifies the exquisite refinement and technical virtuosity of the neoclassical period in France. Borrowing heavily from ancient models, the designer combined female caryatids, flame finials, acanthus leaves, and classical ornament into highly finished sculptural masterpieces.

The candelabra closely resemble a set of four designed around 1775 by the prominent neoclassical architect and draughtsman Charles-Louis Clérisseau for the salon of the Paris residence of the financier and collector Grimod de la Reynière. Architects in the 18th century frequently provided designs for interiors, especially the carved paneling, mantelpieces, furniture, and lighting; these in turn were created by specialized craftsmen in various guilds.

Mantel Clock

1786; Case attributed to Etienne Martincourt (French, died after 1791), movement by Claude-Pierre Raguet, called Lépine (French, 1753–1810); Marble, gilt bronze, enamel, and glass; height 63.2 cm (24 7/8 in.); Bequest of Mrs. Horace Dodge; 71.215

Astronomical clocks were a specialty of Lépine. One of the most innovative Parisian clockmakers, he supplied unique and elaborate clocks to the French court and to foreign clients, including Marie-Antoinette, Louis XVI's brother, and the king of Spain. The finely chased gilt-bronze laurel branches, ribbons, lyre, pine cone finial, and bas relief of putti playing musical instruments represent the unprecedented refinement of French design at the end of the 18th century.

Pair of Wine Coolers

ca. 1817; Jean-Baptiste-Claude Odiot (French, 1763–1850);
Silver gilt; height 36.8 cm (14 1/2 in.); Gift of Mrs. Roger Kyes
in memory of her husband; 71.296–.297

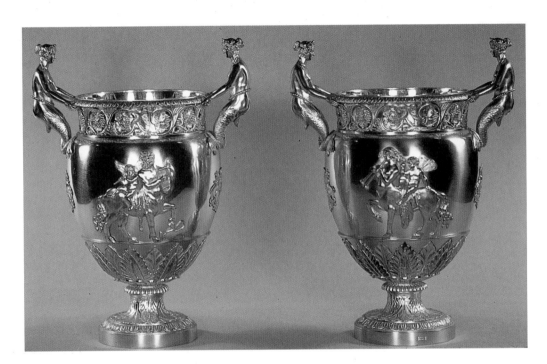

These coolers were originally part of a 119-piece dinner
service delivered by the Odiot firm to Count Nikolai Demidoff,
a Russian prince living in Paris, in 1817 and 1818. The favorite
silversmith of Napoléon I and later official orfèvre (goldsmith)
to King Louis XVIII, Odiot operated the most important silver-
smithing workshop in Paris in the first half of the 19th century,
patronized by a distinguished French and foreign clientele.
The form of these wine coolers is borrowed from the classical
krater, a two-handled vessel used to mix
water and wine in ancient Greece and Rome.

For a Greek krater, see page 112.

Jean-Baptiste-Claude Odiot

1822; Robert-Jacques-François Lefévre (French,
1775–1830); Oil on canvas; 157 x 123 cm
(62 x 48 3/8 in.); Founders Society Purchase,
Robert H. Tannahill Foundation Fund; 81.692

Portrait of the artist.

Ordered for Joseph,
archduke of Austria,
and Princess Alexandra
Pavlovna, daughter
of Czar Paul I, the tea set
commemorates the
summer spent at Pavlovsk
Palace following their
wedding in 1799.
The monogram of the
bridal couple appears
on the sugar bowl.

Tea Set for Two (Tête-à-tête)

ca. 1799–1804; Imperial
Porcelain Factory, Vienna;
Hard-paste porcelain with
colored enamel decoration
and gilding; height of cof-
feepot 13.7 cm (5 3/8 in.);
Founders Society Purchase
with funds from Visiting
Committee for European
Sculpture and Decorative
Arts; 1988.69

Under the direction of Konrad Sörgel
von Sorgenthal from 1784 until 1805, the
Imperial Porcelain Factory of Vienna
developed a unique style of decoration
based on a rich new palette of colors
(such as the *café au lait* ground used here)
and improved methods of gilding. The sim-
plified cylindrical shapes provided ideal
surfaces for painting the large landscape
views popular since the 1770s. Porcelain
decorators, now trained in art academies,
rivaled the finest painters of late 18th-
century Europe. Decorating this tea set are
miniature views of Pavlovsk Palace and
park, the summer residence near Saint
Petersburg of the Russian imperial family.

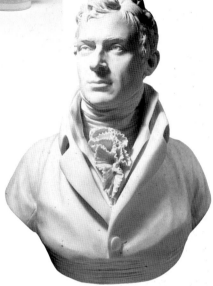

Robert Fulton

ca. 1804; Jean-Antoine Houdon (French,
1741–1828); Marble; height 59.1 cm (23 1/4
in.); Gift of Dexter M. Ferry, Jr.; 49.23

Houdon, the greatest French neoclassical
portrait sculptor, has captured the American
inventor's complex character—intelligent,
self-assured, energetic, and sensitive—
qualified perhaps by the merest trace
of discouragement, reflecting the problems
with his imperfect experiments, thus
far, with submarines and steam-powered
ships attempted off the French coast.
Fulton's strikingly handsome appearance
is reinforced by his austere yet elegant
French attire and fashionable hair style.
He was thirty-eight, an American living in
Paris, when he posed for the celebrated
French sculptor.

Houdon portrays Fulton's tenacity through
restrained modeling. The choice of Fulton
as a subject was consistent with Houdon's
admiration of men of science and diplomacy,
including such pre-eminent Americans as
Washington, Jefferson, and Franklin.

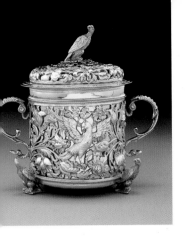

Sleeve Cup and Cover

ca. 1670; Attributed to Nicholas Woolaston (English, active late 17th century); Silver and silver gilt; height 19.1 cm (7 1/2 in.); Booth American Company Centennial Gift in memory of Ralph Harman Booth, President of the Detroit Museum of Art, Founding President Arts Commission and Detroit Institute of Arts; 1985.36

This cup is one of only twenty-five known examples of English sleeve cups, so-called because of the pierced sleeve encasing the cylindrical cup and lid. The silver gilt cup intentionally shows through the sleeve, creating a rich interplay of silver and gold. The sleeve, cast and chased in high relief, depicts eagles with outstretched wings surrounded by dense foliate scrolls. The unusual eagle feet and finial are found on only one other sleeve cup (now in the collection of the Worshipful Company of Goldsmiths, London).

Although the majority are not hallmarked, sleeve cups probably date to the reign of King Charles II (1660–85). These cups, masterpieces of the baroque silversmith's art, undoubtedly served as presentation gifts.

Mrs. Richard Paul Jodrell

1774–76; Sir Joshua Reynolds (English, 1723–92); Oil on canvas; 76.2 x 63.5 cm (30 x 25 in.); Bequest of Eleanor Clay Ford; 77.7

Vertue Jodrell was married in 1772 to her second cousin, the classical scholar and dramatist Richard Paul Jodrell. In a departure from normal practice, the couple commissioned their marriage portraits from professional rivals: his is by Thomas Gainsborough (Frick Collection, New York).

Bust of Isaac Ware

ca. 1741; Louis-François Roubiliac (French, active in England, ca. 1702–62); Marble; height 51.5 cm (20 1/4 in.) without base; Founders Society Purchase, Henry Ford II Fund, New Endowment Fund, and funds from A. Alfred Taubman; 1987.75

This life-size bust is a lively and informal characterization of Roubiliac's friend, the English architect Isaac Ware (ca. 1707-66). Ware's costume, especially the soft cap, loosely fitting jacket with frog closures, and the open linen shirt, is in the style worn by artists and virtuosi of the 1730s and 1740s. A French émigré trained in Dresden and Paris, Roubiliac executed a series of marble and terracotta busts of eminent artists and scholars in London, including the painters William Hogarth and Francis Hayman, the composer George Frideric Handel, the poet and satirist Alexander Pope, and the scientist Sir Isaac Newton.

The well-known architect Isaac Ware published *The Complete Book of Architecture* (1735) and a translation of Andrea Palladio's Renaissance treatise *The Four Books of Architecture* (1738) and was purveyor of His Majesty's Works from 1741, the approximate date of this portrait.

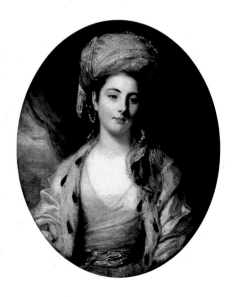

The Cottagers

1788; Sir Joshua Reynolds (English, 1723–92); Oil on canvas; 2.4 x 1.8 m (95 x 71 in.); Gift of Mrs. K. T. Keller; 55.278

"Fancy Pictures," which were a combination portrait and genre scene, became very popular at the end of the 18th century. One type consisted of middle-class patrons, dressed as peasants or farmers, in staged scenes of rural life. In this large canvas painted for Mr. Macklin, a London print seller, Reynolds represents his patron's wife spinning, his daughter feeding chickens, her friend Miss Potts carrying a sheaf of wheat on her head, and the family dog waiting attentively, all outside a country cottage. The grand scale, formal composition, poses, and coloration are all reminiscent of Italian painting, which Reynolds championed as first president of the Royal Academy, but the graceful light and sentiment are his personal invention.

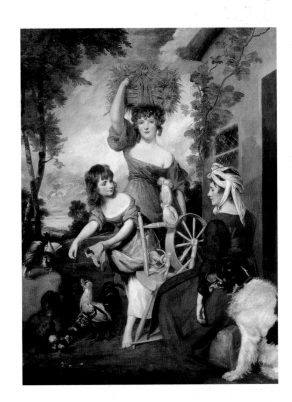

Scene from "Love in a Village"

1767; John Zoffany (English, 1733–1810); Oil on canvas; 1 x 1.3 m (40 x 50 in.); Gift of Mr. and Mrs. Edgar B. Whitcomb; 47.398

Zoffany may be considered one of the English theater's earliest historians, for he documented the dramas of his time. Instead of simply posing actors in costume, he informally arranged them on the stage

as if during the course of a performance, producing a variation on the popular group portrait style called a "conversation piece." Isaac Bickerstaffe's "Love in a Village" opened at Covent Garden on December 8, 1762, with Edward Shuter, John Beard, and John Dunstall in the cast. Zoffany depicts Beard pronouncing the character's motto: "Health, good humour, and competence." It is unlikely that the subject of the painting on the back wall, the Judgment of Solomon, has any implications for the action: in another version of this scene, the painting is Van Dyck's *Children of Charles I.*

The imagery of the late 18th century often shows a fascination with the bizarre and fantastic, as can be seen here in three paintings of swooning women. To paint a portrait or landscape, the artist usually conveys an image of a shared reality, but painting a dream, fantasy, or a scene from a myth or poem is in some ways more personal and presents different challenges.

The Nightmare

1781; Henry Fuseli (Swiss, 1741–1825); Oil on canvas; 1 x 1.3 m (40 x 50 in.); Gift of Mr. and Mrs. Bert L. Smokler and Mr. and Mrs. Lawrence A. Fleischman; 55.5

Being in the grips of a nightmare is a common occurrence that we can all relate to, but we may never experience one exactly as a particular artist depicts it. Here Fuseli conjures up a terrifying image filled with mystery, panic, and yet with a vague and disturbing familiarity. It suggests the way the woman feels in the grip of a demonic nightmare, not what she sees. *The Nightmare* was reproduced as an engraving; a copy hung in Sigmund Freud's apartment in Vienna in the 1920s.

Echo

Echo was a nymph who entertained the goddess Hera, the wife of Zeus, with long stories so that Zeus could pursue other nymphs. Hera punished Echo by making her body disappear and condemning her voice only to repeat words spoken by others.

Echo Flying from Narcissus

ca. 1795–98; Guy Head (English, 1753–1800); Oil on canvas; 2 x 1.5 m (6 ft. 6 3/4 in. x 4 ft. 11 in.); Founders Society Purchase, Acquisitions Fund; 78.70

Guy Head illustrates a story from Greek mythology, showing us the full-figured Echo floating weightlessly against a meticulously painted ideal landscape. She is leaving this beautiful world, soon to become only a voice.

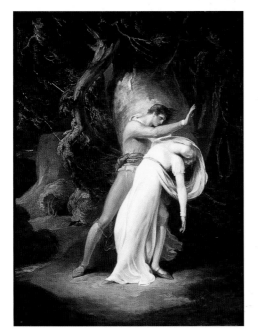

Celadon and Amelia

1793; William Hamilton (English, 1751–1801); Oil on canvas; 1.5 x 1.2 m (60 3/4 x 48 1/2 in.); Founders Society Purchase, by exchange; 68.159

Hamilton chose an English nature poem, "The Seasons," as the subject of this romantic painting. In the section on Summer, the poem tells of the young lovers Celadon and Amelia, a perfect couple who were caught in a summer storm. Amelia was overcome by the powerful force of the tempest and died in the arms of her horrified and distraught lover.

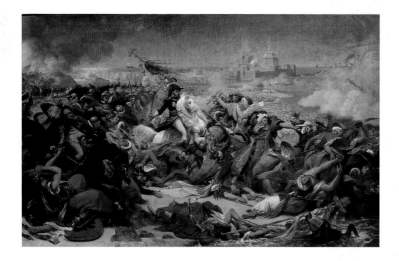

Murat Defeating the Turkish Army at the Battle of Aboukir

1805–06; Baron Antoine Jean Gros (French, 1771–1835); Oil on canvas; 88.37 x 138.4 cm (34 3/4 x 54 1/2 in.); Founders Society Purchase with funds from Mr. and Mrs. Edgar B. Whitcomb; 49.337

The Romantic spirit of battle, victory, and death captivated Baron Gros. Here the French army of Napoleon, while vastly outnumbered, defeats the Turks in a violent battle near the coast of Egypt. The Turkish pasha offers his sword to the French general amidst a scene of bloody destruction. This is a sketch for a larger, final painting now in Versailles; its quick execution conveys excitement with great immediacy.

Tiger Devouring a Gavial of the Ganges

1831; Antoine Louis Barye (French, 1796–1875); Patinated plaster; height 43 cm (17 in.); Founders Society Purchase, Mr. and Mrs. Horace E. Dodge Memorial Fund, and Eleanor Clay Ford Fund; 1983.11

Barye was a keen observer of the natural behavior of animals. Here he treats the Romantic subject of a struggle to the death in the animal kingdom. In startling anatomical detail he portrays the victor and the vanquished not only as an allegory of life and death but as an accurate rendition of exotic animals and their behavior.

This is the original plaster exhibited by Barye in Paris in 1831 that launched his reputation.

Le Génie de la Danse

ca. 1872; Jean Baptiste Carpeaux (French, 1827–75); Plaster; height 2.2 m (7 ft. 2 3/4 in.); Gift of Mr. and Mrs. Allan Shelden III Fund; 1983.16

This personification of the Spirit of Dance leaps exuberantly upward, shaking a tambourine. It is modified from a larger relief sculpture created for the exterior of the celebrated elaborate opera house that opened in Paris in 1869. When it was unveiled, the public was shocked at the figure's wild, unclothed abandon, which violated contemporary standards of decent public behavior.

"It is clear from these sculptures that emotions can at times be more powerfully expressed in three dimensions than they are in two."

Samuel Sachs II, Director

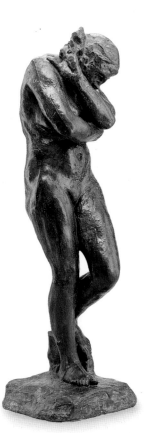

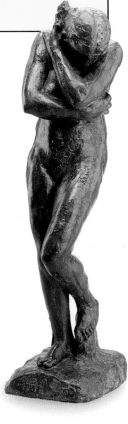

Eve

1881; Auguste Rodin (French, 1840–1917); Bronze; height 1.7 m (68 1/2 in.); Founders Society Purchase, General Membership Fund; 53.145

Here we see a personal and private expression of emotion in an intensely felt interpretation of Eve's shame and modesty. The life-size bronze figure turns in on herself and is closed, still, and rooted in the earth. Like the *Thinker,* Eve was one of the figures associated with the *Gates of Hell.*

For Rodin's *Thinker,* see page 312.

ROMANTIC ART

DIA EUROPEAN ART

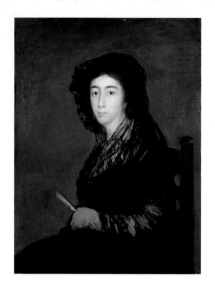

In 19th-century painting women are seen in many different roles, from remote goddesses to intense individuals, innocent girls to seductresses.

Perseus and Andromeda

ca. 1819; Jean-Auguste-Dominique Ingres (French, 1780–1867); Oil on canvas; 19.6 x 16.1 cm (7 3/4 x 6 3/8 in.); Bequest of Robert H. Tannahill; 70.170

Ingres's vulnerable figure of Andromeda is the "classic" idealized figure study. The fact that she is being rescued by Perseus, the hero of Greek mythology, from

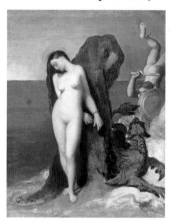

a horrible death in the fangs of a dragon is less important than her sublime and innocent beauty. The tight control of the paint and smooth surfaces, as well as the subject matter, attest to the position Ingres held as the champion of neoclassicism in France.

For a drawing by Ingres, see page 244.

Doña Amalia Bonells de Costa

ca. 1805 and ca. 1813; Francisco Goya (Spanish, 1746–1828); Oil on canvas; 87.3 x 65.4 cm (34 3/8 x 25 3/4 in.); Founders Society Purchase, Ralph Harman Booth Bequest Fund; 41.80

Goya, a powerful Spanish portraitist, shows us an alert, personable, and intelligent woman, poised in her chair. X-rays reveal that Doña Amalia was originally painted wearing a brightly colored embroidered dress and with roses affixed to her mantilla. When her father died eight years later, the artist was asked to repaint her clothes to show her in the black garb of mourning.

Bather Sleeping by a Brook

1845; Gustave Courbet (French, 1819–77); Oil on canvas; 81.2 x 64.7 cm (32 x 25 1/2 in.); City of Detroit Purchase; 27.202

The matter-of-fact presentation of a nude model resting by a stream in a quickly brushed landscape suggests both Courbet's erotic approach to the female subject

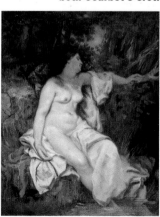

in nature as well as his self-proclaimed realism in the somewhat awkward figure itself. In sleep she is unaware of the viewer, who need not be self-conscious in her presence.

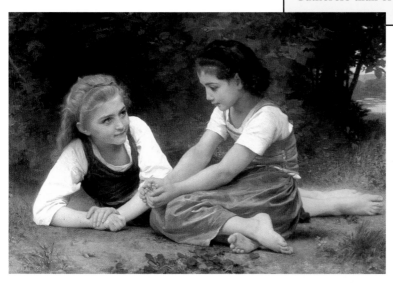

The Nut Gatherers

1882; William Adolphe Bouguereau (French, 1825–1905); Oil on canvas; 87.6 x 134 cm (34 1/2 x 52 3/4 in.); Gift of Mrs. William E. Scripps; 54.458

Bouguereau shows us two innocent girls posing in a glade, unaware of the dangers of life. The fresh faces, smooth skin, and bare feet remind us of the vulnerability of youth and of that privileged world of simple pleasures and intense youthful friendship before the responsibilities of adult life begin. Bouguereau was a teacher who upheld traditional values in painting at the Académie des Beaux Arts in Paris.

Woman in an Armchair

1874; Pierre-Auguste Renoir (French, 1841–1919); Oil on canvas; 61 x 50.5 cm (24 x 19 3/4 in.); Bequest of Mrs. Allan Shelden III; 1985.24

Renoir's finished study of a woman has the quality of a sketch; his rapid brushstrokes describe the play of light across the model's face, arms, and torso. The identity of this sitter remains a mystery.

For another painting by Renoir, see page 235.

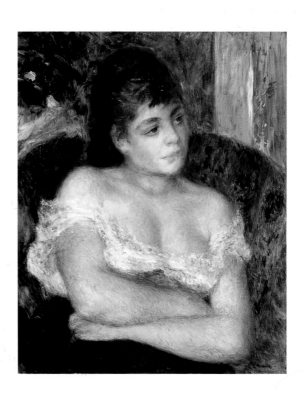

WOMEN

EUROPEAN ART

DIA

The varied approaches of 19th-century artists to landscape painting provide insight into their enjoyment of the natural world. While some artists painted to capture nature's myriad components in detail, others sought to recreate its atmospheric conditions, fleeting impressions, or to grasp its eternal essence.

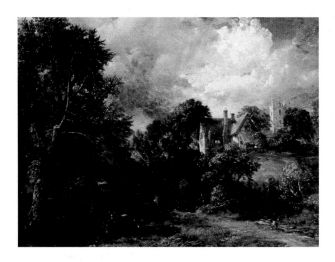

The Glebe Farm, Dedham

1827; John Constable (English, 1776–1837); Oil on canvas; 46.4 x 59.7 cm (18 1/4 x 23 1/2 in.); Gift of Mrs. Joseph B. Schlotman; 64.117

The English painter John Constable was known for his intense interest in the English countryside and its changing atmospheric conditions. The rich, moist greenery of *The Glebe Farm* and its tranquil vistas show why his work was admired by the French Impressionists, who followed Constable's example and also began to paint outdoors.

View of Le Crotoy, Upstream

1889; Georges Seurat (French, 1859–91); Oil on canvas; 70 x 86.7 cm (27 1/2 x 34 1/8 in.); Bequest of Robert H. Tannahill; 70.183

Seurat's unique style of painting (called pointillism, divisionism, or neo-impressionism) was based on scientific theories of how the optical nerve transmits juxtaposed colors to the brain. Seurat painted a border of complementary colors along the edge of the canvas to act as a transition for the darker values painted on the adjoining wooden frame. These dark edges help the painting appear more luminous against the frame, which was designed specifically by the artist to be visually unobtrusive to the image.

The Back Garden

ca. 1850–60; Adolph von Menzel (German, 1815–1905); Oil on canvas; 48 x 68 cm (18 7/8 x 26 3/4 in.); Founders Society Purchase, Robert H. Tannahill Foundation Fund, and Mr. and Mrs. Allan Shelden III Fund; 1991.172

This humble everyday subject, meticulously painted, may be a view from the artist's studio in Berlin. Here, Menzel elected to represent human beings only obliquely, through the traces of their activity: a vegetable garden to supply the kitchen, the red postbox on the fence, the drying laundry. Of particular originality are the unusual viewpoint adopted by the artist and the cropping of the image, so that the whole composition appears to be a fragment as informal as a snapshot.

Mont Sainte-Victoire

ca. 1904–06; Paul Cézanne (French, 1839–1906); Oil on canvas; 55.6 x 46 cm (21 7/8 x 18 1/8 in.); Bequest of Robert H. Tannahill; 70.161

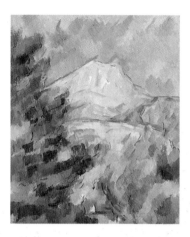

Cézanne often painted Mont Sainte-Victoire, a massive limestone mountain located about ten miles from his home in the south of France. The artist suggested distance only by juxtaposing warm and cold colors. He further diminished the sense of spatial depth by depicting the image in patches of color of equal size and intensity. With all portions of the surface equally handled, there is no sense of the time of day nor, for that matter, of time passing.

Gladioli

ca. 1876; Claude Monet (French, 1840–1926); Oil on canvas; 60 x 83 cm (22 x 32 1/2 in.); City of Detroit Purchase; 21.71

Monet's garden at Argenteuil near Paris provided the subject matter for this painting: a flower bed of tall gladioli shimmering in the light. The figure standing under an umbrella is the artist's wife, Camille, enjoying a leisurely stroll. Rather than being the focal point of the painting, she is merely a figure used to define the space. The flower bed itself dominates the composition. Using thick, short brushstrokes that appear as dabs at close range but synthesize at a distance and juxtaposing red and pink blossoms against green foliage, Monet simulates the shimmering visual sensations experienced on a hot summer day.

The most successful portraits always suggest the personalities of the sitters as well as their physical characteristics. The two self portraits here allow us to see how Van Gogh and Gauguin portray themselves; the images of the Postman Roulin and Madame Cézanne reveal two different attitudes toward favorite subjects of the artists.

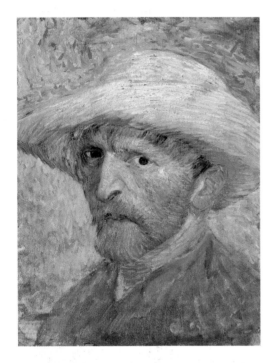

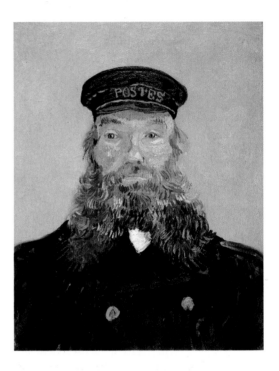

Self Portrait

1887; Vincent van Gogh (Dutch, 1853–90); Oil on canvas; 34.9 x 26.7 cm (13 3/4 x 10 1/2 in.); City of Detroit Purchase; 22.13

"For want of a better model," Van Gogh chose to paint his own portrait on many occasions. While in Paris between 1886 and 1888, Van Gogh lightened his palette under the influence of the brilliant colors of the Impressionists, but he soon reserved the use of such light colors to express particular moods. Van Gogh's stay in Paris was a relatively happy one and in this painting, created during the summer of 1887, he portrays himself with an almost light-hearted appearance.

Portrait of Postman Roulin

1888; Vincent van Gogh (Dutch, 1853–90); Oil on canvas; 65 x 50.5 cm (25 5/8 x 19 7/8 in.); Partial and promised gift of Mr. and Mrs. Walter B. Ford II; T1992.29

In February 1888 Van Gogh moved to Arles, in the south of France, and continued to paint landscapes and portraits. Between late July 1888 and April 1889, he painted at least six portraits of Joseph-Etienne Roulin (1841-1903), a postman in Arles. Here, the artist concentrated on Roulin's head, which he described in a letter as "somewhat like Socrates, hardly any nose at all, a high forehead, bald crown, little gray eyes, bright red chubby cheeks, a big pepper-and-salt beard, large eyes."

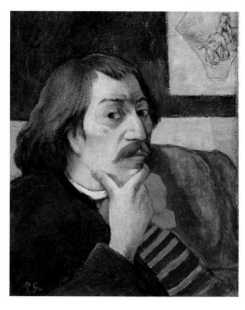

Self Portrait

ca. 1893; Paul Gauguin (French, 1848–1903);
Oil on canvas; 46.2 x 38.1 cm (18 1/8 x 15 in.);
Gift of Robert H. Tannahill; 69.306

Gauguin exemplified the restless artistic spirit.
In this image, painted during a brief return to
Paris from Tahiti in 1893, he plays the role
of "outsider," wearing the clothes and long hair
of a Breton peasant rather than the suit of a
Parisian. The background is divided horizontally,
separating a cerebral and spiritual world from
a physical and material one. His hand points
toward a reproduction of a sketch by the painter
Eugène Delacroix representing Adam and Eve
expelled from Paradise. With this
gesture Gauguin alludes to
his sympathies for the
distraught couple, for he
was temporarily expelled
from the paradise he
had discovered in Tahiti.

Portrait of Madame Cézanne

ca. 1886; Paul Cézanne (French, 1839–1906);
Oil on canvas; 101 x 81.3 cm (39 3/4 x 32 in.);
Bequest of Robert H. Tannahill; 70.160

Cézanne painted more than two dozen portraits of
his wife, Hortense, whom he first met in 1869 as a
nineteen-year-old model. Mme Cézanne's emotion-
less features, severely parted hair, folded hands,
plain dress, and conventional attitude make her
appear almost lifeless in this picture. Cézanne was
not interested in expressing the likeness or person-
ality of his wife, but in conveying his own artistic
personality through his original painting technique.

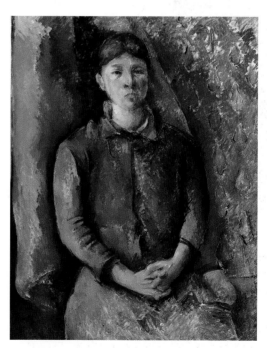

DETROIT CONNECTION

Who was Robert Hudson Tannahill?

Both paintings on this page and many
others came to the DIA from Robert Hudson
Tannahill. A nephew of the founder of
Hudson's department store, he also left a
large endowment fund which can only be
used to purchase works of art.

PORTRAITS

DIA EUROPEAN ART

Edgar Degas

Hilaire-Germain-Edgar Degas (French, 1834–1917) was an exceptionally productive artist who experimented with a wide range of media. His principal subjects were taken from contemporary life. Having been born into the wealthy and cultivated de Gas family (a name he quite early changed to disguise its aristocratic origin), the artist could afford to spend a great deal of time observing people at cafes, racecourses, and the theater.

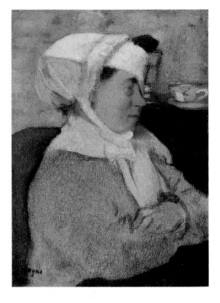

Violinist and Young Woman

ca. 1871; Oil and pastel on canvas; 46.4 x 55.9 cm (18 1/4 x 22 in.); Bequest of Robert H. Tannahill; 70.167

Music was a significant cultural component in 19th-century Parisian society. The informal clothes and the warm sunlight suggest that this is a rehearsal. The artist captures a moment when the musicians are interrupted and the woman turns as if searching for the source of the disturbance. The identities of the sitters are not known but the artist differentiates their characters very succinctly. The loosely drawn and frothily painted woman conveys the impression of surprise and slight apprehension while the more solidly drawn man is oblivious, immersed in the tuning of his instrument.

Woman with a Bandaged Head

1872–73; Oil on canvas; 32 x 24 cm (12 5/8 x 9 1/2 in.); Bequest of Robert H. Tannahill; 70.168

The tenderness of the portrait with its soft colors and the emphasis on the thick bandage seem to betray a certain sympathy that Degas felt for the sitter. Although the woman's identity is unknown, she may be Degas's sister-in-law Estelle Mousson, who began losing her vision in 1866. Degas visited his brother's family in New Orleans in 1872–73, which suggests a date for the work.

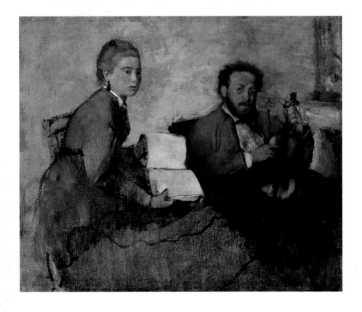

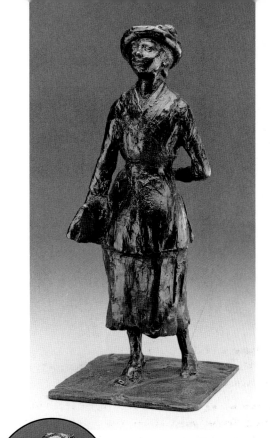

The Morning Ride

ca. 1865–69; Oil on canvas; 85.1 x 64.8 cm
(33 1/2 x 25 1/2 in.); Founders Society
Purchase, Ralph Harman Booth Fund; 48.279

The Morning Ride depicts a group of people
in contemporary dress riding along a beach near
a port in Normandy. The painting is unfinished,
which gives the viewer a unique insight into
Degas's working methods. In a traditional man-
ner, he first applied a preliminary drawing to
lay out the composition. The traces
of this procedure are still
readily visible in the painting.

The Schoolgirl

1881; Bronze; height 27.3 cm
(10 3/4 in.); Gift of Dr. and
Mrs. George Kamperman; 56.173

Although Degas is mainly known as a painter
he also produced a number of sculptures.
Their characteristic rough, almost "unfinished"
surface gives them a sense of tactile immediacy
and liveliness. As in his paintings, Degas was
interested in showing ordinary figures from
contemporary life. *The Schoolgirl* was probably
someone Degas had noticed in the street.

For other works by Degas, see pages 244–245.

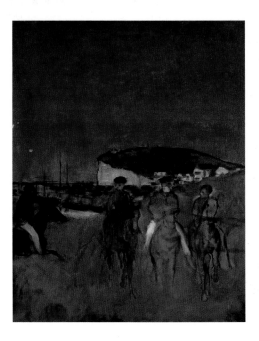

The Industrial Revolution led to the explosive growth of European cities and an increasingly large educated middle class, with leisure time to spend enjoying urban life.

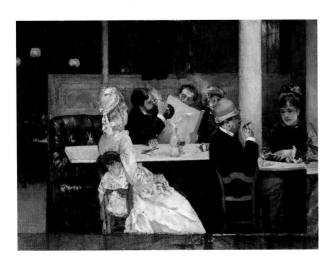

Cafe Scene in Paris

1877; Henri Gervex (French, 1852–1929); Oil on canvas; 100.5 x 136 cm (39 1/2 x 53 1/2 in.); Founders Society Purchase, Robert H. Tannahill Foundation Fund; 1992.8

Cafes provided an important meeting place for artists, writers, and intellectuals in the 19th-century city. News, gossip, and ideas were shared as drinks were poured and pipes, cigars, and cigarettes were smoked. Here the artist painted a group portrait of some of his friends in their neighborhood cafe; he represents himself as the man in the center lighting his pipe.

La Dépêche de Toulouse

1892; Maurice Denis (French, 1870–1943); Oil on canvas; 131 x 89 cm (51 3/4 x 35 in.); Founders Society Purchase, Robert H. Tannahill Foundation Fund; 1985.15

New technology allowed for inexpensive printing and the wide distribution of newspapers, books, and advertisements in the late 19th century. Maurice Denis created a poster advertising the newspaper *La Dépêche de Toulouse*. The owner of the paper was so pleased with the swirling excitement of the art nouveau styled poster that he asked Denis to create this painting as a larger and more permanent image to be hung in his office.

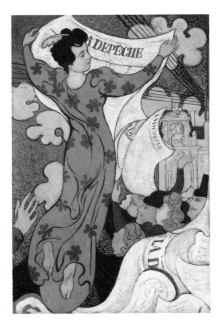

Georg Brandes at the University in Copenhagen

1889; Harald Slott-Møller (Danish, 1864–1937);
Oil on canvas; 92 x 81 cm (36 1/4 x 32 in.);
Founders Society Purchase, Robert H. Tannahill
Foundation Fund; 1991.1

The late 19th century saw the rapid growth and expansion of universities and colleges in Europe and America. Brandes was a charismatic, popular professor in Copenhagen, giving controversial lectures on the contemporary Symbolist movement in literature. Internationally famous, he was invited to lecture at the University of Michigan in Ann Arbor in the 1890s. The portrait shows Brandes elevated on his podium under bright lights with a dramatically simple realism.

Carrousel

1906; Witold Wojtkiewicz (Polish, 1879–1909);
Oil on canvas; 96 x 100 cm (37 7/8 x 39 3/8 in.);
Founders Society Purchase, Friends of Polish Art
Fund; 1988.63

Wojtkiewicz created visions of an unsettling world in which human beings are often reduced to puppets, acting out strange but somehow familiar parts. This painting shows an old couple at a holiday fair, a popular entertainment for country folk and city dwellers alike in the late 19th century.

URBAN LIFE

EUROPEAN ART

DIA

By the 19th century England had the largest industrial economy in the world. The resulting rapid growth of the middle class and weakening of class structure affected ideas about art and design. The Pre-Raphaelite, Aesthetic, and Arts and Crafts movements all stressed a return to the artistic values of pre-industrial times.

Leisure Hours

1864; John Everett Millais (English, 1829–96); Oil on canvas; 86.4 x 117 cm (34 x 46 in.); Founders Society Purchase, Robert H. Tannahill Foundation Fund; 78.59

Anne and Marion Pender were the daughters of Sir John Pender, a wealthy textile merchant from Glasgow. The girls' identical red velvet gowns and plush surroundings convey their affluence, yet one cannot help but feel that they are on display, not unlike the two fish in the bowl before them.

While a student at the Royal Academy in London, Millais co-founded the Pre-Raphaelite Brotherhood as an act of rebellion against the classicizing style of painting taught there. Ironically, *Leisure Hours* was painted just a year after he was elected to be a full member of the Royal Academy.

"Saint Bacchus" Sideboard

1858; Designed by William Burges (English, 1827–81); Stained, painted, and gilded wood, marble, iron; height 105 cm (41 1/2 in.); Gift of Mr. and Mrs. M. E. Cunningham; F82.50

The center panels of the sideboard in the Gothic Revival style are decorated with a tongue-in-cheek homage to the fictitious "Saint Bacchus," picturing the "saint" (named for the Roman god of wine) arguing with figures representing the nonalcoholic beverages of "Water, Ginger Beer, and Soda Water"; his martyrdom by being squeezed to death in a wine press; and finally, pilgrims venerating his earthly remains contained in a wine barrel. Heads representing alcoholic drinks, "Cyder," "Ale," "Sherry," and "Port," decorate the doors on either side, and a lively frieze of cats chasing mice embellishes the base of the cabinet.

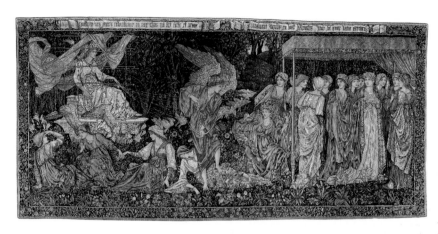

The Passing of Venus

1926 (designed 1901); Edward Burne-Jones (English, 1833–98); woven at the Merton Abbey Looms; Cotton, wool, silk; 2.7 x 5.9 m (8 ft. 11 in. x 19 ft. 3 in.); Gift of George G. Booth; 27.152

Designed in the tradition of medieval *millefleurs* tapestries, Burne-Jones depicts Venus riding on her chariot drawn by doves. Her son Cupid goes before her, drawing his bow as his foot rests on a prostrate woman; the three women to the left have already been vanquished by his arrows. A group of women to the right flee in terror from Cupid, who is looking in their direction.

For other works with Venus and Cupid, see pages 183 and 188.

Corner Cabinet

1873; Designed by Edward William Godwin (English, 1833–86), manufactured by Collinson and Lock, panels painted by Charles Fairfax Murray (English, 1849-1919); Rosewood, painted panels, brass; height 1.9 m (75 in.); Founders Society Purchase, European Decorative Arts Fund, Honorarium and Memorial Gifts Funds; 1985.1

The form of this corner cabinet reflects the simplicity and elegance of Chinese design, a source of inspiration, together with Japanese art, to many artists in the Aesthetic Movement. Depicted in the Pre-Raphaelite style in the central panel is Lucretia, a Roman matron whose suicide after being violated by the son of the king of Rome caused an uprising that resulted in Rome becoming a republic. Lucretia's virtues are inscribed in the halos of the two figures on side panels: CASTITAS (chastity) and FORTITUDO (courage).

DETROIT CONNECTION

George G. Booth, owner and publisher of *The Detroit News,* commissioned the Merton Abbey Looms in England to recreate a tapestry similar to one that had been destroyed by fire. He gave this to the DIA, where it was first exhibited in 1927.

19TH-CENTURY REFORM IN ENGLAND

DIA EUROPEAN ART

In the late 19th century, the nude human figure remained a popular subject for painters and sculptors across Europe, who used it to express pleasure in both the physical nature of the body and its deeper significance in conveying spiritual meaning.

Man with Water Sack

1897; George Minne (Belgian, 1866–1917); Plaster; height 70.8 cm (29 in.); Founders Society Purchase, Mr. and Mrs. Allan Shelden III Fund, and Henry Ford II Fund; 1986.48

The young man strains to pour water from a primitive knotted skin sack, his simple stance contrasts with the contorted pose of his arms and head. A sculptor associated with the Symbolist movement, Minne thus uses the body of the boy to suggest the awkwardness of adolescence.

Seated Bather

1903–06; Pierre-Auguste Renoir (French, 1841–1919); Oil on canvas; 116 x 89 cm (45 3/4 x 35 in.); Bequest of Robert H. Tannahill; 70.177

Late in his career, the Impressionist artist Renoir painted a series of opulent female nudes. The entire canvas is filled with warm light and soft colors, creating a luminous dreamlike atmosphere for the female nude, who lifts her hair in a gesture that is both intimate and timeless.

For another painting by Renoir, see page 223.

Study for Day

ca. 1898–99; Ferdinand Hodler (Swiss, 1853–1918);
Oil on canvas; 106 x 100 cm (42 x 39 1/2 in.);
Founders Society Purchase, Robert H. Tannahill
Foundation Fund; 1988.65

**This study of a figure showing a classical gesture
of awakening from sleep was made for a large
mural composition. In it, a group of five nude
female figures create an image of the renewal of
life at the break of each day. Like Minne, Hodler
was influenced by the Symbolist movement, which
reacted against the increasing secularism and
realism of the late 19th century.**

For a figure of Night, see page 288.

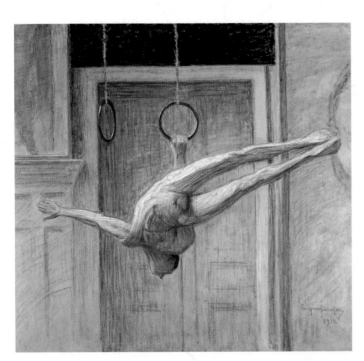

Ring Gymnast No. 2

1912; Eugene Jansson (Swedish,
1862–1915); Oil on canvas; 1.9 x
2 m (6 ft. 2 in. x 6 ft. 1/2 in.);
Founders Society Purchase, Robert H.
Tannahill Foundation Fund; 1990.291

**The extraordinary position of the figure creates
an abstract composition in this large painting
based on sketches of sailors working out in a
Stockholm bathhouse. By his use of thinly brushed
paint applied directly from the tube and by outlin-
ing the figure in blue, Jansson further abstracts
the dramatic presentation of the foreshortened
arching figure in an athletic pose that seems to
defy gravity.**

❶

More than twenty thousand works of art on paper are housed in the Department of Graphic Arts. Included are European and American prints, drawings, watercolors, photographs, posters, and artists' books ranging from the 15th through the 20th centuries. The department maintains a regular exhibition program utilizing the collection in a variety of ways. Prints and drawings are shown in the Schwartz Graphic Arts Galleries and photographs in the Albert and Peggy de Salle Gallery of Photography.

The collection's greatest strength lies in the area of 19th- and 20th-century prints and drawings with works of exceptional quality by Ingres, Delacroix, Degas, Pissarro, Cézanne, Picasso, and Matisse. The German Expressionist watercolors are outstanding, including fourteen by Emil Nolde alone. American masters of watercolor are also well represented with many fine works by artists such as

1

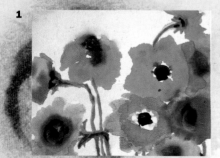

John Marin, Morris Graves, Charles Burchfield, and Charles Demuth. Demuth's watercolor *Still Life: Apples and Bananas* is one of the most stunning in a public collection.

The DIA has the largest corpus of drawings by Thomas Cole in any public institution or in private hands. It comprises 593 individual sheets, nineteen sketchbooks, two notebooks, and seventeen oil sketches. There are also many fine drawings from 18th-century Italy including works by Giovanni Domenico Tiepolo, Canaletto, Rosalba Carriera, and Piazzetta. Of special importance are such 16th-century sheets as those by Barocci, Domenico Campagnola, Michelangelo, and Tintoretto.

Represented in the collection are prints in all the principal media—woodcut, engraving, etching, lithography, and screenprinting. Great painter-printmakers of the past centuries such as Dürer, Rembrandt, Goya, and Manet can be studied in representative examples of their work. The DIA is an important study center for prints by American artists of the first half of the 20th century. Comprehensive collections of prints by John Sloan and Martin Lewis can be seen here. Prints created by contemporary artists such as Jasper Johns, Helen Frankenthaler, Elizabeth Murray, and Robert Rauschenberg also make up an important part of the print collection. Landmark series such as the "Apocalypse" woodcuts of Dürer, the "Carceri" etchings of Piranesi, the "Homage to Goya" lithographs by Odilon Redon, and the "Jazz" stencil prints of Matisse can be seen in their entirety.

1 *Nine Anemones,* ca. 1935; Emil Nolde (German, 1867–1956); Watercolor; 22.8 x 26.4 cm (9 x 10 3/8 in.); Bequest of John S. Newberry; 65.229

2 *Still Life: Apples and Bananas,* 1925; Charles Demuth (American, 1883–1935); Watercolor and graphite pencil; 30.2 x 45.7 cm (11 7/8 x 18 in.); Bequest of Robert H. Tannahill; 1970.253

3 *Double Waterfall, Kaaterskil Falls,* 1825–26; Thomas Cole (American, 1801–48); Graphite pencil, charcoal, and black and white chalk; 41.9 x 37.2 cm (16 1/2 x 14 3/4 in.); Founders Society Purchase, William H. Murphy Fund; 1939.503

4 *The Drawbridge,* plate 7 from "The Prisons" ("Carceri"), 1761; Giovanni Battista Piranesi (Italian, 1720–78); Etching and engraving; 54.6 x 41 cm (21 1/2 x 16 1/8 in.); Founders Society Purchase, Hal H. Smith Fund and Elizabeth P. Kirby Funds; 1942.67

3 **4**

1

2

1 *Calla Lilies*, ca. 1927;
Tina Modotti (Italian,
1896–1942); Platinum
print; 23.5 x 17.8 cm
(9 1/4 x 7 in.); Founders
Society Purchase,
Abraham Borman Family
Fund; F77.18

2 *Triangles,* 1928; Imogen
Cunningham (American,
1883–1976); Gelatin-silver
print; 9.5 x 7 cm (3 3/4 x
2 3/4 in.); Founders
Society Purchase, Edna
Burian Skelton Fund, Mr.
and Mrs Conrad H. Smith
Memorial Fund, Henry E.
and Consuelo S. Wenger
Foundation Fund; F80.175

3 *Rue Transnonain, April 15,
1834,* 1834; Honore
Daumier (French, 1808–
79); Lithograph; 28.8 x
44.1 cm (11 3/8 x 17
3/8 in.); Gift of Mr. and
Mrs. Bernard F. Walker
in memory of Kurt Michel;
72.841

Photography

In 1971 the department began to
systematically collect photographs; a
gallery devoted to photography was
opened in 1983. Today the collection
includes about 2,500 photographs
representing major figures in the history of the medium from
its beginnings in the 19th century including William Henry
Fox Talbot, Anna Atkins, Julia Margaret Cameron, Gustave Le
Gray, Nadar, and Peter Henry Emerson. Vintage photographs
from 20th-century masters such as Alfred Steiglitz, Edward
Steichen, Charles Sheeler, Paul Strand, Ansel Adams, Imogen
Cunningham, Edward Weston, and Paul Outerbridge can also
be seen. A recent focus has been on the acquisition of surreal
photography of the 1930s and 40s. The discovery of approxi-
mately six thousand 19th-century architectural and topograph-
ical photographs in the DIA Research Library revealed some
fine works by photographers such as Adolphe Braun, Edouard
Baldus, and William Henry Jackson, and a group of hand-
colored albumen prints by Japanese photographers.

3

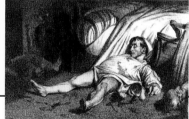

The Print Room

Scholars, students, and members of the general public may
make appointments to view works of special interest to them
in the Ina M. Clark Study Room. Arrangements can also be
made for classes to visit the study room.

The Ina M. Clark Study Room

Since the Renaissance, artists' preparatory drawings have been valued as works of art in themselves. The development of printing technologies—from woodcuts to engraving, etching, and lithography—increased the potential for reaching vast audiences with new forms of images.

The overall use of the sheet in various media reflects the fact that paper was very expensive in the Renaissance. Michelangelo was maximizing the use of this precious commodity.

Scheme for the Decoration of the Sistine Chapel Ceiling

1508; Michelangelo Buonarroti (Italian, 1475–1564); Pen, brown ink, and black chalk; 37.3 x 25 cm (14 3/4 x 9 7/8 in.); City of Detroit Purchase; 1927.2

Scholars have conducted lively debates attempting to link the various body parts of the Detroit sheet with specific figures on the Sistine Ceiling in the Vatican, which occupied Michelangelo from 1508 to 1512. However, no one-to-one correspondence can be made. The Detroit drawing is considered to be a compilation of various preliminary thoughts Michelangelo jotted down during the earliest phase of planning the ceiling design. This double-sided sheet of sketches is one of the few drawings related to the Sistine Ceiling in American collections.

Study of a Kneeling Woman

ca. 1595; Federico Barocci (Italian,
1535–1612); Black and white chalk over
incised outlines, squared for transfer in
black chalk, on pale green-gray paper; 21
x 18 cm (8 1/8 x 7 in.); Founders Society
Purchase, William H. Murphy Fund;
1934.139

This drawing is one of a group of
preliminary studies for the figure of the
Virgin in a *Nativity* painted by Barocci in
1597 for Francesco Maria II, duke of
Urbino. Here, his skillful utilization of
white chalk for highlights, combined with
a characteristically supple line in black,
conveys a sense of the miraculous light
emanating from the Christ Child and the
tender adoration in the face of the Virgin.
Although the drawing is squared for
transfer so that the composition may be
enlarged for a painting, this expressive
pose of the Virgin was not used for the
final *Nativity*, which is now in the Museo
del Prado in Madrid.

Two Studies of Standing Male Figures

ca. 1600–10; Lodovico Cardi, called Cigoli (Italian, 1559–1613); Red
chalk (recto), brush and brown wash (verso); 40.8 x 14.5 cm (16 1/16
x 5 11/16 in.); Founders Society Purchase, Laura H. Murphy Fund;
1934.143

As a young boy, Lodovico moved to Florence from Cigoli with his
family and later assumed the name of his native city. Although he
studied painting with Florentine masters, the major influences on
his work were artists such as Barocci, Correggio, and the Venetian
painters. His red chalk drawings, as in this powerful study, are
notable for their beautiful use of chalk combining firm outlines with
delicate gradations of tone. At the turn of the century, Cigoli was
a central figure in Florence in the transition from the mannerist
to the baroque style.

This double-sided sheet is a fine example of Cigoli's
mastery of two drawing techniques—red chalk (on the recto)
and brush and brown wash (on the verso)

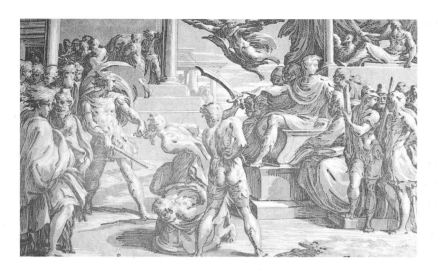

Martyrdom of Two Saints

ca. 1527; Antonio da Trento, after
Parmigianino; (Italian, ca. 1508–after 1550);
Woodcut printed from three blocks in black,
light green, and dark green ink; 29 x 48 cm
(11 1/2 x 19 in.); Founders Society
Purchase, by exchange from Elaine Lustig
Cohen and Arthur A. Cohen; F1989.1

Woodcuts of this type are commonly
referred to as "chiaroscuro woodcuts."
The technique was first developed in the
16th century as a means of reproducing
drawings. Usually a key block in black
established the basic composition; then
two or more color blocks, commonly in
shades of one color, were added. The color
blocks were cut so that the white of the
paper would function as white highlights.
These woodcuts are some of the most
attractive and interesting prints produced
in the 16th century.

Antonio da Trento worked in Bologna,
Italy, producing chiaroscuro woodcuts
after drawings by Parmigianino. About
1530 he absconded from Bologna taking
with him woodblocks and prints by
Parmigianino. He later reprinted the blocks
under his own aegis. A detail indicating
that this could be a first state of the print
pulled under Parmigianino's direction in
Bologna is the small initial ".F." which can
be discerned on the rectangular base of
the throne on which an emperor is seated
and which might indicate Francesco
Mazzuola (Parmigianino).

For a 20th-century chiaroscuro woodcut,
see page 257.

The Temptation of Eve

1546–47; Jean Mignon, after Luca Penni (French, active
Fontainebleau, ca. 1540–47); Etching and engraving; 41.9 x
55.2 cm (16 1/2 x 22 3/4 in.); Founders Society Purchase,
John S. Newberry Fund; 1972.473

Jean Mignon was one of the printmakers who worked at the
palace of Fontainebleau where King François I had gathered
a group of Italian artists to decorate his chateau with wall
paintings and sculpture. This etching was executed after
a drawing by Luca Penni, who had come from Rome where
he had worked under Raphael. Mignon skillfully captured
typical elements of Penni's style such as the exaggerated
anatomy of the nude figures. Like most Fontainebleau
prints, this scene has an erotic and ambiguous, yet courtly
and poetic, quality. Elaborate borders were also character-
istic of the Fontainebleau school.

EUROPEAN PRINTS AND DRAWINGS

GRAPHIC ARTS

DIA

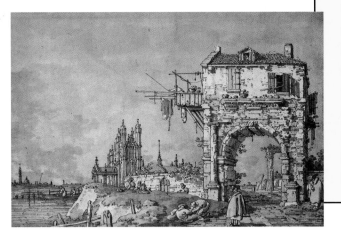

Veduta Ideata with a Triumphal Arch

ca. 1755–56; Giovanni Antonio Canal, called Canaletto (Italian, 1698–1768); Pen, brown ink, and gray wash, with traces of white heightening, over a preliminary drawing in graphite; 25.4 x 38.3 cm (10 x 15 1/8 in.); Bequest of John S. Newberry; 1965.177

Canaletto developed an expressive calligraphic style which combined washes with pen and brown ink. Here, pale and dark gray washes convey a sense of movement and luminosity. A close look reveals that the scene is peopled with small figures engaged in daily chores such as the fishing party in the boat on the left or the figure brandishing a pole on the balcony which projects from the ramshackle house on the top of the arch. Canaletto has included humorous, homely details—a small head peers from the dormer window of the shack; washing hung out to dry, or bedding to air, adorns the ancient arch.

Caterina Sagredo Barbarigo as Berenice

ca. 1741; Rosalba Carriera (Italian, 1675–1757); Pastel; 45.7 x 34.5 cm (18 x 13 5/8 in.); Gift of Mrs. William D. Vogel in memory of her mother, Mrs. Ralph Harman Booth; 1956.264

Rosalba Carriera was a Venetian artist of international stature who created a vogue for pastel portraiture in the 18th century. In 1720–21 she worked in Paris, accepting approximately thirty-six commissions, including one for a portrait of the boy-king Louis XV. In 1730 she traveled to Vienna where she completed a portrait of the empress of Austria to whom she also provided drawing lessons.

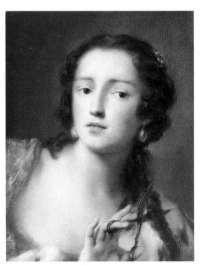

Caterina Sagredo Barbarigo was a flamboyant member of Venetian society, well-known for keeping a magnificent stable of thoroughbred horses. She is depicted here as Berenice, queen of Egypt, who married her brother, King Ptolemy Euergetes. When her husband went off on a dangerous mission to Syria, she sacrificed her long hair in the temple of Venus in exchange for his safe return. Legend has it that Jupiter stole this offering from the temple to create the constellation Coma Berenices.

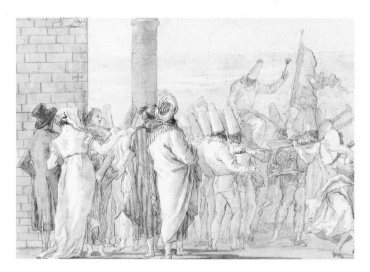

Punchinello Carried in Triumph in a Procession (The Bacchanal of the Gnocco)

ca. 1797–1800; Giovanni Domenico Tiepolo (Italian, 1727–1804); Pen, brown ink, brown wash, and opaque ocher over black chalk; 35.5 x 44.4 cm (14 x 18 5/8 in.); Founders Society Purchase, General Membership Fund; 1955.487

In the last years of his life, Giovanni Domenico Tiepolo completed a series of 104 drawings informally known as the "Punchinello" series. The artist grouped this large body of work under a title page "Entertainment for Children." Represented are scenes from the life of Punchinello, the comic, hooknosed, hunchback fool popularized by the Italian Commedia dell'Arte in the 17th century and eventually adopted by many European countries. England's version is known as Punch. Detroit's drawing weaves together the fictional doings of Punchinello with the real-world festival of Venerdì Gnoccolare, also called La Bacchanale del Gnocco, the last Friday in Carnival before the beginning of Lent. "Gnocco" means fool, as well as a dumpling, and pieces of gnocci appear repeatedly in Tiepolo's Punchinello drawings.

Roland at Roncesvalles

ca. 1800–10; Henry Fuseli (Swiss, 1741–1825); Pen, brown ink, and gray washes, heightened with white over graphite; 57.4 x 68.5 cm (22 5/8 x 27 in.); Gift of John S. Newberry; 1956.48

Fuseli depicted the climactic moment from the *Chanson de Roland* (lines 1753–57) when Roland sounds a mighty horn to alert Charlemagne of their army's doom. Fuseli, an accomplished literary scholar, was familiar with several sources for this episode beyond the original epic poem. The drawing is inscribed with a passage from Dante's *Inferno* (Canto XXXI, line 16), which also refers to Roland's action. The powerful figure of Roland is a body type Fuseli began copying as a boy from prints after the old masters. Clearly visible in the underdrawing are the outlines of several different poses Fuseli plotted for Roland before settling on the final version.

EUROPEAN PRINTS AND DRAWINGS

DIA GRAPHIC ARTS

French Prints and Drawings

The great classical tradition of 19th-century French drawing is epitomized in the elegant portrait drawings by Ingres, of which the museum owns three superb examples. Degas, trained in the tradition of Ingres, devoted himself early in his career to linear expression. However, in his later drawings Degas emphasized tone, texture, and color rather than contours as did Pissarro and Cézanne as well as younger artists associated with Impressionism and Post Impressionism.

Ballet Dancer Adjusting Her Costume

ca. 1873; Hilaire-Germain-Edgar Degas (French, 1834–1917); Graphite pencil and white chalk on pink paper; 39.4 x 26 cm (15 1/2 x 10 1/4 in.); Bequest of John S. Newberry; 1965.145

Although significant in its own right as a masterful work of art, it is not inappropriate to think of this drawing as a reference tool for Degas. Degas's working method was complex and frequently unfathomable. In his studio he maintained a stock of hundreds of sketches and studies. When planning compositions, it was not unusual for Degas to combine newly composed studies with earlier ones, such as this dancer who appears in several of Degas's paintings.

> Degas once told a former pupil that he wanted no funeral oration: "If there is to be one… get up and say, 'He greatly loved drawing. So do I.' And then go home."

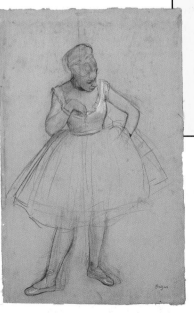

Mme. Jacques-Raoul Tournouër née Cécile-Marie Panckoucke

1856; Jean-Auguste-Dominique Ingres (French, 1780–1867); Graphite pencil; 32.5 x 22.8 cm (12 7/8 x 9 in.); Founders Society Purchase, Anne McDonnell Ford Fund, and Henry Ford II Fund; 1964.82

As a young artist, Ingres received acclaim for portraits drawn in his strikingly pristine style; these portraits provided him with a reliable source of income when he was a student at the French Academy in Rome. This drawing, however, dates from the later years when he had reached the pinnacle of success in French art. Its highly refined yet lively lines and clearly delineated contours capture a vivid likeness of the subject, who was the granddaughter of old friends of the artist. Cécile-Marie Panckoucke was named for her grandmother, whose portrait had also been drawn by Ingres some forty-five years earlier.

For other works by Degas, see pages 228–229 and 245.

Manet Seated, Turned to the Right

1864–65; Hilaire-Germain-Edgar Degas (French, 1834–1917); Etching and drypoint; 19.4 x 12.6 cm (7 3/4 x 5 in.); Founders Society Purchase, General Membership Fund; 1949.338

Given Manet's reputation as a radical modern artist, it is fitting that he served as the subject for this etching that marks a significant shift in Degas's printmaking development. Previously, Degas had used more conservative pictorial devices to compose approximately sixteen prints. In this portrait, details such as the candid pose, the casually dropped hat, and the stark background of stretched canvases are indications that Degas had grasped concepts of style considered to be on the cutting edge of artistic composition. By depicting Manet in the informal pose of an unassuming studio visitor, Degas was demonstrating his allegiance to the avant-garde Parisian artist. This print is a rare second state impression. It remained among Degas's possessions until the 1918 sale of his studio's contents.

Dead Christ with Angels

1866–67; Edouard Manet (French, 1832–83); Etching and aquatint; 39.2 x 32.7 cm (15 3/8 x 12 7/8 in.); Founders Society Purchase, General Endowment Fund; 1970.588

The history of printmaking includes many prints made by one artist copying the work of another. Occasionally these reproductive prints were admired for the skill they displayed but rarely were they considered equal in creativity to the original work they copied. This print by Manet is based on the artist's painting of the same subject now in the Metropolitan Museum of Art. By reworking the composition into a print version himself rather than turning the task over to a collaborator, Manet demonstrated his belief that the process involved more than rote transcription. His intention was to create a graphic equivalent of the painting. *Dead Christ with Angels* was never issued in an edition, so only a few impressions exist.

At the Circus

1899; Henri de Toulouse-Lautrec (French, 1864–1901); Crayon, pastel, and watercolor; 25.2 x 35.6 cm (9 7/8 x 14 in.); Bequest of Robert H. Tannahill; 1970.297

Depicted here is a scene from the ballet *Papa Chrysanthème* performed in 1892 at the Nouveau Cirque in Paris, an establishment renowned for its modern fixtures such as electrical lighting and mechanically operated scenery. For this ballet the central area of the Nouveau Cirque was flooded to produce a lake filled with artificial lotus leaves. The figures in the foreground are dancers dressed in Japanese costumes.

Lautrec was among the most innovative draftsmen of the 19th century. His work—whether executed with a brush, pen, crayon, or pencil—is characterized by vibrant lines that convey the essence of a subject with the deftest of means.

While hospitalized for alcoholism in 1899, Toulouse-Lautrec created a group of drawings of the circus from memory to prove his mental stability. This drawing is thought to be one of them.

Pond at Kew Gardens

1892; Camille Pissarro (French, 1830–1903);
Watercolor over graphite pencil; 17.1 x 25.2 cm
(6 3/4 x 9 7/8 in.); Bequest of John S. Newberry;
1965.222

**Despite its small size, this watercolor captures
the aura of a fine summer day. There is a sense
of movement—in the clouds, in the branches of
the trees, and in the shimmer of the pond. To
best see this work, one must be at least six feet
away. Close at hand, details such as the line
of plants along the pond become totally abstract.
However, at a distance the short fluid strokes of
blue, green, and yellow magically combine. The
pond with its border emerges, and the luxuriant
trees and foliage of a purplish-blue hue take
on more defined shapes.**

Skull and Book

ca. 1885; Paul Cézanne (French, 1839–1906);
Watercolor over black chalk; 23.5 x 31.1 cm (9 1/4
x 12 1/4 in.); Bequest of John S. Newberry;
1965.139

**Cézanne often made skulls the centerpiece
of his compositions. Although one might interpret
them as references to themes of death and the
transience of life, it is more likely that Cézanne
was interested in them purely as form. Skulls
were common props in 19th-century artists'
studios. The ones that Cézanne painted can still
be seen today on a shelf in his studio outside of
Aix-en-Provence in southern France.**

**For Cézanne watercolor was not merely an acces-
sory to oil painting but an independent medium.
During the final years of his life, he concentrated
more and more on producing watercolors. Here,
black chalk defines the basic elements of the
composition, and watercolor strengthens outlines
and models form. The skull is
given volume with green, yellow,
and purplish-gray washes.**

For other works by Cézanne, see
pages 225 and 227.

As a young man, the painter
Emile Bernard had the rare
opportunity of watching
Cézanne work on a water-
color: "He started on the
shadows with a spot of color;
this he followed with a stronger one over
the first, and then a third, until all those
tones, forming a sort of screen, modeled
the object in the process of coloring it."

EUROPEAN PRINTS AND DRAWINGS

GRAPHIC ARTS

DIA

The rapid pace of modern society is reflected in the profusion of styles and movements that define the 20th century. New technological developments such as the production of huge sheets of paper and equally large presses influenced the format of prints and drawings. Older techniques such as the woodcut and stencil print experienced revivals.

The Plumed Hat

1919; Henri Matisse (French, 1869–1954); Graphite pencil; 53.1 x 36.6 cm (20 7/8 x 14 3/8 in.); Bequest of John S. Newberry; 1965.162

While in Nice in 1919, Matisse created a series of drawings and several oil paintings of his young model Antoinette Arnoux wearing a hat fabricated from a straw foundation, white feathers, and black ribbon, and put together with pins on his model's head. Matisse seems to have been fascinated by the pictorial possibilities of women in hats; they were a frequent subject in his early work.

Antoinette's long, aristocratic, rather bony face framed by silky hair falling in waves almost to her waist presented a contrast which must have intrigued the artist. This is the most finished of *The Plumed Hat* drawings and is an impressive example of Matisse's skill in rendering in pencil curvilinear forms and varied textures.

For other works by Matisse and Picasso, see pages 274–277.

Bather by the Sea (Dora Maar)

1939; Pablo Ruiz y Picasso (Spanish, 1881–1973); Gouache; 64.1 x 47 cm
(25 1/4 x 18 1/2 in.); Bequest of Robert H. Tannahill; 1970.339

In 1936 the poet Paul Eluard introduced Picasso to Dora Maar, a strikingly
beautiful painter and photographer who was a member of the Surrealist circle
of writers and artists. For the next ten years she was Picasso's principal
muse, though he continued to see his younger mistress Marie-Thérèse Walter.
Physically, emotionally, and intellectually, Dora Maar was the exact opposite
of the placid, blond, unsophisticated Marie-Thérèse. *Bather by the Sea* is
readily identified as Dora Maar by the shoulder-length dark
hair, long face, bright eyes, and full red lips. Both the
face and the torso of the bather are drawn by Picasso in a
simultaneous frontal and profile view, a device frequently
seen in his portraits of 1938-40.

Picasso and Dora Maar were
enjoying a holiday on the
French Riviera on July 20, 1939,
when he signed this drawing.

20TH-CENTURY PRINTS AND DRAWINGS

DIA GRAPHIC ARTS

German Prints and Drawings

Works of art on paper have played a central role in German
art since the 15th century. This tradition was continued in
the 20th century with the powerful woodcuts created by the
artists of Die Brücke ("The Bridge"), the emotionally stirring
drawings of Käthe Kollwitz, and by the luminous, lyrical
watercolors of artists such as Lovis Corinth, Emil Nolde, and
Karl Schmidt-Rottluff.

Self-Portrait

ca. 1917; Emil Nolde (German, 1867–1956);
Watercolor, reed pen, and black ink;
21.5 x 17.8 cm (8 1/2 x 7 in.); Bequest of
John S. Newberry; 1965.230

Self-Portrait

ca. 1935–40; Emil Nolde (German, 1867–1956);
Watercolor; 21.4 x 17.3 cm (8 1/2 x 6 7/8 in.);
Bequest of Robert H. Tannahill; 1970.319

Selected from a group of fourteen watercolors by Nolde in
the museum's collection, these two self-portraits illustrate how his
method of working in this medium became more fluid and free.
Nolde in his later years abandoned any indication of linear structure
and relied on color to create form.

Nolde developed a deceptively facile method of working in
watercolor. He selected an absorbent Japanese paper which he
moistened with water before applying color. The colors were allowed
to spread across the damp paper and to merge with one another,
forming new colors and blurred edges. Nolde reinforced the image
with added color (often on both sides of the sheet) or lightened it
with the addition of water. After the color dried, he added definition
to the image with a brush using a dark color or with a reed pen
and ink. The additions disappeared in the watercolors created after
1935. The later self-portrait is more transparent. It glows with light
as Nolde has allowed more of the white paper to show, imparting
a radiance to the colors, especially the yellows and the blues.

Burial

ca. 1903; Käthe Kollwitz (German, 1867–1945); Charcoal and pastel with touches of white chalk; 54.7 x 47.9 cm (21 5/8 x 18 7/8 in.); Bequest of Robert H. Tannahill; 1970.308

Primarily a graphic artist, Kollwitz concentrated on themes related to basic and powerful human emotions. The heavy charcoal lines in this dramatic work heighten the tragic mood of the scene. Touches of yellow and white illuminate the face of the grieving mother, stoically digging a grave, and highlight the face of the child, so serene in death that it heightens the pathos of the scene. This drawing was a study for a scene that was not included in the series of seven etchings entitled "The Peasants' War," which Kollwitz worked on during the years 1903–08.

Moonlight

1896; Edvard Munch (Norwegian, 1863–1944); Color woodcut; 40 x 47 cm (15 3/4 x 18 1/2 in.); Founders Society Purchase, Robert H. Tannahill Foundation Fund; F1977.94

In their provocative subject matter and innovative technique, the prints of Munch were very influential on the development of 20th-century art. The group of German artists called Die Brücke was stimulated by Munch's brooding, psychologically complex imagery. The rugged manner in which he carved his blocks helped trigger a revival of interest in creating woodcuts.

***Moonlight* is a rare and unusual print related to an 1893 painting in the National Gallery of Oslo. This particular impression was printed in 1901 but the block was carved five years earlier, when Munch moved to Paris and made his first woodcuts and color lithographs in collaboration with masterprinter Auguste Clot.**

Die Brücke Exhibition Poster

1908; Erich Heckel (German, 1883–1970); Color woodcut; 84.1 x 61 cm (33 1/8 x 24 in.); Gift of Graphic Arts Council, Founders Society Detroit Institute of Arts; 1969.298

This poster was created by Heckel announcing an exhibition of the work of Die Brücke, a group formed in 1905 by four artists who had studied architecture together in Dresden: Heckel, Fritz Bleyl, Ernst Ludwig Kirchner, and Karl Schmidt-Rottluff. Later they were joined by Emil Nolde and Otto Mueller. They exhibited together frequently between 1906 and 1911. This poster is prized not only as a rare document of a seminal period in 20th-century art but also as an original work of art which effectively exploits the expressive power inherent in the woodcut medium.

For other works by the German Expressionists, see pages 268–271.

20TH-CENTURY PRINTS AND DRAWINGS

GRAPHIC ARTS

DIA

Waterlilies

ca. 1934; Karl Schmidt-Rottluff (German, 1884–1976); Watercolor over black crayon; 49.8 x 68.5 cm (19 5/8 x 27 1/2 in.); Bequest of Robert H. Tannahill; 1970.328

When *Waterlilies* was painted in 1934, working in a realistic style was the only safe path a German artist could pursue. The newly empowered National Socialist government of Adolf Hitler condemned all forms of abstract art. As a founding member of the avant-garde group known as Die Brücke, Schmidt-Rottluff was among many artists whose works were singled out and destroyed by the Nazis. In 1933 Schmidt-Rottluff was forced to resign his teaching position at the Prussian academy. By the late 1930s, more than 650 of his works were confiscated from German galleries and museums. Eventually, the artist was prohibited from painting.

DETROIT CONNECTION

The first comprehensive exhibition of Schmidt-Rottluff's work to be held in the United States was in Detroit in 1936. It was organized by Robert H. Tannahill, the original owner of *Waterlilies* and one of the DIA's great benefactors.

Pink Clouds, Walchensee

1921; Lovis Corinth (German, 1858–1925); Watercolor and gouache; 36.2 x 50 cm (14 1/4 x 20 1/8 in.); Bequest of Robert H. Tannahill; 1970.299

In oil paintings, watercolors, and prints, Corinth depicted views from his vacation home situated high above the village of Urfeld on Lake Walchen in Bavaria. They are among the most beautiful and intensely emotional works created during the last seven years of his life, a period which was especially inspired and productive. The construction of the Corinth family home was supervised by his beloved wife, painter Charlotte Berend, and it was given her nickname "Petermannchen."

Sacrificial Meal

1947; Max Beckmann (German, 1884–1950); Watercolor, pen, brush, and black ink over graphite pencil; 50.2 x 31.1 cm (19 3/4 x 12 1/4 in.); Bequest of John S. Newberry; 1965.174

Beckmann's artistic production probes the nature of the human condition. Beginning with the horrors of World War I and a series of crises Beckmann endured personally, his outlook grew increasingly pessimistic. In the early 1930s Beckmann was forced to give up his teaching position by political forces opposed to his modern and confrontational style. By the late 1930s intense persecution forced Beckmann to flee Germany for Amsterdam where he withstood the hardships of World War II. His jarring style enhances the brutal theme of this watercolor—the savagery of humans. It is a preliminary study for a painting (Stephen Lackner Collection, Santa Barbara, California) in which the subject is transformed into one of outright cannibalism. Harsh colors, strafing black lines, and crammed fantastic figures in frenzied spaces are characteristics of Beckmann's style.

For Beckmann's *Self Portrait,* see page 271.

Open-Air Sport

1923; Paul Klee (German, 1879–1940); Watercolor, pen, and black ink; 22.8 x 24 cm (9 1/2 x 10 in.); Bequest of Robert H. Tannahill; 1970.343

Some of Klee's most compelling and accomplished works were produced in the 1920s while he was a teacher at the Bauhaus, an influential German school of architecture and applied arts. This watercolor is a fine example of the wit that critics have delighted in noting in Klee's work. In an era when physical fitness is the fashion, we can empathize with these earnest humans of all shapes and sizes, trapped in an environmental web, the pictorial structure of undulating horizontal bands devised by the artist. However, it is not only the humor of this watercolor which is appealing but also its harmonious colors in shades of blue, green, and pale orange. Klee's art is sensual as well as cerebral.

20TH–CENTURY PRINTS AND DRAWINGS

GRAPHIC ARTS

DIA

American Prints

American artists of the early 20th century were virtuoso practitioners of a variety of printmaking media. Martin Lewis, a master etcher, and John Sloan found prints an appropriate way to depict the realities and nuances of urban life. George Bellows brought artistic vigor to lithography and the Provincetown Printmakers developed new approaches to woodblock printing.

The Violet Jug

1919; Blanche Lazzell (American, 1892–1957); Color woodcut; 30.4 x 29.5 cm (12 x 11 5/8 in.); City of Detroit Purchase; 1920.77

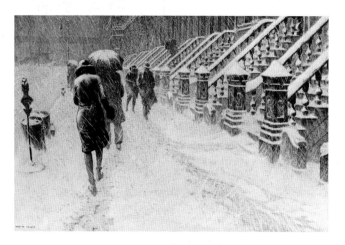

Stoops in Snow

1930; Martin Lewis (American, 1881–1962); Drypoint and sandpaper ground; 25.3 x 38.1 cm (10 x 15 in.); Bequest of Hal H. Smith; 1945.299

A majority of Martin Lewis's prints deal with the nuances of vision. Typically, Lewis concentrated on translating a split second of activity. His prints are like snapshots that capture people in poses and scenes that rarely remain stationary. Often, Lewis organized his compositions from an unusual perspective or point of view and included bad weather or interesting sources of light. Dealing with these later conditions allowed the artist to experiment with the depiction of fleeting forms such as shadows, silhouettes, reflections, the wind, rain, snow, intense light, or the night. *Stoops in the Snow* is among many of Lewis's masterful achievements. To suggest accumulating snow on the streets of New York, Lewis created a density of dots by pressing sandpaper into a soft-ground coating on the plate. In other areas he selectively scraped the plate clean to produce wispy, inkless "white" lines that represent gusting wind and swirling snow.

Blanche Lazzell was a central figure among a group of American artists who left Europe at the outbreak of World War I and settled in Provincetown, Massachusetts. Called the "Provincetown Printmakers," they became known for color woodcuts like *The Violet Jug*, printed from a single block. This technique saved time, labor, and materials as compared to traditional color woodblock printing. According to traditional practices, individual colors were printed from separate blocks and printers strove for an identical image from impression to impression. The Provincetown Printmakers often approached each print as a unique object and frequently made significant color changes from print to print. Lazzell's inspiration for her many floral still lifes came from the flowers she grew around her cottage on the Provincetown wharf.

The DIA owns many of Martin Lewis's tools, including this roulette used in making intaglio prints.

Sloan commented on the "New York City Life" series: "Observation of life in furnished rooms in back of my 23rd Street studio inspired many of my etchings and paintings of this period… this woman in this sordid room, sordidly dressed—undressed—with a poor kid crawling around the bed—reading the Woman's Page, getting hints on fashion and housekeeping. That's all. It was the irony of that I was putting over."

A Stag at Sharkey's

1917; George Bellows (American, 1882–1925); Lithograph; 47.2 x 60.6 cm (18 5/8 x 23 7/8 in.); Gift of Mrs. H.G. Salsinger in memory of her husband; 1959.185

At the same time that Bellows presents us with an image of a contemporary sporting event, he also delves into a theme with a long history in art. By focusing on the physical power and intense engagement of the two fighters, we are invited to see them as battling warriors, a subject that has been treated since prehistoric times.

For many years, public prize fighting was illegal in the United States but was permitted among members of private clubs such as Tom Sharkey's Athletic Club, an establishment frequented by Bellows. Despite insisting that he knew little about the sport, Bellows depicted various aspects of boxing in his paintings, prints, and drawings. The subject was fraught with drama and alluded to more general concepts such as competition, battle, victory, and defeat. This print is related to a work painted by Bellows in 1909 and now in the Cleveland Museum of Art.

The Woman's Page

1905; John Sloan (American, 1871–1951); Etching; 12.7 x 17.7 cm (5 x 7 in.); Gift of Bernard F. Walker; 1964.279

John Sloan was the most accomplished and most dedicated printmaker of the group of New York artists who, because they portrayed the everyday life of the lower classes, were referred to as the "Ash Can School."

For other works by the Ash Can School, see pages 88–89.

DETROIT CONNECTION

The DIA is an important study center for Sloan's graphic work; it has one of the most comprehensive collections of his prints in a public institution in this country.

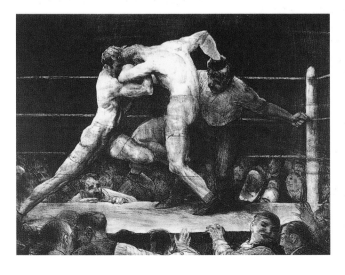

20TH–CENTURY PRINTS AND DRAWINGS

DIA GRAPHIC ARTS

The John Brown Series

John Brown fought to abolish slavery; his heroic life and his death in 1859 have inspired many artists. In 1941 Jacob Lawrence painted a series of twenty-two gouaches on this theme, the only depiction of the abolitionist's story in serial form; these were acquired by the DIA in 1955. Due to frequent loan requests for the fragile gouaches, the DIA worked with Jacob Lawrence to reproduce the series as screenprints so that the images could be more widely seen.

"John Brown formed an organization among the colored people of the Adirondack woods to resist the capture of any fugitive slave."
1978; Jacob Lawrence (American, born 1917); No. 6 from *The Legend of John Brown;* screenprint; 65.7 x 50.7 cm (25 7/8 x 20 in.); Founders Society Commission; F1983.18.6

Jacob Lawrence wrote captions for each of his images in the John Brown series, adapting them from a 19th-century biography and imbuing them with the sound of old–fashioned speech. Here John Brown is seen arming men in New York state to help them protect runaway slaves.

"After John Brown's capture, he was put on trial for his life in Charles Town, Virginia (now West Virginia)."
1978; Jacob Lawrence (American, born 1917); No. 21 from *The Legend of John Brown;* screenprint; 65.7 x 50.7 cm (25 7/8 x 20 in.); Founders Society Commission; F1983.18.21

John Brown is shown praying in his prison cell. This image is a superb example of Lawrence's expressionistic use of color and stylized form to tell a story and establish a mood. Brown's concentration on prayer can be sensed through the expressive curve of his head and the tense locking of his hands around the cross.

Contemporary Prints

A renaissance of printmaking in the 1960s was marked by the establishment of studios where artists could collaborate with master printers to produce graphic works in various media. Artists continued to experiment with innovative techniques, including the incorporation of photography with more traditional methods of printmaking.

L.R.

1966; Georg Baselitz (German, born 1938); Woodcut printed from three blocks in black, gray-green, and purple ink; 45 x 34 cm (17 1/4 x 13 1/4 in.); Founders Society Purchase, Benson and Edith Ford Fund, and Mr. and Mrs. Walter Buhl Ford; F1988.4

L.R.

1966; Georg Baselitz (German, born 1938); Woodcut printed from three blocks in black, gray-green, and light green ink; 45 x 34 cm (17 1/4 x 13 1/4 in.); Founders Society General Endowment Fund; F1988.5

These impressions are two of the twenty variants that Baselitz printed of the second state of this print. Undoubtedly Baselitz was inspired by his study of 16th-century Italian woodcuts, though he has warned against making any "serious comparison." While in Florence in 1965, he began to collect mannerist prints created by masters of the chiaroscuro woodcut. Old master prints of this type line the walls of a long gallery in his home.

For a 16th-century chiaroscuro woodcut, see page 241.

20TH-CENTURY PRINTS AND DRAWINGS

GRAPHIC ARTS

DIA

Bellini #1

1986; Robert Rauschenberg (American, born 1925); Color intaglio; 143.5 x 88.9 cm (56 1/2 x 35 in.); Founders Society Purchase, Graphic Arts Council Fund; F1988.6

***Bellini #1* is from a series of five prints, each of which focuses on a different figure taken from a group of small paintings by the 15th-century Venetian artist Giovanni Bellini. Rauschenberg began by enlarging an 8 x 10 inch photograph of a Bellini figure such as the blue-winged Nemesis seen in this print, mixing and matching it with imagery from other photographs he had taken, and adding handwork such as the splotch of green color. The result is a modern allegory printed in eleven colors from several photo-sensitive intaglio plates.**

For another work by Rauschenberg, see page 300. For a painting by Giovanni Bellini, see page 178.

The history of art has always built upon itself by borrowing imagery from the past and manipulating conventional techniques. When combined with the numerous technical advances of the 20th century and the use of photography, these developments have elevated printmaking to new levels of complexity and innovation.

Untitled

1985; Barbara Kruger (American, born 1945); Nine color lithographs and screenprints; each 52.1 x 52.1 cm (20 1/2 x 20 1/2 in.); Founders Society Purchase, John S. Newberry Fund; F1986.46.1–.9

In this series of prints, Barbara Kruger used images reminiscent of the types found in advertising, an industry in which she had considerable experience. The addition of words as elements of design imbue the works with multiple levels of significance. "We Will No Longer Be Seen And Not Heard" is a poignant statement about communication. At the same time that it stirs up the debate about the contents of visual media, it also refers to a larger societal issue involving the silence of groups of people or individuals whose lives are often overshadowed by more vocal individuals. Sign language is used as another way of imparting ideas.

As a series of nine images that work together to present one message, these works relate to an old tradition in printmaking. Prints were made in pairs or related groups that enhanced each other's meaning.

"From today painting is dead!"
—Painter Paul Delaroche, on seeing his first daguerreotype.

Daguerreotype studios quickly appeared throughout much of the world after the patent for this first practical photographic process developed by Louis-Jacques-Mandé Daguerre was purchased by the French government and made generally available in 1839. In England, working at the same time as Daguerre, William Henry Fox Talbot developed the calotype and patented it in 1841.

Articles of China from *The Pencil of Nature*

ca. 1844; William Henry Fox Talbot (English, 1800–77); Salt print from a calotype negative; 18.5 x 22.3 cm (7 1/4 x 8 3/4 in.); Founders Society Purchase, Lee and Tina Hills Graphic Arts Fund; 1991.3

Talbot was the inventor of negative/positive photography. Unlike the more limited daguerreotype, which created a single image on a silvered copper plate, Talbot's process involved a paper negative from which multiple positive images could be printed on paper. Talbot was the author of *The Pencil of Nature*, the first book to be illustrated with photographs. With this publication Talbot intended to detail the events and experiments that led to his discovery of the calotype process, to expose the public to the fledgling medium, and to suggest a variety of possible uses for photographs beyond portraiture. Talbot's text for this still life specifically stresses the value of photography for record keeping and cataloguing collections.

Sir John Herschel

1867; Julia Margaret Cameron (English, 1815–79); Albumen print from a collodion wet plate negative; 34.9 x 26 cm (13 3/4 x 10 1/4 in.); Founders Society Purchase, Miscellaneous Gifts Fund; 1973.37

It was from Sir John Herschel that Cameron received word of the invention of photography in 1839, but she did not own a camera until 1863. Principally known as an astronomer but also accomplished as a chemist and physicist, Herschel is credited with several contributions to the development of photography during its early years. Cameron's portrayals of Herschel, considered among her finest work, exemplify qualities of style considered revolutionary for their day. The intense close-up pose, evocative lighting, dramatic focus, and

absence of extraneous details combine to present images intended to serve as windows into the sitter's soul. Among the ranks of early photographers few women received the professional acknowledgment granted to Cameron.

"When I have such great men before my camera, my whole goal has endeavored to do its duty towards them in recording faithfully the greatness of the inner—as well as the features of the outer—man"

Julia Margaret Cameron, *Annals of My Glass House*

Brig upon the Water

ca. 1856; Gustave Le Gray (French, 1820–82); Albumen print from a glass plate negative; 31.7 x 40.6 cm (17 1/2 x 16 in.); Founders Society Purchase, Henry E. and Consuelo S. Wenger Foundation Fund; F1978.41

Brig upon the Water **created a sensation when it was first exhibited at the Photographic Society of London in December 1856 because it was reported to have been printed from one negative. Such an achievement was considered extraordinary because the light sensitivity of the materials used was very uneven and typically yielded either well-defined scenes with completely washed-out skies or very dark, unreadable scenes with well-developed skies. To fuse the sky with the scene the photographer usually either in-painted clouds by hand or printed twice, using one negative for the sky and another for the scene. Perhaps Le Gray succeeded with this seascape because he kept the composition simple. Here the exposure time for the sky and water was equal, and the brig, while dark indeed, appears as an appealing silhouette.**

William Henry Jackson was almost one hundred when he died in 1942. His remarkable career in photography began in 1859 when he was fifteen and the invention of photography was not yet twenty years old. During his lifetime he witnessed and adopted most of the technical advancements in the medium.

Shoshone Falls, Idaho

After 1880; William Henry Jackson (American, 1843–1942); Albumen print from a glass plate negative; 51.1 x 43.4 cm (20 1/8 x 17 1/8 in.); Founders Society Purchase, Edna Burian Skelton Fund; F1977.1

This view of Shoshone Falls with its cascading waterfalls and masses of fir trees is typical of Jackson's romantic approach to landscape photography. Jackson often deliberately placed a human figure in his photographs to enhance the viewer's appreciation of the vast scale of his subject. Here a tiny figure can be discerned seated on a rock at the base of the falls. Jackson's photographs had wide distribution through his work for the railroads and his later association with the Detroit Publishing Company. His images played a major role in making Americans aware of the magnificent natural wonders of the West.

PHOTOGRAPHY

GRAPHIC ARTS

DIA

Melancholic Tulip

1939; André Kertész (American, 1894–1985); Gelatin silver print; 15.9 x 24.2 cm (6 1/4 x 9 1/2 in.); Founders Society Purchase, Acquisitions Fund; F1983.69

The skewed perspective and bizarre focusing evident in this photograph were achieved with distortion mirrors. Kertész's first serious experiments with distorted imagery occurred in 1929. In 1933 using a pair of circus mirrors, he produced a series of nudes known as the "Distortions." Although Kertész never claimed specific identification with André Breton and his colleagues of the surrealist movement, Kertész's work of the 1920s and 1930s evinces parallel interests. In the pursuit of visually provocative photographs Kertész actively manipulated his imagery. He sought out ironies, oddities, and mysteries in nature and photographed strangely juxtaposed subjects to which he attached suggestive titles.

Place de l'Opéra Paris

1929; René Magritte (Belgian, 1898–1967); Gelatin silver print; 23.4 x 29.3 cm (9 1/4 x 11 5/8 in.); Founders Society Purchase, Lee and Tina Hills Graphic Arts Fund; F1983.1

Photography played a central role in the surrealist movement. Some of its quintessential images were first published in various magazines such as *La Révolution surréaliste* (1924–29), in which this photograph appeared. The photographs that Magritte created between 1928 and 1956 were, for the most part, small but magical documents of his family and friends in poses invented by him. He also devised haunting photomontages such as this image in which the Palais Garnier (former home of the Paris opera) rises, like a gigantic mirage, from a meadow of serenely grazing cows oblivious to the phantom.

For other surrealist works, see pages 278–279.

The King and Queen of a Senior Citizens' Dance

1970; Diane Arbus (American, 1923–71); Gelatin silver print; 40.6 x 39 cm (16 x 15 3/8 in.); Founders Society Purchase, Mary Martin Semmes Fund, Barbara L. Scripps Fund, and Edna Burian Skelton Fund; 1980.174

Diane Arbus was influenced by press photographer Weegee and his images of New York crime scenes and street life; she was also a student of Lisette Model who often exploited her subjects as isolated figures in a stark, unflattering manner. In the square format portraits characteristic of her work, Arbus incorporated the humor of Weegee's graphic, urban style and the sardonic representations of human existence prevalent in the work of Model. The image is typical of Arbus's documentary style which appears both as a record and as an insight into the psychology of the subjects depicted.

Drive Wheels

1939; Charles Sheeler (American, 1883–1965); Gelatin silver print; 15.9 x 24.2 cm (6 1/4 x 9 1/2 in.); Founders Society Purchase, John S. Newberry Fund, and Lawrence Buell, Jr. Fund; F1983.124

This is one of a series of industrial photographs that Sheeler made in 1939 in preparation for a group of six paintings on the theme of Power commissioned by *Fortune* magazine. It depicts the wheel and disk driver of a Model J3A Hudson Thoroughbred locomotive, one of the ten streamlined versions of the engine designed to pull the legendary Twentieth Century Limited. This engine, designed by Henry Dreyfuss and built in 1937, was regarded by railroad enthusiasts as the most beautiful steam locomotive for a passenger train in America. Focusing on the wheels of the great locomotive, Sheeler created an image that epitomizes the power of the engine and the elegance of its design. As is characteristic of Sheeler's photographs, there is a warm, subtle range of tones and a satisfying balance of light and shadow. Especially masterful are the gradations of tone in the disk driver at the left and in the puff of steam with a trail of vapor.

While employed as a press photographer, Arbus was assigned to a senior citizens' dance.

She wrote this caption: "Their numbers were picked out of a hat. They were just chosen King and Queen of a senior citizens' dance in N.Y.C. Yetta Granat is 72 and Charles Fahrer is 79. They have never met before."

PHOTOGRAPHY

GRAPHIC ARTS

DIA

Color Photography

The dawn of the 20th century saw the beginning of the proliferation of color processes with autochromes (perfected by the Lumière brothers in 1903), followed by color carbro prints, type-C prints, dye transfer prints, cibachrome prints, and Polaroids. In recent years, young photographers, imitating 19th-century works, have revived hand coloring while new technologies such as computerization and digital imaging are revolutionizing the medium.

Images of Deauville

1938; Paul Outerbridge (American, 1896–1958); Color carbro print; 47.2 x 36.1 cm (18 5/8 x 14 1/4 in.); Founders Society Purchase, Ralph Harman Booth Bequest Fund; F1979.90

During the 1930s, Outerbridge enjoyed the reputation of being perhaps the finest color printer in the world. His success was rooted in achieving perfection with the carbro process which yielded color of extraordinary quality. In addition to being expensive, carbro is painstakingly laborious. A print such as *Images of Deauville* took Outerbridge ten hours to produce.

Besides referring to the French seaside gambling resort of Deauville, this still life is a tour-de-force of modern stylistic citations. Overall, the assembled objects evoke a feeling of eeriness not unlike a sentiment associated with many surrealist works. The Machine Age and cubist-inspired ideas are referred to by the inclusion of the shiny sphere and yellow pyramid. Always an advocate of modern art principles, Outerbridge remained a prominent member of the international avant-garde from the mid-1920s through the mid-1940s.

Porch, Provincetown

1977; Joel Meyerowitz (American, born 1938); Ektacolor print; 39.4 x 49.8 cm (15 1/2 x 19 5/8 in.); Gift of Frederick P. and Amy McCombs Currier; F1987.52

During the 1970s, many American photographers established color photography as a serious medium for aesthetic growth and experimentation. Joel Meyerowitz abandoned the earlier black-and-white film, urban subjects, and spontaneous photographic method when he became interested in color photography during 1973. Meyerowitz felt color photography more accurately expressed his memory or experience of a subject. He acquired an 8 x 10 Deardoff view camera and completed the "Cape Light" series during the summers of 1976 and 1977 while living on Cape Cod in New England. He created several versions of *Porch, Provincetown* depicting a view of the ocean during mid-afternoon, dusk, and twilight. Each photograph has a different sensibility of light, color, and sensation and expresses the emotive character of his work and his sensitivity for the unique qualities that color photography offers.

Herringboned

1988; William Wegman (American, born 1943); Color polaroid print; 61 x 50.8 cm (24 x 20 in.); Founders Society Purchase, with funds from Founders Junior Council and a National Endowment for the Arts Matching Purchase Grant; F1989.9

Wegman's artistic production in the 1970s primarily involved video, conceptual art, and, eventually, black-and-white sequential photography. In 1979 he was one of many artists invited by the Polaroid Corporation to experiment with a large-format camera at their studio in Cambridge, Massachusetts. The 20 by 24 inch view camera produces high-resolution prints of exceptionally vivid color. Wegman, who was initially reluctant to use the equipment, became excited about the instantaneous results of the medium and found it comparable to video playback.

Fay Ray

Wegman began to include his dog (or "art partner" as Wegman liked to call him) Man Ray in many photographs from the early 1970s until the dog's death in 1982. Man Ray was eventually replaced by a female Weimaraner named Fay Ray, who appears in *Herringboned*.

PHOTOGRAPHY

DIA GRAPHIC ARTS

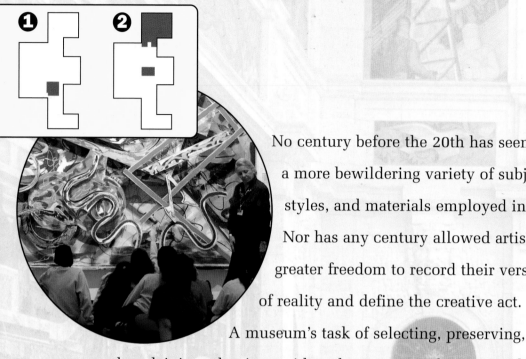

No century before the 20th has seen a more bewildering variety of subjects, styles, and materials employed in art. Nor has any century allowed artists greater freedom to record their versions of reality and define the creative act.

A museum's task of selecting, preserving, and explaining what it considers the most significant visual expressions of the 20th century is aggravated by an abundance of choice and the serendipity of acquisition methods. Collections are shaped less by curatorial forays into studios or the market place than by the donations and bequests of generous patrons.

Painting, sculpture and the decorative arts, as they portray the particular genius of our century, owe their configuration at the DIA to a handful of remarkable individuals. William H.

1

Valentiner, director from 1924-45, was a friend and supporter of the German Expressionists in the 1930s when the Nazis reviled them as "degenerate." Through his efforts, Expressionist painting, sculpture, and graphic arts are among the recognized strengths of this collection.

1 *Home Sweet Home,* 1931;
Charles Sheeler (American,
1883–1965); Oil on can-
vas; 91.4 x 73.7 cm (36 x
29 in.); Gift of Robert H.
Tannahill; 45.455

2 *Noah's Ark: Genesis,*
1984; Charles McGee
(American, born 1924);
Mixed media on masonite;
3 x 4.6 m (10 x 15 ft.);
Gift of Joan Lovell and
James A. Tuck; F1985.12

3 *Standing Woman II,* 1960;
Alberto Giacometti (Swiss,
1901–66); Bronze; height
2.7 m (9 ft.); Bequest of W.
Hawkins Ferry; 1988.175

4 *Still Life,* 1916; Juan Gris
(Spanish, 1887–1927);
Oil on canvas; 81 x 60 cm
(31 3/4 x 23 1/2 in.);
Founders Society Purchase
with funds from the Dexter
M. Ferry, Jr., Trustee
Corporation; 64.84

2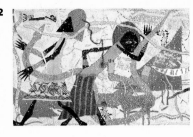

In 1932 industrial magnate
Edsel Ford commisioned the
controversial Mexican Diego
Rivera to fill the museum's
central courtyard with murals
depicting the city's industry. Gifts from Cranbrook Academy
founder George G. Booth in the 1920s laid the foundation
for a collection of design objects and the crafts. Robert H.
Tannahill bequeathed the DIA a stellar collection including
important early modern paintings. W. Hawkins Ferry, archi-
tect and driving force behind the museum's Friends of
Modern Art, with great foresight gave the DIA two sculptures
by Laszlo Moholy-Nagy in 1946. Upon his death in 1988, he
left other major examples of mid-20th-century art.

The collection encompasses works in all media in the
Western tradition. It is particularly rich in European mod-
ernist painting, including works by Picasso and Matisse and
mid-century European painters such as Dubuffet, Giacometti,
and Francis Bacon. As American painters began to dominate
the international arena after World War II, their triumphs are
documented by strong holdings of Abstract Expressionism,
Minimalism, and Pop Art. Regular additions are made of
work by young and often controversial artists from both
Europe and America, such as Mimmo Paladino and Julian
Schnabel. The important role attributed to sculpture at the
DIA is evident from the large examples on its lawn, no less
than from the pride of place given inside to Moore, David
Smith, Judd, and di Suvero.

The decorative arts collection is distinguished by its strong
holdings in early twentieth-century design, particularly in
furniture and metalwork. Ceramics, in both vessel forms and
sculpture, span the century. The contemporary studio glass
movement is comprehensively documented and a variety of
works in other media are also collected.

The work of artists from Michigan continues to be regularly
collected and displayed. Purchase Prizes in the early years
of this century and close attention to local work in
recent years have given the DIA a comprehensive
survey of Michigan art.

3

4

German Expressionism

The DIA's extraordinary collection of avant-garde German Express-ionist painting from the first decades of the 20th century was due in large part to the efforts of William R. Valentiner, the museum's director from 1924 to 1945. A friend and contemporary of many of the Expressionists, Valentiner encouraged the muse-um and some of its major patrons to buy important works by these artists. His committment to their work, at a time when it was being defamed by the Nazis in their own country, helped to make the DIA's collection of modern German art one of the most comprehensive in the United States.

Self Portrait

1912; Otto Dix (German, 1891–1969); Oil and tempera on panel; 73.7 x 49.5 cm (29 x 19 1/2 in.); Gift of Robert H. Tannahill; 51.65

Dix's early work illustrates the renewed interest of the Expressionists in their cultural patrimony. This painting pays homage to past masters of the German and Flemish Renaissance in its composition and technical execution. Painted with a glaze technique in which oil and tempera paint are applied in thin, translucent layers, Dix produced a luminous surface which also permitted precise graphic detail. The spare, formal rendering of the young man is enlivened by the intensity of his penetrating gaze.

Old Peasant Woman

ca. 1905–06; Paula Moderson-Becker (German, 1876–1907); Oil on canvas; 75.6 x 57.8 cm (29 3/4 x 22 3/4 in.); Gift of Robert H. Tannahill; 58.385

Attracted by the simplicity of rural life in the village of Worpswede (near Bremen), Moderson-Becker began a series of paintings of peasants from the area. This image of an old woman is given dignity by the reduction of the subject to simplified large forms and by the harmony of color, to reveal the inner meaning of her subject. Her gesture, traditionally used in depictions of the Annunciation as Mary's acceptance of her role, here can be interpreted as the old woman's recognition of her place in the cycle of human life and is underscored by the flowers in her lap.

For this gesture in an Annunciation, see page 176.

Die Brücke (The Bridge)

In 1905 an association of artists formed in Dresden who called themselves "The Bridge" to signify their perceived role in linking revolutionary thought with notions of an art of the future. Founded by four architecture students—Karl Schmidt-Rottluff, Fritz Bleyl, Erich Heckel, and Ernst Ludwig Kirchner—the group was intent on creating an egalitarian utopia through art. Their interests lay in primitive art, the expression of strong emotion through brilliant color and crude drawing, and figuration rather than pure abstraction. Personal rivalries and diverging politics led to the collapse of the group in 1913.

Winter Landscape in Moonlight

1919; Ernst Kirchner (German, 1880–1938); Oil on canvas; 1.2 x 1.2 m (47 1/2 x 47 1/2 in.); Gift of Curt Valentin in memory of the artist on the occasion of Dr. William R. Valentiner's sixtieth birthday; 40.58

Winter Landscape in Moonlight **depicts Tinzenhorn mountain in the Swiss Alps with vibrant intensity. This vista had special meaning for Kirchner, who had first gone to the Alps to recover from a nervous breakdown several years earlier. Kirchner wanted to paint his experiences with nature, as they stimulated his return to spiritual and physical health. An insomniac, he became familiar with the variations in the landscape at particular times of night and day.** *Winter Landscape in Moonlight* **suggests the unusual spectrum of color produced by a bright moon over slopes blanketed with snow: brisk strokes of blue, magenta, deep orange, and purple animate the pre-dawn landscape, accentuating the sharp angularity of the peaks.**

The Avenger

1914 (cast 1930); Ernst Barlach (German, 1870–1938); Bronze; height 44.5 cm (17 1/2 in.); Gift of Mrs. George Kamperman in memory of her husband, Dr. George Kamperman; 64.260

Barlach used dramatic gesture as a means of expressing a wide range of human emotions. *The Avenger's* **strong silhouette and fanlike robe suggest a powerful kinetic thrust and unrestrained aggression. The relatively inexpressive face of the figure is subordinated to the dynamic use of the entire figure as projectile. This work testifies to the enthusiasm with which Barlach, like other German artists and intellectuals, welcomed the outbreak of World War I, although their patriotism was, in Barlach's case, short-lived.**

DIA 20TH–CENTURY ART GERMAN EXPRESSIONISM

Der Blaue Reiter (The Blue Rider)

Founded in Munich in 1911, this group was a loose association
of painters, including Franz Marc, linked by their desire to
create a spiritually oriented abstract style. Various approaches
to representation, including pure abstraction, were pursued
in order to evoke nonvisual phenomena and sensations. The
international nature of the group, which included Russian
artist Wassily Kandinsky, and its interest in the possibilties
of abstraction distinguished it from Die Brücke. The group
disbanded at the onset of World War I in 1914.

Study for Painting with White Form

1913; Wassily Kandinsky
(Russian, 1866–1944); Oil on
canvas; 99.7 x 80.3 cm (39
1/4 x 34 3/4 in.); Gift of Mrs.
Ferdinand Moeller; 57.234

Study for Painting with White Form **represents one of several
stages in Kandinsky's efforts to express the spiritual. His painting
became increasingly abstract as he restricted his images to pure
color and form. In this work, non-representational shapes, colors,
and lines dominate; yet, abbreviated references to the outside
world are still apparent, as in the upper right where buildings and
trees are discernible. Below this, a smattering of lines is an
abstraction of a recurring motif in Kandinsky's work: the mounted
horseman, which serves as a symbol for spiritual energy and
human potential. The artist's use of terms borrowed from music,
such as "composition" and "improvisation," point to his fascination
with the potential for sounds and colors to evoke one another
and to reach the soul via intuition.**

Animals in a Landscape

1914; Franz Marc (German, 1880–1916);
Oil on canvas; 1.1 m x 99.7 cm (43 3/8 x
39 1/4 in.); Gift of Robert H. Tannahill;
56.144

**Marc's gentle paintings depict animals—
with the conspicuous absence of man—
in nature. His search for an unspoiled
state of existence, in which all elements
of the world live in harmony, led him to
choose animals as the most fitting sym-
bol of a harmonious state of being in a
primeval world. Kaleidoscopic patterns
of vibrant color fuse the animals and the
landscape elements, expressing Marc's
belief in nature as an interrelated force.**

For prints, drawings, and watercolors by the German Expressionists,
see pages 250–253.

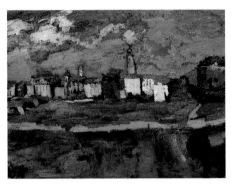

The Elbe Near Dresden

ca. 1921; Oskar Kokoschka (Austrian, 1886–1980); Oil on canvas; 59.7 x 80 cm (23 1/2 x 31 1/2 in.); City Appropriation; 21.203

This picture most likely depicts the view from the window of Kokoschka's studio in Dresden, from which he enjoyed a splendid view of the Elbe River, its bridges, and the houses on the far shore. The three elements of the landscape—water, embankment, and sky—are suggested by bold patches of bright color, and the simple, strongly horizontal composition emphasizes the low buildings and the river's edge. Painted between 1919, when Kokoschka moved to Dresden, and 1921, this painting is one of the earliest works by the artist to have been acquired by an American museum.

Assunta

1921; Georg Kolbe (German, 1877–1947); Bronze; height 1.9 m (76 in.); City of Detroit Purchase; 29.331

Georg Kolbe's work carries the emotional intensity of the German Expressionists, but his sources are in the French sculpture of the early modern period of Rodin and Maillol. Like Maillol, he preferred the nude figure—generally in quiet, contemplative poses as in this figure. His capacity to synthesize anatomy and to reduce salient forms to masses and planes lend a mannered grace to this elongated figure.

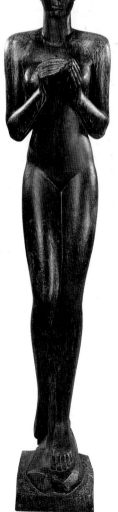

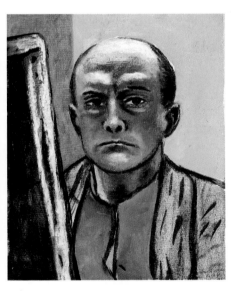

Self Portrait in Olive and Brown

1945; Max Beckmann (German, 1884–1950); Oil on canvas; 60.3 x 49.9 cm (23 3/4 x 19 5/8 in.); Gift of Robert H. Tannahill; 55.410

Beckmann often represented himself in disguise or costumed to express his own view that life is a series of roles to be played. In this late *Self Portrait,* the artist seems to have shed disguise: unsmiling, he stands plainly dressed, close behind an easel. The figure is rendered in the strong black outlines characteristic of Beckmann's rather flat painting style. Tight space presses in around the figure, conveying a claustrophobic sense that underscores Beckmann's physical presence and close proximity. His gaze is challenging, but it also creates a sense of immediacy in its directness.

The history of design in the early 20th century is a series of many stylistic currents, frequently overlapping and interacting. In Austria the craftsmen of the Wiener Werkstätte (1903–32) reacted against borrowing from the past, arguing that objects of daily use should be both functional and beautiful with simple ornamentation and priority given to geometric form. This approach influenced the Bauhaus, a German school that pioneered concepts of modern industrial design.

Chair

1904–06; Otto Wagner (Austrian, 1841–1918) designer; Gebrüder Thonet, manufacturer; Beechwood, plywood, and aluminum; height 77.4 cm (30 in.); Founders Society Purchase, Dr. and Mrs. George Kamperman Fund, and Honorarium and Memorial Gifts Fund; 1985.3

Wagner was the architect of the Österreichische Postsparkasse (Imperial Austrian Postal Savings Bank) constructed in Vienna from 1904 to 1906. Co-founder of the Wiener Werkstätte and one of the earliest proponents of functionalist design in the 20th century, he designed this armchair for the bank's board room from two materials that had never been used in this upper class environment before: bentwood and aluminum. Wagner used aluminum for both decorative and protective purposes, just as 18th-century cabinetmakers had used gilt bronze.

Cake Plate, Teacup, and Saucer

ca. 1915; Josef Hoffmann (Austrian, 1870–1956); Porcelain; Cake plate diameter 19.1 cm (7 1/2 in.); Founders Society Purchase, Jerome M. and Patricia J. Shaw Purchase Fund; 1985.13.1–.2

Flatware

ca. 1906; Josef Hoffmann (Austrian, 1870–1956); Silver plate; Knife 21.3 cm (8 3/8 in.); Founders Society Purchase, Benson and Edith Ford Fund, Mr. and Mrs. Alvan Macauley, Jr. Fund; 1985.33.1–.7

Hoffmann and Wagner founded the Wiener Werkstätte in 1903. Following the principles of the Wiener Werkstätte, the objects designed by Hoffmann have simple functional forms like the complete silver-plate Flatware place setting. Also following the Wiener Werkstätte concept, he used geometric form as decoration.

Loving Cup with Cover

1909; Carl Otto Czeschka (Austrian, 1878–1960); Gilt silver with lapis lazuli; height 24.5 cm (9 3/4 in.); Gift of Mr. George G. Booth; 23.161

Although Czeschka designed for the Wiener Werkstätte, he turned from the purist style of the Werkstätte to an eclectic individualism. Up until about 1907, Werkstätte production had been dominated by architectural principles, but after that period simple surface planes and structural forms were often abandoned in favor of complex plays of all-consuming pattern as seen on the base of this cup.

Wall Hanging

1926–27; Gunta Stölzl (German, 1897–1983); Cotton, silk, and synthetic threads; height 1.8 m (71 in.); Founders Society Purchase, Octavia W. Bates Fund, and Matilda R. Wilson Fund; 1987.38

Stölzl began her studies at the Bauhaus in 1919, participating in the development of the weaving department as an instruction workshop. From 1926 to 1931 she was a teacher in the textile workshop of the Bauhaus, which cooperated with industry by utilizing synthetic materials that had not previously been used for textiles. The workshop experimented with the possibilities of technical improvements in textiles in respect to the wear and tear quality of the material.

Pablo Ruiz y Picasso

Born in Malaga, Spain, in 1881, Picasso spent his youth in Barcelona, first visited Paris in 1900, and settled there in 1904. With Georges Braque, he invented cubism, a style that seemed to analyze and then reconstruct the visual world in a jigsaw composition. Ever leading, never following, Picasso kept discovering new ways in which to portray the world until his death at ninety-two in 1973. No artist has had a more profound effect on painting and sculpture in this century.

Bottle of Anis del Mono

1915; Oil on canvas; 46 x 54.6 cm (18 1/8 x 21 1/2 in.); Bequest of Robert Hudson Tannahil; 70.192

Picasso's synthetic cubism is elegantly exemplified by these objects on a tilted pedestal table, painted by laying down dots and dashes with the tip of the brush. This painting may be a self-portrait in disguise: the elongated bottle resembles a harlequin, the artist's favorite motif, and the trompe l'oeil nameplate with "Picasso" underscores this possibility. It is also supported by the silhouette of a blue bird, the still life's secondary feature, thought to represent the expiring soul of Eva Gouel, the artist's companion, then dying in a Paris hospital.

Melancholy Woman

1902; Oil on canvas; 1 m x 69.2 cm (39 3/8 x 27 1/4 in.); Bequest of Robert Hudson Tannahill; 70.190

Throughout 1902, living in Barcelona for lack of money, Picasso painted scenes of deprivation and depression, haunted by a close friend's suicide in Paris and by the memory of sketching prostitutes at the women's prison of St. Lazare. Blue was rich in associations for the turn-of-the-century Symbolists, suggesting night, evil, and death; it invaded the young artist's palette at this time. *Melancholy Woman* probably portrays the mistress of his dead friend; a woman to whom Picasso himself felt attracted. She is shown in the guise of an inmate morosely staring at the wall of her cell.

For a gouache by Picasso, see page 249.

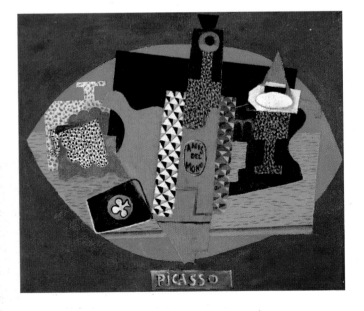

Fruit, Carafe, and Glass

1938; Oil on canvas; 65.1 x 81.3 cm
(25 5/8 x 32 in.); Bequest of W.
Hawkins Ferry; 1988.178

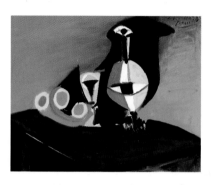

Woman in an Armchair

1923; Oil on canvas; 1.3 m x
97.2 cm (51 1/4 x 38 1/4 in.);
Bequest of Robert Hudson
Tannahill; 70.193

During the latter half of 1922, Picasso's style underwent a
change. He abandoned the earlier, heavy-limbed women and
injected his new subjects with a grace reminiscent of the
High Renaissance. Recent scholarship has uncovered that
the object of the artist's gently melancholic attention was
the spirited Sara, who was married to the American painter
and socialite Gerald Murphy. It can now be assumed that
this three-quarter length portrait is a "Romanized" version
of the woman who stole Picasso's heart on the beach at
Cap d'Antibes in the south of France.

Nature morte, the French word for
still life, has been used at times as a
vehicle to carry the symbolic freight
of man's mortality. In the final months
of 1938, troops of the reactionary
dictator Franco were winning in Spain
and in Barcelona the artist's mother
was close to death. It is no coinci-
dence, therefore, that this grouping of
objects on a table is painted in the red,
yellow, and black of the Spanish flag
and that it casts an ominous shadow
into the room's mournful purple corner.

Seated Woman

1960; Oil on canvas; 1.5 x 1.1 m (57
1/2 x 45 in.); Bequest of W. Hawkins
Ferry; 1988.176

In 1954 Picasso met Jacqueline Roque
who became his wife shortly after this
portrait was painted. That year, at
the castle of Vauvenargues, the artist
devoted a dozen life-size portraits to
Jacqueline. In a cavernous room,
divided by sun and shade, his slender
fiancée fills a capacious Louis XV-style
armchair. Returning to his 1930s
stylistic distortions, Picasso shows Jac-
queline's head both frontally and from
the sides, evoking, with the sly hint
of a man who knows, the three faces of
Eve locked in a conspiratory huddle.

In a letter, Matisse described this painting: "Through the window of the drawing room one sees the green of the garden and a black tree trunk, a basket of forget-me-nots on the table, a garden chair and a rug...The picture is green and white with some accents, blue for the forget-me-nots, and red for the zigzag in the rug; the table is red, too."

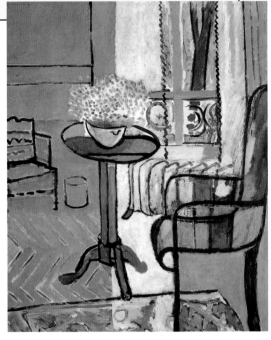

The Window

1916; Henri Matisse (French, 1869–1954); Oil on canvas; 1.5 x 1.2 m (57 1/2 x 46 in.); City of Detroit Purchase; 22.14

Indicative of the abstracting power of Matisse's vision are the parallel white curtains, fringed in black; the left one, as it transmits the sunlight, divides the room in two. The tilt of the glass-topped tripod table, the flattening of the parquet floor and turquoise wall into one unified plane, and the rug's perpendicular position are hints that Matisse was challenging the Cubists and their distorted perspective.

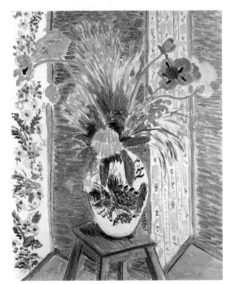

Poppies

1919; Henri Matisse (French, 1869–1954); Oil on canvas; 1 m x 81.3 cm (39 5/8 x 32 in.); Bequest of Robert Hudson Tannahill; 70.175

Leaving Nice where he had rented a room at the Hôtel Méditerranée, Matisse returned to the family home at Issy-les-Moulineaux near Paris to pass the summer there. Quite naturally he turned to what gave the country its charm, flowers from the garden and the bric à brac of domestic comfort. Matisse devoted more of the composition to the decorative play of patterns by drawing from his extensive collection of wall hangings, folding screens, and carpets. In *Poppies* the flamboyant June blossoms arch across the picture plane like fireworks fanning out across a night sky. The blue and white Chinese porcelain vase rests on a plain wooden stool whose tilted top pushes the bouquet toward the viewer. The angular stool and the zig-zag of the four-paneled folding screen in the background serve as foils for the curving, organic shapes of the vase and its flowers.

Flora, Nude

1910–11; Aristide Maillol (French, 1861–1944);
Bronze; height 1.7 m (67 in.); Gift of Ben L.
Silberstein; 76.77

This full-length sculpture of a young woman
is a preparatory study for the four life-size
nudes, representing the seasons, commis-
sioned by the pre-Bolshevik Moscow collector
Ivan Morosoff. Maillol, by then at the height
of his creative powers and a calm and classi-
cal alternative to Rodin, was aesthetically
akin to Matisse, Morosoff's favorite painter.
Both were firmly planted in Mediterranean
soil and instinctively drawn to modeling.
Maillol's subjects, the earthy nudes no less
than the woodcuts he began making after a
1908 journey to Greece with Count Kessler,
for that patron's sumptuously produced
Eclogues of Virgil, were inspired by antiquity.
Flora, Nude has a slightly later, dressed
counterpart. In her youth, Dina
Vierny, Maillol's dealer and
biographer, served as the
model for both sculptures.

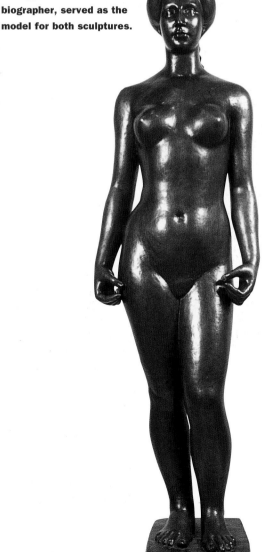

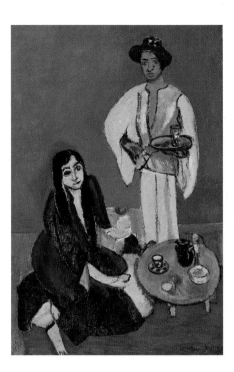

Oriental Lunch

1917; Henri Matisse (French, 1869–1954);
Oil on canvas; 1 m x 65.4 cm (39 5/8 x 25
3/4 in.); Bequest of Robert Hudson Tannahill;
70.174

Just before moving to Nice at the end of
1917, Matisse divided his time between
the family residence at Issy-les-Moulineaux
and his studio on the Quai St. Michel in
Paris. Though *Oriental Lunch* may have been
painted at either location, the subject makes
it clear that the artist's mind was on Morocco
where he had spent the winter of 1912-13.
His favorite models, Lorette (seated) and
Aicha (standing), pose as mistress and
servant in a Moorish café scene dominated
by the earth's ocher and the sky's azure.
Matisse's years of residence in Nice on the
French Riviera and those immediately pre-
ceding it are crucial in terms of his develop-
ment of a new, simple, figurative style.

For a drawing by Matisse, see page 248.

Surrealism, the direct heir of dada, was first formulated in France principally as a literary movement. It attracted a complement of painters from 1927 onward; Jean Arp and Max Ernst were dadaists coopted by the surrealists. The purest contribution to surrealism's abstract language was made by Joan Miró and André Masson. On the sidelines, Joseph Cornell made boxes that were paradigms of surrealist poetry in word and image.

Moonmad

1944; Max Ernst (French, 1891–1976); Painted and varnished plaster; height 98 cm (38 1/2 in.); Founders Society Purchase with funds from Friends of Modern Art, and W. Hawkins Ferry Tribute Fund; 1986.102

In the summer of 1944, Max Ernst and his wife, the artist Dorothea Tanning, shared a house with their art dealer friend Julian Levy in Great River, Long Island. Ernst, having gone ahead, sent Levy a postcard reading "No Chess Set Available at the Village Store." When Levy arrived, he found Ernst, completely diverted from painting, making a chess set and some small-scale sculptures by pouring plaster into molds of tools and kitchen utensils. Similar implements are transformed into *Moonmad.*

Self Portrait II

1938; Joan Miró (Spanish, 1893–1983); Oil on burlap; 1.3 x 2 m (51 in. x 6 ft. x 5 in.); Gift of W. Hawkins Ferry; 66.66

In this surrealist version of a realistic self-portrait, Miró has abstracted and reduced the elements of his earlier composition so that the facial features are expressed uniquely through graphic symbols. For example, the long-lashed eyes are magnified into sunbursts or sharp-petaled daisies. These surrealist transcriptions of realistic features appear in pairs or as mirrored images. The black background, traditional in Spanish painting, heightens the brilliance of the primary colors projected against deep space. That illusionistic effect, however, is canceled by the coarse burlap surface showing through the paint and reclaiming its essential flatness.

Tanguy did not begin to paint until the age of twenty-six when two pictures by Giorgio de Chirico intrigued him so much that he jumped off a Paris bus to see them more closely.

Shadow Country

1927; Yves Tanguy (French, 1900–55); Oil on canvas; 99 x 80 cm (39 x 31 1/2 in.); Gift of Lydia Winston Malbin; 74.122

The unreal light, exaggerated perspective, and undefinable furnishings of Shadow Country, evocative of a seabed littered with coral rock and the desiccated remains of marine life, may well have their origin in the artist's wistfully remembered seaside vacations in Brittany where dolmens and menhirs lined the shore. Tanguy offered a vision of a world frozen in time where gravity is suspended and human life exists as only a memory.

Night Songs

1953–55; Joseph Cornell (American, 1903–72); Mixed media; height 26 cm (10 1/4 in.); Founders Society Purchase, W. Hawkins Ferry Fund, Catherine Kresge Dewey Fund, Gift of Mrs. George Kamperman, by exchange; 1993.77

Cornell's boxes fuse found objects and cutout images into exquisitely constructed miniature theaters for children and adults alike. He was the first American artist whom the surrealists embraced, arguably because he used their strategies of working with minimally altered objects and slyly refigured images.

Night Songs alludes to the tragic romance of an anonymous Florentine youth, depicted in a painting once attributed to Caravaggio.

Building Abstraction, Lancaster, 1931

1931; Charles Demuth (American, 1883–1935); Oil on panel; 70.8 x 60 cm (27 7/8 x 23 5/8 in.); Founders Society Purchase, General Membership Fund; 54.118

The title Demuth gave to this skyline view of the small town in which he was born, and to an industrialized version to which he later returned, is as terse and concise as the painting itself. The artist employs the directional lines, analytical structure, transparent planes, and incidental lettering pioneered by the cubists. He was also familiar with adaptations of cubism by the Purist painters Jeanneret and Ozenfant who introduced the modern machine look in the 1920s. The resultant style in the paintings of Charles Demuth and Charles Sheeler is known as "Precisionism," an art of photographic clarity and puritanical restraint, steeped in geometric abstraction.

Log Jam, Penobscot Bay

1940–41; Marsden Hartley (American, 1877–1943); Oil on canvas; 76.4 cm x 1 m (30 x 40 7/8 in.); Gift of Robert H. Tannahill; 44.5

The Penobscot River, an important source of power for pulpwood and paper mills, empties out into the Atlantic Ocean in central Maine. Nature wreaks havoc on man's industry in this desolate corner of the artist's native state where he spent his summers painting. In this late, expressionistic picture an immovable mass of starkly drawn logs has piled onto shore, trapping a barrel, a spool, two bottles, and a shoe.

With the typical northern New England elements of water, sky, rocks, and timber, Marsden Hartley had fashioned a style indebted no less to Cézanne's landscapes than to the German Expressionist painters he befriended prior to the war. Hartley exemplifies the American Modernist's direct attitude toward subject matter. He permitted himself only minor formal alterations to instill the emotive power and mystical élan characteristic of American landscape painters and abstract painters alike.

The *Detroit Industry* fresco cycle in Rivera Court is the finest example of Mexican muralist work in the United States; Rivera considered it the most successful work of his career. In 1932, when Rivera was well known in the United States as one of the leaders of the Mexican muralist movement, he was commissioned by Edsel Ford, president of the Arts Commission as well as of Ford Motor Company, and Dr. William Valentiner, director of the DIA, to create two murals for the museum in its Garden Court.

The only stipulation of the project agreement was that the theme of the murals should relate to the history of Detroit and the development of industry. Rivera was so captivated by Detroit and Ford's Rouge industrial complex that he soon suggested painting murals on all four walls.

Garden Court in 1927 (right)

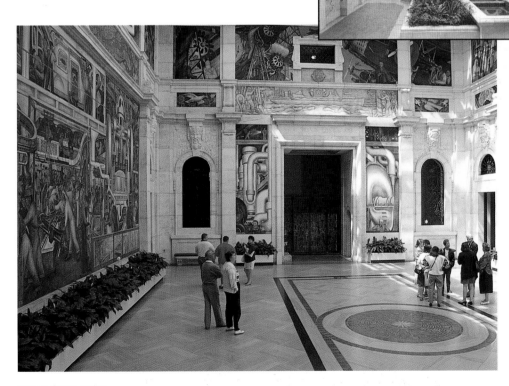

Rivera Court today

Rivera and his wife, the painter Frida Kahlo, arrived in Detroit in April 1932 and spent over a month studying the Ford Rouge automotive plant, taking photographs and observing. By mid-June Rivera was ready to begin work on the murals themselves.

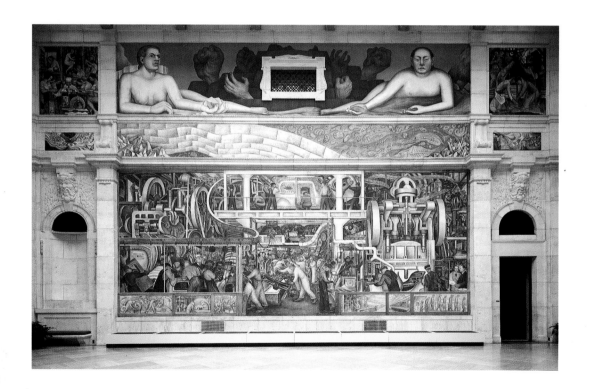

Detroit Industry, south wall

1932–33; Fresco, 13.1 x 20.4 m (43 x 67 ft.); Gift of Edsel B. Ford; 33.10

The major panel of the south wall is devoted to the production of the automobile's exterior. Unlike the north wall panel, this panel is not arranged sequentially, though all major operations are included. In the center distance, the finished car can be seen rolling off the assembly line. At the far right, Dr. William Valentiner and Edsel B. Ford hold a paper bearing the commission date and artist's signature.

Rivera spent approximately a month working on his preliminary designs, some of which are preserved in the DIA, and on July 25, 1932, he began to paint. The mural project took eight months to complete.

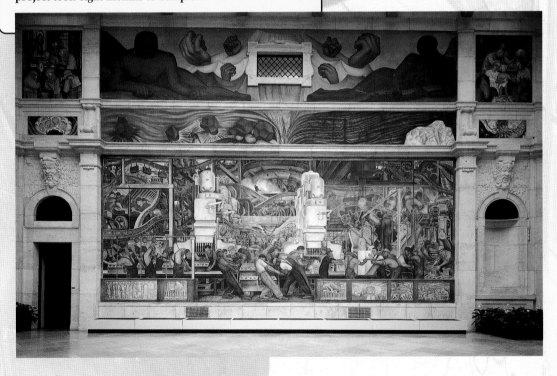

Detroit Industry, north wall

1933; Fresco, 13.1 x 20.4 m (43 x 67 ft.); Gift of Edsel B. Ford; 33.10

The north and south walls are devoted to three sets of images: the representation of the races that shape North American culture and make up its work force, the automobile industry, and the other industries of Detroit (medical, pharmaceutical, and chemical). At the bottom of the walls are small panels which depict the sequence of a day in the life of the workers at the Rouge. The central panel of the north wall represents important operations in the production and manufacture of the engine and transmission of the 1932 Ford V8.

DIA 20TH–CENTURY ART RIVERA COURT

Detroit Industry, east wall

1932; Fresco, 13.1 x 15.2 m (43 x 50 ft.); Gift of Edsel B. Ford; 33.10

Rivera's fresco cycle begins on the east wall, where the origins of human life and of technology are represented. The child in the plant bulb at center (referred to as a "germ cell" by Rivera), representing human birth, is flanked by symbols of agriculture, the first form of technology. The fruits, grains, and vegetables represented are all indigenous to Michigan. The themes of dependence on the resources of the land and the evolution of technology are developed throughout the fresco cycle.

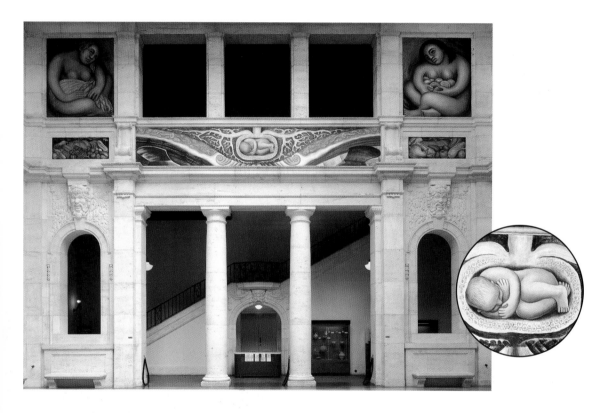

Rivera made large drawings to scale for these frescos. After being lost for many years, they were discovered in a storage area in 1978.

Detroit Industry, west wall

1932–33; Fresco, 13.1 x 15.2 m (43 x 50 ft.); Gift of Edsel B. Ford; 33.10

The themes established on the east wall are continued on the west wall, where the technologies of the air (aviation) and water (shipping and pleasure boating) are represented in the upper panels. The half-face/half-skull in the central monochrome panel symbolizes both the coexistence of life and death as well as humanity's spiritual and physical aspects, while the star symbolizes aspirations and hope for civilization. This heraldic image introduces another major theme of the cycle: the dual qualities of human beings, of nature, and of technology. Vertical panels on each side of the west entrance to the court introduce the automobile industry theme through the representation of Power House No. I, the energy source for the Rouge complex.

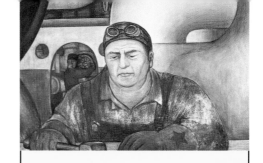

At the bottom of the vertical panels, the worker depicted is a generalized self portrait of Rivera, while the engineer is a composite portrait of Henry Ford and Thomas Edison.

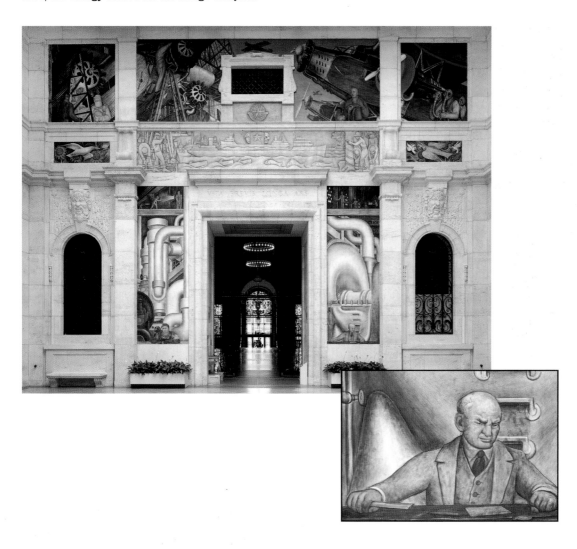

Reclining Figure

1939; Henry Moore (English, 1898–1986); Elm; height 94 cm (37 in.); Gift of the Dexter M. Ferry, Jr. Trustee Corporation; 65.108

Like many pioneers of 20th-century art, Henry Moore drew greater inspiration from the primitive and archaic than from classical sources, lending his sculpture a timelessness that guaranteed its endurance in an age of changing fashions. The reclining female nude was Moore's favorite subject. Treating the female form like the earth from which, in myth, it had been molded, the sculptor transformed female curves and cavities into a metaphor for terrestrial hills and dales. Moore attracted the attention of the surrealists and of the psychoanalyst Carl Jung because of his use of biomorphic forms, archetypal imagery, and his awareness of the collective unconscious. *Reclining Figure* is one of the rare major sculptures by Moore carved in wood.

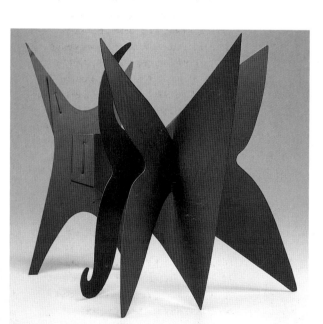

The X and Its Tails

1967; Alexander Calder (American, 1898–1976); Painted steel; height 3 m (10 ft.); Gift of W. Hawkins Ferry; 67.113

The literal and the whimsical meet in *The X and Its Tails*. Long before the Minimalists talked about lifting sculpture off its pedestal, the pragmatist Alexander Calder made some sculptures hover in the air and other sculptures squat on the ground. Son and grandson of Philadelphia sculptors, Calder had been trained as an engineer but he drew the art world's attention in the 1920s with an animated circus built from wire figures and wooden toys.

Prompted by Mondrian's drastically simplified paintings, Calder began to experiment with free-standing abstract shapes and primary colors. Jean Arp gave them their name of "stabiles." Next, Calder cut leaflike shapes, reminiscent of Miró, from sheet metal, attached them to rods and suspended them from the ceiling. Marcel Duchamp obliged and called them "mobiles."

For Miró's *Self Portrait II*, see page 278.

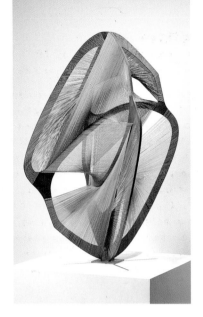

Space Modulator: Red over Black

1946; László Moholy-Nagy (American, 1895–1946); Oil on plastic; 46 x 64.8 cm (18 1/8 x 25 1/2 in.); Gift of W. Hawkins Ferry; 48.3

László Moholy-Nagy was a Hungarian contributor to the international style in Europe between the wars. The Bauhaus, an experimental art school in Germany, counted him among its star faculty. When the Nazis closed the school in 1933, Moholy-Nagy fled to Holland, then to England, and finally settled in Chicago where he founded an American version of the Bauhaus.

The 1940's innovative, war-driven technology and early notions about the conquest of space gave the undaunted immigrant artist a final boost of creative energy before leukemia ended his brilliant career. The plastic developed for airplane windshields and gun turrets provided Moholy-Nagy with the ideal material to mold, pierce, and engrave. The motif in *Space Modulator* derived from photographs the artist shot of the street below through the ornate railing of his balcony. The result, with its curvilinear shapes, parallel and crossing lines, and airy perforations, was abstract in a futuristic way.

Linear Construction in Space No. 4

1962; Naum Gabo (American, 1890–1977); Bronze, stainless steel, and piano wire; height including base 1.3 m (50 1/2 in.); Gift of W. Hawkins Ferry; 72.437

Naum Gabo and his brother, Antoine Pevsner, active supporters of the Russian Revolution, dreamed that through industrialization a new social order would emerge and that Russia would call upon its creative elite to guide it into the future. They drafted a document, the *Realist Manifesto* (1920), in which the principal tenets of constructivism were spelled out. As it turned out, their future lay elsewhere. One brother emigrated to Paris, the other to England and ultimately the United States.

Consistent with a rejection of solid form that dates back to the *Realist Manifesto*, Gabo defines the boundaries of his skeletal construction with two intersecting bronze ribbons that seem to embrace the maximum amount of space with the minimum amount of mass. Initially the artist had planned to attach a motor to its base to make the sculpture rotate which would permit viewing from all angles.

Europa and the Bull

ca. 1926; Carl Milles (American, 1875–1955); Bronze; height 80 cm (31 1/2 in.); City of Detroit Purchase; 29.357

This sculpture is a small-scale replica of the central figures of Milles's *Europa and the Bull* fountain in Halmstad, Sweden; erected in 1926, it was the first great fountain Milles designed. Stylistically, the Detroit bronze belongs to Milles's mature period, when he was no longer under the influence of French sculptor Auguste Rodin. The figures are characterized by smooth, simplified, and clearly defined forms. The monumental quality achieved by this approach is countered by the bull's upward thrusting pose and Europa's fluttering drapery, which energizes the grouping. Milles invites us to escape into the world of art and poetry with a modern reworking of the story from Greek mythology of Europa's adventurous ride. A rearranged version of the *Europa and the Bull* fountain also exists at the Cranbrook Academy of Art.

For works by Rodin, see pages 221 and 312.

The Moods of Time: Evening

1938; Paul Manship (American, 1885–1966); Bronze; height 1.1 m (44 in.); Founders Society Purchase, Mr. and Mrs. Allan Sheldon III Fund; 82.3

In 1936 Paul Manship was commissioned to execute four fountains, *The Moods of Time,* for the 1939–40 New York World's Fair. The works were intended to stand in front of the Trylon and Perisphere, the tower and spherical exhibition hall that were the visual and symbolic center of the fair. The scale model of each of the fountains was cast in bronze. In Manship's own view, *The Moods of Time* "particularize man's earthly concept of time in relationship to the movement of the sun." Evening, for the artist, was a time of inertia, halfway between wakefulness and sleep. The figure is relaxed and fluid, falling asleep, surrounded by owls—the birds of the night—and by cloud forms—the shadows of evening.

The Piper

1953; Hughie Lee-Smith (American, born 1915); Oil on canvas; 55.9 x 89.5 cm (22 x 35 1/4 in.); Gift of Mr. and Mrs. Stanley Winkleman; 66.391

Lee-Smith, an African-American painter who grew up in Cleveland, lived and worked in Detroit between the years 1945 and 1958. *The Piper* explores the loneliness of the urban individual and the psychological alienation of the young. Personal symbolism guides the formal construction of this work: the wall, an indicator of the difficulty of escape; the young boy, a metaphor for mankind; and music, a symbol of the longing to break free. The crumbling wall is in the shadow of a modernist building, suggesting the plight of the urban poor left behind by the growing city.

Sea Boots

1976; Andrew Wyeth (American, born 1917); Tempera on panel; 73.7 x 50.2 cm (29 x 19 3/4 in.); Founders Society Purchase with funds from Mr. and Mrs. James A. Beresford; 77.12

Andrew Wyeth is perhaps best known for his realistic landscapes of two areas he knows intimately: Pennsylvania's Brandywine Valley and Cushing, Maine. He is equally recognized as a portraitist who paints only his friends. *Sea Boots* is a portrait of sorts, characterizing Maine lobsterman Walt Anderson, one of the artist's closest friends; the boots depicted belong to Anderson, and it is likely that the weathered gable in the background is a portion of Anderson's house. Working in his favorite medium of tempera on masonite panel, his painstaking attention to detail and meticulous brushwork lend the painting remarkable verisimilitude.

Abstract Expressionism

After World War II, New York artists drew upon the organic abstraction that characterized surrealism and experimented with an emphasis on gesture to create a powerful new style known as "Abstract Expressionism." This term has come to designate a group of artists who are linked by their creative vision. Abstract Expressionism takes two principal forms: Action painters who are concerned with the gesture of the brush and the texture of the paint; and Color Field painters who create an abstract sign or image through large, unbroken areas of color.

Portrait of Pegeen

1942–43; Richard Pousette-Dart (American, 1916–92); Oil on linen; 1.2 x 1.3 m (50 x 52 in.); Founders Society Purchase, W. Hawkins Ferry Fund; 1989.71

In 1942 art patron Peggy Guggenheim invited Richard Pousette-Dart to exhibit at her New York gallery and paint a portrait of her teenage daughter Pegeen.

The right half of the painting mirrors, and formally dissolves, the firmly articulated left half. Pegeen's pony-tailed profile teems with biological activity even as it competes with the unmistakable presence of African sculpture: a Senufo face mask, a Kota reliquary figure, and a Bambara antelope can be seen in the painting's textured surface. Eyes abound as symbols of the young girl's curiosity.

For an African face mask, see page 34.

Tom

1959; Mark di Suvero (American, born 1933); Wood, metal, rope, and cable wire construction; height 2.7 m (9 ft.); Founders Society Purchase, Friends of Modern Art Fund, Mr. and Mrs. Walter Buhl Ford II Fund, and contribution from Samuel J. Wagstaff, Jr.; 74.5

Between 1959 and 1961, di Suvero made his first group of sculptures, seven large works constructed mostly of scavenged wood from nearby razed buildings, but also including chains and ropes. Full of burly energy and unlikely grace, Tom projects the powerful gestures of the Abstract Expressionists into three dimensions.

The Bay

1963; Helen Frankenthaler (American, born 1928); Acrylic on canvas;
2 x 2 m (6 ft. 8 3/4 in. x 6 ft. 8 3/4 in.); Gift of Dr. and Mrs. Hilbert H.
DeLawter; 65.60

The Bay **is the first of Frankenthaler's "stained" canvases, introduc-
ing a new direction for her painting. Painted in a studio alongside
Provincetown Bay, Massachusetts, the work evokes thoughts of water
and weather through color and abstract shape, rather than functioning
as a depiction of the actual bay. Frankenthaler applied the paint in
thin layers, allowing the edges to seep into the unprimed canvas and
creating form through both the deliberateness of the artist's gesture
and the unpredictable interaction of the materials.**

Merritt Parkway

1959; Willem de Kooning (American, born 1904); Oil on canvas; 2 x 1.8 m
(6 ft. 8 in. x 5 ft. 10 1/2 in.); Bequest of W. Hawkins Ferry; 1988.177

**Unlike his contemporaries Jackson Pollock and Mark
Rothko, de Kooning's paintings refer to natural forms and
specific places or events, pushed into pure abstraction
by his reliance on color and the deep build-up of paint to
create form. Depth and perspective are subordinated
to the flattening effects of his slashing, violent brush-
work. Some of the "abstract landscapes" from 1957–63
are based on the landscape around Long Island Sound,
including Merritt Parkway, a local highway. Speed is
suggested by the controlled thrusts of the brush while
the naturalistic palette conveys the criss-cross of the
road through the landscape.**

Siskind

1958; Franz Kline (American, 1910–62); Oil on canvas; 2 x 2.8 m
(80 x 111 in.); Founders Society Purchase, W. Hawkins Ferry
Fund; 65.7

**Like his friend de Kooning, Kline used abstraction to com-
memorate specific people, places, or events. Dynamic line
and powerful brushstrokes loaded with paint reduce his
compositions to a few large forms. Both the white and black
areas seem to project from the work with equal force; this
dramatic surface tension releases and yet controls the energy
of his process. Kline's dialogue of black and white in *Siskind*
evokes the abstract photographs of Aaron Siskind, his close
friend, to whom this work is dedicated.**

Be I

1970; Barnett Newman (American, 1905–70); Acrylic on canvas;
2.8 x 2.1 m (9 ft. 3 1/2 in. x 7 ft.); Founders Society Purchase,
W. Hawkins Ferry Fund, and Mr. and Mrs. Walter Buhl Ford II
Fund; 76.78

**Newman has described the dark cadium red of this painting
as a symbolic reference to the earth. The unmodulated,
painstakingly applied color is interrupted by the precisely
centered white stripe, which he called a "zip." The "zip" sug-
gests an instantaneous moment, like a flash of lightning,
which enlivens the enveloping spell of the red field. The title
connotes existence or being, reduced to a single compelling
command: Be! This painting, one of the artist's last completed
works, is a later version of a similar painting of 1949 that
was damaged beyond repair.**

Elegy to the Spanish Republic #131

1974; Robert Motherwell (American, 1915–91); Oil on canvas; 2.4 x 3 m (96 x 120 in.); Gift of W. Hawkins Ferry; 77.48

Robert Motherwell's most acclaimed series of works is a group of more than 150 "Elegy to the Spanish Republic" paintings originally created in 1948 to accompany a poem by Harold Rosenberg titled "Elegy to the Spanish Republic I." The motif, alternating black vertical rectangles and suspended ovoid forms against a white or gray background, has had many symbolic translations but it is meant to express the savage in the human soul. This painting was created during a dramatic revival period of the "Elegies" theme. It exemplifies Abstract Expressionist painting with its combination of primitive rawness and sophisticated elegance and its effect of huge, spontaneous brushstrokes.

Before, Again II

1985; Joan Mitchell (American, 1926–92); Oil on canvas; 2.8 x 2 m (9 ft. 2 in. x 6 ft. 6 3/4 in.); Founders Society Purchase with funds given in memory of Henry Ford II by his sister, Josephine F. Ford; 1988.18

Known as a "second generation" Abstract Expressionist, Mitchell left New York for Paris in 1959, just as this movement began to be hailed as the "new American painting." She was unapologetic in her preference for living in France and her work reflects the French landscape tradition and the paintings of Claude Monet in particular. In her paintings from the late 1970s through the mid 1980s, Mitchell refined her technique to overlapping, calligraphic lines, evoking images of flower-covered hills. *Before, Again II* is painted in intense colors, laid across the canvas in short strokes and long drips with enormous freedom and luminous effect. The artist described *Before, Again II,* painted during an illness, as a preoccupation with mortality, but one that reaffirms life and defeats death.

Study for Nude

1952; Francis Bacon (English, 1910–92); Oil and sand on canvas; 2 x 1.4 m (6 ft. x 54 in.); Gift of Dr. William R. Valentiner; 55.353

Few painters have defined the post-World War II era with its existential loathing better than Francis Bacon, the brilliant son of an Irish horse trainer. His breakthrough came with a 1945 triptych, ostensibly a Crucifixion but more properly described as ghouls gathered around a spectacle of human degradation. An avowed homosexual, Bacon seemed preoccupied with the subject of male nudes, huddling alone or in groups in stifling enclosures. Bars and railings, as in *Study for Nude,* separate the incarcerated subject from the curious spectator. His scenes appear airless and contained within imaginary glass walls. The artist's asthmatic condition may have contributed to the aura of suffocation that weighs down these voyeuristic nightmares. The sources for Bacon's pictures are surprisingly diverse. He borrowed from Eisenstein's movie stills, Velasquez's court scenes, and Joyce's meandering writings, as well as from medical textbooks, the tabloids, and Muybridge's photographic experiments in motion.

Le plomb dans l'aile (Shot in the Wing)

1961; Jean Dubuffet (French, 1901–85); Oil on canvas; 1.9 x 2.5 m (6 ft. 2 1/2 in. x 8 ft. 2 3/4 in.); Gift of W. Hawkins Ferry; 69.1

Directly after World War II, Jean Dubuffet emerged as the most important French painter to speak for his generation. That his voice was seemingly inarticulate like the voices of small children, or even incoherent, as that of the severely mentally impaired, conforms to the expectation that the language of art is oracular. With his *art brut* or "art in the raw," Dubuffet sought to overhaul a visual language which, for too long, had followed idealized classical canons.

Le plomb dans l'aile was painted at the height of Europe's Existentialist crisis. The generally upbeat Parisian street theater has coagulated in a candy-colored mass of molten rock with a bird flapping its wings at the center of the picture, homunculi peering from cellular enclosures and cacophonous graffiti screeching like chalk on this urban blackboard.

Homage to the World

1966; Louise Nevelson (American, 1900–88); Painted wood;
2.6 x 8.7 m (8 ft. 6 in. x 28 ft. 8 in.); Founders Society Purchase,
Friends of Modern Art Fund, and other Founders Society Funds;
66.192

Nevelson built her "wall" sculptures from prefabricated wooden
boxes, stocking them with objects that she found around her: in
the case of *Homage to the World,* she used hat stands and table
legs. In her use of the "found object," she extended the legacy
of the wood constructions and collages of Picasso and his circle
after World War I, but pushed this idea to an architectural scale.
Her "walls" also owe a debt to the iconoclastic innovations of
American painters in the 1950s—notably Rothko, Still, and
Newman—for the increased scale, use of non-traditional materi-
als, and interest in creating an engulfing, sensuous environment.
In these works, Nevelson sought to create her own universe,
perhaps as a shelter from her personal loneliness. The uniform
coat of matte black paint that covers the "wall" suggests infinite
space, distance, mystery, and shadow.

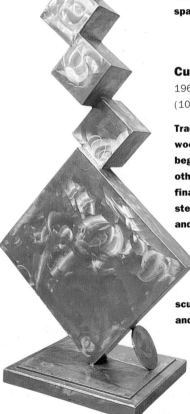

Cubi I

1963; David Smith (American, 1906–65); Stainless steel; height 3 m
(10 ft.); Founders Society Purchase, Special Purchases Fund; 66.36

Traditionally, sculpture was created by carving in stone or
wood or casting in bronze, but American sculptors in the 1950s
began to make "constructed sculptures" by welding, bolting, or
otherwise affixing elements together. *Cubi I,* the first of Smith's
final series of sculptures, is constructed of cubes of stainless
steel welded together, their surfaces polished to a high gloss
and then abraded. The burnishing allows the surface to take on,
without directly reflecting, the colors of the world around it.
By giving this work a strongly frontal orientation, Smith
plays with our perception of the difference between two-
and three-dimensional objects; our understanding of the
sculpture equivocates between flatness and bulk, between line
and volume, and between balance and weight.

DIA 20TH-CENTURY ART

Minimalism

A distinctly American movement that emerged in the 1960s, Minimalism is distinguished by its spare geometric shapes which reduce structures and materials to their essential forms. These non-representational objects were often fabricated by a manufacturer based on the artist's conception. The works are monochromatic, using either pure primary colors or leaving the material in its natural state. A unitary design, frequently based on a grid, was created out of symmetrical repeating forms. The simplicity of the clear, elemental forms tends to command the space around them, asserting an authoritative presence.

Modular Open Cube Pieces (9 x 9 x 9): Floor/Corner 2

1976; Sol LeWitt (American, born 1928); Painted wood; 1.1 x 1.1 x 1.1 m (43 1/2 x 43 1/2 x 43 1/2 in.); Founders Society Purchase, Friends of Modern Art Fund, and National Endowment for the Arts Matching Museum Purchase Grant; 76.83

Sol LeWitt utilized his interest in geometry and spatial relations to construct sculptures based on a grid form. Employing mathematical concepts, he joined open, identical cubes together to form proportionately larger units where the outline of the cubes suggests the completed volumes. The purity of the whole is reinforced by the monochrome white surface and the repetition of the simple, cubic forms.

Tomb of the Golden Engenderers

1976; Carl Andre (American, born 1935); Western red cedar wood; 91.4 cm x 2.7 m x 91.4 cm (36 in. x 9 ft. x 36 in.); Founders Society Purchase, Friends of Modern Art Fund, Mr. and Mrs. Walter Buhl Ford II Fund, and National Endowment for the Arts Matching Museum Purchase Grant; 78.68

Carl Andre uses ordinary materials, such as pieces of uncarved wood, to create his sculptures, arranging them in simple, geometric patterns that are held together by gravity and balance. He positioned the solid pieces of wood in a rectangular shape and did not use any color to preserve the purity of the wood's natural state.

Blue Red

1964; Ellsworth Kelly (American, born 1923); Oil on canvas;
1.8 x 1.5 m (72 x 58 in.); Gift of W. Hawkins Ferry; 75.32

**Ellsworth Kelly was a precursor of Minimalism,
developing his own "hard-edge" style of painting which
reduced geometric elements to their most basic state.
The smooth, blue oblong shape lies flatly against the
contrasting monochrome red surface, showing no signs
of depth or illusionistic space.
The only compositional element is
the relationship between the
colors which replaces any repre-
sentational meaning or content.**

Monument for V. Tatlin

1969; Dan Flavin (American, born 1933); Fluorescent
tubes; height 3 m (9 ft. 11 in.); Founders Society Purchase,
James F. Duffy, Jr. Fund, and National Endowment for the
Arts Matching Museum Purchase Grant; 80.104

**One of the first artists to exper-
iment with light as a medium,
Flavin places seven fluorescent
tubes in a symmetrical, vertical
arrangement. This work is one
in a series of tributes he made to
the Russian constructivist artist
Vladimir Tatlin and his colossal
sculpture Monument to the Third
International.**

Stack

1968; Donald Judd (American,
1928–94); Stainless steel,
plastic; height 4.3 m (14 ft. 3 in.);
Founders Society Purchase,
Friends of Modern Art Fund; 69.50

**Donald Judd's sculptures
with their austere, geometric
forms and monochrome colors
epitomize the Minimalist
aesthetic. Repeating the same
basic box form in a symmetrical
arrangement unites the com-
position into a single structure
while its large scale commands
the space. Judd had all of his
works industrially fabricated so
that each box shape would be
identical, leaving no sign of the
artist's handling of the work.**

DIA 20TH-CENTURY ART MINIMALISM

The Blind Leading the Blind

1949; Louise Bourgeois (American, born 1911); Wood and stain; height 2.1 m (84 in.); Founders Society Purchase, Mr. and Mrs. Walter Buhl Ford II Fund; 79.2

In this sculpture, a single, angled lintel links the upright elements which the artist calls "personages"; she uses this abstracted human form as a highly personal totem. Created in her rooftop studio in New York City not long after she left France, this series of sculptures express her loneliness at being a foreigner in a strange city and her fears about her identity as mother, wife, and artist. The Detroit sculpture has six pairs of long, tapered legs, which appear to stand "on tiptoe" when viewed from one vantage point. From another, they are more firmly set on the ground. In either case, their delicate balance suggests an upward, not just forward, movement.

Sphère-Trâme

1962; François Morellet (French, born 1926); Stainless steel; height 2 m (80 in.); Founders Society Purchase, Thomas L. and Diane Schoenith Sculpture Fund; 1989.70

***Sphère-Trâme* employs the strategy that Morellet developed called superimposition. Based on a design by Morellet, fabricators welded circular, stainless steel grids together, which progressively lengthen in size toward the center to form a perfect sphere. This sphere hovers above the ground and, as movement activates the grid patterns, it affects the eye as a shimmer.**

Accession II

1967; Eva Hesse (American, 1936–70); Steel and rubber; 78.1 x 78.1 x 78.1 cm (30 3/4 x 30 3/4 x 30 3/4 in.); Founders Society Purchase, Friends of Modern Art Fund, and Miscellaneous Gifts Fund; 79.34

Eva Hesse was an influential artist of the Postminimalist movement that began in the late 1960s. Incorporating the Minimalist principles of reduced geometric forms and grid patterns as her foundation, she felt unsatisfied by their rigid masculine forms and sought out more flexible materials for greater expressive content. Because women were having difficulty being accepted in the art world,

Hesse struggled to reconcile what she felt to be her two opposing identities, the one as an artist, the other as a woman.

The result is the simple cube form with a systematic grid on the outside with a controlled and fixed appearance, while on the inside the tubing allows gravity and chance to pull it in different directions. This became a highly charged work for Hesse, symbolizing the detached state she maintained on the exterior in contrast with her chaotic feelings inside.

Site Uncertain–Non Site

1968; Robert Smithson (American, 1938–73); Metal bins and cannel coal; 38.1 cm x 2.3 m x 2.3 m (15 x 90 x 90 in.); Founders Society Purchase, Dr. and Mrs. George Kamperman Fund, and New Endowment Fund; 76.95

Smithson was intrigued with synthesizing two contradictory aspects of art: his ecological concerns with nature and geology, and his cynical notions about public art. The title of the work refers to the transfer of the rocks from their original "site" to a gallery or museum setting, which is the "non site." His use of the unconventional material of cannel coal draws attention to his preoccupation with the notion of entropy, which is the slow degradation of matter and energy.

His work is classified as part of the Postminimalist movement, which diverged from the highly structured principles of Minimalism. The steel bins reflect the Minimalist's rigid aesthetic of serial ordering; inside the bins, however, the order becomes chaotic as the cannel coal is not arranged in any particular configuration.

Stone Line

1978; Richard Long (English, born 1945); Texas corkstones; 14 cm x 1.6 x 10.4 m (5 1/2 in. x 5 ft. 4 in. x 12 ft.); Founders Society Purchase, Mr. and Mrs. Walter Buhl Ford II Fund; 80.56

Called a "landscape poet" in his native England, Richard Long wants to communicate his love and reverence for nature with the viewer. He begins his works by taking long walks through the countryside and then collects and arranges stones in simple, geometric shapes that symbolize the landscape through which he has traveled. In this work, Long arranged stones as a metaphor for a path, acting as a distance marker or token of passage.

Pop Art is a pictorial embrace of tabloid imagery, middle-class values, advertising, and the shorthand of cartoonists. Moreover, Pop Art is patriotic, flamboyant, optimistic, and a deliberate reaction to Abstract Expressionism's introspectiveness and tendency to pontificate.

Creek

1964; Robert Rauschenberg (American, born 1925); Screen print in oil on canvas; 1.8 x 2.4 m (6 x 8 ft.); Gift of W. Hawkins Ferry; 69.48

Rauschenberg integrated printing techniques, using photographs gleaned from newspapers and magazines and transferred to canvas by a silkscreen method, to continue the spirit of assemblage he had pioneered earlier. *Creek's* iconography balances the topical—space flight and the urban landscape—with the timeless—Rubens' *Venus before the Mirror.* Their juxtapositions are random, yet provocative enough to make the viewer speculate about the power of love and human feats. Rauschenberg's roots in painting are vividly evident in the expressively brushed passages and in the lyrical combination of colors.

For a print by Rauschenburg, see page 258.

The Construction Tunnel

1968; George Segal (American, born 1924); Wood, metal, and plaster; height 2.2 m (86 in.); Founders Society Purchase, Miscellaneous Gifts Fund; 70.658

Despite its title, this combination of plaster, scrap wood, and galvanized iron refers to demolition rather than construction. It represents that familiar sidewalk device of doors and lumber discards shielding pedestrians from flying debris. Typically, Segal juxtaposes a plaster figure cast from life with a found, but reconstructed, elemental contraption to create a sculpture that questions the viewer's assumptions about reality and art.

Standard Brand

1961; Stuart Davis (American, 1892–1964); Oil on canvas; 1.5 x 1.2 m (60 x 46 in.); Founders Society Purchase, General Membership Fund; 63.156

America's turn to an urban realism in the paintings of the Ash Can School, and European artists' experiments with form from cubism to Purism, determined where Stuart Davis was to find his subjects and in what idiom he would portray them. Davis's forms jostle for attention like flashing neon signs, reflecting America's fast beat and hard sell.

For more information on the Ash Can School, see pages 88–89.

Double Self Portrait

1967; Andy Warhol (American, 1928–87); Screen print in paint on canvas; 1.8 x 1.8 m (6 x 6 ft.); Founders Society Purchase, Friends of Modern Art Fund; 68.292

The close-up view of his own face in this pair of self portraits is a dead giveaway of a cheap photo booth. The rapt attention and the fingers touching his mouth are a mannerism borrowed from the poses matinee idols struck in the 1940s. The colors are chosen with pure indulgence. Despite those affectations, the artist allows us a glimpse of himself as an intensely private individual who hides behind his public persona.

Giant Three-Way Plug

1970; Claes Oldenburg (American, born 1929); Mahogany veneer over wood; height 1.5 m (58 3/4 in.); Founders Society Purchase, Friends of Modern Art Fund; 71.7

A monumental enlargement of a three-way electrical plug with an octagonal body and cylindrical side plugs, this figment of Oldenburg's Brobdingnagian imagination faces downward, safely above the viewer's head. In 1965 the artist built a three-way plug from cardboard, remembering that laying awake as a child he had imagined plugs, light switches, and faucets growing so big that they filled his bedroom.

A Closer Look

"I am trying to create a combination of reality and art," Oldenburg has said. *Giant Three-Way Plug* is a common object, "built in everyday materials, but qualified by an aesthetic intention."

Oldenburg's plug is over twenty-three times larger than a real three-way plug!

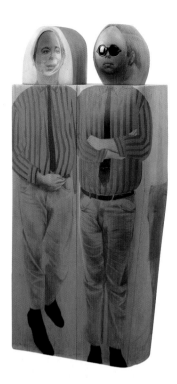

Interior with Mirrored Closet

1991; Roy Lichtenstein (American, born 1923); Oil and magna on canvas; 3 x 3.6 m (9 ft. 10 in. x 11 ft. 8 in.); Founders Society Purchase, Catherine Kresge Dewey Fund; 1992.1

Thirty years after delighting the art world with his cartoonlike imagery, speech balloons, ben-day dots, and process colors, Roy Lichtenstein put these familiar strategies to good use on a grand scale. The 1991 series of "Interiors" sports ultra-bright colors, crisp black outlines, shorthand dots, stripes, and dashes and wow! compositional devices.

Lichtenstein revels in the blandness and sleekness of the American vernacular and the formulaic treatment of home decoration in trade advertisements. But, with tongue-in-cheek matter-of-factness, he spikes those interiors with examples of his own past painting and sculpture.

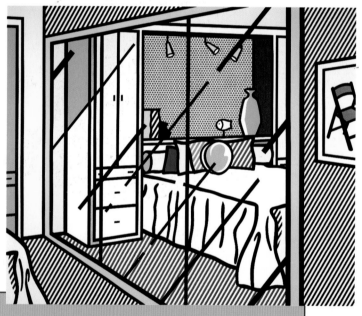

"I just looked in the Yellow Pages," Roy Lichtenstein answered, when asked where he found his inspiration.

Double Portrait of Henry Geldzahler

1967; Marisol (American, born 1930); Wood, paint, and graphite; height 1.7 m (66 in.); Gift of Mr. and Mrs. S. Brooks Barron; 1993.71

The art of assemblage, preceding Pop Art, was the aesthetic propellant for Marisol. She explained her two-dimensional approach to sculpture by conceding that she was untrained and a bad carver. She compensated by adopting a method that included odd pieces of cast-off carpentry, stick-on parts, face masks, cast body parts, and common objects of all kinds.

Fittingly, the artist chose as her subject Henry Geldzahler, the hip curator and critic who chronicled and sometimes participated in Happenings, Pop Art's theatrical sideshow. On two joined columns, the artist drew and painted differently posed versions of his head and striped-shirt-tie-and-pants-clad body.

Recycling

"As a witness of my society, I
have always been fascinated
by the pseudo-biological cycle
of production, consumption
and destruction."

Arman (Armand Fernandez)

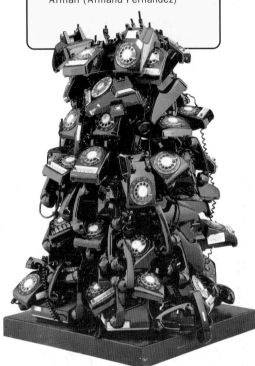

Parked

1987; Gilbert and George (English; Gilbert, born 1943, and
George, born 1942); Gelatin silverprints, pochoir colored;
3 x 3.5 m (9 ft. 11 in. x 11 ft. x 7 in.); Founders Society
Purchase with funds from Founders Junior Council and Friends
of Modern Art, in memory of Samuel J. Wagstaff, Jr.; 1988.11

**Gilbert and George met at London's St. Martin's School
of Art in 1967 and have been inseparable ever since.
In the 1970s Gilbert and George put on metallic make-up
and became "living sculptures." Standing atop a table,
they would sing a popular ditty, accompanied by an old-
fashioned gramophone.**

**Urban creatures by choice, Gilbert and George have sought
to identify with nature by portraying themselves, respect-
fully suited, against the backdrop of London's Kew Gardens.
Their poses are a tongue-in-cheek allusion to British poets'
search, in centuries past, for sustenance and renewal from
nature. *Parked* collapses the two meanings of the work
"park" into one as it shows the "living sculptures,"
stiffly seated one behind the other, to create a receding
perspective that draws our eye to a tree in bloom.**

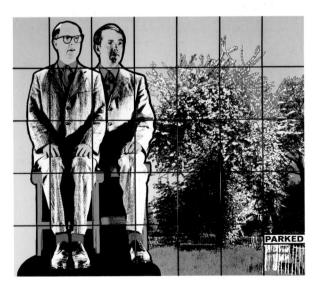

Office Fetish

1984; Arman (Armand Fernandez)
(American, born 1928); Telephones,
metal poles; height 1.3 m (53 in.); Gift
of Brant Thoroughbred Publications, Inc.;
1986.70

***Office Fetish* was commissioned by the
publisher of *Art in America* when the
magazine's offices were moved from
one Manhattan location to another.
As the traditional black telephones
were being replaced by state-of-the-art
equipment, Arman capitalized on the
instruments' associative qualities and
piled them into a critical mass. He
allowed the telephones to speak for
themselves, ring with the imagined
voices of artists and critics, editors and
printers, advertisers and distributors,
in a cacophony of "artspeak." The end
result is a tower of babble.**

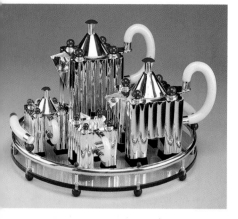

Over the past 150 years, numerous movements have fostered the elevation of the craftsperson's status from a mere tradesman to an artist. Exposed to the same ideas as fine-arts students in the 1970s, craftspeople deemphasized function in favor of innovative techniques and the conceptual concerns of contemporary painting and sculpture. The studio craft movement has manifested itself in unique or limited-edition works created primarily in small studio environments.

Coffee and Tea Service (prototype)

1981–83; Michael Graves (American, born 1934), designer; Alessi (Milan, Italy), manufacturer; Silver plate, laquered aluminum, Bakelite, mock ivory, and glass; coffee pot height 24.5 cm (9 5/8 in.); Founders Society Purchase with funds from Founders Junior Council, James F. Duffy, Jr. Fund, Lenora and Alfred Glancy Foundation Fund, Modern Decorative Arts and Sculpture Fund, Dr. and Mrs. George Kamperman Fund, Mr. and Mrs. Alvan Macauley, Jr., Fund; 1986.27

In 1979 eleven international architects were commissioned to design limited-edition tea and coffee services by the Italian firm Alessi. Every set had to include six pieces and had to function in the normal way. Perhaps not unexpectedly, many of the services look like tiny buildings or parts of buildings.

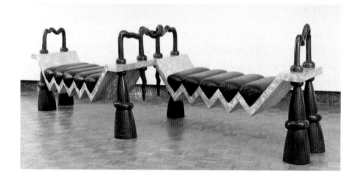

Bench

1988; Wendell Castle (American, born 1932); Amaranth (purpleheart), aluminum, and cowhide; height 88.9 cm (35 in.); Founders Society Purchase with funds from Art of Poland Associates; 1988.19

In 1986 the DIA commissioned furniture artist Wendell Castle to fashion a bench for the museum's permanent collection. Castle creates work that continually challenges accepted attitudes about the design, construction, and purpose of furniture.

The aluminum framework was the first element constructed. Castle then began carving the armrests in the middle of the bench and the six legs from stack-laminated forms. The outer portions of the arms are constructed using lamination in which small pieces of wood are arranged in formations like brick walls to strengthen the joints.

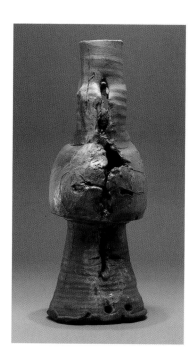

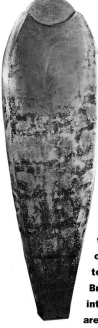

Flacon I

1989; Howard Ben Tré (American, born 1949); Cast glass, brass, gold leaf, pigmented waxes; height 1.3 m (50 in.); Founders Society Purchase, Lenora and Alfred Glancy Foundation Fund, Marvin and Betty Danto, Mrs. William B. Giles in memory of her husband, Modern Decorative Arts Group, Dorothy and Byron Gerson, and Jean Sosin; 1990.15

Ben Tré has broken away from other studio glass artists by working primarily in an industrial environment. He has perfected a series of sand-casting techniques which enables him to create large glass forms. In a factory in Brooklyn, New York, the molten glass is poured into resin-bonded sand molds. The glass forms are then returned to Ben Tré's studio in Providence where he sandblasts the glass and finishes the surfaces by adding copper and gold leaf, wax, and pigment. Ben Tré explores the translucent quality of the glass as it interacts with the metal core and gold leaf surface.

Untitled Stack Pot

1964; Peter Voulkos (American, born 1949); Stoneware, partially glazed; height 26.7 cm (30 in.); Founders Society Purchase, Miscellaneous Memorials Fund; 1985.28

Beginning in 1954 Voulkos created thousands of pots, constantly breaking out of the boundaries of what had been considered acceptable form in Western ceramics. This sculptural, non-functional piece is the earliest example of the distinctive "stack pot" form which Voulkos was to use extensively in the mid-1970s. It is one of the most important, expressionistic, and aggressive examples of Voulkos's muscular clay handling. The clay is torn, cut, drawn into, and assembled from thrown forms, with added patches of glaze painting.

Abakan 27

1967; Magdalena Abakanowicz (Polish, born 1930); Sisal; 1.5 x 1.8 m x 14.6 cm (57 3/8 x 71 3/4 x 5 3/4 in.); Gift of Jack Lenor Larsen; 80.17

In this early work, the unruly, knotty weaving by Abakanowicz breaks the bounds of traditional tapestry-making by departing from the flat-weave format. Similar to the expressionistic use of clay by Voulkos, she creates heavy, aggressively articulated, rough-surfaced, high-relief, fiber sculptures. Sisal provides visual and tactile interest and its coarse, stiff quality contributes to the stability of the intuitively conceived fabric structures.

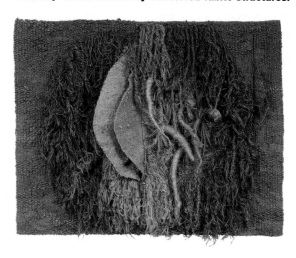

Cabalistic Painting

1983; Julian Schnabel (American, born 1951); Oil on velvet; 2.7 x 2.1 m (9 ft. x 84 in.); Founders Society Purchase, W. Hawkins Ferry Fund; 1992.16

Schnabel rose to prominence along with other Neo-Expressionists who used figurative content and appropriation to create a multitude of layered images taken from history, myths, and contemporary culture. Reviving religious and cultural archetypes, Schnabel uses an image from the Cabala, a system of interpretation of the Hebrew scriptures dating back to the 13th century. He incorporates imagery from both the Old and New Testaments, showing a man seated at a table on which sits an alembic and a torah. In a crystal vial, there seems to be a reflection of Saint John the Divine writing his Book of Revelation. Schnabel's unorthodox use of velvet for the background has historical connections with royalty and an association with kitsch-oriented souvenir pictures, especially black velvet canvases. His loose, streaked brushstrokes recall the gesture and emotion of the Abstract Expressionists in the 1950s, signaling a return to expression in both content and aesthetics.

Oranges on a Branch March 14, 1992

1992; Donald Sultan (American, born 1951); Tar, spackle, and oil on tiles over masonite; 2.4 x 2.4 m (96 x 96 in.); Founders Society Purchase, Catherine Kresge Dewey Fund, and W. Hawkins Ferry Fund; 1994.19

The boldly silhouetted oranges bursting with vivid color are in direct contrast to the thick black surface, provoking a passionate and powerful visual response in the viewer. The sense of drama in Sultan's works comes from his early interest in the theater, which he combines with his inspiration from other art movements, such as Abstract Expressionism, Color Field painting, and Minimalism. As part of the return to figuration in contemporary art in the 1980s, Sultan abstracts, simplifies, and stylizes this representation of painted oranges against a background made of tar and oil. His unorthodox use of these industrial materials symbolizes American industry, reinforced by his incorporation of vinyl tiles taken from office and factory floors. Looking at art from the past for inspiration, Sultan struck upon the traditional still life for his subject matter, with his choice of oranges as a twist on his trademark lemons, originally inspired by a painting by Eduoard Manet which he saw in a retrospective at the Metropolitan Museum of Art.

Quadro Feroce (Ferocious Picture)

1980; Enzo Cucchi (Italian, born 1950); Oil on canvas; 2 x 3.7 m (6 ft. 7 in. x 12 ft. 1/2 in.); Founders Society Purchase, Gift of Mrs. George Kamperman in memory of her husband, by exchange; 1992.212

A prominent member of the Italian branch of the Neo-Expressionist movement, or Transavanguardia, is Enzo Cucchi, who since 1980 has painted alone in an empty church near the Adriatic Sea. He tends to be skeptical about the world and rarely travels, but from his secluded vantage point, he takes pleasure in reading about myths and legends while contemplating the inspirational Italian countryside. The deep, lush colors of the landscape underscore the highly energized subject matter which produces an intense and evocative painting.

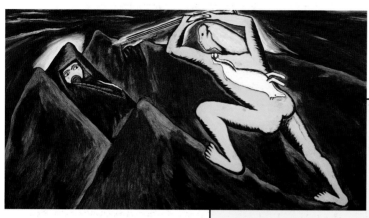

This work refers to the Greek myth in which the hunter Actaeon inadvertently observed the goddess Artemis bathing. She angrily turned him into a stag and he was killed by his own dogs. Here, the naked hunter is about to be crushed by the oncoming train, a metaphor for primitive man being defeated by the wheels of progress and civilization.

Ritiro (Withdrawal)

1991; Mimmo Paladino (Italian, born 1948); Painted bronze and silver; height 1.9 m (77 1/2 in.); Founders Society Purchase, W. Hawkins Ferry Fund; 1992.278

Neo-Expressionism was an international movement in the 1980s which brought back a more traditional style and figurative subject matter in both painting and sculpture. Paladino is among the original group in Italy that was coined the "Transavanguardia" by a critic. Transavanguarde artists appropriate images from Italian history and mythology as well as prehistoric, medieval, and primitive art along with Christian and pagan symbols for their subject matter. Paladino incorporates these themes in this sculpture, which is based on the standing figures of the classical world and wears an all seeing-masklike helmet.

Artists from Detroit

In the late 1960s the area in downtown Detroit known as the Cass Corridor was home to a group of visual artists, poets, writers, and musicians, who together became Detroit's first avant-garde. Their energy and iconoclastic spirit produced works that are a powerful vision of urban life. This aesthetic, which relied heavily on assemblage, collage, and the found object, reflects the troubled, complex, and spirited city.

Monument

1988; Gilda Snowden (American, born 1952); Encaustic on wood with found objects; height 1.9 m (76 in.); Founders Society Purchase, Chaim, Fanny, Louis, Benjamin, Anne, and Florence Kaufman Memorial Trust; 1990.300

A painter who also works with constructions and found objects, Snowden combines the formal issues of surface, texture, and geometric shape with personal history, emotion, and intuition. The death of both of her parents in 1987 led her to produce a series of assemblages, of which *Monument* is the last, dedicated to their memory. Covered with encaustic, a waxy medium which suggests age, these works are charged with personal symbolism that turns them into a "repository of memories."

Untitled

1990; Michael Luchs (American, born 1938); Caulk, latex, oil paint, and oil crayon on unsized linen; 2.2 x 1.3 m (85 x 52 1/2 in.); Founders Society Purchase with funds from the Friends of Modern Art in honor of Anne Markley Spivak; 1992.219

Luchs has shifted earlier imagery of an ensnared rabbit to a continuing obsession with hunted animals, expressing emotional wariness, entrapment, and self-doubt through his evocative juxtapositions of animals and handguns.

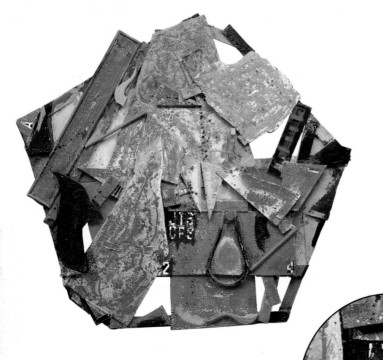

The Cat Approaches

1974; Brenda Goodman
(American, born 1943);
Oil and pencil on canvas;
167 x 129 cm (66 x 51
in.); Founders Society
Purchase, Mr. and Mrs.
Conrad H. Smith Memorial
Fund, and Gertrude Kasle
Gallery; 74.183

**The raw emotional power of
Goodman's work sets her apart
from others of the Cass Corridor
group. Her paintings from the
early 1970s are characterized by
cryptic images, particularly organic
shapes suggestive of body parts.
These recurring symbols, set in
fantastic combinations, explore
the anxiety of living in a threaten-
ing city as well as hinting at
personal tragedy.**

Caged Brain

1990; Tyree Guyton (American,
born 1955); Mixed media; height
40.6 cm (16 in.); Founders Society
Purchase, Twentieth-Century
Painting and Sculpture General
Fund, and Dr. and Mrs. George
Kamperman Fund; 1991.177

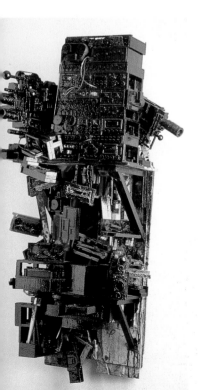

SDX Satellite Delay

1983–84; Gordon Newton (American,
born 1948); Wood, iron, styrofoam,
rubber, polyester resin, and oil paint;
height 1.9 m (76 in.); Gift of Mr.
and Mrs. S. Brooks Barron; 1988.24

**Newton intersperses his fascina-
tion with technology and machines
with his love of literature and
art history. *SDX Satellite Delay*
comments on our preoccupation
with technology in a work that
is both whimsical and frightening.**

**Guyton's art is based in the
modernist tradition of the found
object, in which an object is
disengaged from its normal use
and set into a new context by the
artist. *Caged Brain,* a battered
bird cage and dusty length of
rope, combines two discarded
ordinary objects into a work rich
with surreal associations and
ideas about the oppression of the
urban experience. Guyton is best
known for his major work, the
"Heidelberg Project," a several-
block "art environment" on
Detroit's east side.**

Prentis Court

Large 20th-century works of art are exhibited in Prentis Court, where the South Wing joins the main building. In addition to the paintings and sculpture seen here are pieces by Romare Bearden and Charles McGee.

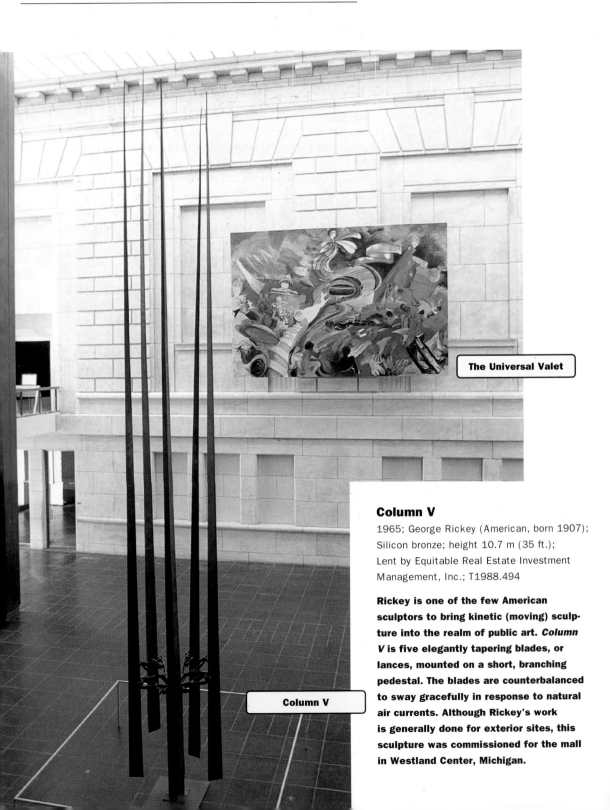

The Universal Valet

Column V

Column V

1965; George Rickey (American, born 1907); Silicon bronze; height 10.7 m (35 ft.); Lent by Equitable Real Estate Investment Management, Inc.; T1988.494

Rickey is one of the few American sculptors to bring kinetic (moving) sculpture into the realm of public art. *Column V* is five elegantly tapering blades, or lances, mounted on a short, branching pedestal. The blades are counterbalanced to sway gracefully in response to natural air currents. Although Rickey's work is generally done for exterior sites, this sculpture was commissioned for the mall in Westland Center, Michigan.

1992; James Rosenquist (American, born 1933); Oil on canvas; 2.3 x 7.9 m (7 ft. 6 in. x 29 ft. 2 in.); Founders Society Purchase, Gift of Mrs. George Kamperman, by exchange; 1993.62

Rosenquist's experience as a billboard painter contributed to a unique vision; his imagery shifts from telescopic to microscopic. Rosenquist bears witness to this country's triumphs and defeats, its explorations of outer space, and its inquiry into inner truths. Every four years since 1964, the artist has created a "Presidential Election" painting, a "reality check" on the viability and survival of the American Dream. Against a background of trade wars and star wars, *Masquerade* sets into perspective man's proclivity for destruction—the Stealth bomber—and nature's wondrous capacity for creation—the butterfly emerging from the caterpillar.

The Universal Valet

1983; Lucio Pozzi (American, born 1935); Oil on linen; 5 x 6 m (16 ft. 1/2 in. x 20 ft.); Founders Society Purchase, Catherine Kresge Dewey Acquisition Fund; 1993.1

In Italian, the term Universal Judgment is used for the Last Judgment. In an irreverent twist on man as God's servant, the artist replaced the traditional seat of Judgment with an all-seeing valet, or clothes hanger, in the center at the top. The damned are falling on God's left, in the red of eternal fire, and the saved are rising through the blue on his right. The kaleidoscope of figures that make up each scene are quoted from sources such as newspaper photographs of riots and the dream—or nightmare—worlds in the art of Bosch and Bruegel. Pozzi's vision of a world in chaos combines these visual references with personal symbolism and vestiges of his earlier abstract style.

Video Flag x

1985; Nam June Paik (American, born 1932); 84 10-inch television sets, video tapes, and plexiglass; 1.9 x 3.5 m (6 ft. 2 1/2 in. x 11 ft. 6 3/4 in.); Gift of Lila and Gilbert B. Silverman; F1986.40

Paik uses video as his art form to create rapidly moving images that combine to form the pattern of stars and stripes of the American flag. The television sets project a flickering series of predominantly red, white, and blue images meant to visually engage the viewer who is accustomed to the passivity associated with watching television. Paik emphasizes the pop cultural influences of America, the stars and stripes of the flag, and the television set, while making a metaphorical statement about the dominance of technology in the 20th century.

Sculpture on the Grounds

A number of large sculptures are displayed outside of the DIA; some of the individual original pieces are represented here. There are also reproductions in bronze of Donatello's *Saint George* and Michelangelo's *Slave* on the Woodward Avenue facade of the building. Two *River Gods* copied from sculpture in the gardens of the Palace of Versailles flank that entrance.

The Thinker

1904; Auguste Rodin (French, 1840-1917); Bronze; height 2 m (6 ft. 6 in.); Gift of Horace H. Rackham; 22.143

The Thinker was conceived as representing Dante, the central figure of Rodin's monumental *The Gates of Hell*. Rodin considered this figure in broad universal terms to symbolize the powerful internal struggle of the creative human mind. Rodin soon designed *The Thinker* as an independent sculpture. In 1904 he displayed the first over-life-size enlargement at the Paris Salon where Dr. Max Linde, a German collector, acquired cast no. 3. In 1922 Horace Rackham purchased this cast from Dr. Linde and donated it to the museum, where it is placed at the Woodward Avenue entrance.

"What makes my *Thinker* think is that he thinks not only with his brain, his distended nostrils, and compressed lips, but with every muscle of his arms, back and legs, with his clenched fist and gripping toes."

Auguste Rodin

Relocating *The Thinker* in 1981.

Normanno Wedge I

1982; Beverly Pepper (American, born 1924); Steel; height 5.2 m (17 ft.); Founders Society Purchase with funds from W. Hawkins Ferry Fund, Byron and Dorothy Gerson, Jerome and Margot Halperin, Maxwell and Marjorie Jospey, and William M. and Janis Wetsman; 1991.167

The title alludes to the invasion of Italy by the Normans in medieval times. The large wedge bears down on the conical base, but the squared ring between them resists its force.

Beverly Pepper began her career as a painter while living as an expatriate in Rome. Later, an intense visit to Angkor Wat inspired, and old tree trunks in her garden encouraged, the artist's first forays into sculpture. Yet her real breakthrough came with the possibility of working with industrial steel at the Italsider plant in Piombino, Italy.

Gracehoper

1971; Tony Smith (American, 1912–80); Welded steel
and paint; height 7 m (23 ft.); Founders Society Purchase
with funds from W. Hawkins Ferry, Mr. and Mrs. Walter
Buhl Ford II Fund, Eleanor Clay Ford Fund, Marie and Alex
Manoogian Fund, and members of Friends of Modern Art;
72.436

**Tony Smith came to sculpture from architecture
and design. About 1960 he turned his professional
attention to organically derived and then to crystalline
and modular three-dimensional forms. A friend of the
Abstract Expressionists, and a teacher who impressed
students by correlating the experience of art and
sculpture with that of life and the environment, Smith
saw his career take off late, almost contemporaneously
with that of Minimalists Judd and Andre.**

**Inspiration for *Gracehoper* goes back to 1963, a reflection on the
tetrahedrons and octahedrons Smith had encountered in crystallogra-
phy. One of his most complex sculptures, it took eight years for him
to realize it on the intended scale. The six separately fabricated steel
units were assembled on the museum's north lawn in 1972. The title,
a pun on the grasshopper it resembles, derives from the mythical
beast of the same name in James Joyce's *Finnegan's Wake*.**

Mozarabe

1971; Richard Serra (American, born
1939); Steel; height 2.4 m (96 in.);
Founders Society Purchase with funds
from W. Hawkins Ferry; 81.694

**With these muscular compounds Richard Serra aims for urban majesty
in a non-imitative, non-symbolic way. It is the counter-balancing of
the square plates that harnesses their downward force and keeps them
poised in a tenuous equilibrium. The viewer experiences Serra's steel
intrusions as potentially threatening, though harmless if left untouched.**

**"Mozarabe" refers to a type of stone building with angled apertures
similar to the ones in this piece. Those buildings can be found in Spain
where they go back to the Middle Ages when Arabs were gaining ground
on Christians and their two cultures were precariously balanced.**

The Detroit Film Theatre (DFT) serves as Detroit's premiere showcase for both modern and classic world cinema. It was established at the DIA in 1974 with a grant from the National Endowment for the Arts. Operating in the DIA Auditorium approximately forty weekends a year, the DFT series is one of the best-attended museum film programs in the United States. A Monday evening series presents historic, experimental, independent, and documentary films.

The Plainsman: Une aventure de Buffalo Bill
1936; French; lithograph; 160 x 121 cm (63 x 47 1/2 in.);
Gift of Mr. and Mrs. John C. Emery, Jr.; T1987.71

Many highly acclaimed films have premiered at the DFT and thematic series have been presented. All films are exhibited in their original format (film gauge, aspect ratio, language, and in the case of silent films, correct projection speed). Lectures and discussions by film artists and critics further enhance the audience's understanding and appreciation of the medium. Printed program notes are provided for all film screenings.

The Department of Film also has a collection of movie and vaudeville posters and approximately 10,000 still photographs from the Bill Kennedy and Detroit Film Theatre collections.

DFT Personal Appearances

Milos Forman

Robert Duvall

Andrew Sarris

Ousmane Sembène

Lizzie Borden

Autographed portrait of Orson Welles,
ca. 1935; Sepia print; 18 x 12.8 cm (7 x 5 in.);
Bill Kennedy Collection

The Auditorium

A prominent feature of the 1927 DIA building is the 1200 seat auditorium, originally planned as a venue for lectures on the arts and for performances of classical music. Museum architect Paul Cret collaborated with Detroit-based architect C. Howard Crane, whose specialty was the design and engineering of the lavish theaters of the 1920s, such as the Fox in downtown Detroit. The Auditorium combines Cret's sense of architectural design and appreciation for craftsmanship with Crane's engineering sophistication.

The front walls and ceiling of the auditorium were designed around the extensive pipes and bellows of a classical pipe organ built by the Cassavant Frères of Montreal. Among the many decorative elements are the wrought-iron grilles in the front lobby by Samuel Yellin and the colorful fountains and terracotta tiles along the staircases from Detroit's Pewabic Pottery.

Auditorium interior, 1927

The Auditorium has seen many different presentations in all of the performing arts over the decades. In the early 1930s the Auditorium was the location of a lecture and film series by world-renown explorers, including Admiral Richard Byrd and Amelia Earhart. The DIA was established as a center for the art of puppetry in the 1940s by Curator of Performing Arts Paul McPharlin, who built a large puppet collection. Established in the 1960s, the Detroit Youtheatre presented full seasons of children's theater performances in the Auditorium.

Auditorium

1925, architectural drawing
by Paul Philippe Cret
(American, 1876–1945)

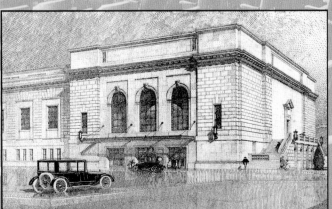

Frequently Asked Questions

How do I get to the DIA? Where can I park? At what times are you open? How much is admission? Can I get something to eat? Are tours available? Are there special classes for children? Do you have a gift shop?

The answers to all these questions are given in Museum Information on page 18.

Are wheelchairs available?

Yes, wheelchairs are available at the Farnsworth entrance.

How large is the DIA? How many people work there?

The DIA is the fourth largest museum in the United States, after the Metropolitan Museum of Art, New York, the National Gallery of Art, Washington, D.C., and the Art Institute of Chicago. The total size of the building is 596,000 square feet. Over 300 full-time and part-time staff and over 900 volunteers worked at the DIA in 1995.

What is in the DIA?

The DIA collects and exhibits works of art from all cultures and all time periods. These include paintings, sculptures, ceramics, furniture, metalwork, glass, fabrics, photographs, prints, and many other types of objects. The DIA also presents films, performing arts, and special exhibitions.

What should I wear to the DIA?

Dress comfortably (shoes and shirts are required) and be sure to wear good shoes for walking. The building covers two city blocks and there are galleries on three floors.

Can I take photographs?

You may photograph works in the DIA collection but you must ask for a permit when you arrive. You may not use a flash or tripod and photography is not allowed in special exhibitions.

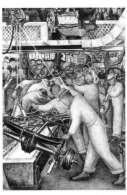

Detroit Industry (detail),
pages 282–285.

What should I see if I only have an hour to spend in the museum?

Highlights of the collection include the *Detroit Industry* frescoes in Rivera Court, the African and Native American galleries, the French and American 19th-century galleries, the 20th-century German Expressionist collection, the Italian galleries, the Flemish and Dutch galleries, and the Gothic chapel. You should decide to see whatever you think will interest you the most.

What do children especially enjoy seeing?

Most kids enjoy seeing the Egyptian mummies, European armor (left), and 20th-century art, such as *Video Flag x.* They also like going up and down the spiral staircase in the Gothic gallery and enjoy patting the *Donkey,* which is the only work of art anyone can touch.

Is everything in the DIA real?

Yes, everything in the DIA was made as an original one-of-a-kind object or to serve a specific function. In the case of prints and photographs, many copies of an image may exist, but these are created for a medium that can produce more

than one copy. Likewise, there may be more than one cast of a piece of sculpture.

The Wedding Dance, page 172.

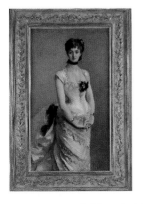

For the value of this painting in 1885, see page 78.

How much is all this art worth?

The value of any work of art increases or decreases over time depending on certain factors, such as the artist's popularity, the demand for his or her work, the condition of the object, and the rarity of it. For security reasons, monetary values assigned for insurance purposes are not public information.

Why is each wall in Kresge Court designed in a different way?

When the museum building was planned in the 1920s, the galleries dedicated to the art of each culture were built to look like architecture of that time period. The north wall is in the Gothic style and incorporates the Gothic Chapel; the east wall imitates the style of an Italian renaissance palace. The south wall is built in a Flemish style, and the west wall

suggests English architecture. The sculptures that decorate Kresge Court are mostly original French and Italian medieval and renaissance pieces.

A northeast view of Kresge Court.

What is a curator? What is a docent?

A curator is a person responsible for the care, selection, presentation, and interpretation of objects in a specific part of the collection. The DIA has many curators; each has studied a particular field in the history of art. Docents are volunteers who have been trained to give tours of the museum.

Who decides what art belongs in the DIA?

Curators propose works of art to add to the collection at the DIA. Works are purchased from art dealers or at auction or are gifts to the museum. A committee of museum board members reviews proposals to decide which works to accept for the collection.

Are the frames original?

Most paintings in the DIA are not exhibited in their original frames. Curators usually buy frames or have them made to resemble the ones used at the time the painting was made.

This is an original frame; see pages 72–73.

Why isn't my favorite work on display?

Works of art may be lent to an exhibition in another museum; they may be in the conservation laboratory for treatment; or they may be in storage since galleries are periodically changed to allow for more works to be on exhibit. We apologize for the inconvenience.

African art storage room.

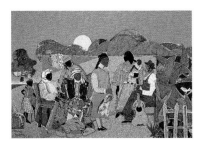

Quilting Time, 1986; Romare Bearden (American, 1914-1988); Glass tesserae; 2.9 x 4.3 m (9 ft. 6 in. x 14 ft); Founders Society Purchase with funds from the Detroit Edison Company; 1986.41

What works were made by African-American artists?

African-American artists whose works are found in this book are Romare Bearden, Tyree Guyton, Jacob Lawrence, Hughie Lee-Smith, Charles McGee, and Gilda Snowden. Included in the American Art collection are 19th-century works by Robert Duncanson, Edmonia Lewis, and Henry Ossawa Tanner; in the 20th-century collection there are works by Benny Andrews, Sam Gilliam, Richard Hunt, Al Loving, Joyce Scott, Thurman Statom, and Robert Thompson, among others. The Graphic Arts collection includes prints and photographs by Roy DeCarava, Glenn Ligon, P. H. Polk, Vincent Smith, James Van DerZee, and many others.

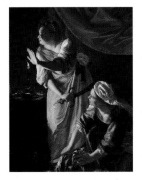

What works are by women artists?

The DIA owns works by several women artists living before the 20th century—those by Artemisia Gentileschi (left), Rosalba Carriera, Anna Claypool Peale, Lily Martin Spencer, Maria Oakey Dewing, and Mary Cassatt are included in this book. Our collection includes too many modern women artists to list here; see the 20th-century and Graphic Arts sections of this book. In addition, many pieces in the Native American collection were created by women (see pages 46–47).

Why does some modern art look like something a child can make?

Artists in the 20th century are free to record their personal versions of reality and to challenge the look of traditional works of art. As a result, modern art displays a variety of subject matter, styles, and material. Often the artist's intent is not readily apparent and some works of art deliberately raise the question: what is art?

Merritt Parkway, page 291.

Bacchus: see Dionysus

baldachin: a structure in the form of a canopy placed over an altar or a throne

baroque: a style that originated in 17th-century Italy and is characterized by dramatic effects of light and dark, exuberant decoration, and bold curving forms

candelabrum (pl. candelabra): a large, decorative candlestick having several arms or branches

Candelabrum, page 213.

chiaroscuro: in Italian, "chiaro" means "light" and "scuro" means "dark." The two words are joined to describe a painting or print with strong contrasts of light and dark

chinoiseries: Western imitations of Chinese, Japanese, or Korean art

classicism: a style using the principles of the art and architecture of ancient Greece and Rome, characterized by simplicity and a restrained use of ornament

constructivism/constructivist: an art movement beginning in Moscow in 1920 and characterized by the use of industrial materials such as glass, sheet metal, and plastic

cubism/cubist: a non-realistic style of art developed in Paris in the early 20th century and characterized by the reduction and breaking apart of forms into abstract shapes and geometric forms

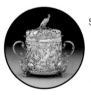

Cubist painting, page 274.

cuneiform: written characters originally formed in clay by small, wedge-shaped tools used in the ancient Near East

Cupid: the Roman god of love, called Eros in Greek; often a boy with wings, used as a symbol of love

dada: a European artistic and literary movement that rejected conventional values by producing works marked by random nonsense, travesty, and incongruity

Dionysus: the Greek god of wine, called Bacchus by the Romans

diptych: a work consisting of two painted or carved panels that are hinged together

Ivory diptych, page 158.

edition: the entire group of similar or identical works of art produced as a set

Eros: see Cupid

fresco (pl. frescoes): the method of painting on fresh, moist plaster with pigments dissolved in water; a painting made in this way

genre: representations of everyday life

gilded/gilding/gilt: covered with a thin layer of gold

Silver gilt cup, page 216.

gouache: a painting in non-transparent watercolors mixed with gummy material

Hellenistic: of or relating to post-classical Greek culture from the death of Alexander the Great in 323 B.C. to the accession of Augustus as the first Roman emperor in 27 B.C.

intaglio: an engraved or incised carving into a surface

krater: a bowl used for mixing wine and water

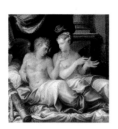

Mannerist painting, page 183.

mannerism/mannerist: a 16th-century European style characterized by curving and elegantly contorted forms and acid colors coupled with complex compositions

marquetry: a decorative veneer applied as an overlay to furniture and composed of shaped pieces of wood or other material to form a pattern

mural: a very large painting applied directly to a wall or ceiling

neoclassical: a revival in the 18th and 19th centuries of ancient Greek and Roman art styles, characterized by order, symmetry, and simplicity of style; see classicism

Neoclassical painting, page 222.

parquetry: inlay of wood, often of different colors, in a geometric pattern

pointillism/pointillist: a style characterized by the application of paint in small dots and brush strokes

Pointillist painting, page 224.

polychrome/polychromed/polychromy: many or various colors

Purism: a movement linked with the modern aesthetic of "machine art" established in Paris from about 1918 to 1925

recto: see verso

rococo: a style of art beginning in France in the 18th century, characterized by delicately curving, light, and elaborate ornamentation

surrealism/surrealist: a 20th-century literary and art movement that attempts to express the subconscious; it is characterized by dreamlike imagery and strange combinations of objects

Surrealist painting, page 278.

symbolism/symbolist: European art and literary movement of the late 19th century which expresses ideas and emotions indirectly through symbols

tempera: a water-based paint medium that, upon drying, produces a non-transparent surface

triptych: a painting or carving made on three panels, usually hinged together

veneer: a very thin layer of wood applied to the surface of furniture

verso: a left-hand page of a book or the reverse side of a sheet of paper; the other side of the recto

Book of Hours, page 169.

verso recto

volute: a spiral, scroll-like decoration often found in ancient Greek and Roman art

Volute Krater, page 112.

Index

INDEX

A VISITOR'S GUIDE

DIA

Credits

Designed and typeset in Franklin Gothic
and Melior by Three Communication Design,
Chicago

Printed by Toppan Printing Company, Japan

All photography copyright DIA Photography
Department (Dirk Bakker, Director, and
Robert Hensleigh, Associate Director).
Other photographs courtesy of DIA Museum
Archives; Charfoos & Christensen, P.C.,
(page 72); Mike Ditz (cover, pages 3, 4,
13, 16, 17, 18, 20, 50, 51, 92, 130, 236,
239, 266, and 281); and Elsie H. Peck
(pages 95 and 98).

The paper used in this publication meets the
minimum requirements of American National
Standard for Information Sciences—
Permanence of Paper for Printed Library
Materials, ANSI Z39.48–1984